ART OF THE SIXTIES AND SEVENTIES

ART OF THE SIXTIES AND SEVENTIES

THE PANZA COLLECTION

Interview
with Giuseppe Panza
by Christopher Knight

Preface by
Richard Koshalek
Sherri Geldin

RIZZOLI
NEW YORK

First published in the United States of America in 1988
by RIZZOLI INTERNATIONAL PUBLICATIONS, INC.
597 Fifth Avenue, New York, NY 10017

Copyright © 1987
Editoriale Jaca Book spa, Milan, Italy

ISBN 0-8478-0916-1
LC 87-43270

On the jacket
Robert Irwin, *Varese Window Room*, 1973

Printed and bound in Italy

Contents

ERRATA CORRIGE

A pagina 59, terz'ultima riga, invece di Maurizio Michetti si legga Maurizio Mochetti.
Nella didascalia della tavola a colori n. 20, invece di *Vestigal Appendage* si legga *Vestigial Appendage*.
Nella didascalia della tavola 53, invece di DJ 10 si legga DJ 11.
La didascalia n. 67 si riferisce alla tavola a colori che segue.

ERRATA

In the caption to the color plate n° 20, *Vestigal Appendage* should read *Vestigial Appendage*.
In the caption to plate 53, DJ 10 should read DJ 11.
Caption 67 refers to the color plate that follows.

FE DE ERRATAS

En la leyenda de la lámina a colores n. 20, en lugar de *Vestigal Appendage* léase *Vestigial Appendage*.
En la leyenda de la lámina 53, en lugar de DJ 10 léase DJ 11.
La leyenda n. 67 se refiere a la lámina a colores siguiente.

Foreword

Conducting an interview is a bit like trying to drive through a snowstorm while looking only in the rearview mirror: You have a vague idea of where the destination lies (even if you can't see it in the blinding distance ahead), but the only way to inch resolutely forward is to keep your thoughts spiraling resolutely backward. In part, the aim is purely archival: to record, in the respondent's own voice, the people, places, and events that have been of primary significance in his past. Equally important, however, is the goal of articulating such decidedly less concrete but nonetheless tangible qualities as the sensibility, convictions, personality, and values that have given shape to a human life.

Fortunately, this approach is perfectly appropriate to a conversation with Milanese art collector and businessman Giuseppe Panza di Biumo. Ask him about a Robert Rauschenberg "combine", a James Turrell light-and-space installation, or a Robert Ryman painting of delicate, feathery-white brush strokes, and he quite naturally responds with an erudite reference to Leonardo's *Virgin of the Rocks*, an aspect of Renaissance philosophy, or a detail in a painting by Raphael. The union of past and present, cast as an intricate relationship between nature and mortality, is a leitmotif in his understanding of the very character of art; and these perceived qualities of art itself have informed the remarkable progress of his life as a collector, as well.

The interview on the following pages was conducted in three-hour sessions over a sequential three-day period in the spring of 1985. Six weeks earlier, the Los Angeles Museum of Contemporary Art had opened the inaugural exhibition of eighty paintings and sculptures, encompassing Abstract Expressionist and Pop art, that it had acquired the previous year from the Panza Collection. On the mornings of April 2, 3, and 4, we sat in a hotel room on Sunset Strip, high above the haze-filled basin of Los Angeles, and talked about Panza's life, his family, the development of his abiding interest in art, the philosophical crisis engendered by the human tragedy of World War II, the "mail order" purchase of a Franz Kline painting that sparked his affinity for postwar American art, his faith in nature as pre-eminent touchstone and, not least of all, the healthy blend of insight, luck and even errors that conspired to shape one of the most important private collections of contemporary art in the world today. This book constitutes a catalogue of the entire collection and a reflection on its formation.

The interview was conducted as part of the oral history program of the Archives of American Art, a department of the Smithsonian Institution, Washington, D.C., and was funded through a generous grant from the Edythe and Eli Broad Family Foundation.

Los Angeles 1986 Christopher Knight

Preface

Giuseppe Panza di Biumo has emerged in his lifetime as one of the most significant collectors of the art of our era. His commitment to the art of his time calls to mind such celebrated predecessors as the Medicis in Renaissance Florence, Duke Vincenzo I Gonzaga in 17th-Century Mantua, Richard Boyle, Earl of Burlington, in 18th-Century England, and Gertrude Stein and her brother Leo, Dr. Albert C. Barnes, and Samuel Courtauld in 20th-Century Europe and America. Each of them created remarkable collections of art reflecting their respective periods in history, at the same time establishing vital links with the seminal artists who were then advancing the various disciplines of art.

Theirs was not simply a passion to amass the very best work being produced at a particular time, but to actively engage and support the leading artists of the period, thereby affecting the evolution of art history in a profound fashion. While the collected or commissioned works themselves survive in the world as permanent testimony to the superb aesthetic judgement shared by these collectors, equally essential to their ultimate achievements was a certain spirit of inquiry that inspired them to seek and confidently support the most compelling artists then at work. In addition to their responsiveness to and acceptance of new ideas, it is also a strong commitment to patronage that distinguishes these universally respected collectors and that assures Dr. Panza a place among them.

While the works Dr. Panza has assembled over two decades obviously carry tremendous inherent value, they do not in themselves confer upon the collector the unique status he has achieved. Rather it is the combination of a probing and prescient eye, an intellectual rigor, and a quest for beauty and understanding that together have propelled Dr. Panza to make a truly distinctive mark on the world of art. It would seem, in fact, that he did not set out to be a "collector" at all, but was almost predestined to assume that role by virtue of his highly inquisitive attitude, which has come to characterize his approach to contemporary life. It is his desire for an integrated understanding of the complexities and nuances of human existence that have drawn him to the art of his time.

In the mid, 1950s, Dr. Panza began building what was to eventually become an extensive collection by acquiring the work of Antoni Tapies, whose work he found to "reflect aspects of traditional Spanish spiritual life."[1] He then turned to the work of the French expressionist Jean Fautrier, in whose work he perceived a "refined sensitivity to color and shape, an almost post-impressionist sensibility for the beauty of color and elemental shapes of matter." In both cases, Dr. Panza's acquisitions were prefaced by a prolonged and serious study—a search for the elemental meaning behind the works of art.

Following a trip to the United States, Dr. Panza became intrigued by the pioneering work of American artists: the New York School paintings of Franz Kline and Mark Rothko; the transitional and historically important «combines» of Robert Rauschenberg; and the pop culture-inspired imagery of Claes Oldenburg, James Rosenquist, and Roy Lichtenstein—works that had not been extensively shown or collected in Europe. With each individual artist, Dr. Panza felt compelled to acquire a defined series of works that would more comprehensively reflect the scope and depth of that artist's expression. "My experience was not simply intellectual but also the opportunity to share life in some way with the artist."

Although Dr. Panza's early collecting primarily involved paintings, even then the appropriate installation of these individual works was of paramount importance. He strongly believed that the works of each artist should be presented together within their own controlled space, allowing for a reverberating energy among them and thus making possible a greater comprehension of the artist's ideas and concerns. This instinctive sensitivity on the part of the collector to the inseparability between works of art and their installation spaces logically evolved into the exploration of environmental works which he began to pursue in the mid-1960s. Focusing on such artists as Donald Judd, Dan Flavin, Sol LeWitt, Bruce Nauman, Richard Serra, Robert Morris, Robert Irwin, James Turrell, Douglas Wheeler and Maria Nordman, he devoted his energies to studying the perceptual, intellectual and emotional impact of this symbiotic interchange between the work of art and a specific space.

In particular, Dr. Panza's intensive involvement with artists of Southern California derived from what he perceived to be their forging of a "new kind of relationship between man and his perception of space." He considers the work of these artists to be "extremely important in art history, because something new has been discovered. This discovery is related to the development of space exploration, because it was necessary that scientists consider experience beyond the earth and acquire knowledge of an environment that is completely alien to human senses." Dr. Panza finds the works of Robert Irwin, James Turrell, Maria Nordman, or Doug Wheeler to have a resonance beyond their existence as art—to possess a fundamental connection to the broader questions of life itself.

By his own account, it was "a deep interest in being alone, a love of the desert, a need to live in a silent space, and a pessimistic attitude toward the reality of daily life" that initially drew Dr. Panza to an artist such as Antoni Tapies, but these same fundamental forces are equally manifest

[1] All quotes from Dr. Panza are from an interview with Julia Brown Turrell included in *The First Show: Painting and Sculpture from Eight Collections, 1940-1980*, ed. Julia Brown and Bridget Johnson (Los Angeles: The Museum of Contemporary Art, in association with The Arts Publisher, New York, 1983), 69-90.

in this affinity for the minimal, conceptual, and environmental works that form the later part of this collection. Just as Dr. Panza refuses to be constrained by the established art historical dogma that separates the artist of one idiom from another, so too does he discard the automatic assumption that what is contemporary is by definition distinct from what is past. While he acknowledges that the shapes, forms, and artistic approaches may be different, he maintains that the essential ideas, the foundation of each really important work, are basically the same. "We cannot believe in art if we do not believe in some kind of unchanging attitude toward, or a timeless standard of, what is beautiful, what is important, and what is essential in life."

Here is a collector whose primary impulse has been not to enrich his personal domain by acquiring the cultural symbols of his time, but rather to enhance his understanding of the evolution of mankind through the continuum of art. This is not a collection formed either in self-tribute or in tribute to the artists whose work is included, but an investigation into humanity itself and the enduring qualities that have set mankind apart in the universe. Dr. Panza sees art as "the visualization of men's minds," and he considers the artist in society to be a window of sorts through which we can gain a deeper understanding of life.

The activity of collecting therefore becomes one that requires a serious commitment of time and extended periods of concentration. To identify a "masterpiece" is to find a work that holds repeated surprises and new discoveries, even after multiple viewings over many years. And to collect such masterpieces cannot, according to Dr. Panza, be learned, but rather must be a genuine and intuitive expression of the collector's unique sensibility.

Richard Koshalek
Sherri Geldin

Interview with Giuseppe Panza

CHRISTOPHER KNIGHT *We should start at the beginning: When and where were you born, and what were your parents like?*

GIUSEPPE PANZA I was born in Milan in March 1923. My father was from Monferrato, in the Piedmont. He had come to Milan when he was very young, and he was in the wine business. It was a business of wine distribution from the south to the north, from the area of production to the area of consumption, buying when the market was low, selling when the market was high. The task of a good dealer. My mother was from Varese, and her family was also in the wine business. My parents had four sons; I am the third.

My father always lived the life of the good bourgeois in Milan. He was very successful in business and increased his wealth substantially, but he was also a man with great respect for people and for work. He worked hard all his life. Because he had a very strong will and a feeling for opportunities in life, he was able to make wise decisions at the right moment. In business, when he realized he had to lose money he was ready to lose money, because to lose some soon was better than to lose more later.

CK *So he was very down-to-earth and practical?*

GP Yes; he was devoted to reality, to making his life useful. He came from a family who lived in a small town in the Piedmont, near Alessandria. My grandfather was not a wealthy man; he was a dealer, too, and had a small business in his town.

My mother was completely different. Her family was her main interest, but she also had a sensibility for fine things. Before she married, she liked to paint. Some paintings are still at home, and they're good, because we can feel how she liked to look to nature. When I was a boy she brought me to see museums and exhibitions, especially on Sundays.

My mother's sister had the same interest in art. Even when she was very old she liked to paint. My aunt was different in temperament from my mother, a very active woman. She married an in-

dustrialist. When my uncle died, she ran his business. She went through difficult times but ran the business well. When she retired, she spent weekends driving to see museums and old cities. She had a love for art.

CK *Did you travel much in Europe when you were young?*
GP No. We traveled to Rome, Florence, Turin—in Italy, mostly, but rarely outside the country. We did take a long boat trip to Spain and Portugal in 1932 and another to Istanbul in 1933. But we didn't travel much.

CK *When did your family acquire the Villa Litta in the town of Varese, north of Milan?*
GP The house was bought by my father in 1931. It was built in 1751 by the Marquis Menafoglio, who was a banker. During the time of Empress Maria Theresa, the Duke of Modena was also the governor of Milan, and the Marquis Menafoglio was his minister of finance. All important people in Italy needed to have a large house as a symbol of power. In 1780 the Marquis died, and his son sold the property.

Early in the 19th century it was bought by the Litta family. They had political difficulties during the war against Austria for the unification of Italy. They were liberal, and they were involved with Napoleon when the French came to Italy. When there was a revolution against the Austrians in 1848, the Litta family paid to equip a regiment of soldiers against them. General Radetski, the Austrian soldier in command of northern Italy, seized the family's property.

CK *How did your family title come about?*
GP It was given to my father in 1940 by the King of Italy, Vittorio Emanuele III. My father was active in business, a wealthy man, for many years mayor of the town where he was born. He was the head of several public associations related to wine production. For these reasons he was given his title.

CK *Would you describe your family as intellectually inclined?*
GP Well, my father was a man who didn't read much. He started his business very young. An uncle, the brother of my mother, had a lot of interest in art. Before the last war he restored a castle, built in the Middle Ages near Varese, that he had bought in the '30s. He restored many frescos in this building, paintings of the 13th, 14th and 15th centuries that were all under a coat of paint. When I was a boy I liked to help him. There was a restorer doing the main job, but it was easy to remove the coat of paint with a small blade. I spent hours removing this coat of paint in order to see the frescos come out.

CK *You grew up in a city that houses one of the most famous paintings in the world—Leonardo's Last Supper—as well as the extraordinary Brera Museum. What is your earliest recollection of art?*
GP In the '30s my father bought an old farm, and there were many paintings left in this old house. Some were good. So this was my earliest interest in art. But when I was fourteen years old, I got

a disease common among young boys: scarlet fever, which is contagious. So it was necessary to be out of school, segregated in a room for forty days, to avoid the spread of the disease. In my room I kept an Italian encyclopedia—a very large one, about thirty-five books—with a lot of space and pictures devoted to art history. I spent these forty days studying art. By the end, I was able to hide the label below each picture and tell the name of the painter, the school, the approximate date. I learned a lot. It was mostly Italian art, but not modern. The encyclopedia only went up to the 19th century, not the 20th. This was in 1937.

CK *Had you studied art in school?*
GP No. In the gymnasium, which is the middle school in Italy, there was no art teaching. Only in the last three years of high school, and then only one hour a week. When I entered high school, I was the best in the class!

I was interested in every kind of cultural activity. I liked to read poetry; I liked philosophy, history, literature. Between sixteen and eighteen I read Dostoesvky and Tolstoy. I was fascinated by Dostoevsky. I felt very close to his world, because the problems he explored in his novels were very close to my problems. When I was fourteen, I began to have psychological problems, as all young people have. I was very pessimistic. One way to be happy was to read, to have culture, which was against the main trend of my family life. I was educated at a time in Italy when the authority of the father was important. My father had some kind of religious respect for work, and for people who worked. People who were just thinking, not making something, did not have his consideration. And I was a son who liked to think. He was really worried about this, and believed I was a "lost son" who would be unable to run the family business. Happily, I had an older brother.

CK *Did you fight about this with your father?*
GP No; it was impossible to fight with my father. He was a man with a very strong will.

CK *This was in the late 1930s; what effect did the political situation in Italy have on you?*
GP Almost everybody in Italy was a Fascist. In the beginning the Fascist regime was popular, because Mussolini was successful in most everything he did. He overcame the economic recession of the '30s. He made that stupid war in Ethiopia because the Italians felt deprived of something after World War I. We had an inferiority complex in relation to France and England. These two countries had great power because of their colonies, but Italy and Germany had nothing. The ambition to be as powerful as France and England was strong, and Fascism used this to win popularity. Unions had become stronger, and people of the middle class felt that a left-wing revolution was possible. There was fear of a communist uprise. Fascism was able to use this situation to gain power.

A few were against Fascism. Young people were educated in the Fascist way, but I had a chance. I wasn't interested in studying Latin and mathematics, so I couldn't go to public school. In Milan, there was a very good private school, called Malagugini, made up of teachers who had been fired from the public schools for political reasons: they wouldn't teach in the Fascist way. Malagugini was excellent because it was made of the best men in the public schools. It was named for the head

of the school; after the war he became a deputy in Milan, from a left-wing Socialist party. So the school had a liberal, socialist orientation.

CK *Milan had been the center of the Futurist movement in the 'teens, and it's generally felt that Futurism played a significant role in shaping Fascism. Were you aware of Futurist art?*
GP Yes, but in the '30s there was very little interest left in Futurism. Most people judged Futurism a strange idea; there wasn't much interest in it anymore. Good art was "well-painted art," not this strange alteration of shapes. We were going into a conservative situation, and there wasn't much interest in contemporary art. I remember in 1931 there was the first exhibition of Modigliani in Milan, which caused a lot of talk. My mother and aunt brought me to see it, but I don't remember much because I was too young. But they weren't much interested in Modigliani; they liked Italian Renaissance masters like Titian or Michelangelo.

CK *Tell me about your life during the war.*
GP I was in Milan at the beginning of the war but wasn't drafted because I was still a student. When the armistice came on the eighth of September, 1943, and the north of Italy was under the control of the German army, I was on the list to be drafted by the Germans. In order to avoid this, I left Italy and went to Switzerland as a political refugee. My brother was in the Italian army, but when the armistice came he was not willing to fight for Germany. I went with him to Switzerland and spent a year and a half there until the end of the war. The war had a devastating impact. I came back to Varese in May 1945. Varese is north of Milan, and only a few miles from the Swiss border.

CK *When you returned from Switzerland, did you go back to school?*
GP I was a student of law in Milan, and I graduated as a doctor of law in 1948.

CK *I imagine your father was pleased with your law degree.*
GP Oh yes, he was very pleased. He realized I was willing to work for the family business rather than become a philosopher! I had my degree in '48 and started to work, but my father died in '49. For me, to work in business was a painful decision. After the war, the wine business was closed and my father began a business making industrial alcohol. He also had a business in real estate, which I thought was better to develop. I felt my temperament was not adapted to working in trade, because I did not have the capacity to make quick decisions. When you work in trade, you have to make quick decisions—to sell when you realize the market is going down, to buy when you realize the market is going up. But I was a very slow thinker. So trade was something completely alien to me. I felt very uncomfortable.

CK *Did you continue to pursue your interest in art?*
GP Oh, yes. When I was in the refugee camp in Switzerland, I bought a lot of books on philosophy, art history, literature, poetry. This period in Switzerland was good for me, because my vision of

life changed. I felt very deeply the changes happening from the war. The rationalist vision of life and the idealist philosophy of culture had been popular in Italy. But I came to feel it was not a good answer to real problems, because the war was such a tragic event. It was deeply shocking to the belief in man's rational capacities that had developed since the Renaissance. Science had become the religion of Europe, and we had believed reason and science would make everything better. To see how reason was failing totally during the war was a great crisis for European culture.

I had been interested in Renaissance art history, and in Titian, Michelangelo, Leonardo, Giorgione, Tintoretto, Botticelli. Piero della Francesca was perhaps the one I liked most. I believed Raphael was superficial—which was a mistake I understood only a lot later.

Rationalism and expressionism are the main aspects of art—death, life, suffering, why we have to suffer, why we have to die. These artists lived with these problems, which were important to me.

CK *Piero's art, especially, is completely rational, ordered and clear, but it's taken to such lengths that it becomes almost abstract.*
GP Yes, because he realized art is a vision of something ideal. It was the projection of a perfect world which the artist has seen, but which is not real. It's an attempt to make it real. When we look at nature we find that this ideal beauty could exist, because nature has this quality. When I was young, I liked to be in the country, to be alone in the mountains, to walk alone in the garden at night when there was a full moon. I felt happy just being in nature.

CK *You began to collect contemporary art in 1956, yet most of the artists you have mentioned so far are not contemporary. How did your interest in new art develop?*
GP I wanted to make a collection of high quality, and to buy paintings of high quality from the past was financially impossible. I was not willing to have second-rate paintings. This was the first requirement of the collection.

Also, I was always very curious about the new. In Switzerland I had read many books about science, biology, natural history, physics, astronomy. The attempt of physical theories to understand the mystery of matter is a fight between the known and the unknown. I was interested in new art because it was something yet to be understood. Through art history I realized that many artists were not understood in their own time. I was interested to know why van Gogh, during his lifetime, never sold a painting. It was something strange to me. For this reason, I believed my task was to find the best new artists. And with the limited means available to me, it was the only way to make a collection of masterpieces, not of medium quality paintings. When I realized that something was second-rate, it was impossible to keep in front of my eyes. I had to push it away.

A painting has to be very beautiful or it cannot be with me, because I have a personal relationship with the work. A beautiful work speaks to me in an endless way, because each time it looks different. When I am sad and look at a beautiful painting it changes my mind. But I have to throw a bad one away.

CK *How much time elapsed between your decision to start collecting and the first purchase you made?*

GP A short time. I began after I got married in 1955. I had a house with empty walls. Because I had early 19th-century furniture, in the beginning I bought some paintings of this period, just to fill the house. But I also had some money to spend, and the first thing I wanted to do with it was find good paintings. So I began a systematic investigation. I looked at Italian art in Milan. Afterward, I went to Paris to look at art made in France. I bought several paintings by young artists, some Italian but mostly French. I realized a year later that these paintings were no good.

This search began in January 1956. But the first important purchase was made in the spring of 1956 in Paris, when I bought several paintings by Antoni Tapies. In September, or perhaps October, I read an article in the magazine *Civiltà delle Macchine*, which means "The Civilization of Machinery." It was a good magazine, published by the state-owned steel industry. There were some pictures in it of paintings having some relationship to industry, such as Charles Sheeler's. There was also a Franz Kline, because it looked like a steel structure, only broken. And I was impressed by this image. I read that the painting was from the Sidney Janis Gallery in New York. I wrote to him to ask for photographs of Franz Kline's work, and through them I selected the first painting, which is *Buttress*. The price was about $550. I asked Sidney Janis to reduce it to $500. He agreed.

CK *A mail-order purchase! Were you at all surprised when the painting arrived at your door?*
GP Oh no, I was very pleased. It was better than I was expecting. I loved Franz Kline because it reflected my state of mind. I always had this desire to reach something I could not reach. Man is born in order to be happy, but he cannot be happy. We want to reach perfection, but we cannot. We are deeply deprived of perfection, and deeply deprived of happiness. The world has limits. This opposition of reality and desire for something more beautiful was always strong in my mind. The images made by Kline gave me the same feeling. This man was looking for something which was impossible to have but desperately needed. This kind of stress was my condition, and I felt close to his art for this reason.

CK *Had you imagined what sort of scale this picture would have? It's a very small painting by Kline's standards.*
GP Yes, this one is small for Kline, but it was already bigger than the European scale. I was coming out of a culture in which the paintings of Morandi were the usual size. Three feet was already big. Before the war there was the belief that a smaller painting was better than a large one. The paintings of Paul Klee, for example, were perfection because they were very small. To realize something small was to do something more perfect, more beautiful—perhaps it came from the confrontation with Baroque paintings in the churches in Italy; they were big paintings but with little meaning.

CK *When you bought the Kline painting, had you ever been in the United States?*
GP I had made a long trip between 1953 and 1954. After my father's death. I was interested in doing something else. I was paying attention to the real estate inherited from my father, but my eldest sister was also working in the administration of the real estate because she was not married. My sister had some of my father's qualities, but not the best ones. She was very authoritarian.

22

She had a kind of idolatry for my father, and believed what my father said had to be followed but not discussed. She had no consideration for my interests in art and philosophy, in things that did not provide income. So there was always a potential fight between this sister and me. For this reason I made this trip, first to South America, then to North America, to learn about business. I spent several months in Brazil and Argentina, and then seven months in America. I didn't speak English. I spent three months in New York to learn English and then traveled through Canada, California, Texas, Louisiana, and so on.

CK *Did you look at art in America?*
GP Yes, but not much. I went to the Metropolitan and to the Museum of Modern Art, but I didn't go to galleries. I wasn't yet collecting. I was more involved in finding a solution for my life as a businessman. I visited many kinds of industries.

I was fascinated by life in America, by the landscape, by a kind of life that was more free. In Italy there was a lot of social convention. In America the relationship among people was based more on individual capacity, not on social ranking. Crossing the continent there was nature still untouched, still as it was before the emigration of the white man. The light was so different from the north of Italy, which is always gray and foggy because of the humidity. Here, especially in the midwest and the west, the light is pure. It gives the sense of a world which is more ideal.

When I went back to Italy I believed America was starting a new kind of civilization. It was possible to develop a different culture, because the social situation was so different from the European one. We have the weight of the past, of what was inherited from the centuries. Respect for rules made in the past was too strong. In America, perhaps it was possible.

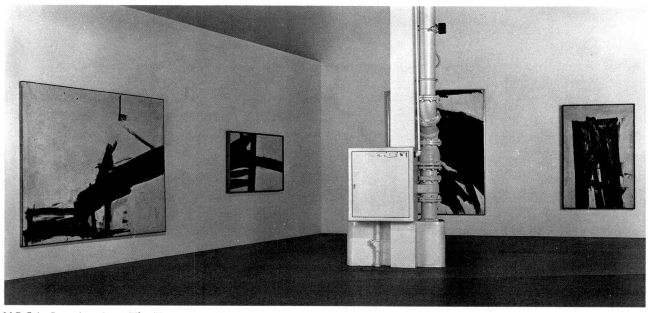

MOCA, Los Angeles, «The Temporary Contemporary», February-September 1985, Kline Hall.

CK *When the Kline painting arrived at your door a few years later, did you sense in it any of what you had felt in America?*

GP Oh, yes. I felt strongly the life of New York. I was very impressed the first time I went to New York. For me it really was a new world. It looked to me like a romantic city—a city struggling for things impossible to have but that it was trying to have anyway. The only goal was the infinite.

CK *Your mother passed away shortly after you began collecting?*

GP Yes; she died in November 1956.

CK *In 1956 and 1957, you were buying Tapies and Kline; the following year you began acquiring work by Jean Fautrier and in 1959 Robert Rauschenberg and Mark Rothko. What led you, from the beginning, to concentrate only on specific periods of an artist's work, and to buy several pieces from those concentrated periods?*

GP Because I was looking for the best period of each artist. Artists of the 20th century, more than artists of earlier times, have a shorter period of strong creativity. When this period is finished, the later work is not as good as the earlier work. There are exceptions to this rule, like Picasso, but they are few. But even in Picasso there are periods that are better than others. Braque is an example, because the Cubist works are very much better than all the others made after.

CK *Why do you think 20th-century artists have shorter periods of excellent work?*

GP Information runs faster and the social context changes much faster than before. Each artist develops his work in a context, and if this situation changes, art changes. De Chirico is a clear example: He made masterpieces between 1912 and 1918, but afterward the quality of his work went down. For others, like Morandi, it was not the same, but most of the artists of the beginning of the century, the historical avant-garde, stopped doing important work around 1930. Miro made his best work before. Dali also. And Magritte. Max Ernst, too.

CK *So you have no interest in "late De Chirico" or "late Picasso"?*

GP No. The market is buying the late period works of artists anyway, because many people don't understand art but like to have it, so they buy the signature. They don't buy the painting. They pay for the reputation of the artist, not for the work itself.

Tapies made his best work between 1955 and 1959. Like other European artists, Tapies lived through the crisis of the last war. If you look at his paintings you always see the matter of the earth and forms that look like dead bodies. Near the edge you will see the horizon, but never the sky. The colors are all dark, and you have a pessimistic vision of life. But this was the attitude of Europeans after the tragedy of the last war. We needed to find new motivations, valid motivations, to start from the suffering of the crisis that all Europe was going through.

CK *At this time did you make it a practice to meet the artist when you bought his work?*

GP In some cases it was necessary, but it wasn't a goal for me. What was important was to see

as many of his works as possible. And to have documentation, to have many photographs. I spent much time at home just looking through photographs, which is useful if you have already seen the original. You can have an intuition about what the artist wants to express, but in order to be sure you have to live with the work. I spent all my evenings at home looking at paintings, or looking at photographs and documentation. Only in this way do we know the artist; we rebuild his mind inside our head. This kind of partnership with the work is beautiful.

CK *Shortly after you began collecting Rauschenbergs and Rothkos, in 1959, you stopped buying the work of Tapies. Subsequently, you've collected primarily work by Americans and very few by Europeans. Why?*

GP A very simple reason: in America there were more important artists than in Europe. Soon after the war, the best artists in Europe were Fautrier, Jean Dubuffet, and Wols. In America, only Dubuffet is well known. Francis Bacon was important, but in some way he was very far from my vision of art. Even if I respected him very much, I was never too interested in his art. I was shocked by the Bacon world. It was too expressionist, a kind of expressionism with a wrong erotic attitude. I was more interested in American art. Rauschenberg and Jasper Johns had a different vision.

Also, their relationship to Duchamp was very interesting. I discovered Duchamp through Rauschenberg. Before, I didn't pay too much attention to Duchamp; his work looked too eccentric. But what looked too eccentric to me was not at all. I realized that his ready-mades are not objects picked up to show his own choice, but are made in order to give the viewer the opportunity to make an analogical connection to other facts related to his own life. This I discovered through Rauschenberg, and because of Duchamp I started to look at Italian Renaissance art in a different way.

I looked at Leonardo da Vinci with more attention, and I discovered another Leonardo who was richer and more original than I had thought before. I discovered the field of Italian Mannerist painting, which I had judged of not very good quality, and I discovered how great these artists are. I understood why Raphael is great: what is important in Raphael is not the first look, but what you see slowly, paying attention to the details. The detail becomes a painting in Raphael; if you look at a finger of the virgin you see a landscape, because this finger is an element of nature.

This steady transition from the part to the whole is extremely interesting, and I understood it through Duchamp.

Before, I always had a very emotional relationship to art and not enough of an intellectual relationship. Through Duchamp I realize how this intellectual relationship opened up new emotional fields, which cannot be perceived if we stop at the image.

CK *So Duchamp was the source of a more conceptual interest in art?*
GP Yes.

CK *Were you spending much time in New York then?*
GP Well, I was going once or twice a year, and each time spending two weeks.

CK *Coming from Italy only once or twice a year, how did you find artists whose work you wanted to see? Were there dealers or critics or curators you were listening to?*

GP I was always asking people which young artists were interesting to see. I had a long list of names and went to galleries and studios all day. I always gathered documentation, and when I was back in Milan I looked at it. After long study, I decided what to buy. I was sure the work had to be purchased to the largest extent possible.

CK *The eleven Rauschenbergs in your collection are astonishing. How did you first learn of his work?*

GP I knew of Rauschenberg through John Cage. He came to Milan in 1958 to work at the Italian National Radio in the studio of electronic music—with Berio, I believe. He knew that I was buying American art, Kline and Rothko, and for this reason he was willing to meet me. He came to lunch at my home and spoke to me about Rauschenberg and Jasper Johns.

I bought the first Rauschenberg not from Leo Castelli but from Larry Rubin, because he had a painting he was willing to sell called *Kick Back*. It was shown at Documenta in Kassel in 1959, where I saw it. In the catalog I saw it belonged to Rubin, and I bought it from him for $750.

At the same time I wrote to Leo to send me photographs, but he didn't send them. He told me sometime later he didn't believe an Italian was really willing to buy Rauschenbergs! Anyway, he finally sent the photographs and I began to buy Rauschenberg's work. In 1960 I was in New York and went with Leo to the warehouse—a room full of beautiful Rauschenbergs of the '50s. I bought several.

CK *John Cage had also spoken to you of Jasper Johns; why didn't you collect his work?*

GP Because Johns was making very few paintings, and a few collectors in New York were buying them. They could come to his studio and buy the painting as soon as it was finished. I wasn't interested in commissioning work, or in asking an artist to keep a work for me, because I wanted to choose. I never bought without having seen the work, so I lost the opportunity to buy Johns.

CK *You bought Rauschenberg's* Factum I, *but not* Factum II. *Why not?*

GP *Because I didn't understand the relationship between the two paintings. I chose Factum I because it looked more beautiful than Factum II. I didn't understand it would be better to keep the two paintings together. Rauschenberg made the same kind of operation as Leonardo da Vinci did with the Virgin of the Rocks. Leonardo himself made the first version, that is at the Louvre. And in collaboration with his best pupil, Ambrogio de Predis, he made the version that is in London. They are very similar. It's often difficult to find a difference; only some details are different. The quality of the two paintings is excellent. Both are beautiful. And this introduced the problem of duplication: what is the original, and why can't the copy be like the original? How important is the hand of the artist? Does the artist have to do the work himself, or could it be made by somebody who followed the artist's mind very closely? Is the work of the hand more important, or of the mind of the man that makes the hand work?*

This is the problem, and this is why it would be very important to keep the two Rauschenbergs

together. But at the time I hadn't yet understood Duchamp and Leonardo enough. I believe *Factum II* is now in the Neuman collection in Chicago.

CK *Whether or not their reputations were widely established, most of the artists we've been discussing had been working in their mature styles for at least a few years when you began to collect their work. But in 1962 you began to acquire the work of Claes Oldenburg, Roy Lichtenstein, and James Rosenquist. They had only just begun their best work. After six years of collecting, were you feeling more confident in your own taste?*
GP Oh, yes. I believed these artists were important.

CK *Three of the Lichtensteins you acquired form a wonderful capsule response to Abstract Expressionism. There's the diary, which is "autobiography"; the slab of meat, which is "beefy"; and the hand-grip exerciser, which is "muscle". All three are painted as machine-made reproductions. It's a very neat critical commentary on the cliches of Abstract Expressionism.*
GP The connection between Abstract Expressionism and Pop art was made through Rauschenberg. If you look at Rauschenberg, you see the sign of the painting. For this reason it was natural for me to arrive at Pop art.

When the Rauschenbergs first came into my house there were some people who were interested, but few. Some were fascinated by the work of Rothko, Kline, Tapies, but to see Rauschenberg's art, so different, so vulgar, made with objects found by tipping over a trash can, was a scandal for these people. But I was greatly interested in Rauschenberg's work because of its relationship to the past. His work is an inducement to memory. All the ties are made to something real, which is fading away. The perishable materials—the paper, the wood, the objects—add distance to memory. It's a matter of fact, but we experience it as the distant past. Through memory it's in some way changed, made more beautiful, because it loses reality and becomes more an ideal reality. This process is very strong in the work of Rauschenberg, especially from the '50s.

CK *It would seem a very long way from Fautrier and Tapies to Lichtenstein and Oldenburg, but you just used the word "perishable" in relation to Rauschenberg. In my review of the portion of your collection now owned by the Museum of Contemporary Art in Los Angeles, I suggested that a notion of death and rebirth informed all the work that you acquired between 1956 and the early 1960s. Is there any legitimacy to that speculation?*
GP Oh, yes. I believe this opposition of death and life, and the search for endless life, is a constant problem of every human being. If we didn't have the notion that life, in some way, will go on, it would be impossible to live. To have this hope is essential to living. When we realize that we will have to disappear, it is something really shocking, a deep wound in our being. We are crushed by the fact that we cannot live forever.

CK *In addition to questions of mortality, what other philosophical threads do you see running through the work in your collection?*

GP The problem of truth. It is the basic problem of philosophy, whether knowledge is relative or absolute. Is there something which is true, valid forever and in any situation? I was always interested in this problem because it's the basic problem of philosophy. If we don't solve this one, we cannot solve any other.

CK *Is it a problem that can be solved?*
GP No, but we have to try to solve it. We cannot be quiet if we don't try to solve it. We are human because we are trying to solve this problem that cannot be solved. But we can prove that wrong solutions are wrong, and this is very important.

CK *On a rather more mundane level...why did you acquire only four pictures by Lichtenstein?*
GP Because I made a big mistake. It was one of the biggest mistakes of my life as a collector. In 1962 I bought seven Lichtensteins for $600 each. My wife, Giovanna, didn't like Lichtenstein. She is always with me in my judgments of art, and is the main support for the collection. Without her it would be impossible to have the collection I have. She's smarter than I. She understands immediately if an artist is good or not. She tells me, "Don't buy, it's no good", or "Buy, it's good." I don't trust her immediately because I want to study, to think—but I arrive at the same conclusion! She understands sooner. But on the Lichtensteins, we had different judgments. I liked them very much, but she didn't. So I decided to trade in three Lichtensteins for three Rosenquists — which was not really a mistake. But it was a mistake to lose the Lichtensteins, which were beautiful. It was 1963. I traded with Sperone, a dealer in Turin.

CK *What paintings were they?*
GP One was a ring on a cushion, called *The Engagement Ring*. Another was the hand of a woman with a sponge cleaning a glass window. The other was called *Engagement*, a very beautiful painting with a boy and a girl exchanging an engagement statement. Every time I think of this mistake I feel bad!

CK *Yesterday I was talking with Andy Warhol, who had just come from seeing your collection at the Museum of Contemporary Art. He was very complimentary and very sorry that he wasn't represented in it.*
GP Yes, that was another mistake. When I was in his studio it was full of beautiful paintings, about fifty of them, one atop the other. This was in the fall of 1962. There were all the most famous paintings, many of which I saw in the Saatchi collection two weeks ago. Then, they were for sale for $600 and I didn't buy. I believed Lichtenstein was better, and in 1962 Warhol looked to me very close to Lichtenstein, but not as good. But it was a mistake, because it wasn't true. They're very different. Lichtenstein's goal is to make beautiful what is not beautiful, to make archetypal images of common images, images that don't have any aesthetic quality. He gives cultural dignity to images that don't have any. This way of making art is very close to the way of making paintings in the past, when the image was an opportunity to make something beautiful. It com-

28

Arturo Schwarz, Marcel Duchamp and Giuseppe Panza, Milan 1963.

pletely loses its usual capacity for communication, because it's no longer just information.

Warhol is very different, because his art is a criticism of American society. His goal is to show how this society is wrong. He's very harsh, very aggressive in this attitude. It's direct and without compromise. Using photographs is the best way for him to realize this.

CK *In 1962 you also went to Claes Oldenburg's* Store *in downtown New York. What sort of experience was it?*
GP It was a beautiful experience. To reach the *Store* we had to go through the Jewish section in downtown New York, which was full of shops selling used dresses. You had the strange feeling of seeing used dresses as good and beautiful things, so different from what you saw in the shops on Fifth Avenue. The Oldenburg *Store* was on a small street, after the Jewish section. It was glowing with beautiful color. These poor objects, which had lived so long with somebody who didn't use them anymore, so connected to individual lives, were changed into something brilliant by Oldenburg's strong, pure colors. The opposition was strange, very moving. I went to the *Store* be-

cause, a few days before, I had seen his exhibition at the Green Gallery, which impressed me very much. At first I was shocked, because it attempted to make beautiful what was ugly. I realized these ugly things had a strong attraction, that in reality they were beautiful. I asked Dick Bellamy to show me more, and he took me to the *Store*.

CK *In an interview you did with Bruce Kurtz for Arts Magazine in 1972, you said that when you met Oldenburg and saw his work, you felt a relationship with German Expressionism.*
GP Yes, because of the opposition of different colors. The German Expressionists used the same technique of putting very strong colors next to one another—not different tones, but pure colors without any transitions. This was used to give violent force to the expression, and I found the same thing in Oldenburg.

CK *Pop art is usually considered such an American sensibility, but in this case you connect it with a European tradition.*
GP In some ways, yes. Perhaps I am wrong, but it was helpful in my understanding of Oldenburg.

CK *Were there artists who were telling you about other artists that you should see?*
GP Most of the Pop artists I met through Leo Castelli. In his gallery in 1960 I first saw a painting by Lichtenstein, which wasn't so good but was very interesting. In '61 I saw an exhibition of young artists at the Martha Jackson Gallery, with some early work by Oldenburg—which was good, but which looked too much like Dubuffet in some ways. In June 1962 I met Ileana Sonnabend at the Venice Biennale. We had an appointment with Leo. They showed me some photographs of Lichtenstein and Rosenquist, and asked me to see them in New York. So I went in October and bought many works.

CK *The installation you designed for your Abstract Expressionist and Pop works at the Museum of Contemporary Art is very precise. Great attention was given to lighting; there are no labels; an attempt was made to remove all distractions. It's almost chapel-like and very much like the converted stables that serve as galleries at the Villa Litta.*
GP I wanted a situation in which the viewer is inside, not seeing one work but a totality. This is possible only when there's a single artist represented in a room. In some way, you breathe the soul of the artist. This is a quality we can only achieve when there are several works by the same artist together in a private space, without any interference. You live with the artist, you are inside his mind. This is a different dimension, which is difficult to realize in museums.

CK *The precision of the installation is very different from, say, Oldenburg's* Store.
GP Well, in some way it's not. When I was in the *Store*, the whole space was filled with his work, only his objects, so brilliant in color. This accumulation was extremely strong. But when you are in a museum you cannot do the same thing, because to repeat the experience of the *Store* it would be necessary to have forty Oldenburgs, not just sixteen.

CK *You'd also need the Jewish neighborhood to walk through!*

GP Yes, the context was important, influential. You saw a reversed situation in the street outside. When you were inside the *Store*, you saw the same objects in a different dimension, like seeing a person who came back to life.

CK *I'm curious about the reaction of your family when you began to collect art.*

GP Well, the reaction of my family was negative, especially on the part of my elder sister. She was educated under my father's concept: money spent for art was really risky. Investment in art is a volatile investment. If the market is not strong when we have to sell art, we lose money. This was very counter to my father's way of thinking. Indeed, he never bought art. He used an example from the 1930s, when there was a crisis in Italy. There was a rich industrialist that built a large collection of modern art in the '20s, but it was a collection of the fashionable artists of the time. It wasn't French Impressionists, but Italian followers. When the crisis came, he was forced to sell the paintings acquired at high prices ten years before, but they didn't sell because the market was down. This concept was dominant in my family: don't spend money for art because it is a risky investment.

But my wish to have good art was so strong that I didn't pay attention to the advice. I started collecting. At the beginning I was not spending our family's capital, which I had inherited from my parents, but just the income. And I was spending all the income I could spend. I avoided leisure travel or a bigger car. With time, I realized my family's idea was wrong. If we buy art from successful artists the risk of losing money is strong, because later, when the success is over, the value goes down. The best artists aren't the successful ones, they are artists who have real quality related to art history, not to the fashion or the taste of the moment. This was my concept, and I believe it is right because the facts show that it is right. But I always had to fight against my family, against the idea that money spent for art was wrong. Except with my wife, who always helped me.

With time, I was willing to spend more, even part of my capital. I had an inheritance from the family of my mother, and I sold out the estate in order to buy art. And this was judged a crime by my brother and my sister, who saw it as an attempt to destroy the family wealth, the wealth accumulated by a lifetime of work by our grandparents and by our father. I was destroying it; this was their concept.

CK *So you had no investment considerations whatsoever?*

GP No, no. Indeed, it was impossible to have investment considerations when you were buying something everybody else refused to buy. For instance, when I bought Kline in 1956 everybody said that I was crazy, that a child was able to do these paintings, just throwing some black paint on canvas. Even the opinion of competent people—so-called competent people—was similar. A few said that Kline was very good, but the majority were against a positive judgment for Kline. In this situation, to buy as an investment would be impossible to imagine.

CK *Did your sister think the primary reason to buy art was for investment?*

GP She was against any kind of investment in art because she followed my father's concept. Investment in art had to be avoided. It was fine to buy something in order to have some good paintings in the house, to have a better house, but not to have an investment.

CK *To what degree do you think your having collected the work of certain artists has made them successful, or has contributed to their success?*
GP I never bought art with the idea that I would contribute to the success of the artist. I always bought because I was interested in a work's ideas, because I felt it was sympathetic to my way of life, because the vision of the artist was also my vision, because the work gave me new experiences and new possibilities to better understand situations of life about which I had a confused notion. This experience of art gave me the possibility to live better, to understand important things which I was not able to learn otherwise.

I never thought to give a contribution to the success of the artist. I was giving moral and psychological help because I was somebody sympathetic to his work, who understood and loved it. But this was, in my opinion, my contribution to the artist. For a new artist, who usually sees his work refused, to find somebody who liked it could be psychologically helpful. And I also gave him some money, which could be useful for solving his practical problems. But no more than that. I never thought to have any influence on the market.

CK *I understand you were once offered a Jackson Pollock painting for $4,000, and you turned it down.*
GP Yes. It happened that in 1956, when I was buying Franz Kline, I was also interested in other painters. Sidney Janis offered me a painting by Pollock that was less expensive than other drip-paintings because it was made in an unusual way: It was not on canvas but on a large glass plate, about two meters wide and 1.5 meters high. But the price was too high for me. I was buying Franz Kline at $500, and to pay $4,000 for a single painting looked to me to be too much. I would prefer to buy eight Klines with the same sum rather than a single Pollock, even if I realized that the Pollock was very beautiful. Indeed, I believe it is now in a university museum.

CK *Do you regret not having the Pollock?*
GP Oh surely. But unfortunately I have lost many other opportunities. In 1960 I met Barnett Newman. I was in his studio and in his home, and he offered to sell me several works for $6,000—very large works of the '50s, the best of Newman. When I was in his studio he was finishing *Vir Heroicus Sublimis*, which is now in the Museum of Modern Art. He was still working on the painting, yet there were others he was willing to sell; but it was too much for me in 1960. I lost a wonderful opportunity.

CK *It has been said that you've never paid more than $10,000 for a single work of art. Is that true?*
GP Yes, surely.

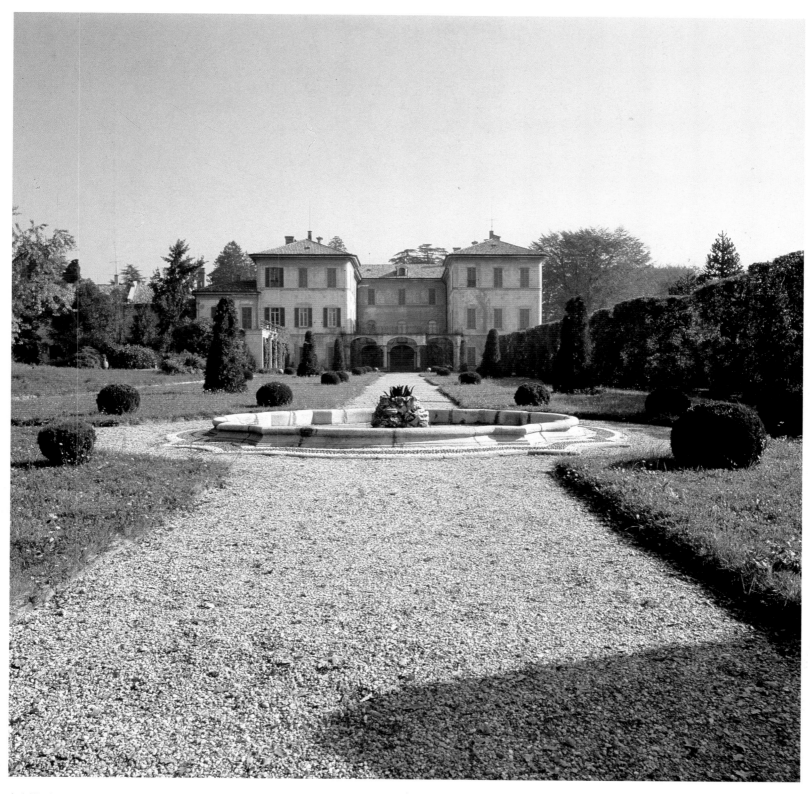

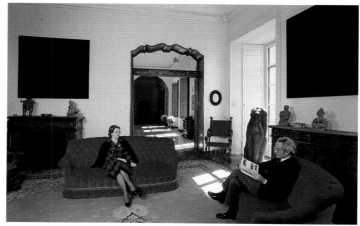

1. Villa Menafoglio Litta Panza,
Biumo Superiore, Varese

2. Giuseppe, Giovanna Panza

▶

3. Walter De Maria,
Lightning Field, 1977

4.5. Dan Flavin,
Varese Corridor, 1976. DF 19

6. James Turrell, *Roden Crater*

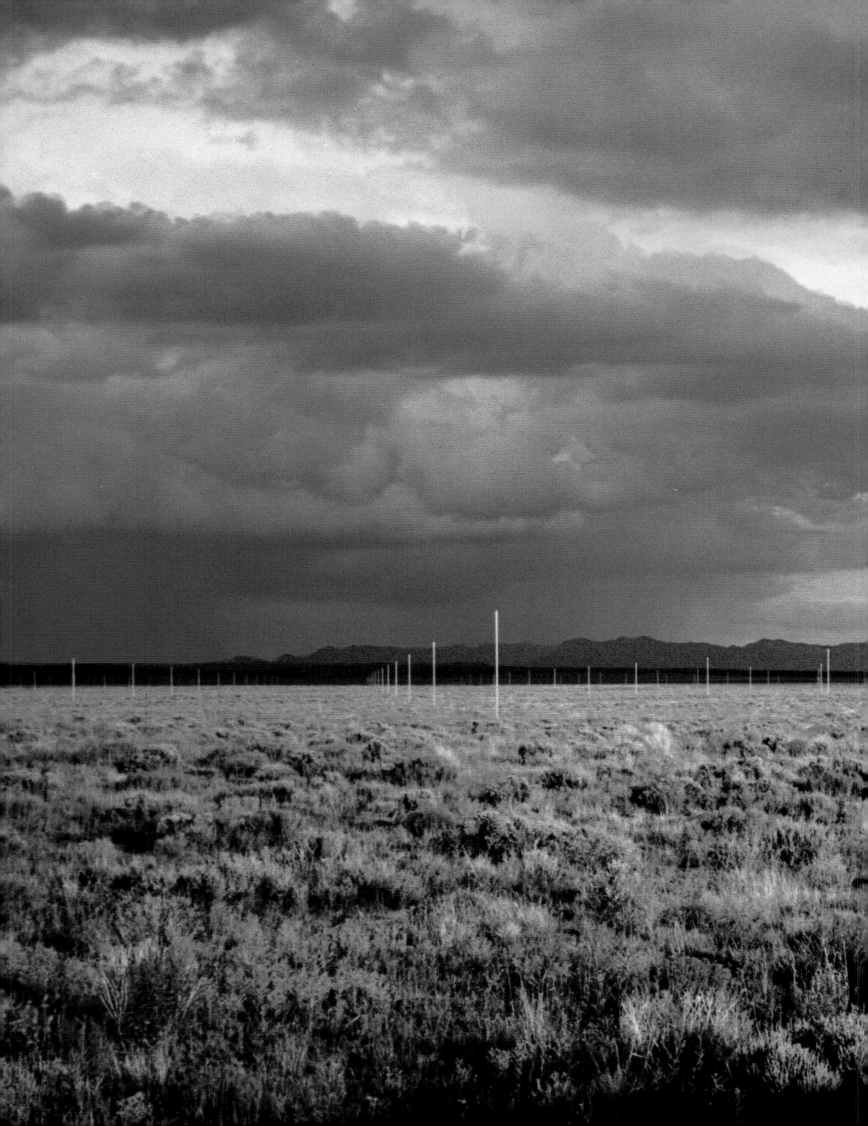

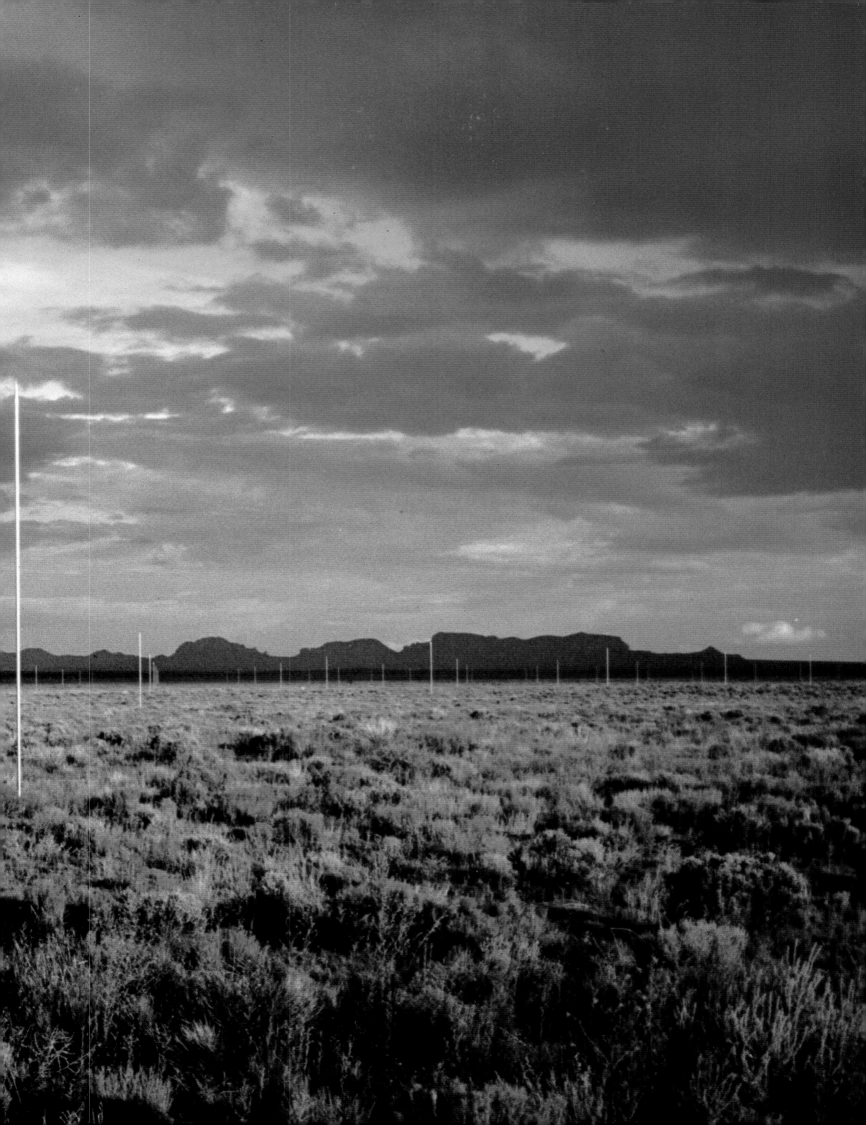

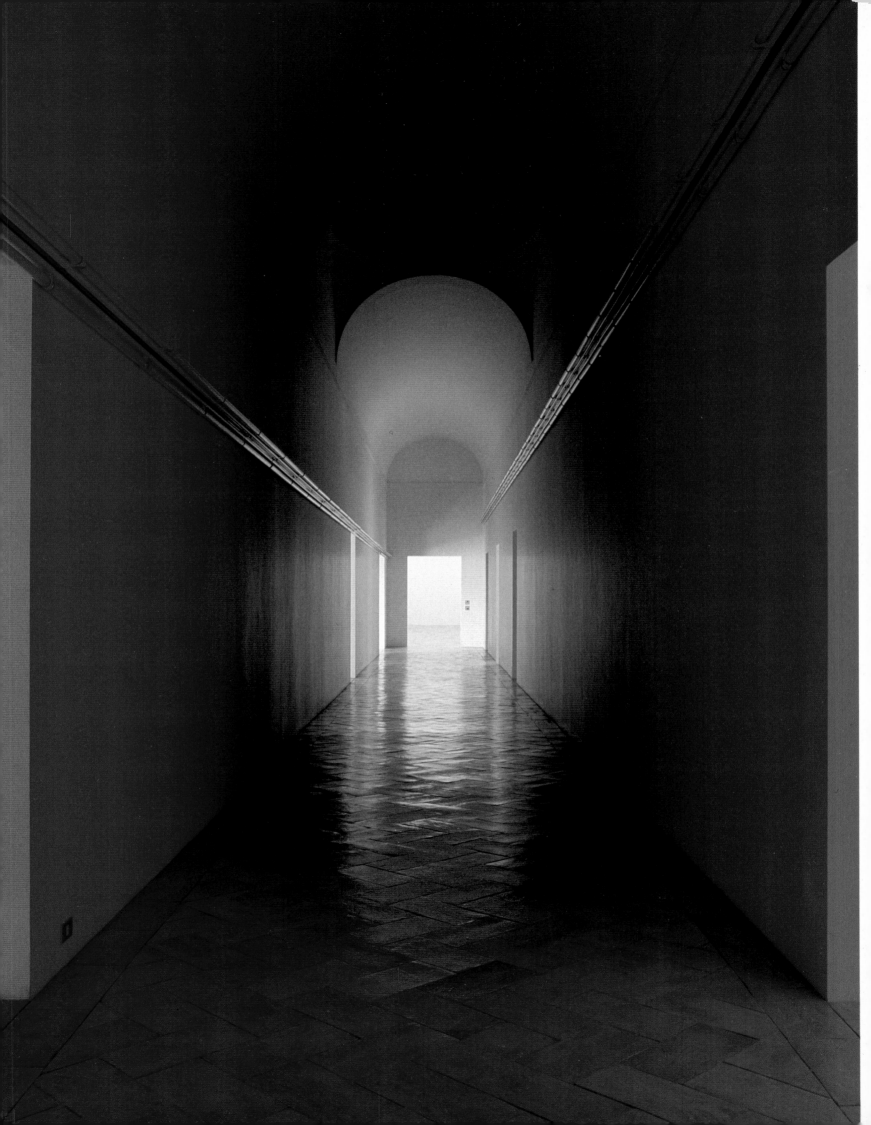

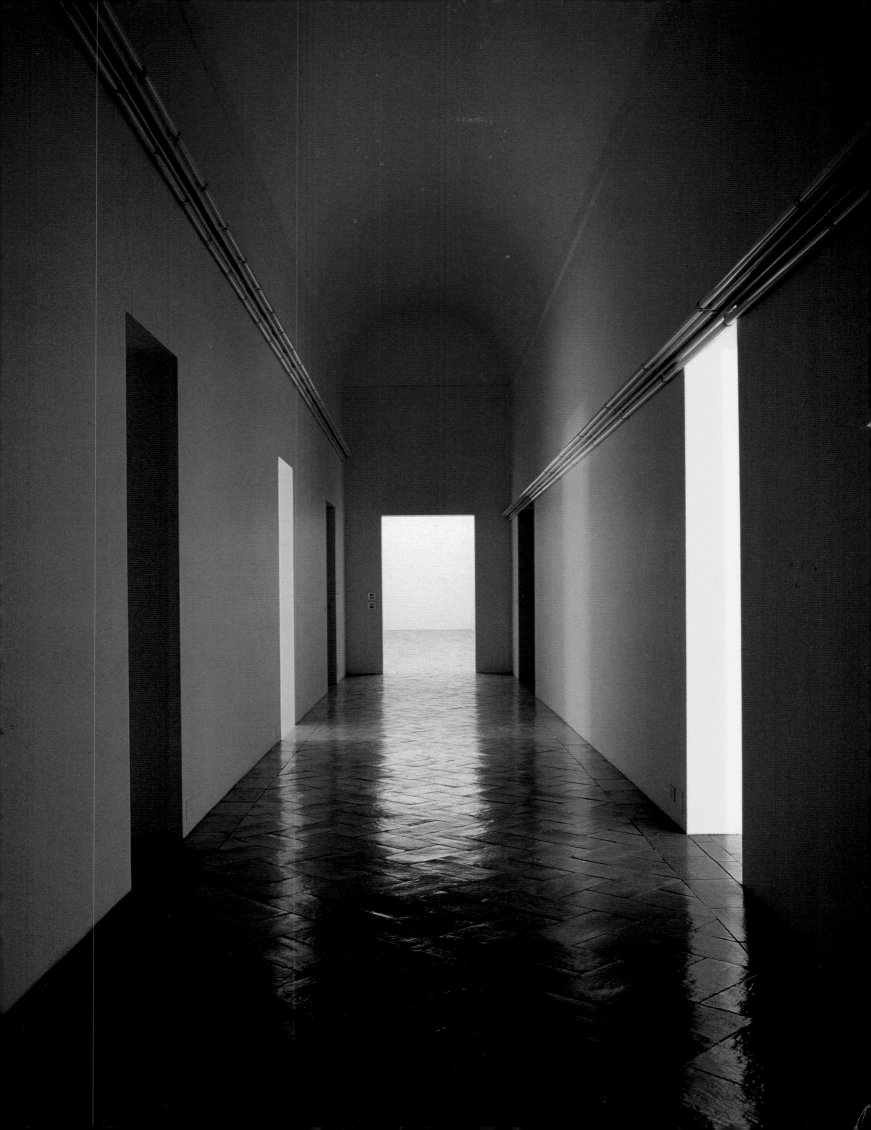

CK *Was that amount a conscious decision on your part?*

GP No, it was just dictated by the fact that I didn't have too much money to spend. I had to organize my expenditures wisely in order to have the maximum results with the minimum of money. Otherwise it would have been impossible to make a large collection. For this reason I had to concentrate on artists who didn't already have an established reputation. The time to buy at a low price is very short. It lasts only one, two, three years. If you lose this short period for buying, the price goes up, becomes twice as costly, and you lose the opportunity.

CK *Given your philosophically inflected attitude toward collecting, and the period and place in which you began, I've often wondered why Yve Klein was not part of your collection.*

GP This was another mistake I made. I met with Klein several times. He was a very close friend of Pierre Restany, who was my friend and who often spoke to me about Klein. I saw the first exhibition he did in Italy, at the Galleria Apollinaire in Milan in 1958. Each painting cost 20,000 lira, which was about $150. But I didn't understand his work. In 1958 I hadn't yet learned the importance of Duchamp, and Yve Klein looked much too radical to me. The paintings didn't have enough visual qualities. It was too intellectual, too conceptual. Only later did I realize the importance of the conceptual in art. For this reason I lost entirely this opportunity.

CK *That was in 1958, and you came to understand Duchamp through Rauschenberg, whose work you began to collect in 1959. It's too bad the Klein show wasn't a year or two later.*

GP Yes, because in just two years the value of Klein changed rapidly. When he began to exhibit in the United States the work became expensive, and it was no longer so easy to buy it locally, in Paris or Milan.

CK *In addition to your friendship with Pierre Restany, you've had a long friendship with the critic Germano Celant. How did you meet?*

GP I believe it was in 1970, when he did the Arte Povera exhibition in Turin. I went to Turin often to see exhibitions at the Galleria Sperone, which was the first gallery to show American art in Italy. He began with Pop art in 1963. I might have met Germano Celant before—I don't remember exactly—but surely 1970 was a turning point. I saw a lot of work by the Arte Povera artists, who were interesting to me but less so than the Americans. They were the best Italian artists of the period, with an international value, not only an Italian phenomenon. But at this time I was buying the work of Richard Serra and Bruce Nauman—especially Serra—both of whom are closely related to concepts of Arte Povera. But in my opinion, they were stronger. I decided to keep my attention concentrated on the Americans, not the Italians.

CK *Your friendships with Restany and Celant apparently have been important to you, but you obviously had an independent mind in choosing the work to collect.*

GP Oh, yes, surely. These people were friends, and they were very useful to me because we had an exchange of ideas. But I was very independent in my judgments. With them, I had a confronta-

41

tion in how to judge art. I always did that with people who had other opinions, people who I respected. But at the same time I was judging from my feelings, from my opinions, from my ideas. I wanted to keep my independent judgment because I believe the only way to make fewer mistakes is to make our own mistakes, not to also make the mistakes of others.

CK *In 1966 you began to collect Minimal art.*
GP I began first with Robert Morris and Dan Flavin, and soon after Donald Judd, and in 1969 Carl Andre, Serra, and Nauman. At this time I was not traveling to New York, because my business had been depressed since 1963. I was going through a difficult time, and from 1963 to 1969 I had little cash available. But in 1966, through photographs I got from Leo Castelli, I became interested in the works of Robert Morris. I bought several, which were still very cheap at the time.

Also in 1966 there was a Flavin exhibition in Düsseldorf, and then at the Sperone gallery in Milan. Sperone had a gallery in Milan for a short period of time. I bought several Flavins from this exhibition for 220,000 liras each, which was about $400.

CK *What did you respond to in Morris's work and in Flavin's work?*
GP The attempt to look for something essential in shapes was very interesting, to avoid what is not necessary and to look only for what is permanent; Rational forms are related to something permanent; pure shapes are an image of the capacity of man to think. At the same time this art finds a great variety of solutions, even using very simple shapes. Simplicity is not just one way; there are an endless array of possibilities because the capacity of minds to think is endless.

These shapes looked cool to me, but at the same time warm because they were the result of a struggle for simplicity. It was the end of a long process balancing all the elements necessary to make the shapes. These shapes, which are apparently so intellectual, really hide something extremely emotional. I believe that the greatest emotion of life is knowledge, the discovery of truth. The research of truth is the main goal of man. This art revealed the research of truth through simple forms.

CK *In what way was it emotional?*
GP It is emotional because it is the image of this process, the process of thinking, of learning, of understanding life, of understanding the law of nature—the real law, the deep, hidden law of nature.

CK *Around this time I believe you also bought the two sculptures by George Segal.*
GP Actually, I bought them some years later; I believe in 1971 or '72. I missed the opportunity to buy them in the '60s, but they were still reasonable in price. I went to Segal's chicken farm in New Jersey, and I found these two works there. It was a beautiful place. I took a bus on the freeway to New Jersey, about 100 miles south of New York. The freeway runs along the coast, which is heavily industrialized—a very interesting landscape made of huge steel constructions. There are many chemical plants and docks and shipyards, and there are many beautiful, minimal structures. I very much like this kind of industrial landscape. Segal's "chicken factory" was a very large wooden building with several rooms. In each room there were sculptures. These white plaster peo-

ple in this empty space were like ghosts, but at the same time alive in some way.

The opposition of these real and unreal qualities was strong.

CK *Given your interests at this time, it's surprising you didn't collect the work of Robert Smithson.*
GP Well, I didn't understand the quality of Smithson's work. I met him several times, and I read his articles, which were beautiful. He was a good writer, an intelligent man. I had great respect for his personality, but I had less consideration for his work as an artist. It was a mistake because the work is very good. Also, perhaps, I never had the opportunity to see a good, full-scale exhibition of his work. I saw only a few works at John Weber Gallery, or reproduced in photographs. They looked too intellectual, too much an attempt to make concepts visual, but without the right relationship between concept and shape—which is essential. But I was wrong.

Also, I didn't much like the Earthworks he made. The *Spiral Jetty* and the others didn't seem to me really connected to the environment. They fight against the natural situation around them. This looked wrong to me.

CK *Do you still feel that way today?*
GP Still, yes. But the sculptures are different, because they don't have this relationship to the environment. They're objects with their own qualities.

CK *You began collecting Minimalist sculpture two years before the* Primary Structures *exhibition at the Jewish Museum in 1968. Did you see that show?*
GP No, unfortunately not.

CK *Was Flavin the first artist who worked with light whose work you acquired?*
GP Yes. When I saw his exhibition in Milan in '66 I was impressed by the capacity of light to fill the space in which the work was exhibited, have this color which made the work. It wasn't only the shape of the fluorescent tubes. In Flavin there are two qualities. The composition of the fluorescent tubes are like the lines in a Mondrian painting; the way these are combined makes the work. But this quality is less important in Flavin; it's more important that the work is not confined to the shape of the material but expands into the volume of the room.

For the first time I realized how light could have a very strong emotional effect, as well as a very strong capacity to make a new relationship to something of which we have a common experience. Light is something physical and not physical, it's radiation made by photons. The photons don't have mass when they do not move, which in some way is not logical, but they are real, they have color, they make surfaces warm. They don't have mass, but everything real has mass and weight. The photon doesn't have this quality, only radiation. For the first time I realized that light is something extremely beautiful; the colors of this artificial light were very moving.

One of the first works in the gallery in Milan was a square made by blue fluorescent lamps. The blue color filled the empty room.

Blue is the color of the sky. Everything that is perfect, everything that is ideal we believe comes

from the sky, because instinctively we think that the sky is the perfection of nature.

CK *Let's take what you've been saying about Flavin and double back to the very beginning of your collecting activities: Tapies, Fautrier. What connections do you—or don't you—see between where you started and where you were at this point with Flavin?*
GP I believe there is always a link between different situations. Flavin is an artist who deals with some kind of metaphysical entity. He's a man who looks for something that is not tangible, and he feels very strongly the need for something absolute. In his work I believe this research becomes very clear, very strong.

And I felt the same kind of attitude in Tapies. The paintings by Tapies I bought were interesting to me because there was this struggle of a man, involved in a pessimistic view of life, for something great, something beautiful, which was not possible to achieve. He was involved with matter and the physical limits of everything, but at the same time he was looking for this infinite freedom of mind. These two facts are present in both artists, who look so different. Tapies deals with an earthly material; his colors are without light. It is matter suffering the situation of being matter. And in Flavin there is the capacity to overcome the limits of matter, using light.

CK *So you could begin with Flavin and work all the way back to the Venetians and to Raphael.*
GP Oh, yes.

CK *Was Larry Bell the first artist from Southern California whose work you bought?*
GP Yes. I bought one cube by Bell, and one disk by Robert Irwin, in 1968. I saw the 1968 exhibition by Bell at the Ileana Sonnabend Gallery in Paris, and at Documenta I saw two disks by Irwin. I was very attracted to these works, which dealt with light, with illusion, with perception. They were a step beyond the experience I had with Flavin. Flavin was using light, and Larry Bell was using light, because glass is a transparent material. This material is partly reflective and partly transparent. It makes an interchange between the two qualities. Sometimes you see reflections in these surfaces, sometimes you see what is behind—you go through the material.

In the work by Robert Irwin I found another field of research: the attempt to establish the limits of perception, to understand what perception is. To see how perception is related to memory, to our personality, to our participation in making judgments. We believe we see reality as it is, but we see what we believe it is. All the work by Irwin reveals this fact, that our knowledge is mostly something related to our memory, to our already-made judgment. We judge, we recognize and we experience what we already know. Seldom do we have new information from experience. We can only experience something new if our judgment is able to think something new. Otherwise, our experience of reality is always a repetition of something we already know.

CK *You first saw Bell's work and Irwin's work in Europe. Had you spent any time in Southern California, aside from your brief trip in the early 1950s?*
GP No. I was in Los Angeles in 1954, but only for a few days, just passing through.

Rothko, Red and Blue
over Red, *1959*
Villa Menafoglio Litta Panza,
living-room.
Photograph by Ugo Mulas, 1966.

CK *When did you first come to Los Angeles for any length of time?*
GP It was in the fall of 1973.

CK *What were the circumstances?*
GP I wanted to buy more work by Irwin. I had news of Doug Wheeler, Jim Turrell, Eric Orr, and Larry Bell, and I wanted to know more about them. In New York, it was impossible to see art from Los Angeles because it wasn't shown much. I had seen a room installed by Irwin at the Museum of Modern Art. Before that I saw a beautiful show at the Stedelijk Museum in Amsterdam in 1970, with work by Wheeler and Irwin. There was the plastic square by Wheeler with the neon light on the edge and a large environment with light coming out of the edge of the wall, which was a beautiful work. And there was the disk by Irwin.

 The room by Irwin I saw at MOMA, I believe in '69 or '70, was great. There was a scrim from the ceiling taking up half the room, and there was a string of steel, very small, crossing near the end of the room. It was very impressive—so absolute, so simple, so strong, and only dealing with light and space.

 I was very involved between 1969 and 1973 with Minimal sculpture and paintings. In 1970 I had acquired many paintings by Robert Ryman. I had seen Ryman, and also Brice Marden, in

45

New York in 1967. But I didn't then realize the quality of their work. When Ryman showed at Lambert Gallery in Milan in '69, suddenly I realized how beautiful this radical way of painting was, how strong this way of conceiving art was. I decided to buy all the Ryman paintings available in Europe and America. At this time Ryman had several shows in Europe, but he sold almost nothing. So it was possible to buy about twenty paintings in just a few months, which was Ryman's production of several years.

CK *You've described Ryman in the past as among the most important artists of this century. That's a fairly grand statement; could you elaborate?*

GP I believe Ryman has the same quality as Rothko. He's a man who has developed a strong exploration of his own mind. And the greatest thing in nature is surely the human mind. The wrong side of our mind prevails, because we are always acting, always willing to do something, but we are less able to think, to look inside ourselves. The world inside us is a universe; life becomes life the moment men have self-awareness. Matter does not. The highest achievement of life is self-consciousness, the capacity to understand that we are alive. Animals have some kind of consciousness, but in man this capacity is most complete.

Our lives would be different if we would use this capacity inside our minds, but it is difficult. It's much easier to act, rather than make this exploration which demands a great deal of energy— more energy than lifting up some heavy weight. We are lazy in using our brains, and we have the habit of repeating what we usually do. But self-exploration is the discovery of the flux of life inside us, and is the most creative act. Life in each instant is the possibility of a creative act.

Ryman revealed this capacity. He was able to establish a direct relationship between what is inside our mind and what could become visible. The great achievement of Ryman is this connection between the hand, the finger, the nervous system—the objects for making paintings—and our mind. I realized how different art is if seen in this way. Because of this, I realized how great Raphael is. If you look at Raphael, with a magnifying lens, you see the quality of a Raphael painting in the details. You see a whole world in a small part of his painting. How the pigment is laid on the canvas shows the personality of the artist. This simple act is beautiful, just the moment when the pigment is laid down on the canvas. When the artist is able to achieve full control between his nervous system and his mind, it's great. The total relationship is complete. At this moment he's able to make masterpieces.

CK *So obviously you would see a direct relationship between Ryman and the work of Robert Irwin or Doug Wheeler.*

GP Oh, yes, sure.

CK *Why do you suppose that it was easier for you to see Irwin's and Wheeler's work in Europe, rather than New York, and that you had to come to Southern California to see more?*

GP Because this attitude is against the attitude of New York. New York is a city where people work. People work making art. People are competing for something to be made. Some people have

a different attitude—like Rothko, Ryman, Flavin. But the dominant taste of dealers and collectors is against the attitude of artists from Los Angeles. They were making things difficult to sell. We can sell painted canvases, white canvases by Ryman, if a person is able to understand the quality of his work. But it's more difficult to sell a room by Irwin or by Wheeler because space is difficult to have. Such a room is difficult to install as well. Galleries in New York weren't willing to engage money and time in something that is difficult to sell. I believe these were the two reasons why it was not possible to see this art from Los Angeles in New York.

CK *Was it primarily a market reason?*
GP A market reason and also a different cultural attitude. New York is a city more related to the will to act than the will to think.

CK *In addition to the artists you've mentioned, whom did you meet when you came to Los Angeles in 1973?*
GP We met Jim Turrell, at his studio in Los Angeles—in Santa Monica. We went to his house in the late afternoon. The house was white, with empty white walls and almost nothing else around. There was a doorway, but no door. There was an empty room in his house with light coming in near the floor, and at the top of the front wall, facing west toward the ocean, there was an opening to the sky. It was a small opening, about three feet wide, and the room was perhaps 10 feet by 20 feet. We sat in this room and saw the sunset through the hole.

At the beginning the sunset was dark blue, and the space inside looked empty. The dark blue appeared to be on the surface of the wall, because there was a sharp edge around the opening and you couldn't see the thickness of the wall. The wall and the opening appeared to belong to the same plane, to the same surface. The opening looked like a surface, not a void. When the light of the sunset began to change, this feeling shifted from an empty space to a surface to a solid colored material. It was very strange to see something that didn't exist but, at the same time, was real. The colors were always changing, but in a way we don't realize when we see the sunset outdoors. The sunset started with dark blue, became pale blue, and then red, light red, dark red, gold, green, violet—a steady variation of color.

Turrell is a man, like Irwin, with a broad knowledge of science and philosophy—a cultivated man with a strong cultural background. What is different about Turrell from many other artists is his capacity to do everything related to technique himself. He's a pilot and restores old planes to resell to collectors. He lives in this way because his is not an income-making kind of art. He's a fascinating man, because he's devoted to making an art that is difficult to sell but he does it because it's beautiful.

His vision of the universe is great, his interest in nature and its importance to our lives. Life came from inside the universe, but we don't know how the universe was made. These theories about the "big bang" are very interesting, but how did the "big bang" happen? What was the beginning of the "big bang"? There was an infinite density of energy, which is something no scientific theories can explain. The beginning was an undifferentiated situation, but the world became so differ-

ent. There is a wonderful, logical architecture of nature, where every phenomenon is connected to every other phenomenon. How beautiful this construction is!

Western civilization has lost interest in this because we work for other goals. We spend our energy, our time, in order to have a better life. We use resources from nature, but we don't pay attention to the fact we are alive because the universe was born one day, that everything we have is a gift we received. We are intelligent not because we made man intelligent, but because nature made man intelligent. Our culture has lost this essential relationship. Turrell was making this relationship evident again; for this reason I believe his work is so important.

In Turrell's house in Santa Monica there was another room that was completely dark. The room was near a street corner with a stoplight. One side of the room overlooked a small road with a little track. The other side faced the main street with many cars passing by. At the end wall of this room, Turrell had made several holes, windows that could be opened and closed, in different positions on the wall. Opening the hole facing the stop light, the room filled for some minutes with a beautiful red light. And after that, a yellow one. And after that, a green one.

Closing this window and opening another one, it was possible to see only the lights projected by the cars passing in the main street. This light came inside the room like lightning, filling the room with very strong light but only for a short time. Afterward, the light disappeared and the room became dark again.

Opening another hole, it was possible to see only a light coming from the small road; for some minutes the room was dark, but then a small, dim light came into the room and got stronger and stronger. This light had a shape, and the shape went around the room as the car outside turned into the main street.

Opening another one, it was possible to have only the light coming from faraway street lights. This light was very dim, but it filled the room in a very peaceful way. It looked like moonlight. It gave the same kind of emotion, because only the shadows of objects were visible inside the room. There was a confused notion of the volume of the space. The room looked much larger, almost endless, because there were only very faint shadows. Everything inside the room looked like it had lost its material quality and gained some kind of ideal entity—which wasn't earthly but heavenly. It was very strange, very metaphysical. This series of beautiful experiences was made in a very simple way and showed the qualities of many kinds of light. Only the hole in the wall was the work of the artist.

After our visit to Turrell's house, my wife and I decided to have him make some rooms at our house in Varese.

CK *How long did you stay in Los Angeles on this first visit?*
GP In the first trip we spent about ten days. We saw the galleries, and we met Betty Asher. She was working at the County Museum of Art and had a beautiful collection—especially the Pop Art. We also met her son, the artist Michael Asher, and we met with Bell, Wheeler and Bruce Nauman. Nauman's work I had seen many times before, in New York. I had started to buy Nauman's work from Leo Castelli in 1969—early works.

CK *Did visiting Los Angeles and seeing Turrell and other artists change the way you thought about Nauman's work?*

GP No, because Nauman was involved in a different area. He was more concerned with the relationship of the space to the perception of the viewer and his physical presence. The relationship between space and our body is the main research of Nauman. The work he made with televisions is a way to duplicate ourselves, to explore the perception we have of ourselves through our own senses. This was very interesting, but different from the work of other Los Angeles artists. It was more physical; it dealt with the constraints to which our life is submitted every day. Man was made by nature to live inside nature, not in an urban landscape. But we live in an urban landscape and, because of this, we lose the connections to nature and to our own bodies. We believe we are the center of everything, but in fact we are not. We are a temporary living object in a fast-changing environment. When we split our senses from our perception, we realize this opposition in a powerful way. This is the main lesson I received from looking at Nauman's work.

CK *Would you say, then, that the primary aspect of Nauman's work is to manipulate artificial, constructed elements in such a way that one "rediscovers" his own body and perceptions?*

GP Yes.

CK *Who else did you see on your first trip to the West Coast?*

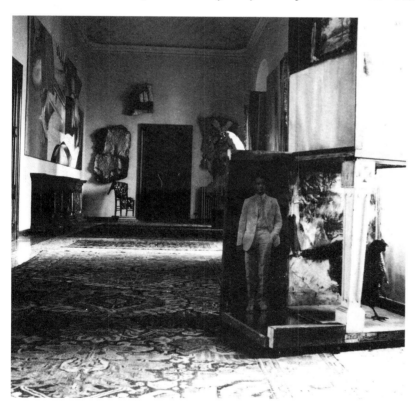

Villa Menafoglio Litta Panza, passage, 1966.

GP After our meeting with Turrell, we paid our first visit to the desert, which is a beautiful space. We planned to stop in Nevada to see the Earthworks of Michael Heizer and Walter De Maria. I met De Maria some years before in New York and was very interested in his work. Few works were available, and they already cost more than $10,000, but I was interested in seeing the work he made in Nevada. I came with Helen Winkler and Heiner Friedrich. He had galleries in Cologne and New York, where I had bought several works by Flavin and Ryman. He was also the dealer of De Maria. Helen Winkler had come to the West several times with De Maria to look for a site for the *Lightning Field*. He made a test site near Flagstaff and made a work in Nevada, not far from Las Vegas. There was also Heizer's *Double Negative* to see on the Mormon Mesa, near Overton and Lake Mead. Because Turrell had to go to Nevada, too, we used his airplane.

CK *You have a reputation as a "collector of uncollectable art". What that were the works the first installation or environmental work that you purchased?*
GP The first was the disk by Robert Irwin. After that were the works by Turrell and Wheeler, in 1973. But these didn't exist yet; they were just projects. I knew Wheeler's work from the show in Amsterdam, but when I went to his studio there was nothing made. He was thinking about making a room with rounded corners in order to have an illusion of disappearing, limitless space.

CK *So you bought the plans for that work?*
GP Yes.

CK *Had you already converted the stables at the Villa Litta into galleries?*
GP I was beginning to make them. In 1973 I commissioned Irwin to come to Varese to realize three works in three different rooms. At the same time, my wife and I asked Turrell to do the same with five other rooms which were available in Varese. We had also met Maria Nordman, because we went to the University of California at Irvine to see a room she had made there. We were very impressed by it. We asked her to do one in Varese, which she made in 1975.'76.

I bought many other projects in 1975—for instance, fourteen by Wheeler. But I soon ran out of money and it was not possible to do the installations. Indeed, all the space in Varese was used up. There was no possibility to do even one room by Wheeler, whose work I like very much.

CK *Are the plans you've acquired works that could be executed by someone other than the artist—say, fifty years from now?*
GP I believe all the works by Wheeler could be executed by someone else, because they don't have a specific relationship to the environment. If there is the right space they could be made anywhere. The work by Irwin is different, because Irwin is very concerned about the relationship to the environment. For Turrell, the participation of the artist is necessary, because the relationship to the outside is important. There are other works by Turrell made with light-projectors where this is less important, but there are adjustments to the projectors that are better if made by the artist. The works by Irwin, Turrell and Nordman in Varese were commissioned for the existing space.

They could be remade elsewhere, but only with the participation of the artist.

CK *So you were not using the stables as galleries before 1973?*
GP I started to use the stables in 1968 and '69 for the large works by Robert Morris. In this period I bought about thirty works by Morris, twenty-eight by Donald Judd, forty by Nauman. I had many works by Flavin, Andre, Serra, Marden, Ryman. There were a lot of things to put inside! It was only possible to show part of this work. I was using all the space available, even for storage.

CK *The paperwork alone for a collection of that size is staggering. Museum have staffs. Did you have help?*
GP I did everything by myself. I never had a secretary helping me. My wife was busy with the family, with her own charitable activities, and she didn't have the time to help. I had people working in my office, but this work I liked to do myself. However, it was very time-absorbing. I used all my free time for the collection. In the evening, I would usually go to sleep around one o'clock. From nine o'clock, after dinner, to one o'clock, I would work on the collection. On Sundays I didn't go around by car, I went to Varese to work on the collection, to write, or to look at photographs. On holidays, often I would work on the collection. Sometimes I would walk in the mountains, but almost every available hour I worked on the collection.

I never watched television, and very seldom would I go to the movies or the theatre. I like music very much, and I would listen to records to relax for an hour after dinner. I liked to listen

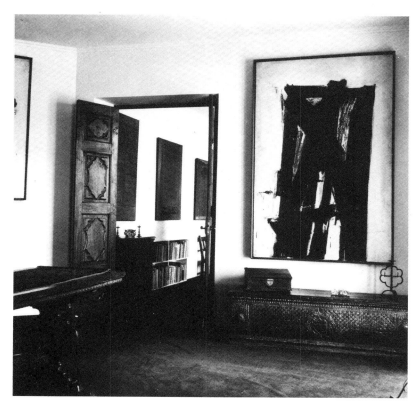

Kline, Tower, *1953. Milan, Panza's House, 1962.*

51

to operas by Wagner or Bach. I also liked to read articles in science magazines; science is something very fascinating to me. And I read magazines or books about art.

CK *Not much time to go to La Scala.*
GP No, I never go to La Scala. I go once every three years!

CK *What unique problems do you face as a collector of environmental and installation works?*
GP The problem is to find the right space. Not only is the space itself important, but also its relationship to the space around it. With the window by Irwin at Varese, it's important that it faces a garden with many dark green trees in the background and large branches in the foreground. From the empty room, which is all white and neutral, you see nature full of life. The opposition of the empty space inside, to the outside seen through the opening, looks like a painting. The window becomes like the frame of a painting—a very strange painting which is real and not an illusion. This shifting image is very interesting. It's beautiful to see this wall of green, living trees. If there weren't trees, if there was a street behind this wall of the house, everything would be lost.

CK *Different picture?*
GP Yes.

CK *Do you own any of Irwin's stripe-paintings?*
GP No, but I have a beautiful dot-painting made, I believe, in 1964. Unfortunately, it is in storage, like the two disks and the plastic column. I have several projects which were made by Irwin at the Pace Gallery in New York and the Ace Gallery in Los Angeles, but they exist only as projects. My problem is to find the space to install these works permanently. It's my great concern, because I believe these works are an important achievement of our culture. But they don't exist. It's important to find a way to give the public access to these works; for this reason, I am actively trying to find space in museums interested in keeping this work in a permanent way.

CK *In the late 1960s and early 1970s you began collecting the work of Joseph Kosuth, Lawrence Weiner, and other Conceptual artists. At the same time you were collecting the work of Richard Serra. His sculptures are so physical, so much about gravity and weight and tensions. How do you reconcile the purely Conceptual work of Kosuth or Weiner with your simultaneous interest in Serra?*
GP Conceptual art deals with ideas, with philosophical problems, but it can also have a strong visual impact if it's shown in the right way. Because these artists are artists, not philosophers, they are able to make synthetic definitions of our thinking, and these synthetic definitions become art.

If we make an analysis of intuition, we realize it is not a simple thing but a very complex one. We can go on and on analyzing intuition and find out how many things are inside. It looks like something very simple, but it's not. There is the possibility of understanding in the first second, but at the same time it has all the qualities of a complex intellectual development of ideas.

This is very new in the history of art, and it is new because it was never possible before. Leonardo

da Vinci or Piero della Francesca were artists with strong philosophical backgrounds, and the work they made was related to these philosophical ideas. When we look at their work we can understand this background, but the relationship is very indirect. We can see the relationship if we know the philosophy behind it, if we know other sources and the prevailing ideas of the Renaissance. But looking at a work by Kosuth or Weiner or Robert Barry or Sol Lewitt, you have a more direct reference to philosophical research about knowledge, language, the relationship between meaning and expression, and about how something could be valid as a tool for translating thought into images.

Linguistic philosophy is a very interesting field. For instance, the work by Lawrence Weiner, which is made of words, is something absolutely new in art history. In early Renaissance and, especially, Medieval times, we see words used in relation to paintings. There are many examples. But these words belong to speech; they explain the image. In the work by Lawrence Weiner the word becomes something completely independent of speech. It becomes art because it is independent of the development of logical reference to a situation. Both words and images have an essential quality: to have the possibility to express different contents; to be symbols used for saying different things, to have different meanings. Usually we don't pay attention to this fact. When we open the dictionary and look at a word, we realize how many different meanings it could have. If its position in speech changes, its meaning changes.

CK *And from language to language, as in Kosuth's* Definition of Nothing *in six different languages.*
GP Words could be art because of this ambiguity. Images and words are useful because of this capacity for having different meanings. The fact that the meaning is not exact, but could shift, gives the viewer the possibility of stimulation to think about different things. Art is art because of this. A work of art is beautiful when it gives different ideas and different suggestions to the viewer.

CK *And how does this mesh with your simultaneous interest in Richard Serra?*
GP As with every great artist, the meaning of his work could be read in different ways. It's physical, because the weight of the mass deals with gravity, which is a force acting on every existing thing; but at the same time it's something we don't see because it's a force. We feel it but we don't see it. The more mass an object has, the more we feel its heaviness. If an object is large but light, these perceptions of mass change.

The force acting in Serra's work is energy. Intelligence is also energy. We cannot see the process of intelligence—how it moves, how it works, yes. There are two aspects of intelligence: logic, which is a process of dealing with quantities and definitions of facts; and intuition, which is completely different.

CK *You said earlier that Robert Ryman's paintings gave evidence of the moment of consciousness of the self. This is very much the kind of experience offered by Maria Nordman's piece in Varese, which is one of the most remarkable light-and-space installations I've ever seen. So whether it's a painter or an installation artist, the work you were acquiring is an extension of a central concern that goes back*

to the work you were collecting in the 1950s. In this regard, I wanted to ask you about your collection of death masks.

GP I was interested in these skulls because I believe the problem of death is the main problem of life. We cannot understand life if we cannot have a clear awareness of death. Life and death are two aspects which cannot be split. It's wrong to think of life as endless. We don't have much time and must use well the time available to us. If we see life in this perspective, it becomes different. Many things which look important are in reality less so. Life is good if we leave behind us something useful to others. I believe this is the main goal of life. For this reason, I was interested in keeping these objects, which give evidence of this idea.

Most of them are skulls carved in ivory. They're Japanese, Italian and German, from the 15th, 16th and 17th centuries. Some are African. It's a small collection, and not very important as a collection. But it's important to me because it reminds me of this fact that life and death are two things which always go together.

They were *memento mori*. The attitude of people in the 16th and 17th centuries was different than today. Now we try to avoid the image of death in any way we can. People like to think death doesn't exist, and they pay attention to avoiding anything which recalls this fact.

CK *How did you acquire these masks?*
GP Mostly, I found them in antique stores in Milan. The *memento mori* was a common object in the past.

CK *Was it in 1975 that you stopped collecting?*
GP Yes, I stopped in '75. There are a few works that came into the collection in 1976, but they were works which had been engaged in '75.

CK *How many pieces were there in the collection then?*
GP There were 600 of museum quality, and a hundred more which were good but, being of small dimensions, would not be interesting in a museum installation. Some small paintings by Robert Mangold and Ryman, for instance. It wouldn't be right to put them in a museum next to larger works.

CK *After collecting for almost exactly twenty years, why did you stop?*
GP I stopped for economic reasons: I ran out of cash! There was no more money available. I always spent all the money it was possible to spend. Unfortunately, after 1975 my business wasn't as good as before. I had already done something dangerous, from a financial point of view, having spent so much money between 1969 and 1975.

CK *Your sister warned you!*
GP Yes, I was just undermining the financial situation of the family. For this reason, I had to stop. It was a very difficult decision, but it was dictated by the situation. Indeed, I was very busy

looking for a way to show the collection, which was almost completely hidden in storage. This became a full-time job, just trying to find a way to show the collection.

CK *If you had about 600 major works that you had collected over a twenty-year period, that works out to about one new acquisition every twelve days. Was it difficult to stop?*
GP Oh, yes, it was a terrible decision. When I see an artist who I realize is good, I feel a tremendous need to buy. And I cannot. It isn't easy for me. But although it is something I cannot do now, I hope to resume buying if the situation improves and I am able to sell out my business in Italy. I don't know if it will be possible.

CK *Are there other collectors you admire?*
GP Yes. I believe the best collection assembled recently was made in Zurich, Switzerland. It's shown now in an old factory made available by the city of Schaffhausen. It was assembled by Raus-Muller, an artist who for several years ran the Ink Institution, a space in Zurich for showing art. He made a beautiful collection of American artists of the '60s. There are also European artists of the period, but mostly American. He didn't have money, but he had a group of friends who gave him the means to buy the collection. The collection is called Crex. It really is the most beautiful collection of American art of the '60s in the world.

The Ludwig collection in Germany is very large, but that was made with a different goal. It's very broad, having documentation of every event in art, and is not as selective as the Crex collection. That one was made like mine, a careful selection of the best work of the best artists.

The Saatchi collection in London is very good, but it has a different orientation. The Minimal art is excellent. There are also many works by the German Neo-Expressionists and the Italian Trans Avant Garde, which interest me less. I believe the good artists of the '80s are not the Trans Avant Garde and the German Neo-Expressionists. I believe that the best artists of these years are in Los Angeles, and some in New York. Not in Europe.

CK *Why aren't you interested in the German and Italian painters?*
GP Because these artists are expressing instincts coming from a lower part of the body. I like artists who express instincts coming from a higher part of the body!

This kind of art is very far from my vision of life. It's not concerned with the problems that are essential for me. For me, art is something which improves the quality of life, the quality of thought, the quality of our inner level of intellectual activity. This art gives no improvement. It's an art which looks to the past, not to the future. It doesn't take the risk of making something new that tries to expand the experience of existence.

If you look at this art, you find elements coming from German Expressionism of the early years of the 20th century. You find forms coming from Surrealism, Metaphysical art, Abstract Expressionism and all these brought together. But these were important because they were new experiences, and all of them were motivated by an idealistic view of their situation. It was a test made to explore the human mind, a new answer to a changing social situation. It was a projection, or a forecast,

of how life in the modern world was changing. But the relationship of Neo-Expressionism to the art of the past is completely deprived of this motivation. It only uses the formal body, the shell of this earlier art, not its meaning, not its content. In this way it's useless. Art is art when shapes have a direct relationship to a given experience; when this relationship doesn't exist, it's just an intellectual exercise about shapes. Shapes without anything behind them are nothing, just a void.

CK *So you're an idealist?*
GP Oh, yes, surely.

CK *German Expressionism attempted to reconnect contemporary culture to its source in nature. Neo-Expressionism, with its interest in history, seems to me a reflection that nature is no longer the source from which culture derives. Today, culture is itself the source from which culture derives, and culture has a life, a "nature" of its own. So the Neo-Expressionist interest in the "nature of history" and the "nature of images" suggests that nature has become indistinguishable from culture.*
GP I believe that this lack of reference to nature is a negative quality of this art. It's an exercise about past cultural experience. There is no engagement with anything, and this lack of engagement is the main reason this art is made. This is its main feature about which I disagree very deeply. Art is not a pleasure, not a relaxing activity, an amusement or entertainment. Art is an engagement with life and reflects this engagement with life.

This lack of a relationship to nature is the lack of a relationship to a real motivation to be alive. If we don't feel this relationship to nature, we are cut off from reality. We are real because we are born from nature. And this art is useless to me because it's an intellectual experiment and nothing else.

The main reason this art is the way it is, I believe, is because it came out of a generation of people who lived through the revolution of 1968 in France. This revolution gave the hope of total freedom, the possibility of doing anything we wanted to do. But this kind of freedom is really not freedom. Real freedom is the obligation to make what is best for the evolution of man. This is the goal that nature gives to man, to continue evolving. We are thinking animals because we came from animals who do not think, who lived on instinct. Man has this privilege. The history of nature is evolution. From the "big bang"—from undifferentiated energy to physical differentiation—man is the very last event in the long history of evolution. He's the last, and perhaps he is the beginning of something else. We don't know where nature will lead us. But it's clear that we are the instrument of something else, and this "something else" is evolution.

Inside our mind we always feel this desire for things above what we have reached. This is the voice of nature speaking inside our mind, this endless desire for the best.

CK *If, in your view, the student riots in Paris in 1968 had a great deal to do with these developments, it's curious that the artists who have subsequently come to the forefront are German, Italian and American, and not French.*
GP Well, Figuration Libre is a version of this in France.

CK *But it has much less...notoriety, shall we say.*

GP Yes, it came after, but it belongs to the same psychological situation. These people who lived with the hope—the wrong hope—of 1968 were disillusioned very fast. It's clear that total freedom leads to self-destruction because it leads to nothing. They were disillusioned by what came after, because not one of their great hopes for total freedom was realized.

The generation coming out of 1968 had no strong moral readiness to face disillusionment. And for this reason they make this kind of art—which shows great disillusionment with life. They lack engagement because they don't have hope. If we do not have goals, we cannot be alive. If we have a goal, we have hope to reach something better than we have today.

CK *So you believe that this desire for total freedom meant that there was no touchstone, and that nature must be the primary standard?*

GP Yes.

CK *I believe you have two works by Joseph Beuys in your collection. How does Beuys—who many would regard as the father of certain of these recent developments—fit into your collection, and why did you stop collecting his work?*

GP In 1968 there was an exhibition of Beuys and Robert Morris at the Eindhoven Museum. I went because I was collecting Morris's work, and it was a beautiful exhibition of his early work. In this way, I also saw the Beuys exhibition. It was the first time I saw Beuys's work, the first time I had even heard his name, and I was extremely impressed by him. But his work has nothing to do with the post-Expressionist art of Germany. It's related to the experience of a real German Expressionism, to the whole culture of Central Europe. And it's very much related to Surrealism. He's the parallel of Rauschenberg in some way.

The art of Beuys is extremely important. It's related to the Medieval life of Europe—not to the Renaissance tradition, but to the hidden world which is deeply inside our mind. It's the exploration of instincts which lay down every act we make, things of which we have no notion but which are basic in our lives. This exploration is made in a powerful way, through analogy, through opposing objects which have some relationship to memory, as in Rauschenberg. But Rauschenberg is romantic in his own way. Beuys goes to the roots of Central European culture, which comes out of the Middle Ages. The Renaissance in Germany didn't have roots as strong as in Italy. The Italian Renaissance was closely related to Greek and Roman culture, and rediscovered classical harmony. But German culture is more closely related to the Middle Ages, to the gods, to this world we don't see. It relates to the Medieval belief that hell and the devil are true. This is very strong in the Beuys experience, as is the mystical experience. Both of these are together, a strong erotic and mystical experience and the opposition of god and evil. To look at Beuys's work is like reading the *Divine Comedy* of Dante.

His best work was made in the 1950s and early '60s. I tried hard to buy his work, but a German collector was buying all Beuys's work at this time. There were no good ones available, and soon his work became expensive. I only have two small objects. Stroher, the collector, had acquired a collec-

tion of Pop Art from New York, but his main engagement was with Beuys, whom he started to collect very early. There are four rooms devoted to his early work at the Darmstadt Museum—the core works and really powerful. The work Beuys made in the '70s and '80s is fine, but notas strong.

CK *So the pressure of the marketplace kept you from being able to acquire Beuys's work. The market has changed dramatically since you first began to buy art in New York in the 1950s. What other effects do you think market pressure has on art?*
GP Today the market pressure is very negative. It's costly to live in New York. Artists have to make things which can be sold. The prevailing taste is for this kind of art, Neo-Expressionist art, which is an art that can be sold easily. It's figurative art. There are strong colors, large canvasses, we recognize images and we understand what the painter is saying. For this reason, people are happy to buy it; they believe they are buying avant-garde art. Collectors with a low cultural background in modern art buy it because they've found some avant-garde art they can understand. This is why prices are so high. It's successful art, and I never liked successful art because, usually, it's easy art. After some years this art will disappear. Many times I have seen so-called famous artists be forgotten.

CK *When you began collecting Robert Ryman's paintings, they were very inexpensive. Shortly after you began acquiring them, their prices increased significantly. Although investment has never been a consideration for you, your stature as a collector would seem to have an effect on the market. Would you agree?*
GP Perhaps. I don't know. There are some artists whom I bought early who became famous artists. There are others whom I believe are very important artists who didn't become famous at all. I can give some examples. One of the few Italian artists whose work I have is Maurizio Mochetti. He makes kinetic art, and I believe he's the best at this kind of work. Kinetic art is related to time, and I believe nobody expresses the value and meaning of time as well as Mochetti. But nobody knows him. Have you ever heard his name?

CK *No.*
GP Yes, but in my opinion he's a very important artist. I also collected paintings by Bob Law and Peter Joseph, who are very good artists but not famous at all.

CK *So you're saying you are only one factor among many.*
GP Yes. There are situations in which an artist is not able to find a good dealer, or is not able to have a relationship with dealers. Or he makes something which other people don't react to the way I do. This work is left out of the market. However, if I do collect some good art, people around are not stupid and they collect it too.

CK *You've never collected figurative art, except for art that derives from photographic sources, such as Pop. Nor have you ever collected photography per se; although Douglas Heubler and Jan Dibbets use photographs, they aren't really photographers. Why do you favor abstraction?*
GP It is a distinct quality of 20th-century art to explore new dimensions and visions of reality.

I don't believe that abstract art is better than figurative art, because there is no difference. For instance, some artists of the Italian Renaissance, the so-called Mannerist painters, were in reality abstract painters; for them, the quality of the image was more important than the meaning of the image. What was important was the relationships of color, the harmony of shapes, not the fact that the image was related to something real. The image was only a way to build forms that were intellectual creations.

But I believe that modern science revealed to our knowledge a world which is far above what is possible for our eyes to see. Our eyes have limits in perceiving reality. But knowledge goes far above this limit. For this reason we no longer need the images which our eyes can see. The world we can know through our intellect is wider than the image coming through our eyes. If you look in the microscope, you see an abstract image. If you look at photographs of the stars, they are abstract images. Abstraction is a closer image of the reality around us. It's a more efficient tool to inform us about reality.

CK *How do you reconcile being an idealist and a realist?*
GP Well, we cannot really be an idealist if the idealism is only an intention. Life is not made of good intentions. If the intentions are not related to the facts, they're just words. Words are no good if they're not related to something real. Idealism and realism have to be together. The quality of our idealism is in relation to our attempts to make it real. We can fail, but what is important is the engagement we have in order to make it real. It's not important if we fail, but it's important that we try. Engagement is the only important thing in life. It's not so important that the ideal becomes real, but it's extremely important that our energy be devoted to the goal we have in mind.

CK *Would you describe that as a political dimension for art?*
GP It's a political dimension for art because I believe it's an obligation which every man has.

CK *In 1980, a comprehensive exhibition of your collection had been planned in Düsseldorf.*
GP Yes, in the Kunsthalle and in the City Museum. But the City Museum was closed for restoration, so we used a large room at the fair nearby. There was also a plan to make a long-term loan to the Düsseldorf Museum, of Nordrhein Westfalen, of the works which are now owned by the Museum of Contemporary Art in Los Angeles. The director was Mr. Schmalenbach, who had made a beautiful collection of modern art. But this program could not be carried out because of the Italian law forbidding long-term loans abroad of works of art.

CK *So the exhibition was never completely realized?*
GP No. In the early '70s, I had already bought many works of art, and the need to find space for them was pressing. Only a small number of them could be shown at my house in Varese. So I began to investigate museums in order to find one that would be interested in having the first

part of my collection. I believed this was the more interesting part for a museum to have because it was made up of well-established artists. I asked many museums, but the first answer came from Germany, from the Moenchengladbach Museum and, afterward, from Mr. Schmalenbach at the Düsseldorf Museum.

Johannes Cladders, the director at the Moenchengladbach Museum, was an excellent man; he made beautiful, early exhibitions of several American and European artists, and I went to see them many times. They were of the same artists I was beginning to collect. The museum was in a small old house, but there was a plan with the city to build a new museum. The task was given to Hans Hollein, whom I read this morning was given a very important prize in architecture, which was given last year to Richard Meier.

CK *The Pritzker Prize.*
GP Yes; I'm very happy because I like his work very much. But the museum was yet to be built, and I was very interested in making a long-term loan. The city didn't have the money to buy the collection, but was very interested in having it for a fifteen-year loan. The negotiation started in 1973. In '74 we reached an agreement, and I crated all the works. I sent them to storage in Switzerland, awaiting the construction set to begin the next year and to be finished no later than 1978. But unfortunately, there was an economic depression in Germany in 1974, and the start of construction was postponed. So the museum wasn't ready until 1982. Because the possibility of building the museum appeared to have vanished, I was approached by Mr. Schmalenbach to loan the works to Düsseldorf.

Schmalenbach had built a beautiful collection of modern art, starting with Cubism, Metaphysical art, Surrealism, abstract art, and Pop art. There are just a few paintings by each artist, but all are masterpieces. I believe it's the most beautiful collection made in postwar Europe, really top quality. There are no mistakes in this collection. It was made with funds provided by the state—about three million marks a year. The amount of money Schmalenbach had each year was not too much less than all the money I spent on art in my whole life!

CK *What is the equivalent of three million marks in dollars?*
GP Well, I'm not strong in money conversion. But when the dollar was very low in value, two marks bought one dollar, so it was about $1.5 million a year.

CK *So you've spent a little more than that on your entire collection?*
GP Yes.

CK *I keep thinking of your sister having told you to be careful. You have proven her wrong!*
GP Oh, yes.
Schmalenbach also had a plan to build a new museum. There was an international contest for the project. But for economic reasons, it was delayed, too. Indeed, this museum wouldn't be ready until 1986. I had stored my collection in Switzerland as a permanent export from Italy, in order

to avoid complex regulations in force in Italy. When you have to export something, you cannot make it a long-term loan, only a loan of one or two years. It's very complex. So I made a Lichtenstein Trust, which became the permanent owner of the collection, and this Trust was the property of my wife and I. In this way, I was free of all the complex formal obligations with the Italian administration.

CK *This Trust included only the eighty works which are now in the collection of L.A.'s Museum of Contemporary Art?*
GP Yes. This operation was possible to do in Italy at that time. It was not allowed by law, but if somebody did it there were no consequences. We had to pay a fine, but it was a small fine.

CK *It's a good thing you were a lawyer.*
GP But in 1976 the Italian government passed a new law, which required that every Italian resident having property in a foreign country had to bring it back to Italy, or else sell it and send back the money. I asked the government not to impose this obligation because mine was not an investment abroad, not capital kept abroad. It was a cultural activity.

This law required me to dissolve the Trust I had made, which I did, and the works became mine. But the Italian administration rejected my request. We were obliged to bring back the work or the money in a very short period of time. We asked for a delay, but that was also rejected. Because the new law was very strong in forbidding anyone to keep money or property abroad, there was a risk of going to jail. We were denounced to the criminal court in Rome because we were guilty! We ran the risk, my wife and I, of going to jail because we kept works of art abroad to be shown in museums!

CK *What reason did they give for refusing your request for a waiver for cultural reasons?*
GP Just because it was the law. There were no distinctions, even if there was some valid reason to keep something abroad. This law was very simple: Everything had to come back—either the estate or the money, if it was sold.

CK *That was in 1976, and you sold the collection in 1984. So for eight years you were avoiding the police?*
GP Almost, because we had to await trial by the criminal court in Rome, which would establish whether we were guilty or not. And we had to wait six years, because Italian law is very slow! The courts were not pressed because they realized that our crime was not very dangerous to Italy. But my wife and I had to go to trial, to sit on the bench of the guilty people and have a discussion with the three judges—all sitting in a very large, empty room in Rome.

CK *They didn't handcuff you?*
GP No, we had a discussion. I showed them catalogs, I explained why I was keeping these works abroad, because there was this cultural interest that was real, not just something I had made up. After having seen the material and having a short discussion with my lawyer, the court retired.

They spent half an hour in the room where they had to decide our sentence. And we had to spend one of the worst half hours of our lives, just waiting to see if we were guilty or not!

At last, they came out. They read the decision and we were declared not guilty at all. The interpretation that the court gave was this: When something was kept abroad for cultural reasons, it was within the intent of the law. The law was made only for people who had assets abroad for investment. So we were completely free, and we believed we had solved every problem and could make the long-term loan to Düsseldorf.

CK *When the court looked at the catalog, what did they think of the work of Hannah Darboven and Jan Dibbets?*
GP Well, we also gave them many articles about the collection from Italian newspapers. They realized that, even if they didn't understand it, it was judged to be something good by competent people.

But the problem was not really solved. The Italian administration in charge of foreign exchange still interpreted the law differently from the court. And we still ran the risk of being caught again and going to another criminal trial, which was not an experience we wanted to repeat a second time. So I decided to look for another solution, which was to sell the collection and bring back the money. I tried to sell the works to Schmalenbach, but unfortunately his funds had been cut by the state of Westphalia because of the economic depression in 1982. So in June of 1983 I wrote to Richard Koshalek, the director of the Museum of Contemporary Art in Los Angeles, to ask if the museum was interested. He said yes.

CK *When you sold the collection, you had to return the money to Italy?*
GP Yes. The dollars go to the Bank of Italy and the Bank of Italy gives me liras at the rate of exchange of the day.

CK *That's very clever of them.*
GP Yes. If I brought back the paintings, which was the other possibility, I would have to pay a value-added tax of 20%, which meant millions of dollars—which was impossible. I would have to sell one-third of the collection just to pay the tax. I would have to break up the collection, which I was not willing to do.

When I saw the only solution was to sell, I asked for an estimate from Christie's and Sotheby's. They *ran* to Milan the next day to make an estimate. The estimates were between $11 million and $15 million, if sold at auction in 1983, but they were prudent estimates. Christie's was the higher. They told me it would be the greatest sale of contemporary art in history, that it would draw museum directors and collectors from the world who wanted to have the paintings.

But money was not my goal. My goal was just to keep the collection intact, to have it housed in a beautiful museum. MOCA was the ideal solution.

CK *But it was clear that the estimates were very conservative.*

GP Oh yes. Leo Castelli told me recently that he had several offers when people realized that I was willing to sell. There were institutions and collectors willing to give me $12 million in cash, immediately.

CK *Well, they could turn around the next day and practically double their money.*

GP Oh yes. Castelli told me if I wanted to sell these paintings I would easily get $20 million.

CK *So the $11 million that MOCA paid for the collection was the low estimate that Sotheby's had given?*

GP Yes.

CK *You had benefited from an inheritance from your family. Do you feel a similar obligation, since you have five children?*

GP Yes. If I didn't have children, I would give my collection as a gift. I don't feel a need to be rich. I feel the need to reach my goal, which is to have the collection installed in the best way possible in good museums. I am not a good businessman, but as an art connoisseur I believe to be good. If I have inherited this talent from nature, I have to use it in the best way. It is my duty.

CK *You once wrote that art was essentially a vehicle for social integration. In reference to Renaissance frescos, you wrote that those artists "interpreted the feelings that were shared by a community, since they were works executed in buildings destined for public use. The individualistic conception of art which Romanticism introduced into our culture shattered this relationship."*

 You seem to be saying that, in the intellectual and moral crisis of the 18th century, which gave birth to modern culture, we somehow made a wrong turn. Could you elaborate?

GP A Renaissance, Baroque, or Medieval artist was not working for a private collector. He was working for the church, for the king, for the duke, for the prince, but always for a building with a social and political function, whether church or palace. The palace, where policy was made, had to be decorated with works dealing with the social achievements of the man in power or, through symbols, to show the goal the prince wanted to reach for the good of the people for whom he was responsible. Only with the development of the bourgeoisie did this function diminish. Art was needed for private houses. This began in Holland in the 17th century, when the bourgeoisie became rich through trade with foreign countries. In Italy, paintings made for private use mostly had a religious function, to have religious images in the home. In the early 16th century it became common to make portraits to have the memory of the family in the house. It was related to the Medici commissions for paintings of mythological stories, which were analogies for what was happening in their family.

 An artist's work was mostly made in connection with social or political events. He was the man who interpreted the moral and ethical life of the community. This was the goal of art. And it was used in this way by people who wanted to have art made.

CK *It was for a particular social class, though.*

GP Yes, that was one important consideration. The people who commissioned artists were the dominant social class. The most important families had sons who became cardinals or bishops of the church, or sons who became soldiers and had political power—and sometimes even economic power. Leadership was concentrated in a few people, in the class that had the highest level of education. There was no public education, with one teacher and twenty-five pupils. Each son had his own teacher, who was a man with a high cultural reputation. The best writer, the best poet, the best painter lived in the palace to teach the son.

CK *Wasn't the rise of individualism essential to changing that?*

GP This happened because of the French Revolution. The system ended when the great monarchies collapsed at the end of the 18th century, because the bourgeoisie was becoming more important economically. The system didn't work anymore. Power shifted into the hands of the people who had economic power. Social life was also changing. The quality of education of the new rich people was lower, because they didn't have the best humanists teaching texts in Latin and Greek. The close relationship between the intellectual world and power was lost.

In Rimini, there is a beautiful church by Alberti, the great architect of the 15th century, which was made for a Malatesta prince. Outside the church are the graves of the prince and his court. The first is the grave of the prince. The second is the grave of the poet, who was the poet of the prince. The third is the grave of the painter, who was the painter of the prince. The fourth is the grave of the man of law. The fifth is the grave of the general. And so on.

But the poet is first. Today, it would be the minister of finance! Most important is the man who pays for the election.

We can see how power and culture were together and couldn't be split. The prince, the man of power, realized that his power didn't have any reason if there was no cultural motivation. The identity of good government and the cultural appreciation of the value of life was the same. This was extremely important. It's not the same now.

CK *Do you believe that the artists whose work you've collected are, in some way, attempting to do something similar?*

GP Oh, yes, surely. The artist, being a man like other men, is also an interpreter of our social situation. And the artist is the best interpreter of social conditions because he's a man of higher sensibility who lives more deeply the life common to other men. Every one of us lives in the same way—in America, in Europe, in Japan.

CK *Essentially, then, you have built a collection for private use, and the dilemma you're facing now is how to transform it into a collection for public use.*

GP Yes.

CK *While you were trying to place the portion of your collection that's now at MOCA—the Abstract Expressionist and Pop works—you also had begun negotiations to place the Minimal, Conceptual, and installation works in two palaces in Turin. How did that project begin, evolve, and finally fall apart?*

GP In the mid-'70s, when the Italian newspapers found out that the first part of the collection would leave the country, they complained that it was not being kept in Italy. Some people asked, Why not keep the rest in Italy? Why not make long-term, fifteen-year loans of my collection, or even a donation, to fill empty, historical buildings then under restoration but with no planned use?

The first suggestion came from a friend, Giuliano Gori, a collector who lives in Prato, to use the stables of a famous building near Florence: the Medici villa in Poggio a Caiano, which was built by Juliano da Sangallo for Lorenzo Il Magnifico. It's a beautiful masterpiece of the Italian Renaissance, built between 1490 and 1498. Construction was begun while Lorenzo was alive, but it wasn't completed until after his death in 1494. Near the villa was a large stable, a beautiful space. On the ground floor were three naves with columns separating them, about 300 feet long and 80 feet wide. It looked like a big church. Above it was a similar space with a huge corridor in the middle and rooms on the sides. There had been a fire—part of the roof fell in—and the Department of Fine Art was starting restoration of the building. The Medici Villa is state-owned.

My friend asked me to make a proposal, and I suggested using the ground floor for a huge work by Dan Flavin—a series of fluorescent lamps, filling the left wall—and on the right a fluorescent work by Bruce Nauman. The space would be lighted by these two works, but the view of the space would not be altered in any way. The second floor would have works by Los Angeles artists who use light: Wheeler, Irwin, Turrell, Nordman, Nauman.

If it was built, this museum would be maintained by the state administration of Tuscany, which was communist and socialist. I had several meetings with the politicians in charge, and they were in favor of my idea. I also met with the Minister of Culture, and everybody always said yes, yes, yes. But it was never done. It was a great pity not to be able to associate these beautiful works with a villa built for a great collector, intellectual, and politician like Lorenzo Il Magnifico, and built by a great architect like Juliano da Sangallo. It was the ideal thing to do: to join history and the art of the past with the best art made today. Nothing similar would be possible anywhere but in Italy.

Two years later, in the summer of 1978, I was in Turin. Previously, I had made two long trips through southern Germany to see the Baroque architecture, which is one of the great achievements of European culture. I was also interested in the Baroque architecture of Italy, and Turin was one of the centers of Baroque art because of the Savoy dynasty. Until 1563 the Savoy dynasty was French, because they had power on the French-speaking side of the Alps and in Switzerland. The French kings needed to regain control of the natural border, along the Alps and the Rhine, in order to protect themselves from the pressure of the German empire. The French king was allied with the Canton of Bern, which also wanted to control this part of Switzerland. The Savoy Duke was allied with the Duke of Bourgogne, who lost the war, so the Savoy dynasty lost control of the whole French-speaking side of Switzerland and of the land on the French side of the Alps. So, they tried to expand their power in Italy, in the Piedmont. In 1562 Duke Emanuele Filiberto moved the capi-

tal from Chambery, in France, to Turin.

Until then Turin had been a small town. With the help of the best Baroque architects, the duke planned a beautiful city and a large number of palaces were built. Two were falling into ruin: Rivoli Castle in the northen suburbs, which overlook the city; and Venaria Castle, the hunting lodge of the most powerful king of the dynasty, Vittorio Amedeo II, which was built between the end of the 17th century and the middle of the 18th century. It was a huge building with huge stables, designed by one of the best Baroque architects in Italy, Filippo Juvara. The building had become an army barracks and was left in ruins. The Rivoli Castle has about 50,000 square feet, the Venaria Castle about 300,000 square feet.

CK *The Venaria Castle alone could accommodate the entire collection.*
GP Oh, yes. It was one of the biggest royal palaces built in Europe. It was smaller than Versailles, and smaller than Caserta, a royal Baroque palace near Naples; but it was bigger than all the other palaces of Europe.

I got in touch with friends, who in turn put me in touch with the administration in the Piedmont responsible for the restoration of the Rivoli Castle. We signed an agreement for a long-term loan, lasting fifteen years, for the Minimal art by Morris, Andre, Flavin, Nauman, and Serra.

CK *So the Italian government would provide restoration of the building, and you would provide the collection?*
GP Yes, that's right.

CK *What was the cost of the restoration?*
GP For the Italian government, the cost was about $4 million. The value of the eighty large works to be housed in the Rivoli Castle was about $8 million.

I also made a proposal to house the whole collection in both castles. The money needed to restore Venaria Castle was about five times bigger than for Rivoli, because the building was about five times bigger. We waited for the allocation of funds in order to sign an agreement.

While this was happening, another possibility came up. Near Milan is the castle of Vigevano, built by the Sforzas in the 14th and 15th centuries. Part of the building was designed by Bramante, and Leonardo had lived and worked there while he was designing hydraulic works for land irrigation around the castle, which belonged to the duke, Ludovico il Moro. Leonardo spent much of his life in Milan, from 1483 until Ludovico was seized by the King of France in 1499. He returned to Milan in 1506 and remained until 1516, when François Premier, who liked Leonardo's work very much, was king of France. The building is very large, at the top of a small hill in the old town, with wonderful spaces for art. And this connection to Leonardo and Bramante made it a very exciting opportunity.

The castle, which has a hundred rooms, was slowly under restoration. It was going to be used by the Brera Museum for paintings that couldn't be shown in Milan due to lack of space. But Mr. Bertelli, who was director of the Brera, realized that there were too many large doorways and win-

dows to accommodate the paintings and that many of the walls were not vertical because the building was originally designed as a fortress. He asked me to make a proposal for housing my collection there. I planned to show the Conceptual art, the Minimal art that wouldn't be shown at Rivoli Castle, several installations by Los Angeles artists, and so on.

It was necessary to have final approval for this plan from local authorities and the Minister of Culture. From Rome, he appointed a committee to decide. Because the castle is in Lombardy, the committee was led by the head of the Lombardy cultural administration. Instead of a long-term loan, Mr. Bertelli had asked me to donate one hundred works for this space. I agreed, but the committee refused the donation.

CK *Why?*
GP I don't know. They decided instead to use the building as a center for the art of Lombardy, which didn't mean anything because they didn't have any Lombardy art to put inside. The building is still empty.

In the meantime, there were many other negotiations. I went to Venice because people there asked me to use the Arsenale to house the collection. It is a huge building, designed as the shipyard of the Venetian Republic and built in the 13th, 14th, and 15th centuries. It was used by the Italian navy until a few years ago, but now it is empty.

There was also a possibility of using the Villa Doria Pamphili, in the middle of a huge park overlooking Rome. There was also a suggestion to use a villa in the suburbs of Milan, but it was too small—only 10,000 square feet, too small for the collection. There was also a plan to use an abbey near Parma, because the University of Parma was developing an art collection. I contacted the director, but when I told him I was willing to make the gift if the work would be shown permanently, he refused the donation.

In Varese I had started negotiating with the city in 1978 to make my house into a museum. I was willing to give the collection in the house as a gift along with one-third of the property because the other two-thirds belong to my brother and two sisters. They were willing to sell their portion at a very reasonable price. But the negotiation never went through. Like all Italian politicians, they always say yes but never do anything.

CK *So you have been through a lot of negotiations all over Italy.*
GP Oh, yes. Just last year, before the sale of my collection from the '50s to MOCA, I asked the museum if they would give the option to Turin to buy the collection at a greatly reduced price—$7 million instead of $11 million—so that the entire collection could be kept in Italy. But the regional administration in the Piedmont couldn't find the money. So I signed the agreement with MOCA.

CK *I understand there were protests against the proposal in Turin by Italian artists. Is that true?*
GP Yes. In March of 1984, a few months after I signed the agreement with MOCA, I offered to make the long-term loan of the Minimal sculptures for Rivoli into a gift. The restoration was almost finished, and the museum would open in December. But on April 26, the head of cultural

affairs for the regional administration called and told me they were no longer willing to have my collection in the museum. They had appointed Rudi Fuchs, the director of the Eindhoven Museum, to prepare a program of international exhibitions. The main reason was to give space to the Arte Povera artists from Turin, who complained that they were not represented in my collection. If the museum had been made as planned, it would have become the first museum in Europe devoted to American art; this would be done by a leftist administration, communists and socialists, without any Italian art. So the program was changed; the gift was refused; the $8 million worth of art was lost.

CK *In a nutshell, the project got started because of complaints that the collection was going to* leave *the country, and it all fell apart because of complaints that it was going to* stay *in the country?*
GP Yes. It is a contradiction.

But the interests of politicians are stronger than anything else. They risked losing some hundred votes from Italian artists. Because they feared losing the help of a few hundred people, they lost the $8 million gift. Rudi Fuchs made an exhibition that was a reduced version of the last Documenta. Some are good; others are not good at all. And it is a temporary installation; all the work is on loan. The regional administration says it will spend a half-million dollars a year on acquisitions. But I don't believe it's true because that's all the money they have for all cultural activities. They've asked for help from the big corporations in Turin, but I am very doubtful that this help will be given them.

CK *I'm sure you were extremely disappointed when this plan didn't work out. Do you feel any bitterness about the difficulties you encountered?*
GP Oh, yes. For me this experience in Turin was a wound, a deep wound, because I trusted this administration. They were really knowledgeable about the quality of the collection and the importance of art. But the political interest was stronger than the interest for art. For me it was a very bitter fact to realize that the interest of parties and politicians were so far ahead of the public interest.

To lose this possibility really broke me, because I always had the idea of putting together the culture of the past with the culture of our time. For me, it is the evolution of the same research. There is no difference between artists of the Italian Renaissance and artists of America. They share the same cultural roots and development, they're branches of the same tree. The opportunity to show this unity of past and present was unique, and it could be realized only in Italy. I looked in France, but there are no buildings large enough or with large rooms. I looked in Germany, but there are no large old buildings available. I looked in England and in Scotland, but the situation is the same.

Another experience that wasn't positive happened in Basel, in 1976. I went to Basel often to see exhibitions. I was friendly with Franz Meyer, the director of the Kunstmuseum, and with all the directors of the Kunsthalle. I had spoken with them about my intention to find space for my collection. I met Mrs. Maia Sacher, the former wife of one of the owners of Hofman-La Roche Corporation, which makes chemical products.

CK *Valium, I think.*

GP Yes. She was willing to make a gift to the museum in order to build an extension to house the collection of contemporary art. The Hofman Foundation was buying beautiful contemporary art for the Kunstmuseum. Mrs. Sacher had come to Varese to see my collection, because she knew I was willing to make a long-term loan. She was very bright and one of the best collectors in Europe. She had beautiful works by Max Ernst, Picasso, and Klee. Mrs. Sacher was seventy-six years old but she was still interested in contemporary art and was buying work by Barry, Weiner, Ryman, Morris, Andre, Serra and others. But the Foundation didn't have more work to put in the new extension, so if another collector was willing to make a loan, it would be useful.

She was very impressed by my collection in Varese; the stables were finished and there were works by Los Angeles artists and Minimalists. She said she would be sure to find a way to do something similar in Basel, and would look for a space. An old factory was found not far from the Kunstmuseum, in the old part of the city near the Rhine. It was owned by another foundation whose director, Hans Meier, was interested in art and willing to construct a museum. I advised the architect on how to make the interior spaces and how to use natural and artificial light. The top floor would have natural light reflected from the sky and integrated with electrical light at dusk. We agreed to select work from my collection, from the Hofman Foundation and from the Kunstmuseum—all Minimal and Conceptual art of the '60s.

But then, Mrs. Sacher's family and others who were not competent in art began to complain that she was spending five million Swiss francs to make a museum for the Panza collection, rather than for the Hofman Foundation which was paying for it. So they changed the program. They did give me one beautiful thing: a chance to exhibit my collection for eleven months. The top floor, with the natural light, was used for my Ryman paintings, and it was something magical to see.

CK *Was this the first time you had seen so much of your collection together in one place?*

GP Yes. There were about seventy-six works—Bell, Andre, Judd, Lewitt, Kosuth, Weiner, Mangold, Serra, Nauman. The rooms of this museum were perfect, and I was very happy to have the opportunity. Unfortunately, it only lasted 11 months.

When she was eighty, Mrs. Sacher retired as president of the foundation because she wasn't in good health. The foundation started to buy successful artists: Julian Schnabel, Anselm Kiefer, Francesco Clemente, Enzo Cucchi, Mimmo Paladino, and so on.

CK *That must have driven you crazy.*

GP It wasn't the best work of these artists, unfortunately.

This was a bitter experience for me. With Mrs. Sacher we had started a beautiful program, but afterward, everything failed. The original project would have been the first museum devoted to Minimal and Conceptual art of the '60s. Now it's a museum without an identity. Today. the Crex Collection in Schaffhausen is the only one devoted to Minimal and Conceptual art, and we can see how much better it is than work bought by the Hofman Foundation.

CK *Now that these various plans have fallen through, I imagine other museums have been knocking on your door. What are your primary criteria for selecting a home, or multiple homes, for your collection?*
GP The primary criterion is to keep a coherent group of works together, as I have done at Varese and as I did with the first part of the collection at MOCA in Los Angeles. I would like to follow the same idea and have each museum specialized in a given period of a given group of artists, not to mix up different artists. I like specialized museums.

However, it's not possible to have forty Naumans together or thirty Rymans in a single place. It would be too much. It would be better to split them into two or three places—the early work of Ryman in one, the period of the '70s in another. Or the steel work of Robert Morris in one place, the fiberglass in another.

I still hope to keep intact the work I have in Varese.

CK *How do you assess the quality of a potential museum as a caretaker for your collection?*
GP It depends on the size, quality, and location of the space. Factories are often very beautiful, because Minimal art goes well with very simple engineering structures. This art, which deals with man's intellectual capacity as a thinker, finds its natural home in these simple spaces. Lighting is extremely important in museums, not just for seeing details better but for making an environment. Light is a key function in giving the feeling of a totality.

I have basically one idea: a museum is not an accumulation of more or less good works of art; it's not a fine warehouse. It's a place where we live in a different condition when we are inside. We have to feel something ideal is present in the space. This is the goal a museum has to reach, or else it fails as museum. Very often museum are just accumulations of art.

I had a bitter experience at the Tate Gallery in London when I went to see the Saatchi Collection. The Saatchi Collection is installed in a beautiful old factory that was cleaned and restored. The spaces are very simple, with few works inside but beautiful ones: Judd, Marden, Warhol, Cy Twombly, Serra. The perfect space increased the quality. Afterward, I went to the Tate Gallery and saw fine works mixed with bad ones, just put on the wall like stamps in a stamp collection. It was terrible, really very sad. To see the Rothkos cramped in a small room with bad light was just sad.

CK *So your task is to find museums with the same conception as your own?*
GP Yes.

CK *I read that Johannes Cladders has said that your approach to installing the collection is admirable but impractical.*
GP Well, I believe it's not true because the experience I had in Basel was positive. It didn't last because the people in power had different interests, but the experience I've had with MOCA proves that it's possible.

The main problem for every museum is the size of the space. To find space is always difficult because museums are in large cities. In the center of the city space is very valuable; to find a city willing to give away income in order to have art is not easy. New buildings are very costly.

But often, cities own buildings in depressed areas, old factories no longer used or a warehouse near a port. The way of shipping materials in containers is different today, so we don't need warehouses in ports. So large buildings are available, for instance in Long Beach, San Francisco, San Diego.

CK *Those cities are in California, and one of the things that pleased you most with the project in Turin was the unique possibility to link past and present. What is unique about Southern California as an appropriate place for your collection?*

GP Well, a large number of artists represented in the collection live in California or worked there. They have a relationship to California culture. Los Angeles is midway between Europe and Asia, is a city by the ocean at the end of the desert. There are few cities in the world with such beautiful light.

The investment that the State of California made in education in the past was very important. Now this country is shaping the future of the world in science and high technology. Science is the religion of the 19th and 20th centuries, but it is also a religion which could destroy humanity. Because of its great concentration of scientific research, California has a great function in the future. Science will be essential for improving life—if it's joined to research in the humanities. The improvement of man's inner world is made through art—not only through art, but mostly. If science doesn't have this joint goal with human values, it will be dangerous rather than useful. For this reason, it is important to develop art and cultural activities in California.

CK *You said earlier that the possibilities for art in New York have been limited by the marketplace. The art market in Los Angeles is not yet strong, but it is headed in that direction.*

GP I believe that the fact that the market is not strong in Los Angeles is a positive thing for art. Positive for art, but not for artists! Many artists in Los Angeles must have a part-time job in order to live. In this way they are free to make what they want. They don't have all the restraints of the market. Freedom is essential for good art. Without it, we cannot have good art.

CK *Having been involved in the art world for thirty years, who among the artists, curators, critics, and collectors has most informed your thinking?*

GP Well, many people. Cladders was influential, and Pontus Hulten. We met in 1963 because he wanted to make an exhibition of Pop Art in Stockholm and he came to Varese to see the work I had. Edy de Wilde was a close friend, and we had many similar interests. In New York, I was very often buying art just before de Wilde arrived. Or sometimes the opposite happened: a work was not available because it had been bought two days before by de Wilde.

CK *Who do you believe to be the most interesting new artists working now?*

GP I believe the most interesting young artists are in Los Angeles now. Perhaps I am not well-informed about what is happening in Europe or New York. But here in Los Angeles there are many new artists who I like: Bob Therrien, Mark Lere, Michael Davis, Susan Kaiser-Vogel, Peter Shel-

ton, Joann Callis. I trust very much the work they are making and believe they will become important in the future.

CK *Could you talk about the work of, say, Bob Therrien in relation to the art you've collected over the years?*
GP Yes. Therrien interests me because he has a very simple way of making shapes, and he joins painting with sculpture. His shapes are not geometrical, like Minimal art, they're organic, close to the shape of a living body. What is most interesting is the sensibility behind his work: it deals somehow with life and death.

CK *We were talking earlier about the "wrong turn" modern culture made toward individualism and away from social integration. Your collection was privately assembled, and I think it could reasonably be described as highly individualistic. How does one then make the transition from private collection to a public museum whose goal is social integration?*
GP My collection is surely individual, because it is my personal choice. But I am a man. I am a man like others. I believe my goal is the goal of a very large portion of the population, not different from others. Because of this, my choices are the potential choices of millions of people. Indeed, I was very pleased at MOCA to see how many people loved this art. This is my greatest pleasure. Nothing more beautiful exists than the possibility of sharing this love with other people. The greatest gift that art gives to me is this pleasure: seeing how many people love what I love. This is the most beautiful thing.

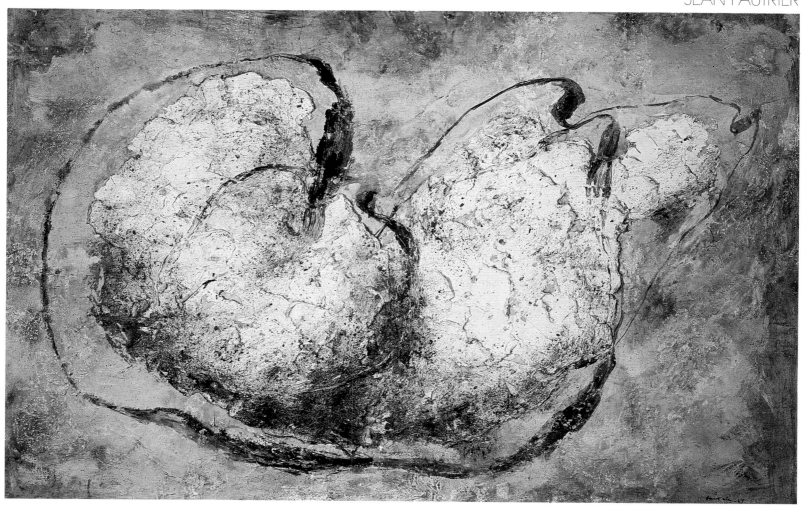

8. *Depouille*, 1946. F5 MOCA

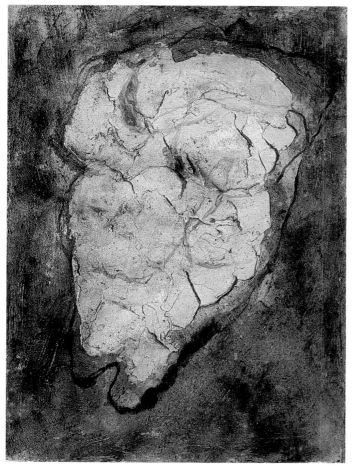

9. *Nu*, 1943. F2 MOCA

10. *Tête d'otage no. 14*, 1944. F3 MOCA

11

11. *Red-Brown, 1958.*
 AT 11 MOCA

12. *Brown-Ochre with*
 Black Crevice, 1957.
 AT 7 MOCA

13. *Hammered Grey,*
 1959. AT 13 MOCA

12 13

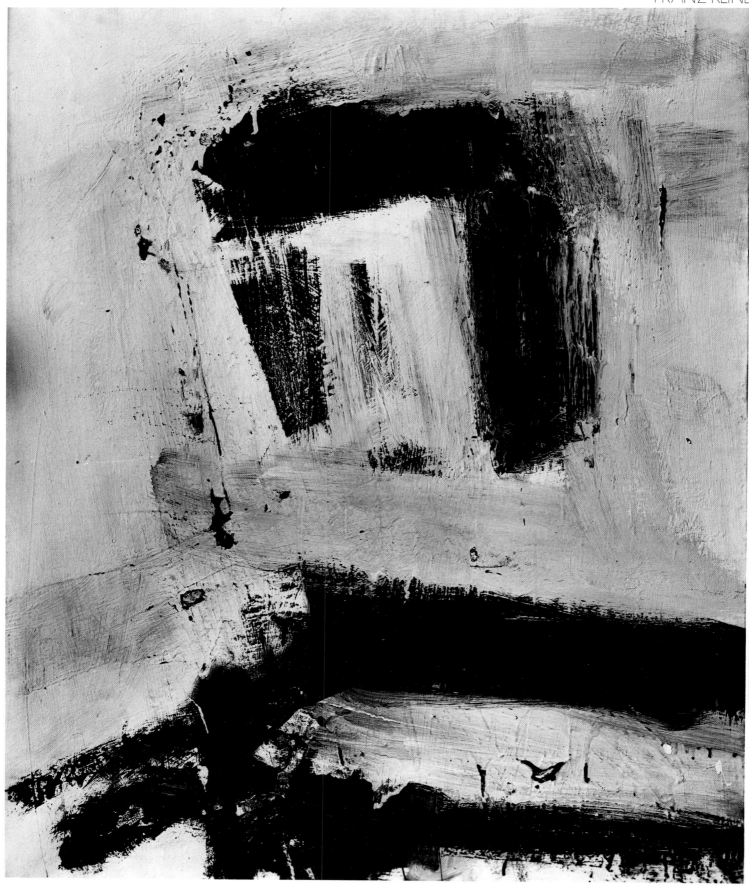

14. *Ilza*, 1955. FK 3 MOCA

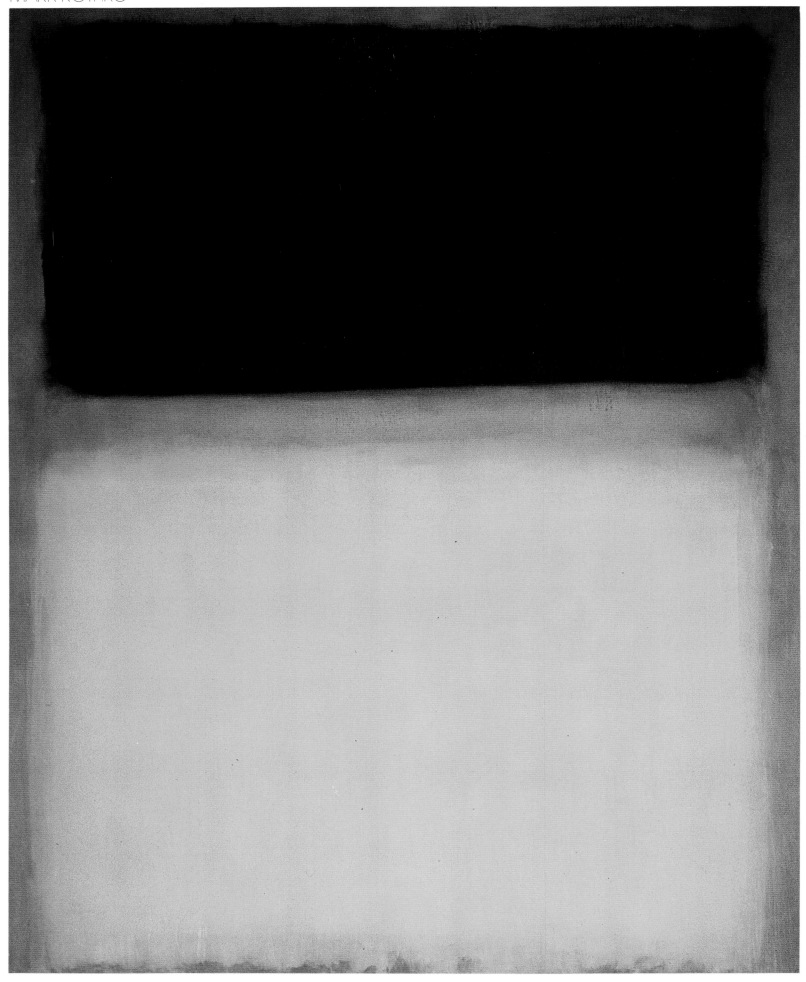

15. *Violet and Yellow in Rose*, 1954. MR 2 MOCA

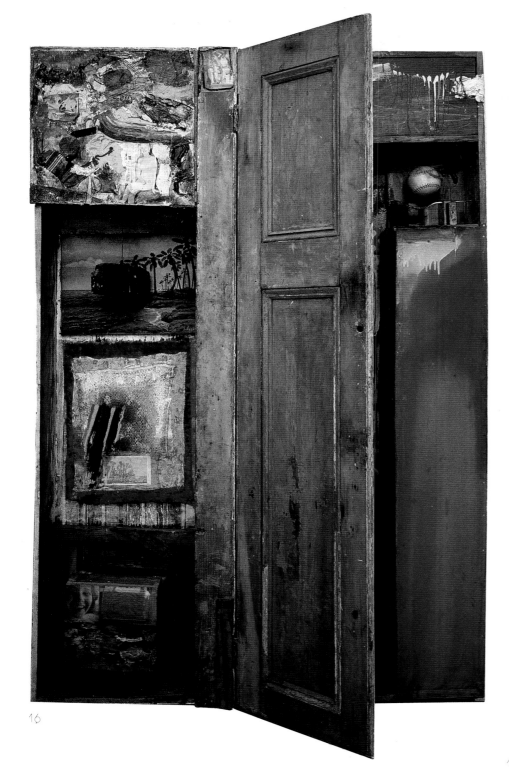

16

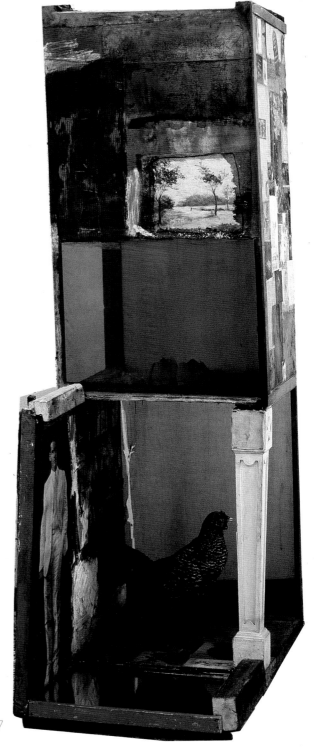

17

18

19

16. *Interview*, 1955. RR 2 MOCA

17. *Untitled Combine*, 1955. RR 1 MOCA

18. *Painting with Grey Wing*, 1959. RR 6 MOCA

19. *Coca-Cola Plan*, 1958. RR 5 MOCA

20

20. *Vestigal Appendage*, 1962. JR 6 MOCA

21. *Waves*, 1962. JR 4 MOCA

21

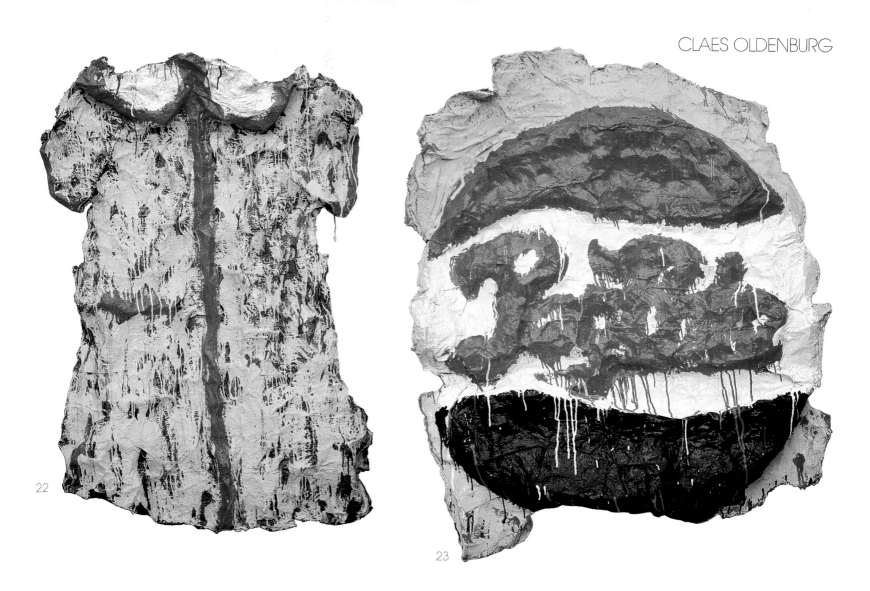

22

23

24

22. *Mu Mu*, 1961. CO 1 MOCA

23. *Pepsi-Cola*, 1961. CO 7 MOCA

24. *Breakfast Table*, 1962. CO 16 MOCA

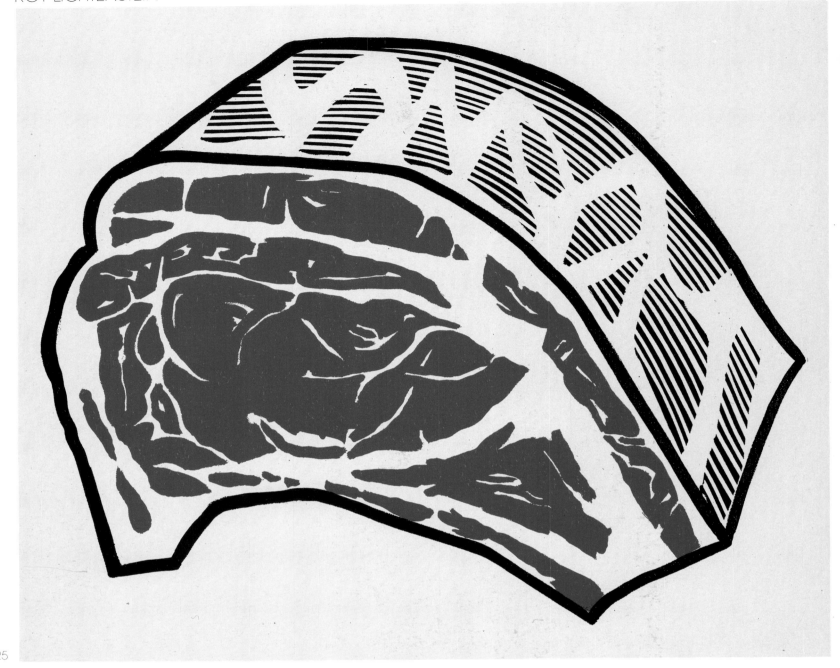

25

25. *Meat*, 1962. RL 3 MOCA
26. *Desk Calendar*, 1962. RL 2 MOCA

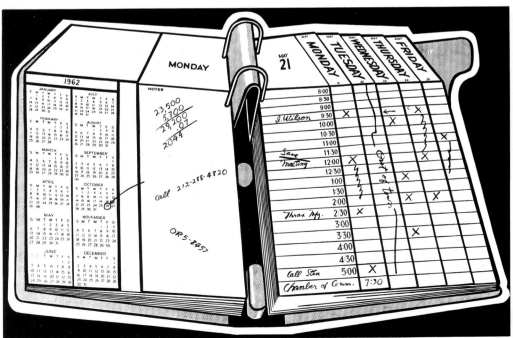

26

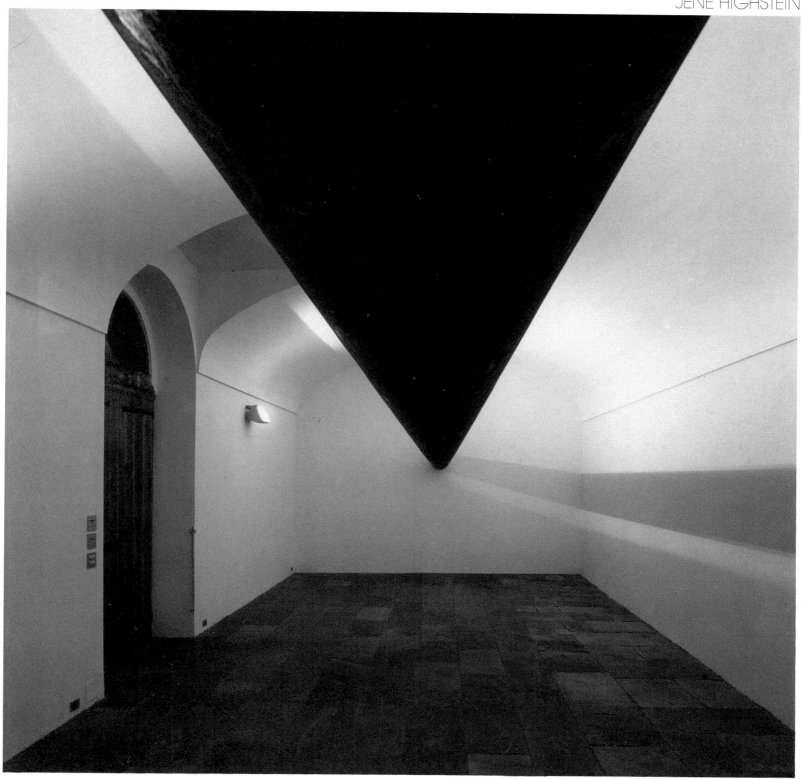

27

27.28.*Untitled*, 1974. JH 1

28

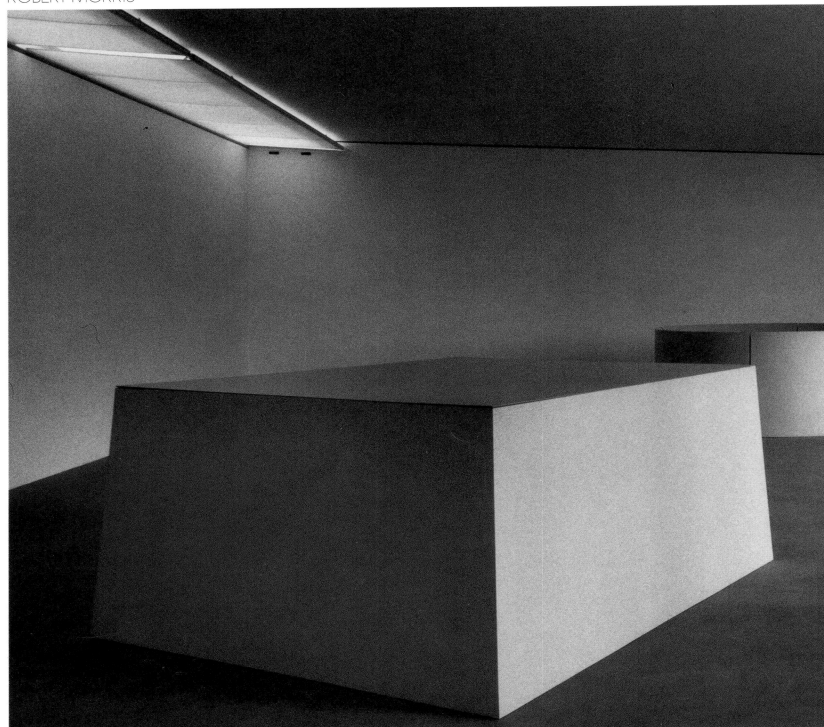

29

29. *Untitled (Piece with battered sides)*, 1966. RM 32
 Untitled (4 round wedges), 1967. RM 5
 Untitled (4 wedges), 1967. RM 5

30. *Philadelphia Labyrinth*, 1974. RM 28

31. *Untitled (5 steel plate piece)*, 1969. RM 26
 Untitled (5 steel plate piece), 1969. RM 24

32. *Untitled (Aluminium I-beams)*, 1967. RM 27

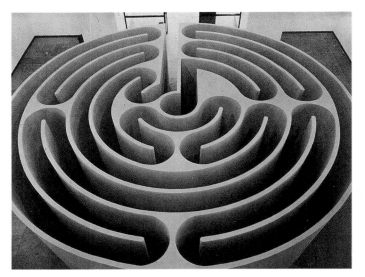

30

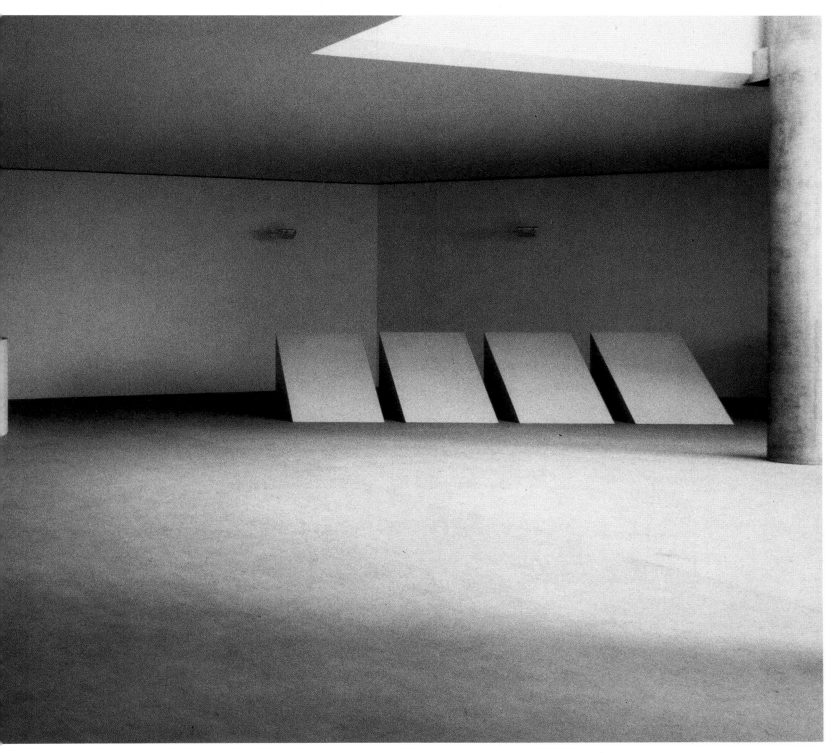

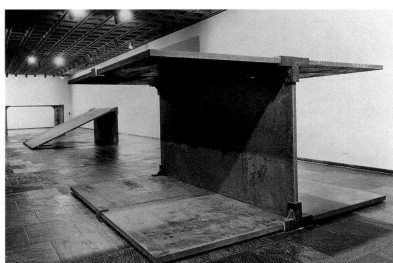

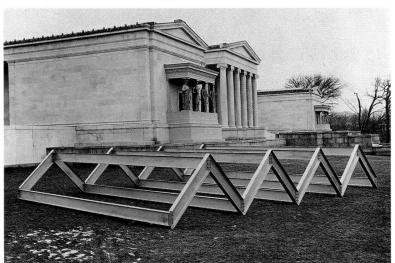

31

32

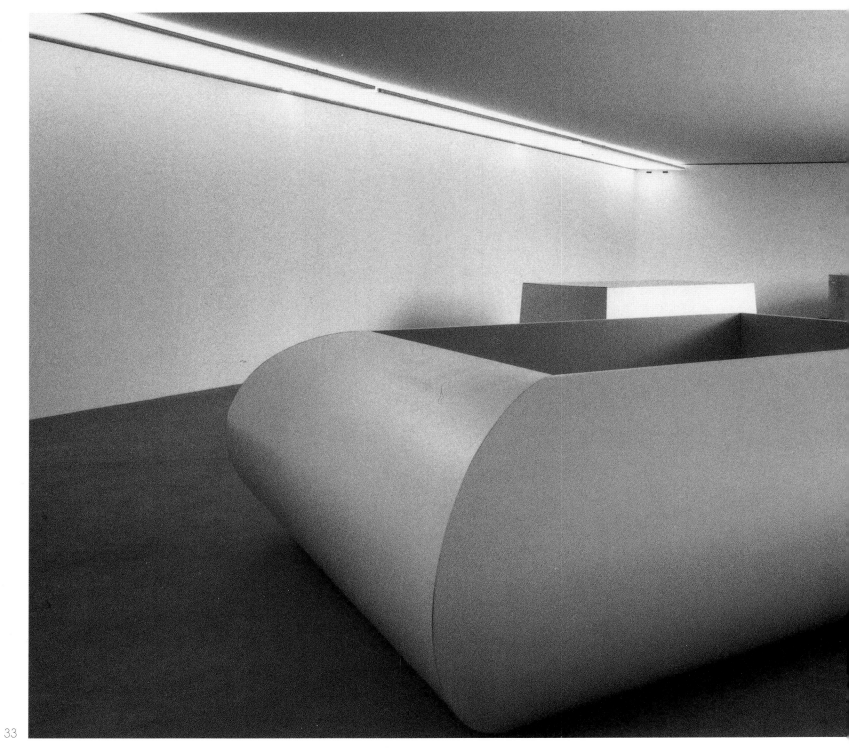

33

33. *Untitled (1/2 round piece)*, 1967. RM 19

34. *Untitled (Aluminium I-beams)*, 1967. RM 6

35. *Untitled*, 1968. RM 10

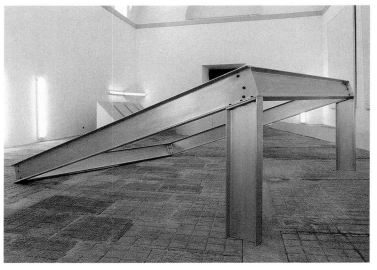

34

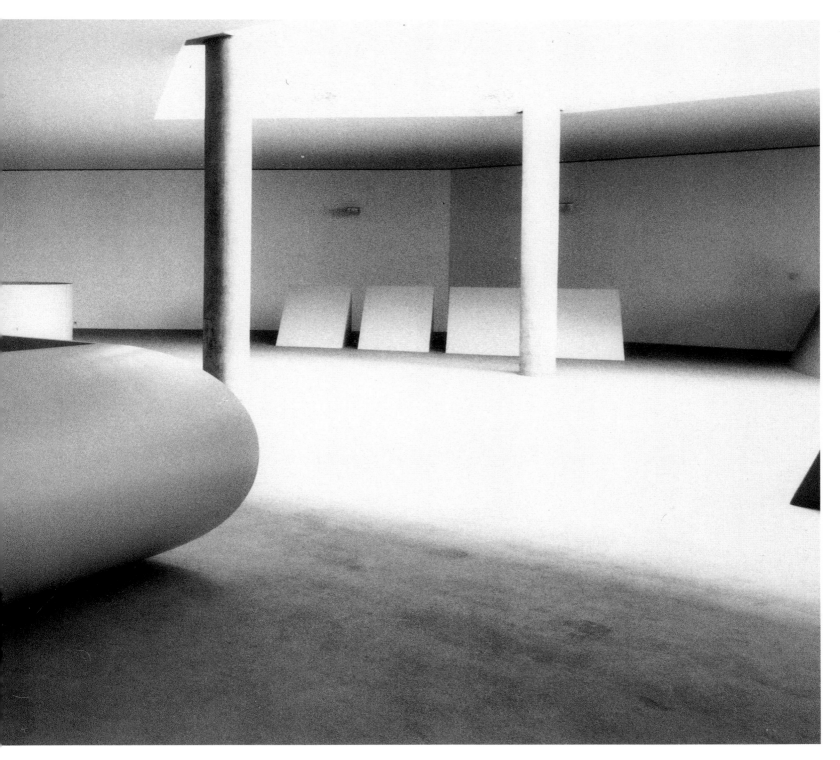

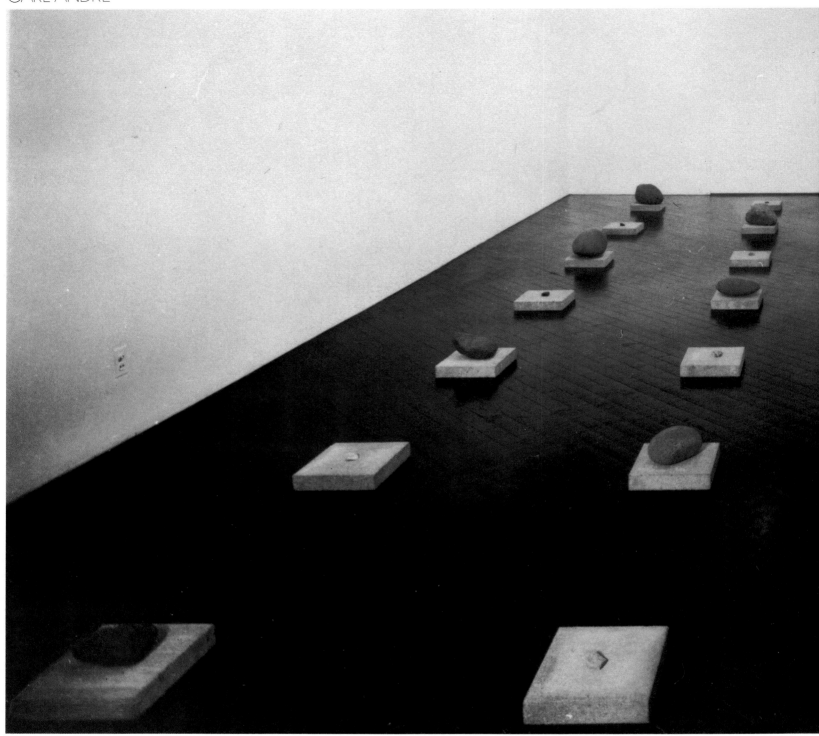

36

36. *Portland Regulus*, 1973-1974. CA 12
37. *2 x 18 Aluminium Lock*, 1968. CA 3
38. *Hague Steel Piece*, 1968. CA 4
39. *Fall*, 1968. CA 5

37

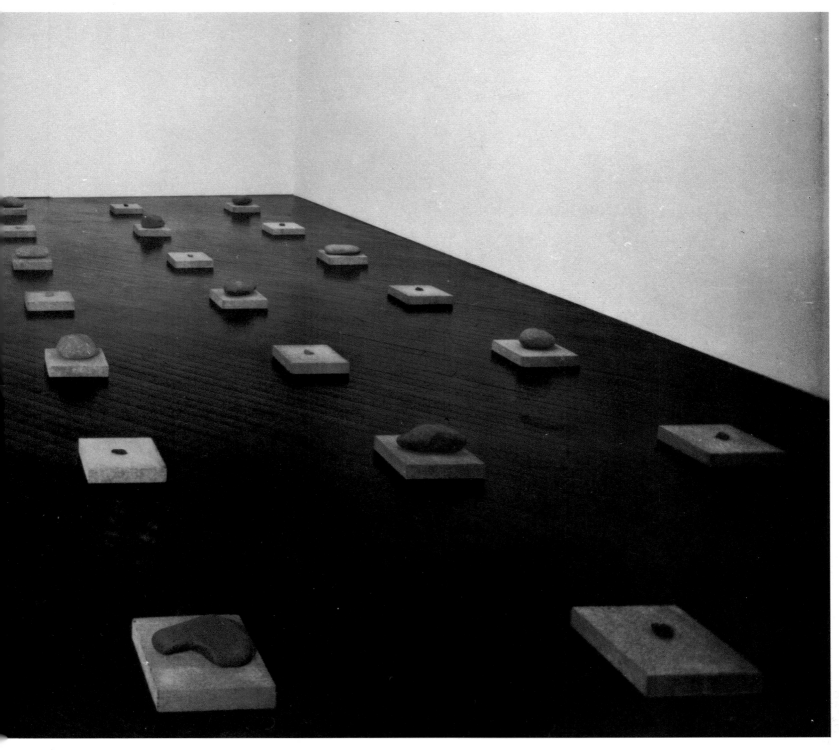

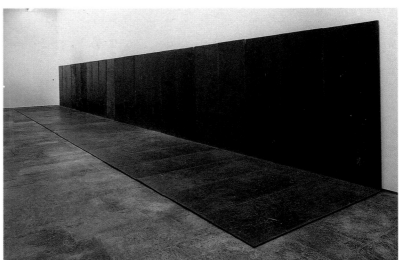

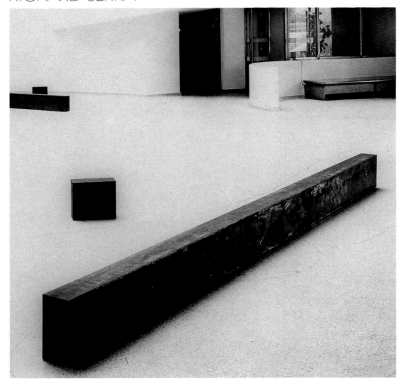

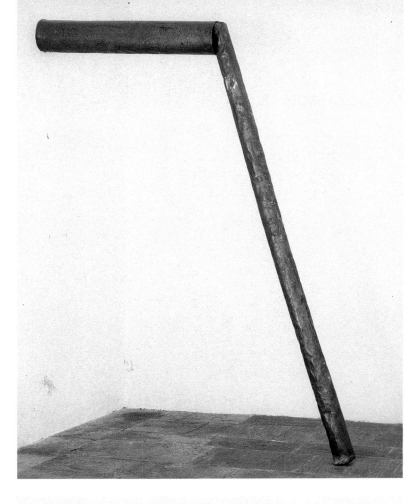

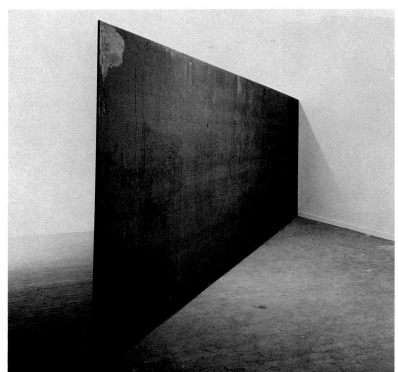

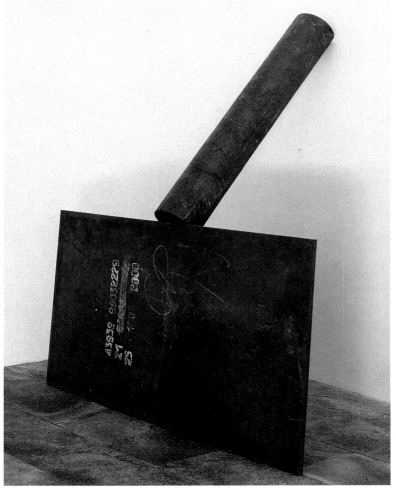

40. *Different and Different Again Unequal Elevations,*
 1973. RS 13
41. *Clothes Pin Prop,* 1969. RS 8
42. *Strike (to Roberta and Rudy),* 1969-1971. RS 9
43. *Shovel Plate Prop,* 1969. RS 5

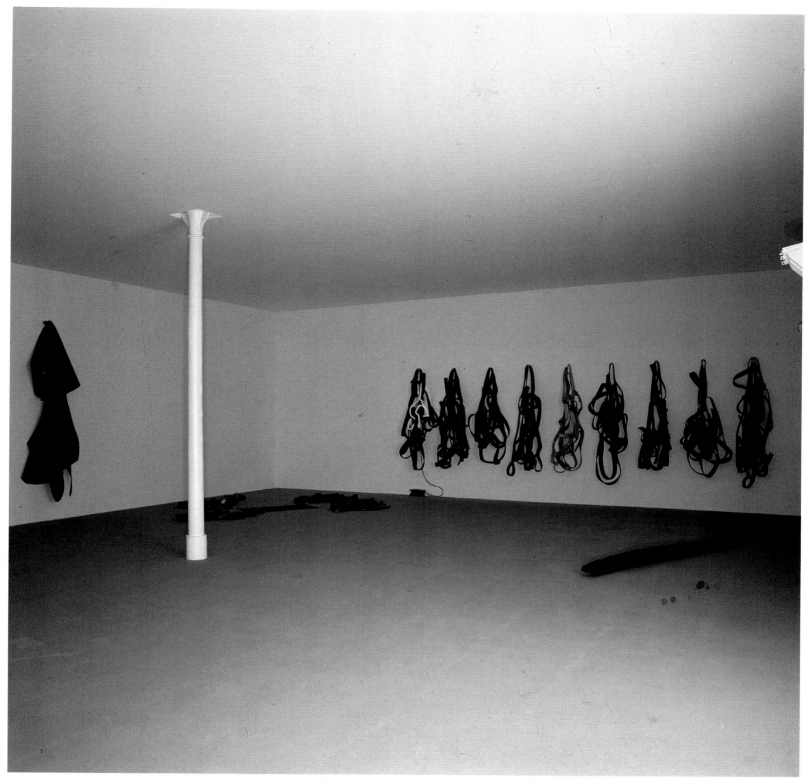

44

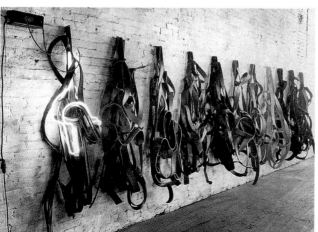

45

44. *Untitled*, 1967. RS 2
Belts, 1966-1967. RS 1
Tearing Lead from 1:00 to 1:47, 1968. RS 4
Angle Slabs, 1967. RS 3

45. *Belts*, 1966-1967. RS 1

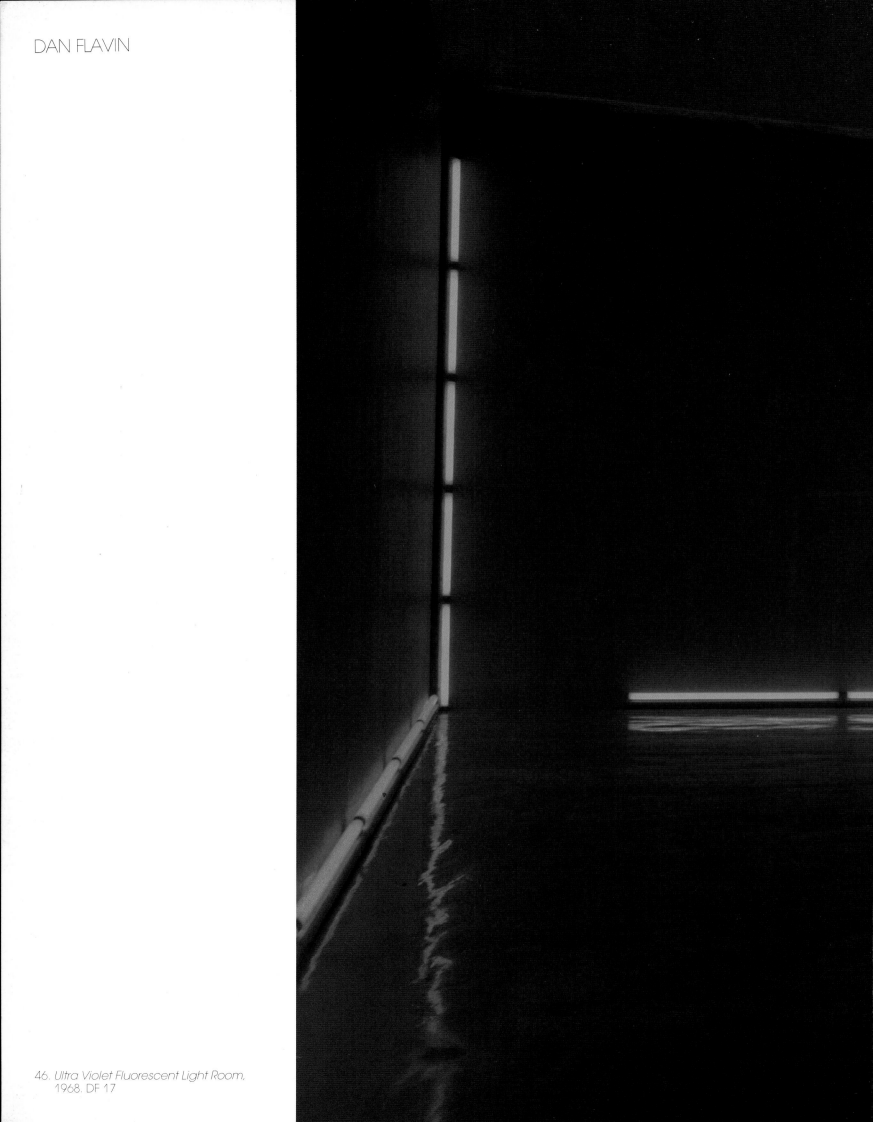

DAN FLAVIN

46. *Ultra Violet Fluorescent Light Room,*
 1968. DF 17

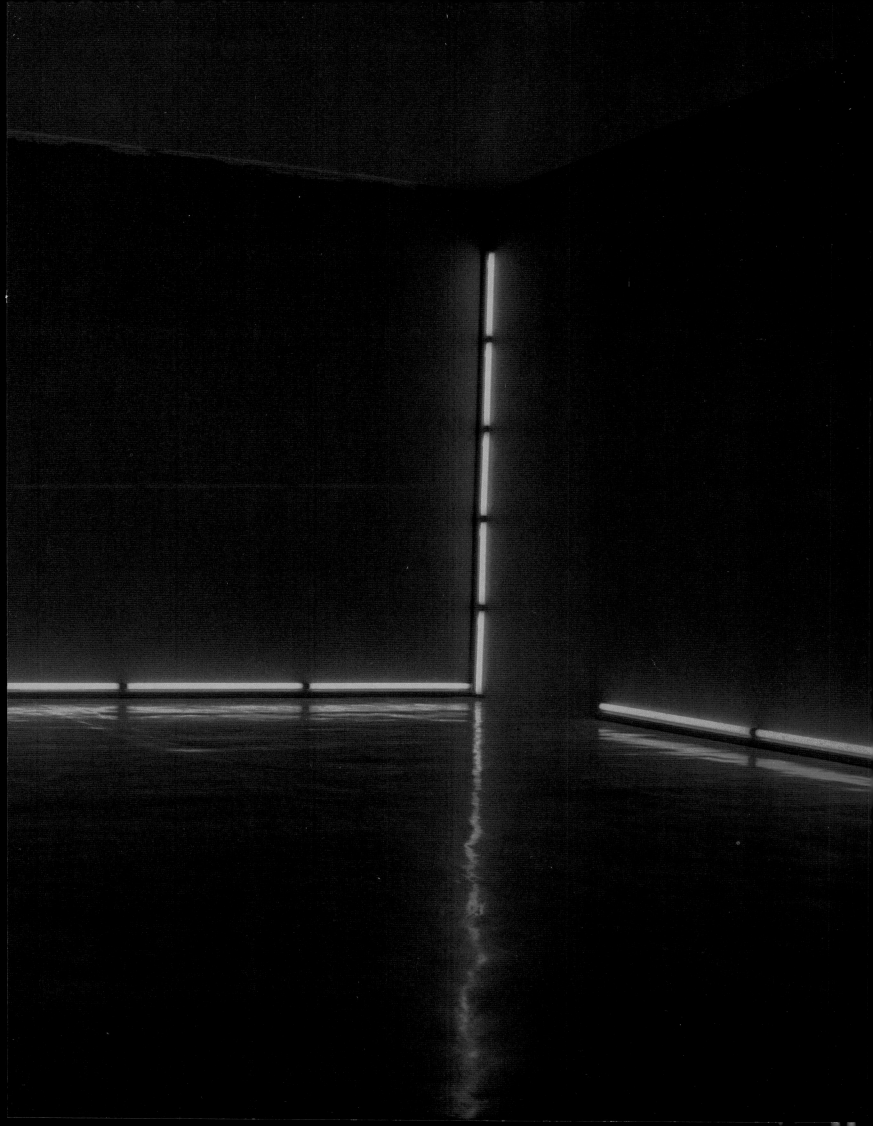

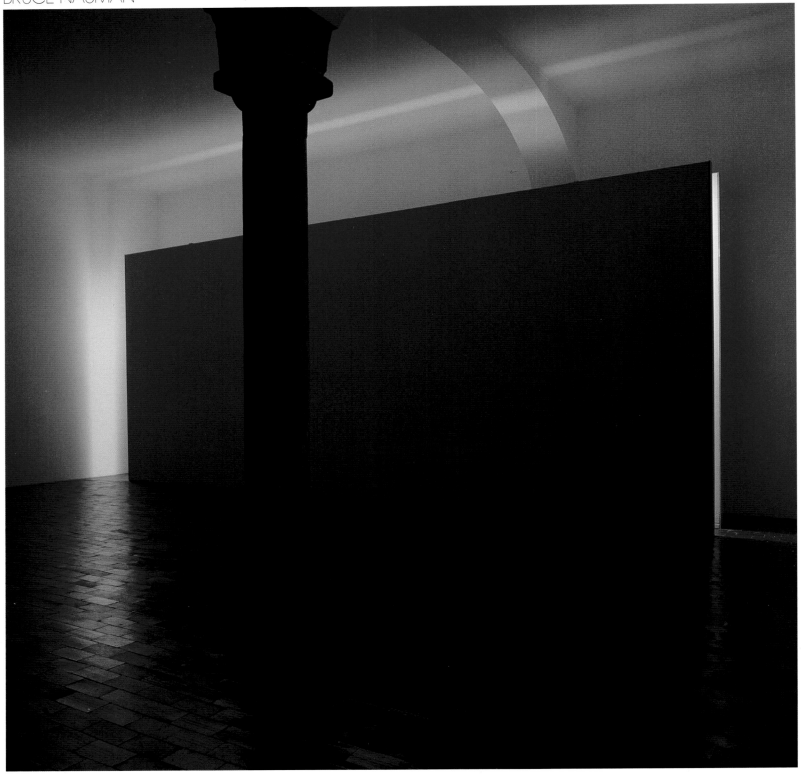

47

47. *Green Light Corridor,*1970. BN 24

48. *Yellow Room (Triangular),* 1973. BN 38

▶

49.50. *Pink and Yellow Light Corridor (Variable lights),*
1972. BN 31

51. *My Last Name Exaggerated Fourteen Times Vertically,*
1967. BN 6

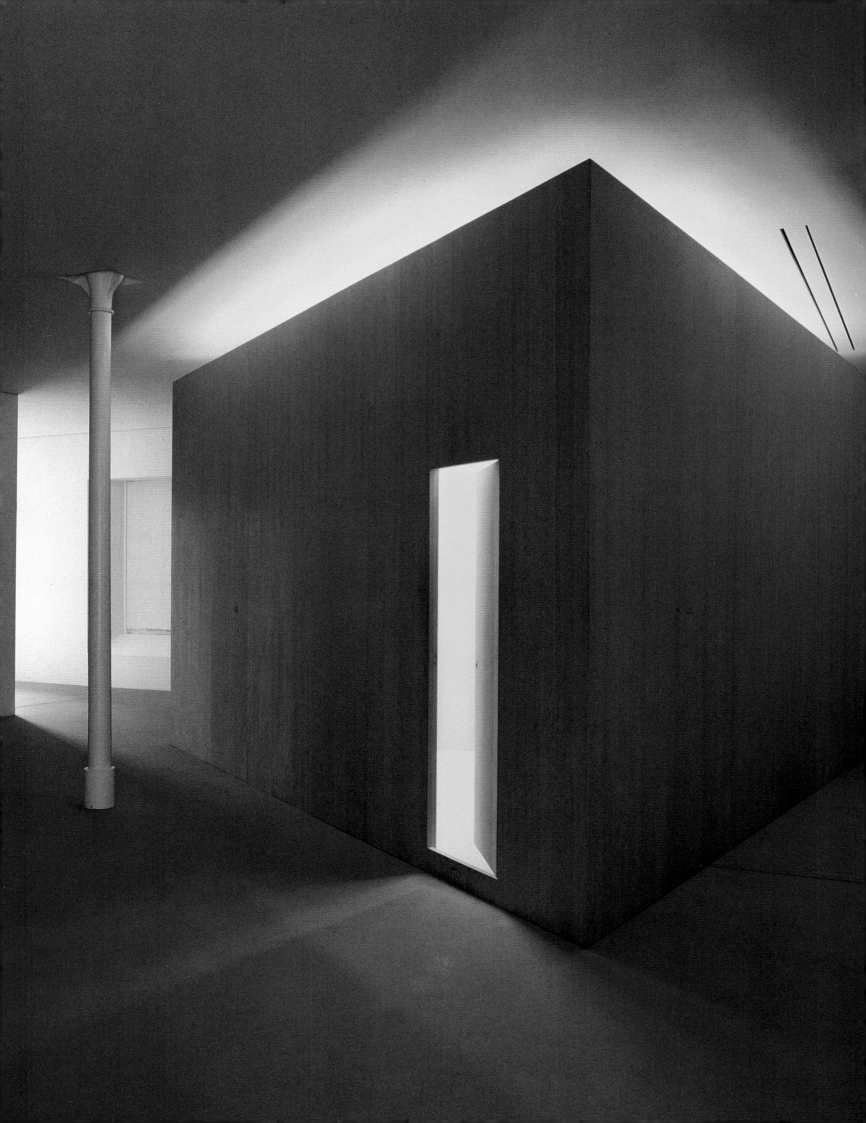

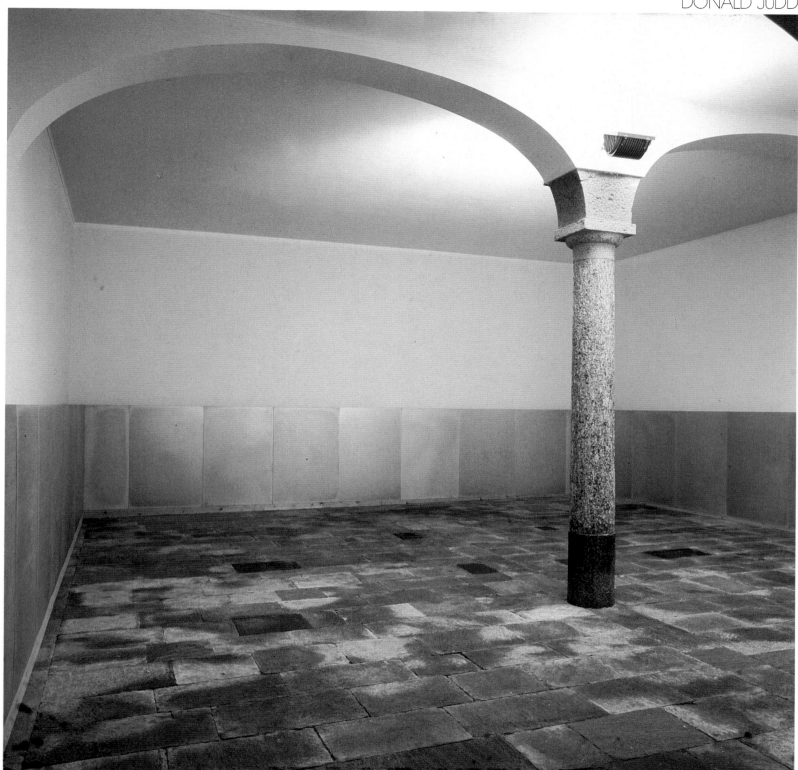

52. *Galvanized Iron Wall*, 1974. DJ 27

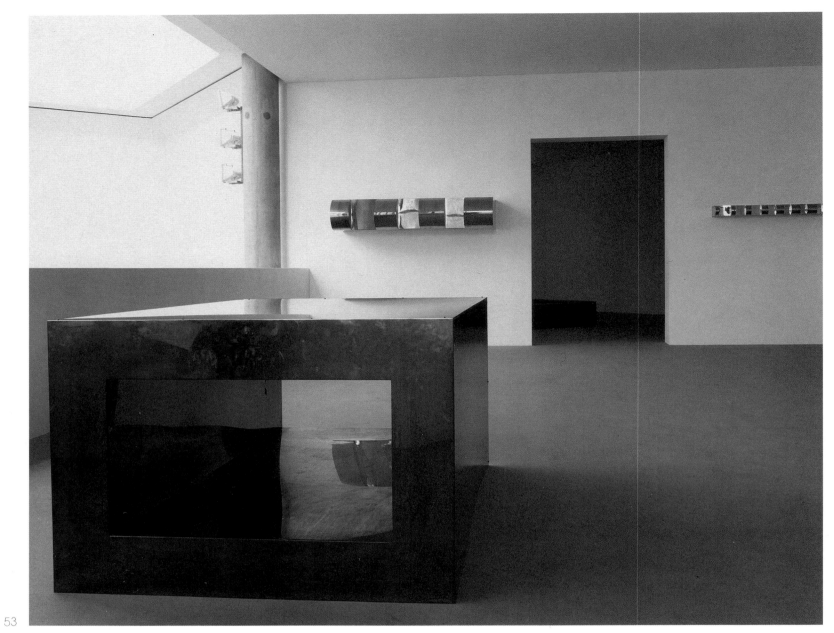

53

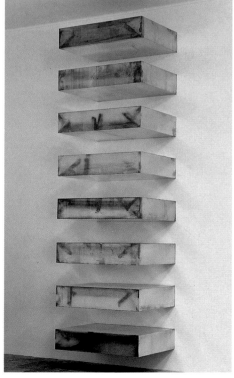

54

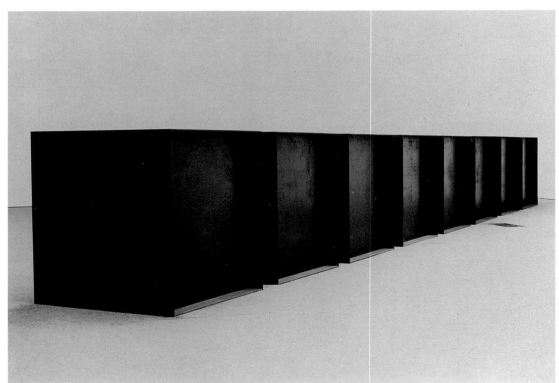

55

56

57

53. *Untitled*, 1973. DJ 10
 Untitled, 1966-1972. DJ 7

54. *Untitled*, 1969. DJ 3

55. *Eight Hot Rolled Steel Boxes*, 1974. DJ 26

56. *Untitled*, 1970. DJ 4

57. *Untitled*, 1972-1973. DJ 12

ROBERT MANGOLD

58

59

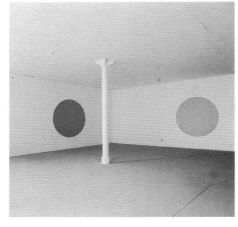

60

58. *Circle Painting 6 (Dark-red),*
 1973. RMA 8
 Distorted Square Within a Circle
 (Dark-red), 1973. RMA 9

59. *Neutral Pink Area, 1966. RMA 1*
 One-Third Grey Curved Area,
 1966. RMA 33

60. *Circle Painting 3 (Green-grey),*
 1973. RMA 7
 Circle Painting 1 (Yellow),
 1972. RMA 5

61. *Distorted Square Within a Circle*
 (Violet), 1973. RMA 11
 Distorted Square Within a Circle
 (Yellow), 1973. RMA 10
 Circle Painting 6 (Dark-red),
 1973. Model. RMA 32

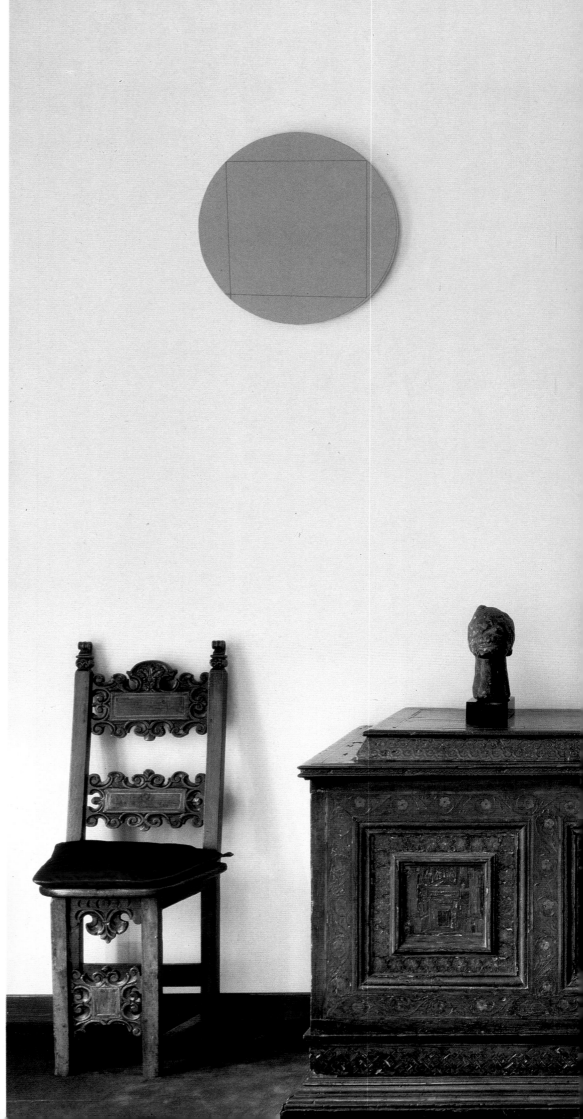

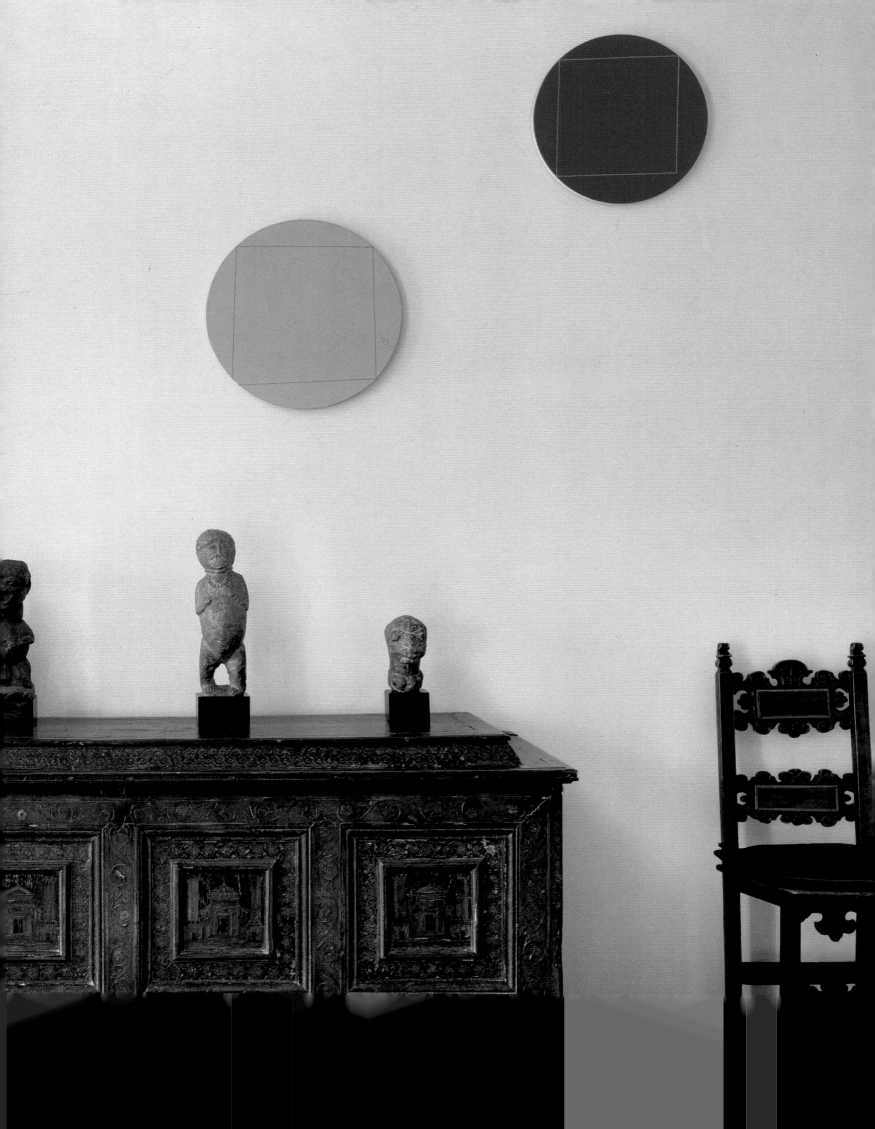

62

62. *Standard no. 5*, 1967. RRY 2

63. *Four Units*, 1969. RRY 11

64. *Empire*, 1973. RRY 30

65. *Classico IV*, 1968. RRY 7

66. *Three Units (nos. 1, 2, 3)*, 1969. RRY 12
 Five Units (nos. 1, 2, 3, 4, 5), 1969. RRY 13

67. *J. Green I*, 1968. RRY 9
 Murillo, 1968. RRY 8

63

64

65

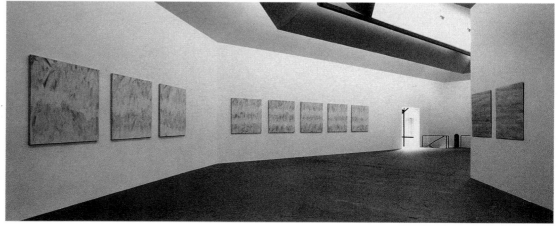

66

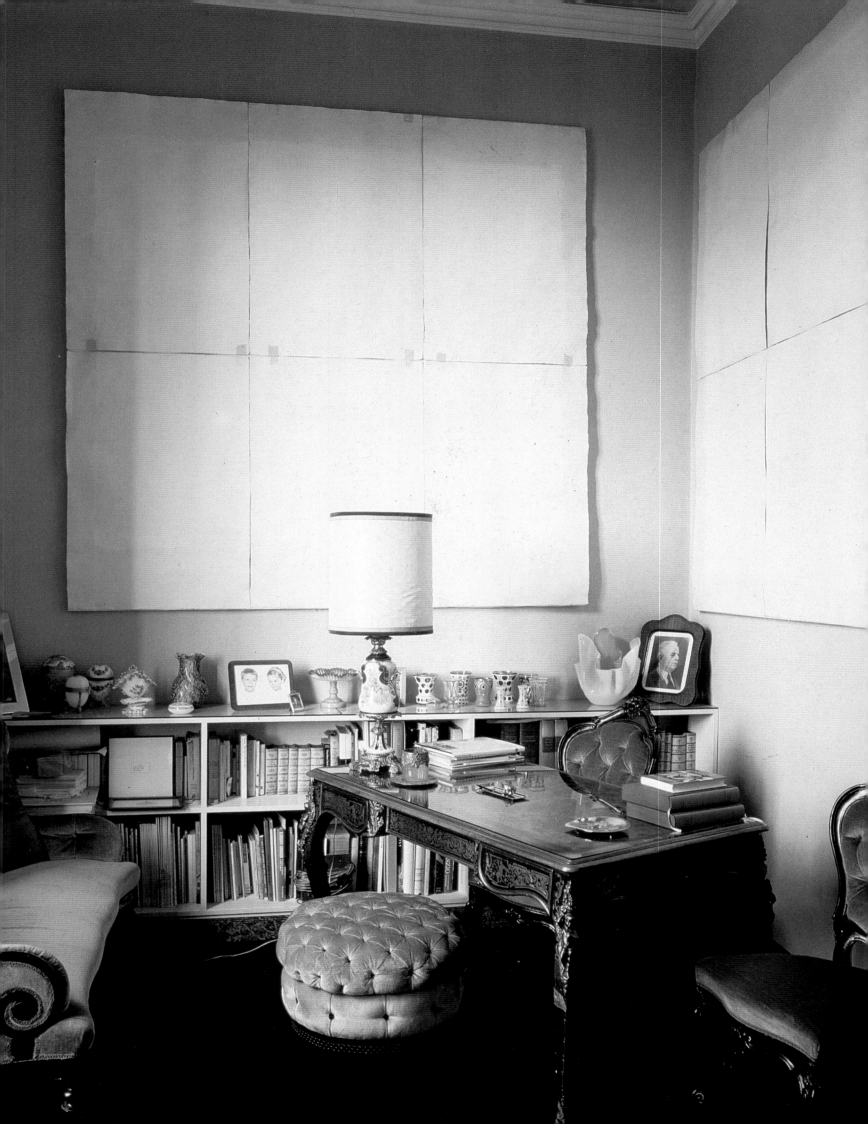

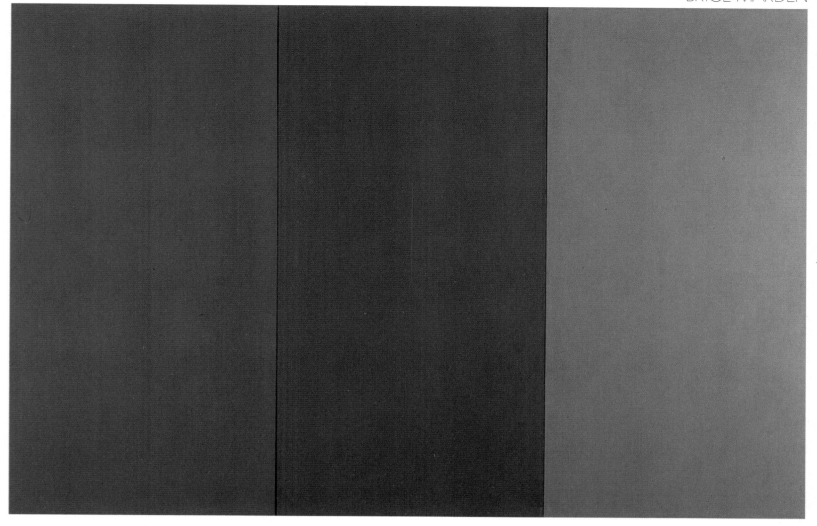

68

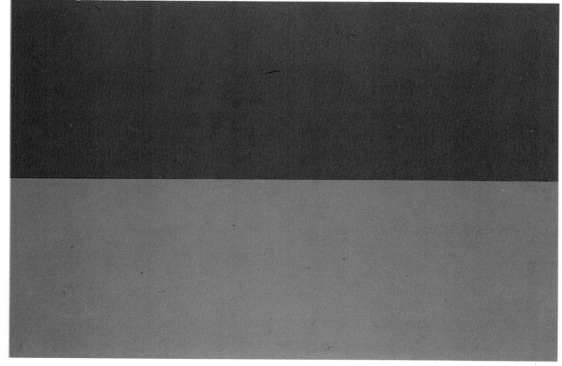

69

68. *D'après la Marquise de la Solana,*
1969. BM 3

69. *Adriatic,* 1972-1973. BM 7

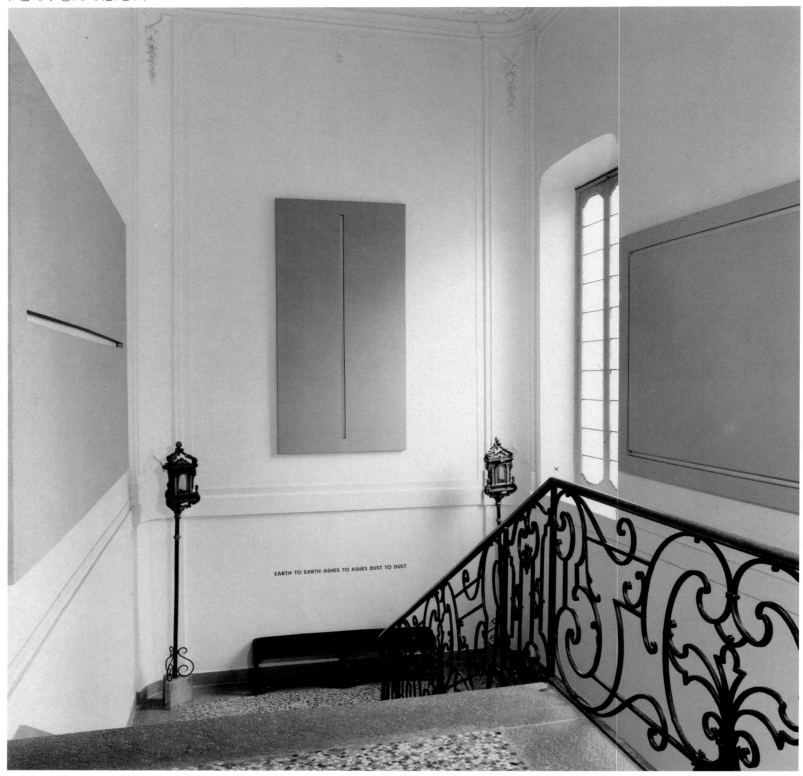

ALAN CHARLTON

70

70. *90 x 180 in., slit 156 in., August-November 1971. AC 8*
 112 x 56 in., slit 100 in., March 1971. AC 7
 Outer piece 84 x 144 in., inner piece 68 ½ x 128 ½ in.,
 channel 1 ¾ in., May-August 1972. AC 17

71. *90 x 56 in., slit 44 in., September 1971. AC 11*

72. *90 x 78 in., each slit 78 in., January 1972. AC 14*

73. *82 in. Square, 1970-1972. AC 3*

74. *Outer piece 60 in. square, inner piece 38 ½ in. square,*
 channel 1 ¾, December 1973. AC 30

75. *Outer piece 58 in. square, inner piece 18 in. square,*
 channel 1 ⅝ in., September 1973. AC 26

76. *Outer piece 63 ½ in. square, inner piece 12 in. square, channel*
 1 ¾ in., September 1973. AC 28

71 72

73

74

75

76

77

77. *Untitled (Cream colour with black border)*, May 1975. PJ 5
 Untitled (Cream colour with dark blue border), 1976. PJ 8

78. *Untitled (Cream colour with brown border)*, March 1974. PJ 1
 Untitled (Grey-blue colour with black border), November 1974. PJ 4

79. *Untitled (Grey with blue border)*, 1975. PJ 7

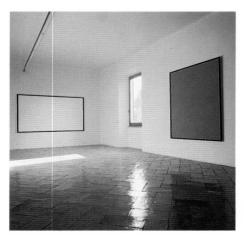

78

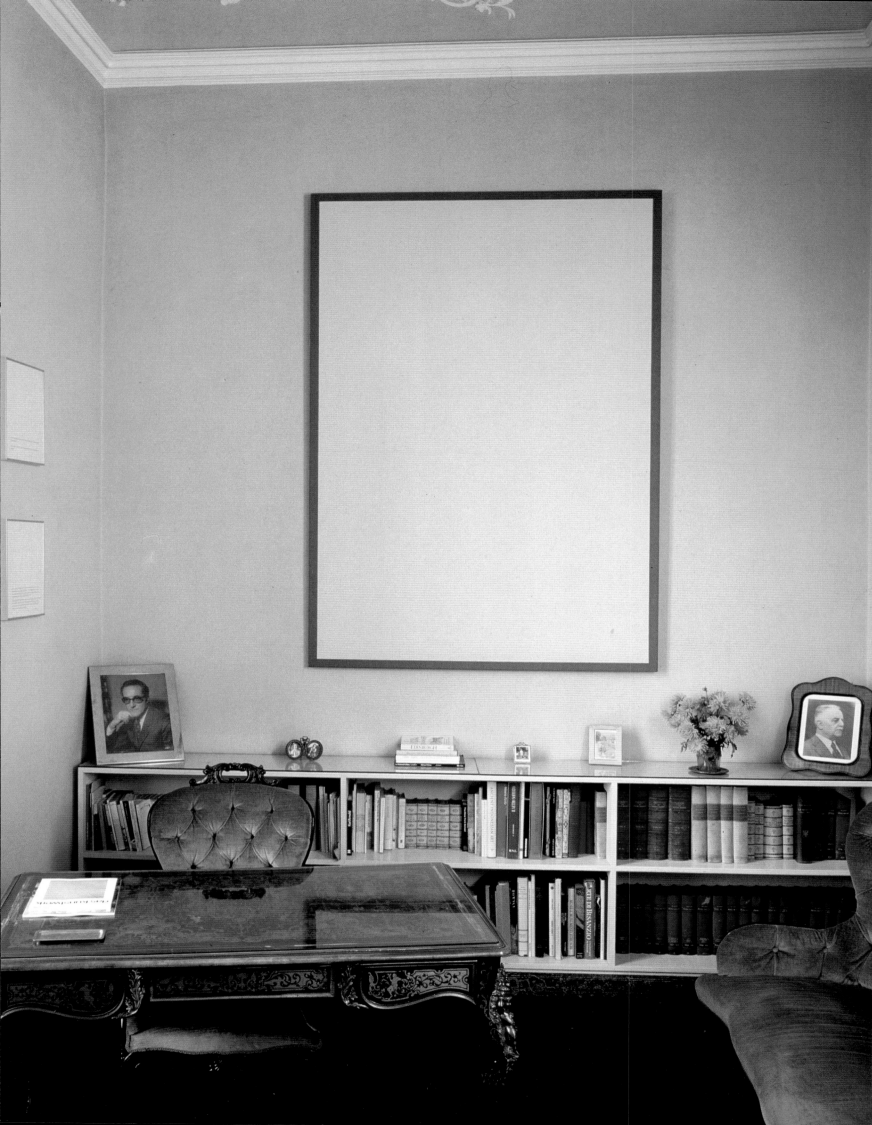

80. *Castle XXVIII*, February 1976. BL 15

81. *No. 83 (Crimson, blue, violet, black)*, 1971. BL 7

▶

82. *No. 64 (Purple, plum, black, violet)*, 1967. BL 1

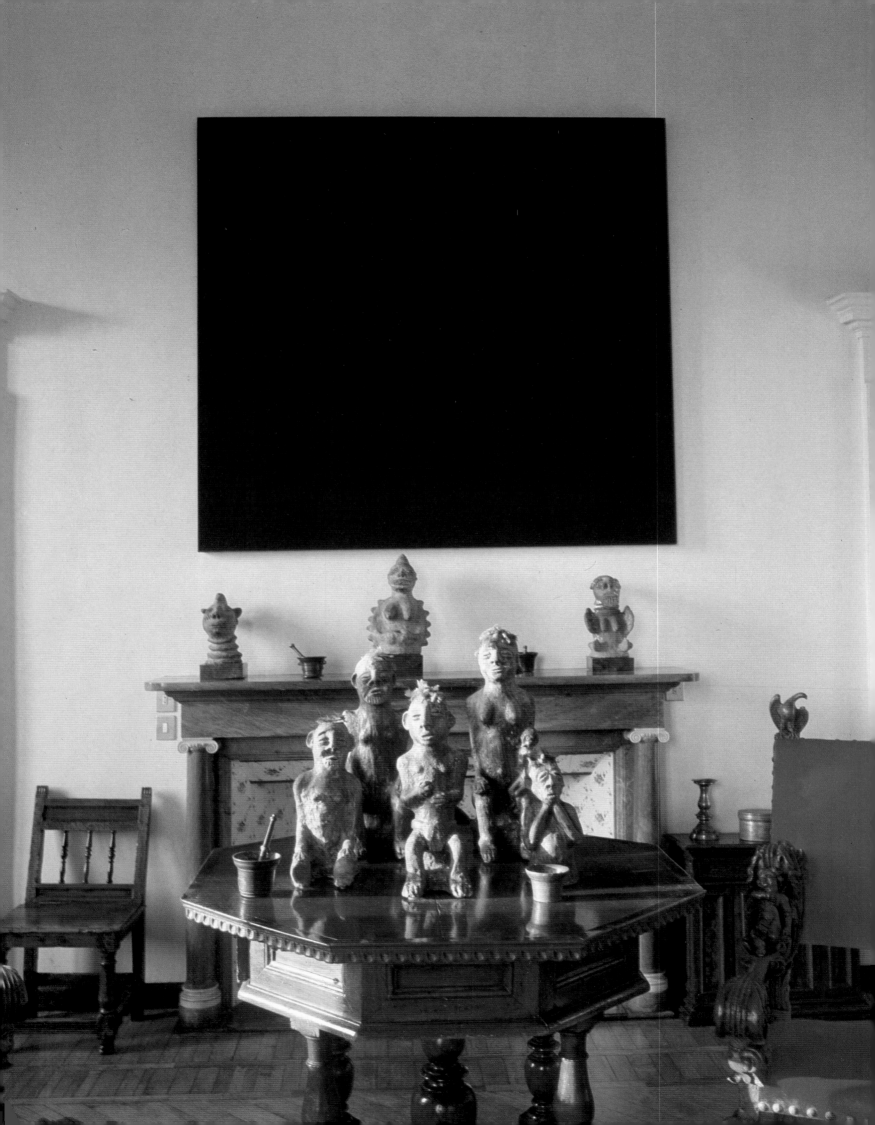

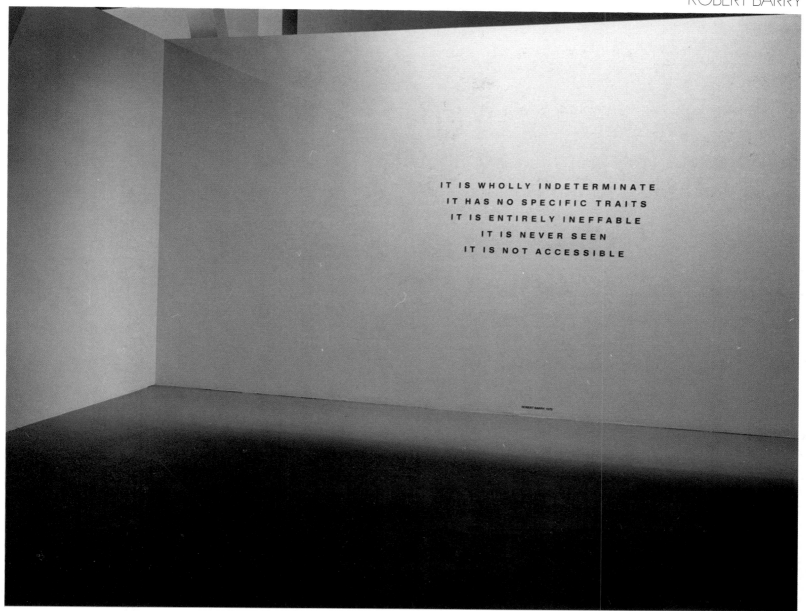

83. IT IS WHOLLY INDETERMINATED. IT HAS NO SPECIFIC TRAITS. IT IS ENTIRELY
INEFFABLE. IT IS NEVER SEEN. IT IS NOT ACCESSIBLE, 1970. RB 6

ANOTHER TIME

1000 GERMAN MARKS WORTH MEDIUM
BULK MATERIAL TRANSFERED FROM
ONE COUNTRY TO ANOTHER

86

EARTH TO EARTH ASHES TO ASHES DUST TO DUST

87

85. *REDUCED, 1970. LW 20*

86. *1000 GERMAN MARKS WORTH MEDIUM BULK MATERIAL
TRANSFERRED FROM ONE COUNTRY TO ANOTHER, 1969. LW 3*

87. *EARTH TO EARTH ASHES TO ASHES DUST TO DUST, 1970. LW 12*

▶

88. *THE JOINING OF FRANCE GERMANY AND
SWITZERLAND BY ROPE, 1969. LW 6*

THE JOINING OF FRANCE GERM

AND SWITZERLAND BY ROPE

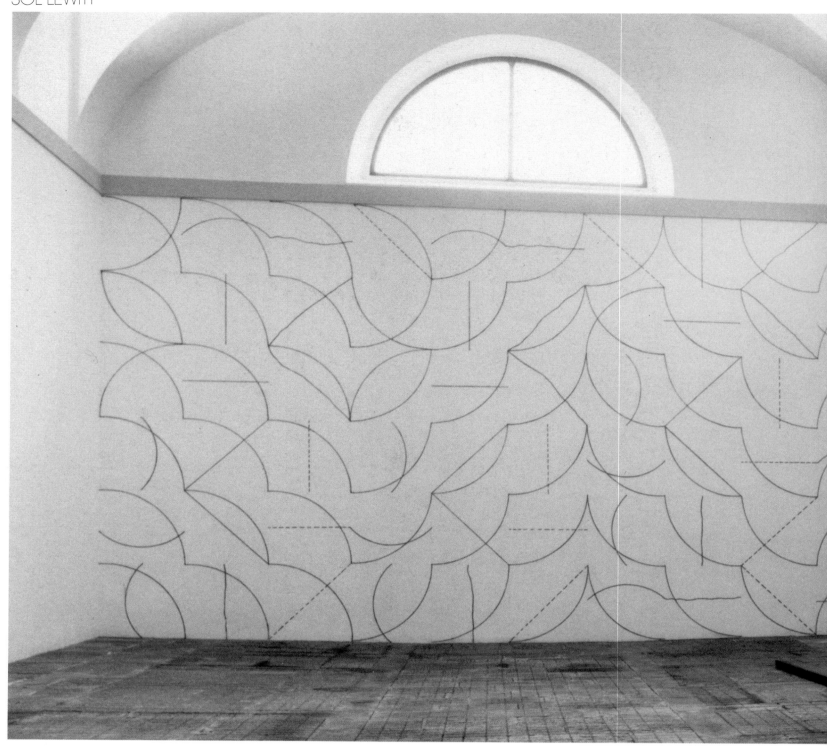

89. *Wall Drawing no. 146*, September 1972. SL 15

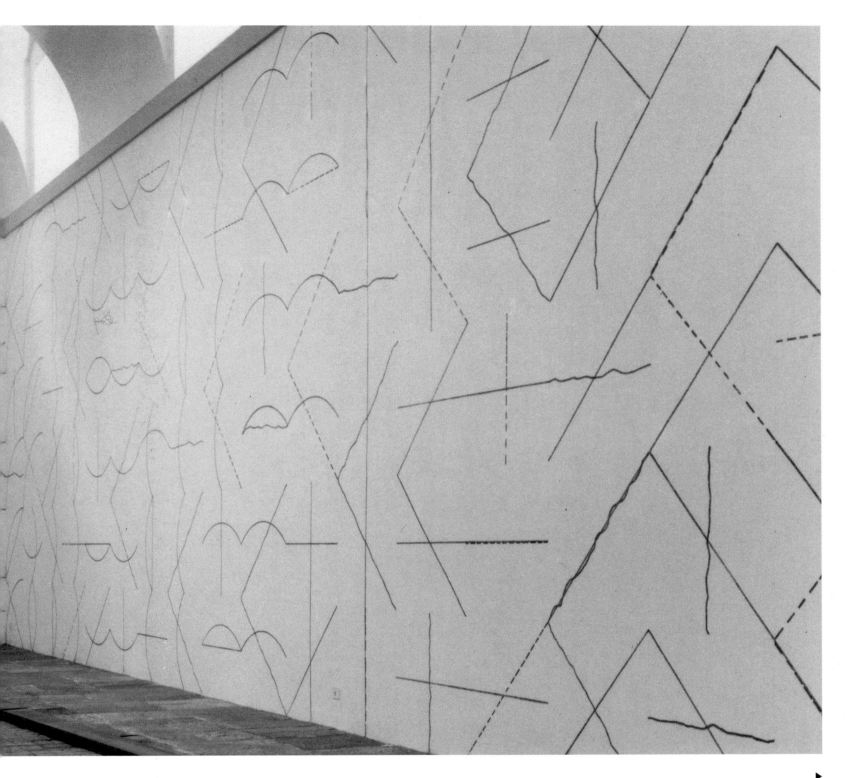

▶

90. *Wall Drawing no. 266*, Varese, July 1975. SL 12

91. *Wall Drawing no. 3*, April 1969. SL 1

92. *Wall Drawing no. 262*, Varese, July 1975. SL 3

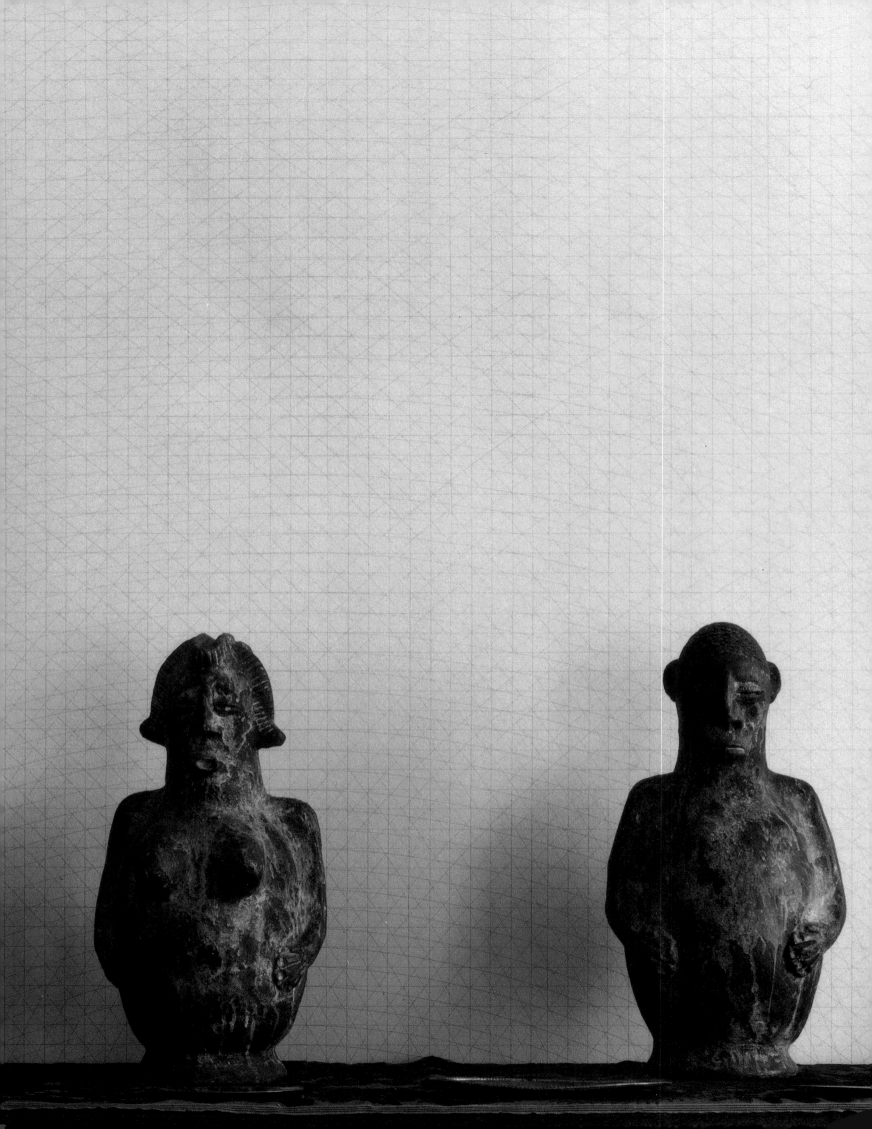

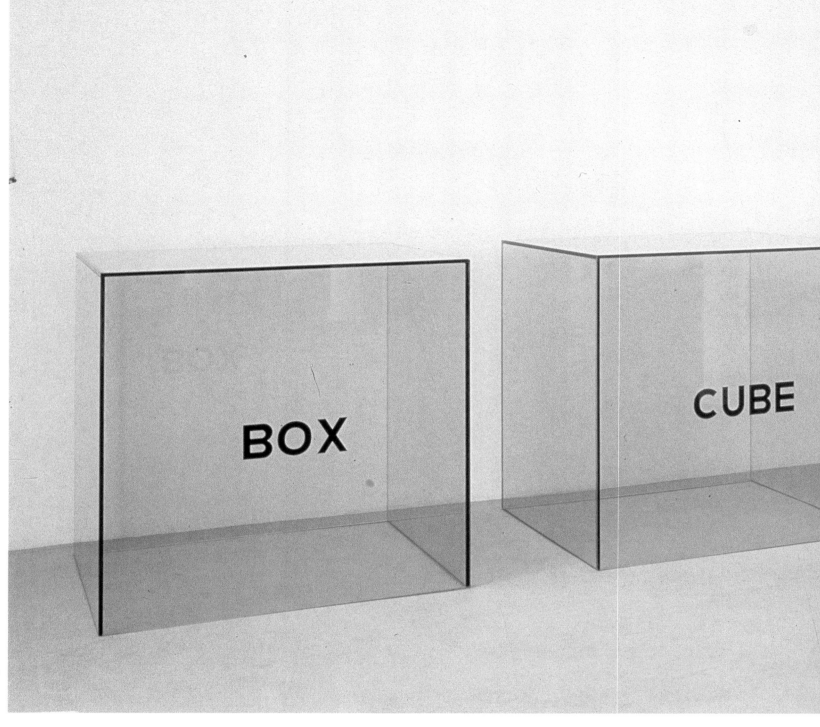

93

93. *Box, Cube, Empty, Clear, Glass-*
 a Description, 1965. JK 7
94. *Titled (Art as idea as idea),* 1966. JK 11
95. *Titled (Art as idea as idea),* 1966. JK 14

94

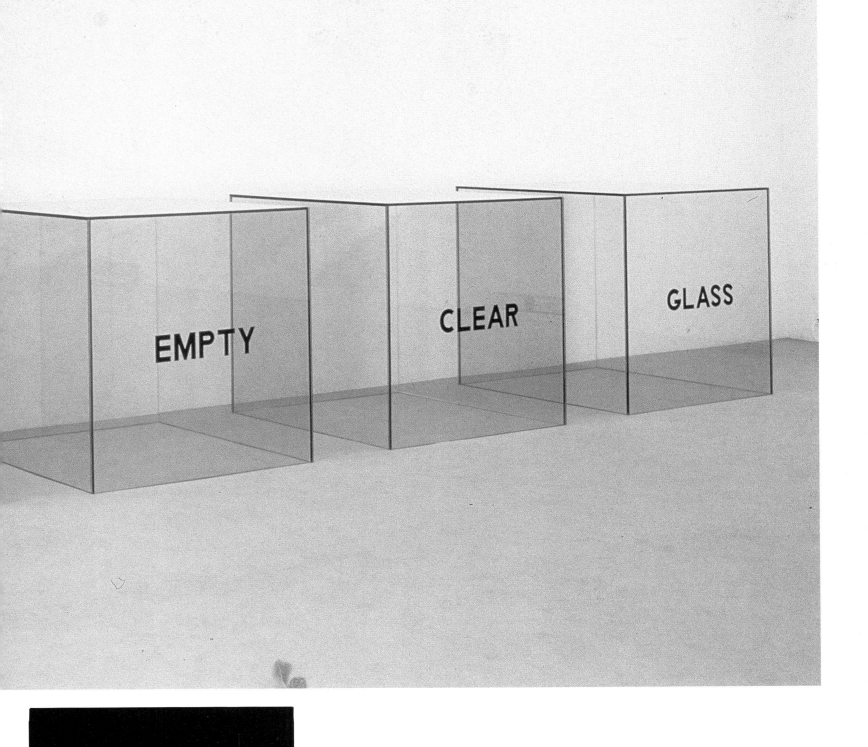

EMPTY CLEAR GLASS

1. *Idea*, adopted from L, itself borrowed from Gr *idea* (ἰδέᾱ), a concept, derives from Gr *idein* (s *id*-), to see, for *widein*. L *idea* has derivative LL adj *ideālis*, archetypal, ideal, whence EF-F *idéal* and E *ideal*, whence resp F *idéalisme* and E *idealism*, also resp *idéaliste* and *idealist*, and, further, *idéaliser* and *idealize*. L *idea* becomes MF-F *idée*, with cpd *idée fixe*, a fixed idea, adopted by E Francophiles; it also has ML derivative *ideāre*, pp *ideātus*, whence the Phil n *ideātum*, a thing that, in the fact, answers to the idea of it, whence 'to *ideate*', to form in, or as an, idea.

95

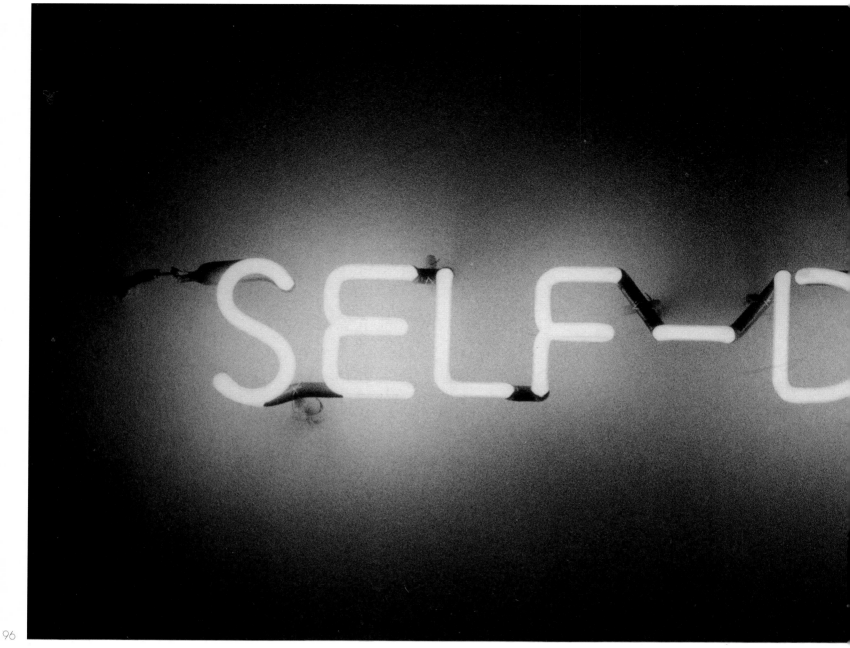

96

96. *Self-defined,* 1965. JK 2

97. *The Eighth Investigation,*
 proposition 3, 1971. JK 24

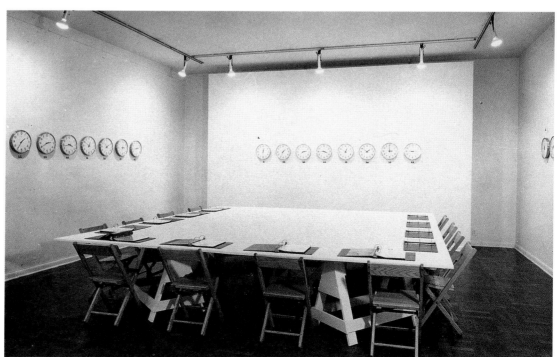

97

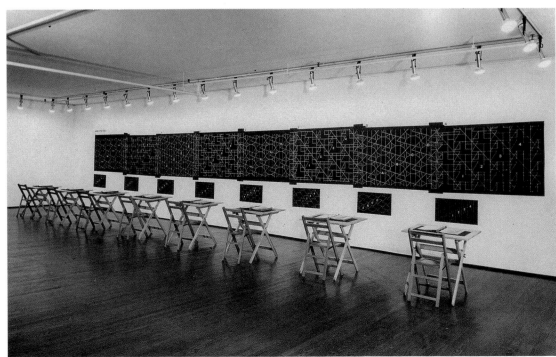

98. *The Tenth Investigation,*
proposition 4, 1974. JK 26

DOUGLAS HUEBLER

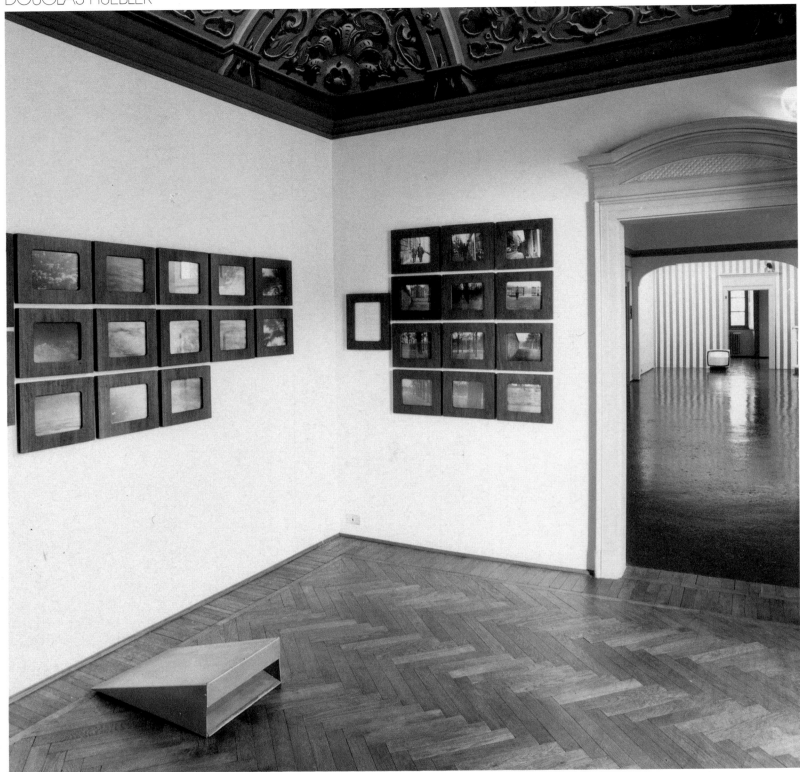

99. *Location Piece no. 1*, New York - Los Angeles, February 1969. DH 4
Duration Piece no. 4, Paris, France, January 1970. DH 14

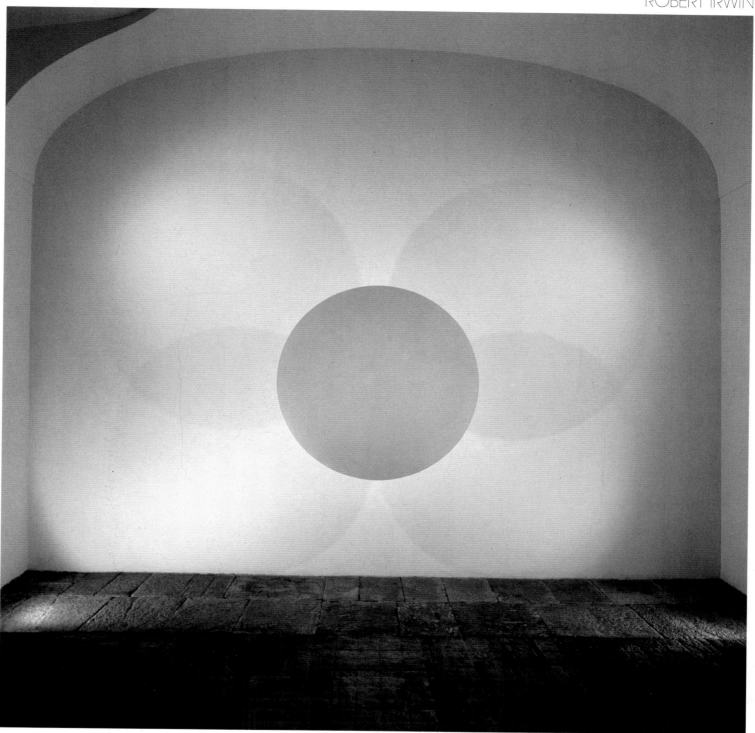

100. *Disc Coloured Pale Grey, Green, Pink, Violet, 1966-1967. RI 2*

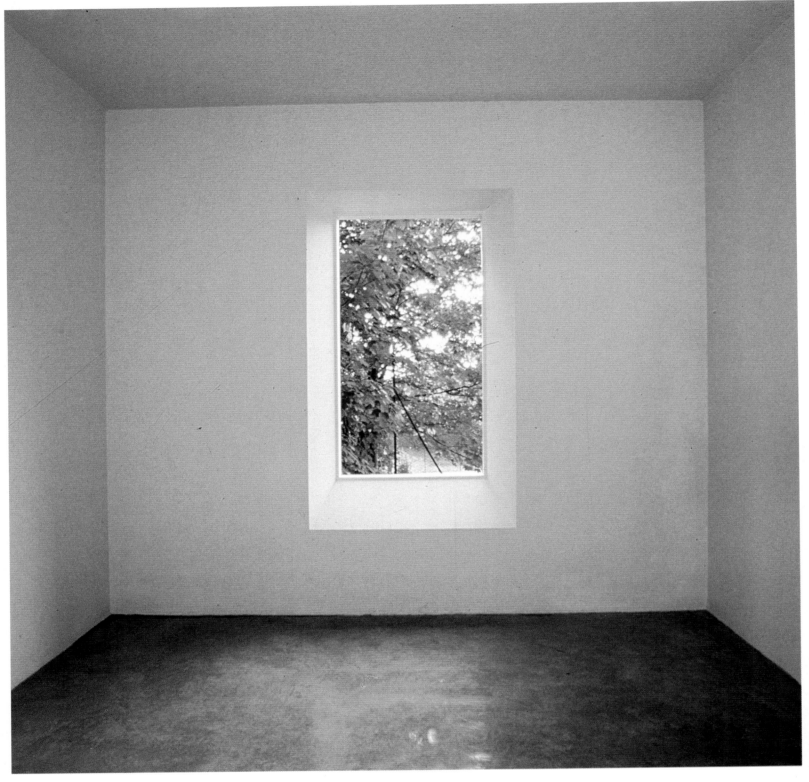

101. *Varese Window Room, 1973. RI 8*

102. *Varese Portal Room, 1974. RI 10*

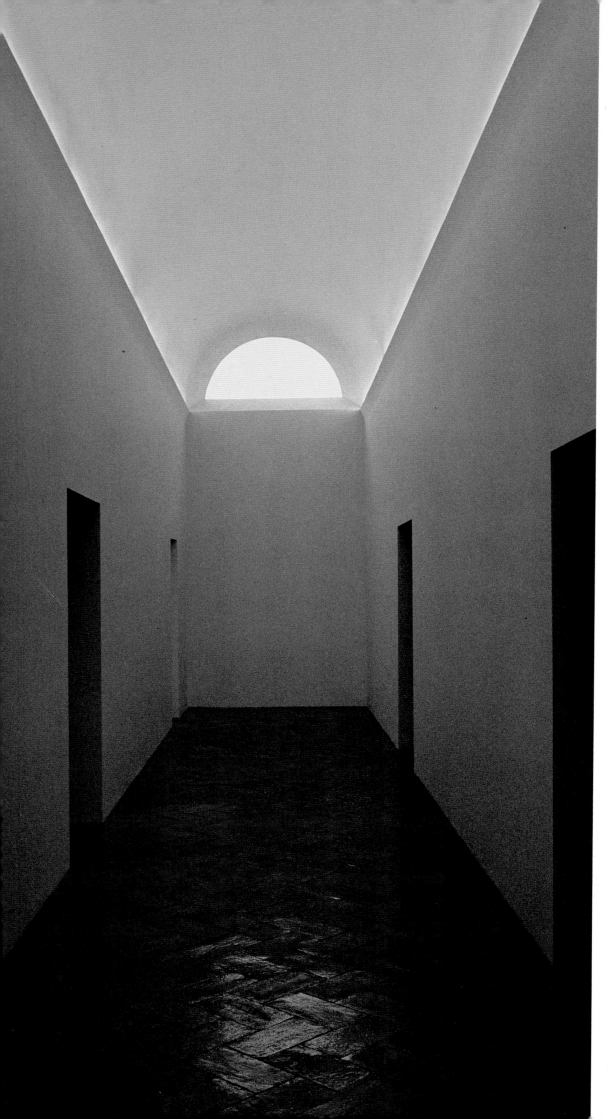

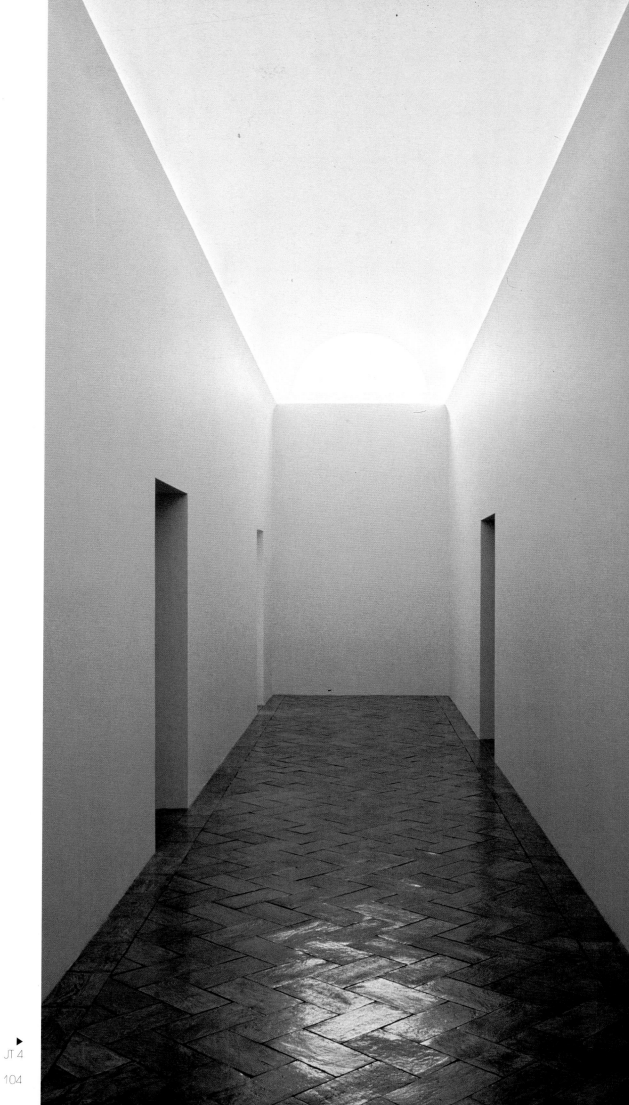

105.106.107. *Sky Space I*, Varese 1976. JT 4

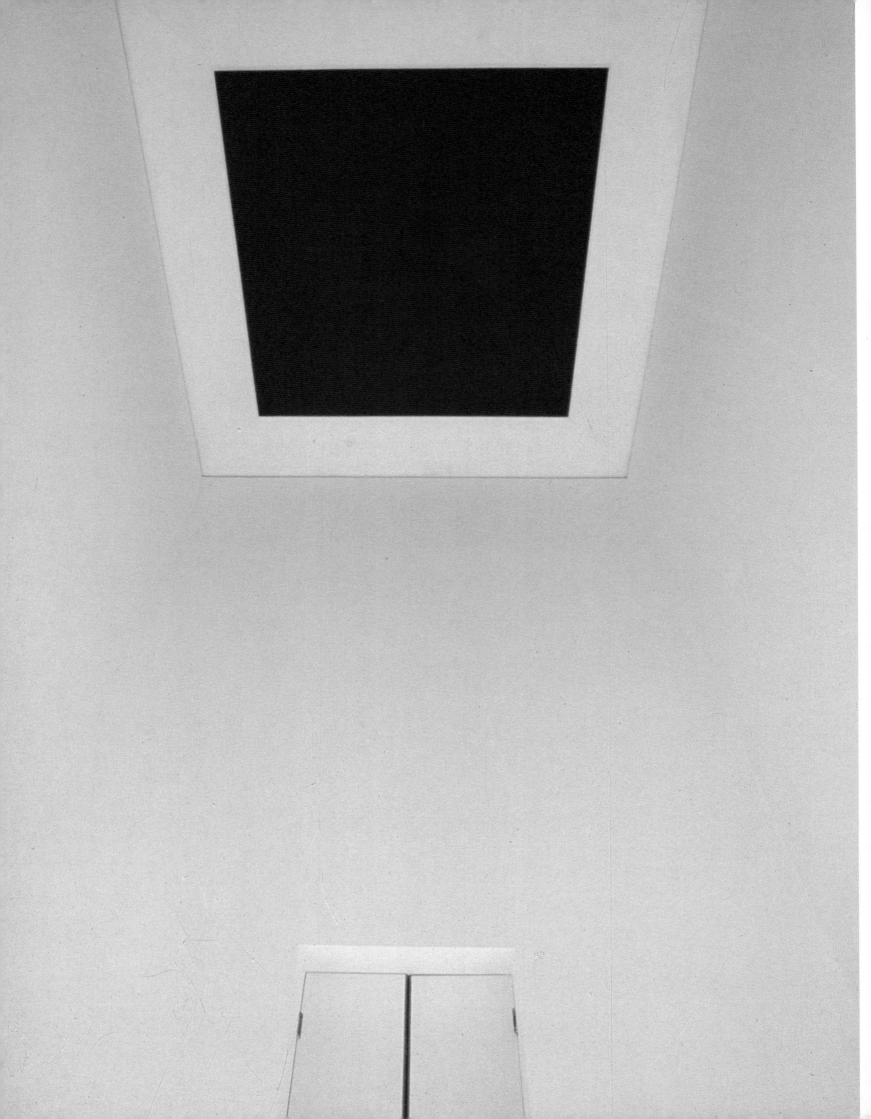

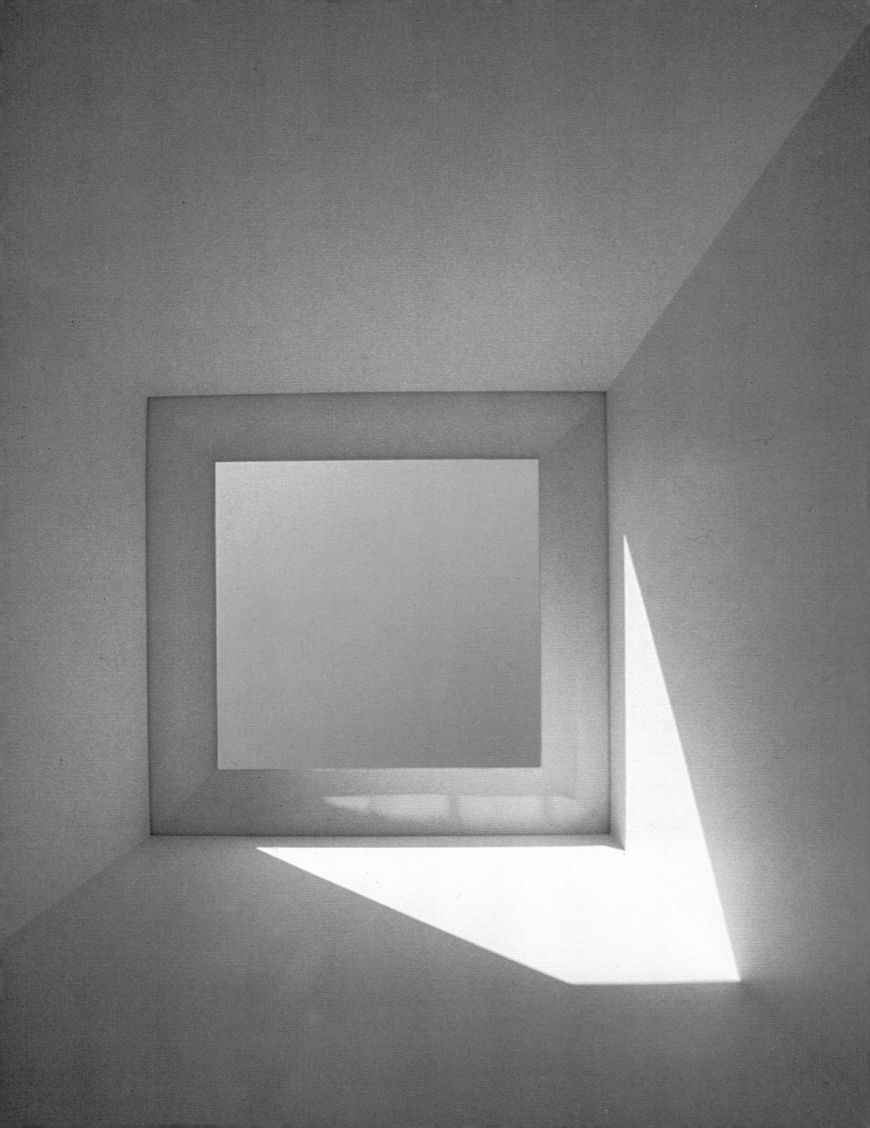

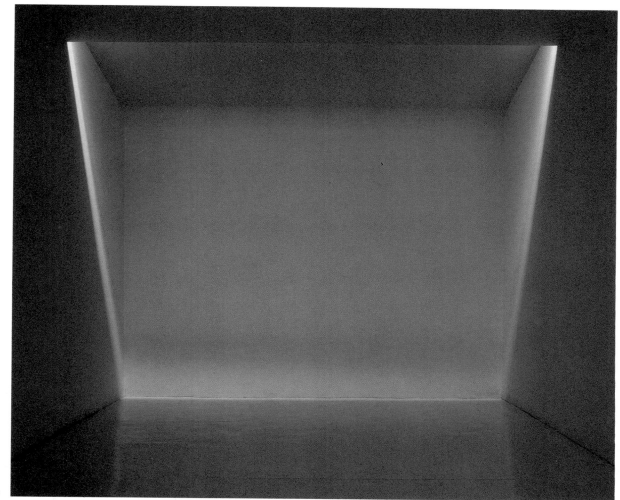

108

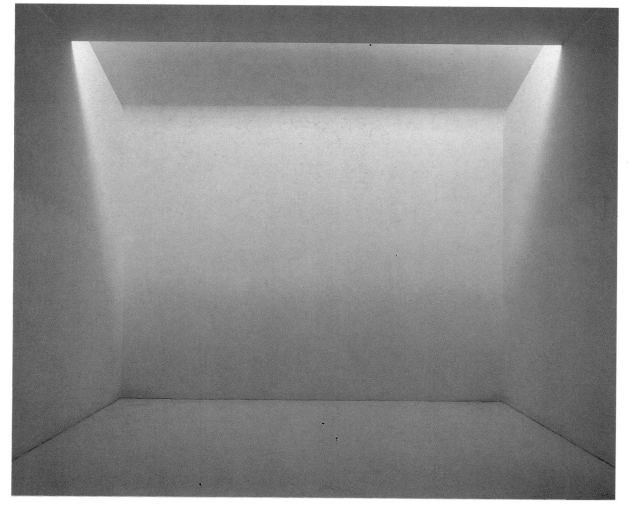

109

108.109. *Virga*, Varese 1976. JT 3

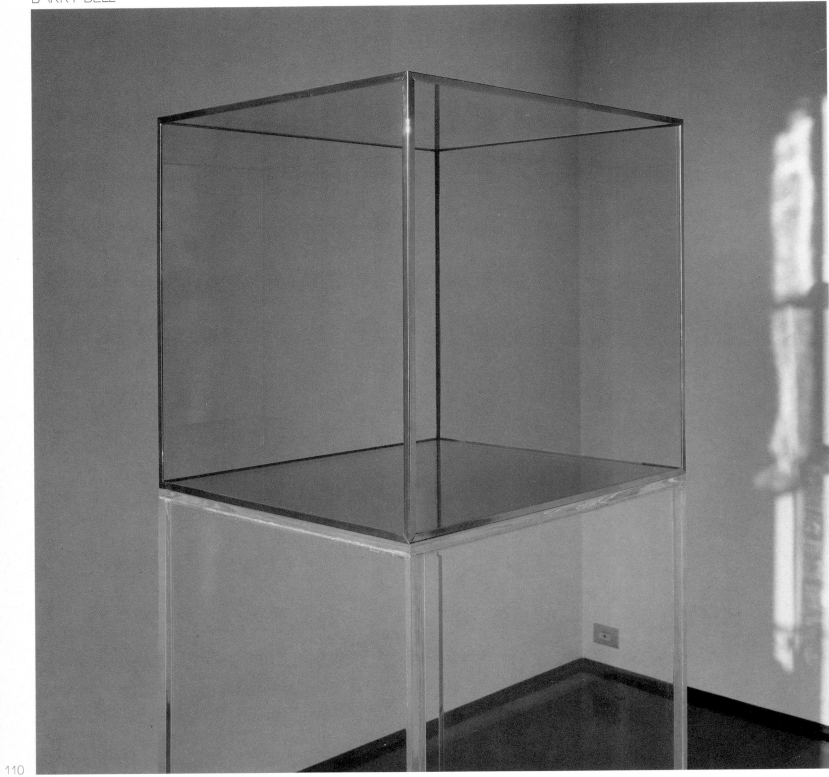

110. *Light Brown Box*, 1968. LB 1

111. *Two Glass Walls-Diagonal Top*, 1973. LB 2

112. *Two Glass Walls*, 1971-1972. LB 3

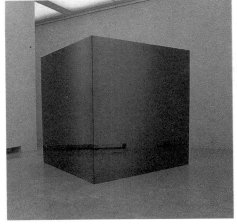

111

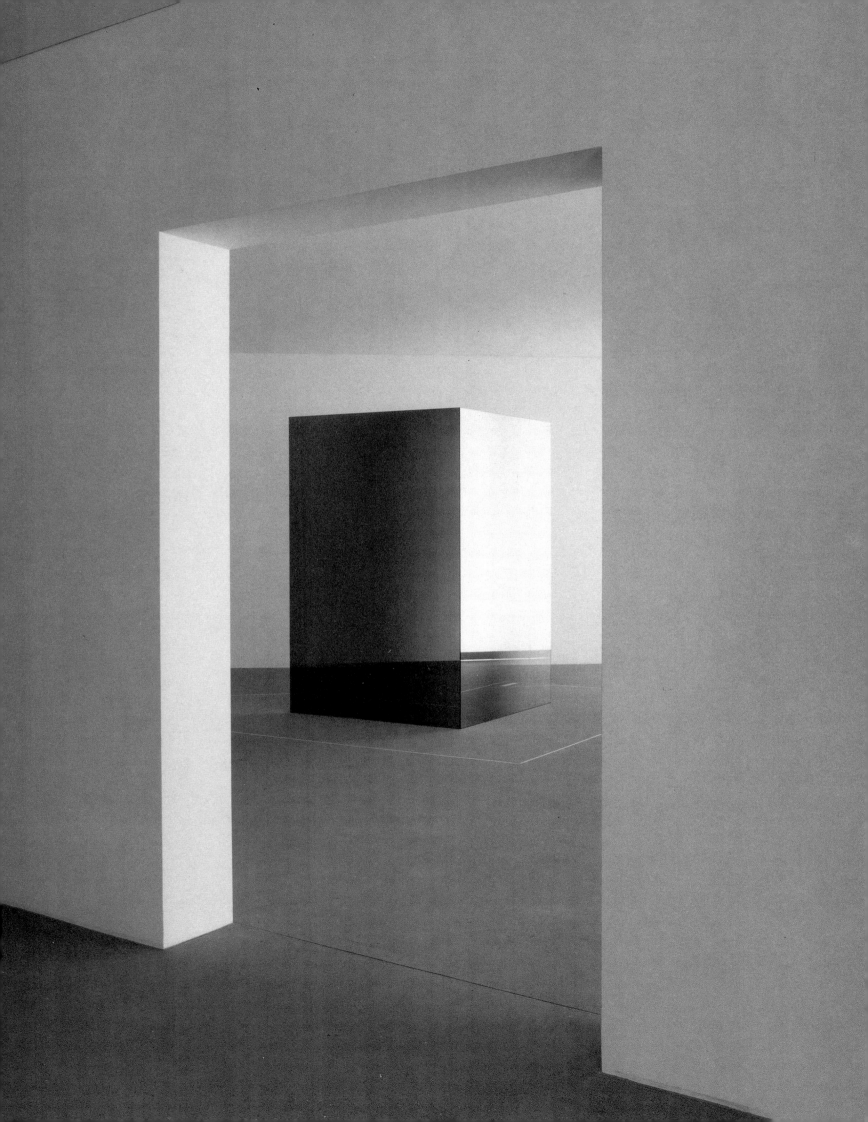

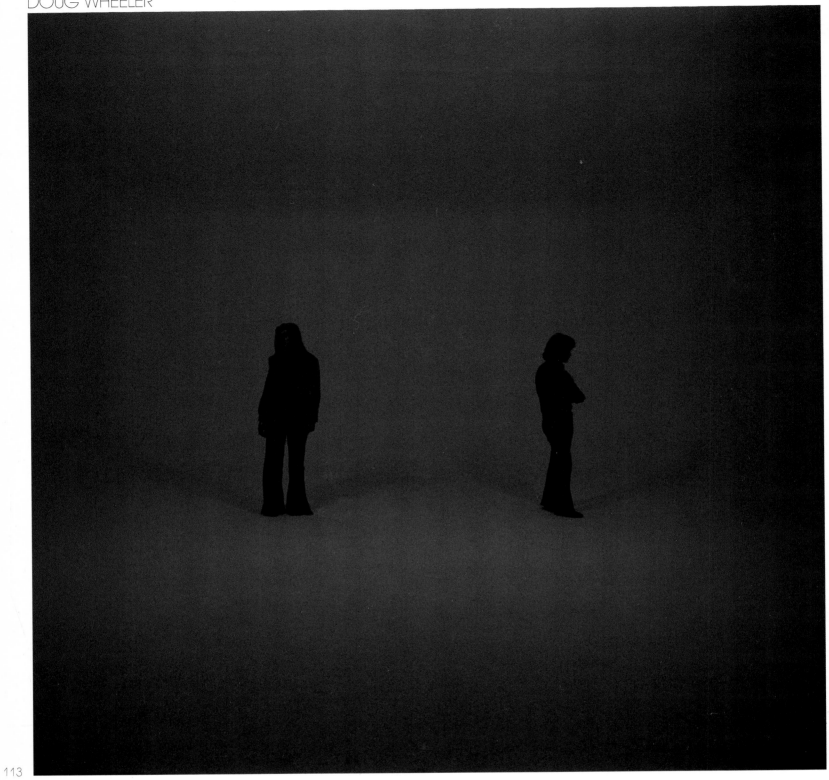

113

113.114. *Ace Gallery Installation*, January 1970. DW 1

114

15

16

17

115. *Untitled (4 photographs with land of stones)*, 1970. HF 11

116.117. *Goat Tell Mountains*, Isle of Arran, Scotland, Spring 1970. HF 7

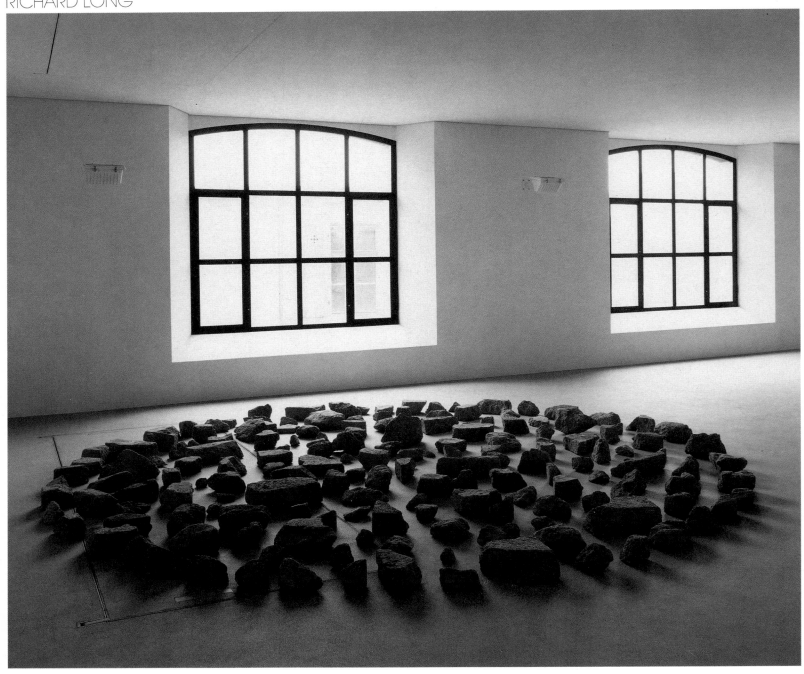

118. *Stone Circle*, Roma 1976. RLO 10

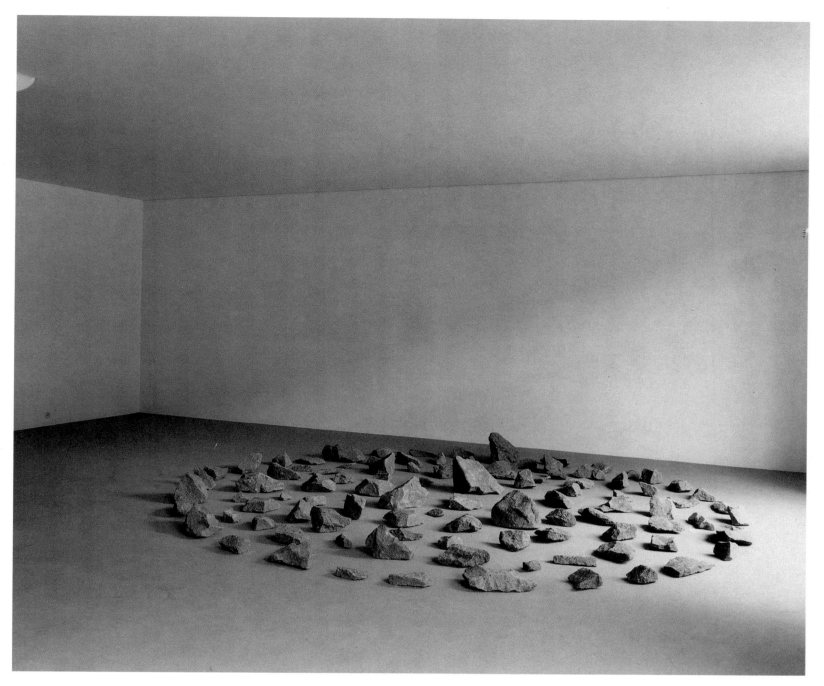

119. *Stone Circle*, Roma 1976. RLO 9

120. *Varese Room*, 1976. MN 12

Catalogo

a cura
di
Francesca Guicciardi

Avvertenza

Preface

Nota preliminar

Di seguito al catalogo fotografico si trova un elenco completo delle opere della Collezione Panza, suddivise per autore. Ciascuna voce riporta il titolo e la data dell'opera, la descrizione del materiale impiegato e l'indicazione delle misure. Le opere sono state elencate secondo l'ordine stabilito dal codice di catalogazione della Collezione Panza. Tale codice è riportato in fondo alla descrizione ed è costituito da una sigla e da un numero progressivo. La sigla MOCA, aggiunta in alcuni casi, indica che l'opera è stata acquisita dal Museum of Contemporary Art di Los Angeles.

Le misure delle opere sono espresse prevalentemente nel sistema imperiale. Nel caso in cui gli stessi autori abbiano usato il sistema metrico decimale si è aggiunta, tra parentesi, la misura equivalente nella scala imperiale.

Le opere dell'elenco sono precedute da uno o più numeri che rimandano alle fotografie del catalogo. Il numero in neretto rimanda alle pagine illustrate che precedono il catalogo.

Following the photographic catalogue there is a complete list of the works of the Panza Collection, divided according to authors. Each item gives the title and the date of the work, the description of the material used and the indication of the dimensions. The works have been listed according to the order established the cataloguing code of the Panza Collection. This code is shown at the bottom of the description and consists of a monogram and a consecutive number. The abbreviation MOCA, added in some cases, indicates that the work has been bought by the Los Angeles Museum of Contemporary Art.

The dimensions of the works are prevalently expressed in the imperial system. In cases in which the authors themselves used the metric system the equivalent in the imperial scale has been added in brackets.

The works in the list are preceded by one or more numbers that refer to the photographs in the catalogue. The number in bold-face refers to the illustrated pages that precede the catalogue.

A continuación del catálogo fotográfico se encuentra una lista completa de las obras de la Colección Panza, divididas por autor. Cada punto contiene el título y la fecha de la obra, la descripción del material empleado y la indicación de las medidas. Las obras han sido detalladas según el orden establecido por el código de catalogación de la Colección Panza. Este código aparece al final de la descripción y está constituido por una sigla y un número progresivo. La sigla MOCA, agregada en algunos casos, indica que la obra ha sido adquirida por el Museum of Contemporary Art de Los Angeles.

Las medidas de las obras están expresadas predominantemente en el sistema imperial. En los casos en los cuales los mismos autores han usado el sistema métrico decimal, ha sido agregada, entre paréntesis, la medida equivalente en la escala imperial.

Las obras de la lista están precedidas por uno o mas números que remiten a las fotografías del catálogo. El número en negrita remite a las páginas ilustradas que preceden al catálogo.

Le fotografie sono di: The photographs are by: Las fotografías son de:
Gian Sinigaglia, Milano
Ugo Mulas, p. 43
Giorgio Colombo, Milano: nn. 1-2 p. 33, 4 p. 36, 5 p. 37, 7 p. 40, 27-28 p. 81, 29 pp. 82-83, 33 p. 84-85, 44 p. 89, 46 pp. 90-91, 47 p. 92, 48 p. 93, 49 p. 94, 50 p. 95, 51 p. 96, 52 p. 97, 53 p. 98, 56 p. 99, 58-60 p. 100, 61 pp. 100-101, 66 p. 103, 67 p. 104, 70 p. 106, 77-78 p. 108, 79 p. 109, 82 p. 112, 84 pp. 114-115, 85 pp. 116-117, 86-87 p. 117, 88 pp. 118-119, 89 pp. 120-121, 90 p. 122, 91-92 p. 123, 93 pp. 124-125, 94 p. 124, 99 p. 128, 100 p. 129, 101 p. 130, 102 p. 131 (e sovracoperta - and jacket - y sobrecubierta), 103 p. 132, 104 p. 133, 105 p. 134, 106 p. 135, 107 p. 136, 108-109 p. 137, 110-111 p. 138, 112 p. 139, 113-114 p. 140, 116-117 p. 141, 118 p. 142, 119 p. 143, 120 p. 144, nelle pagine illustrate - in the illustrated pages - en las páginas ilustradas, nn. 5 p. 162, 14A. 16 p. 164, 14A. 19A. 20 p. 165, 5 p. 166, 9. p. 170, 1 p. 171, 2.4.5.6 p. 172, 10 p. 173, 17.18 p. 174, 16 p. 177, 27-28 p. 179, 7-9, p. 181, 12-14 p. 182, 17-19 p. 183, 21.23.24.26 p. 184, 29.30.33 p. 186, 3.4. p. 195, 11 p. 199, 21 p. 201, 25-26 p. 207, 1-3 p. 208, 17-18 p. 212, 1.2.5.6. p. 213, 1A.3A.7.9.10 p. 214, 4A.11.12/1-12/4 p. 215, 2A.10A.13-17 p. 216, 8A.18-20 p. 217, 3-7 p. 218, 9.13 p. 219, 1-7 p. 230, 1-6 p. 231, 7-8 p. 232, 1/1.1/2.2.3.4. p. 233, 1 p. 234, 1 p. 238, 1.2.5. p. 239, 6.7. 8/1 8/2 9 p. 240, 1-3 p. 241, 6-8 p. 242, 2 p. 243, 1. 1A p. 244, 1-4 p. 245, 7-8 p. 246, 7 p. 249, 2-5 p. 251, 1A. 6-12 p. 252, 13-14 p. 253, nel catalogo fotografico - in the photographic catalogue - en el catálogo fotográfico.

Si ringraziano: Acknowledgments: Agradecimientos:
DIA ART FOUNDATION, New York, per la foto - for the photo - par la foto n. 3 pp. 34-35.
SKY STONE FOUNDATION, Flagstaff, Arizona, per la foto - for the photo - par la foto n. 6 pp. 38-39.

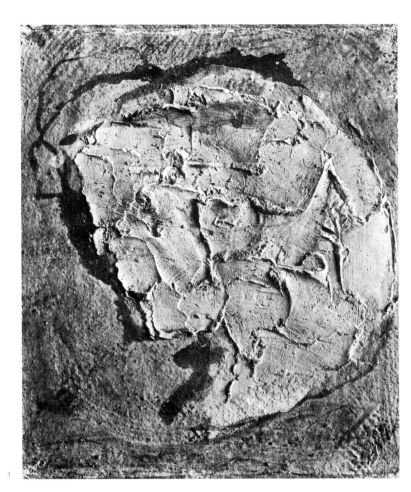

JEAN FAUTRIER

1. *Profil*, 1945. F 4 MOCA
2. *Untitled*, 1936. F 7
3. *Untitled*, 1950. F 8
4. *Tête d'otage no. 1*, 1943. F 1 MOCA
5. *Le pot*, 1947. F 6 MOCA

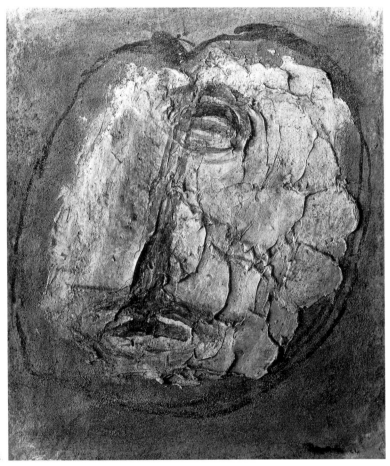

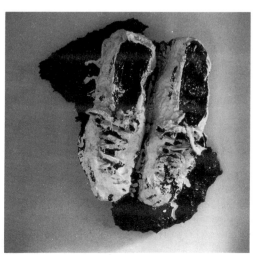

1.

2.

3.

4.

5.

6.

7.

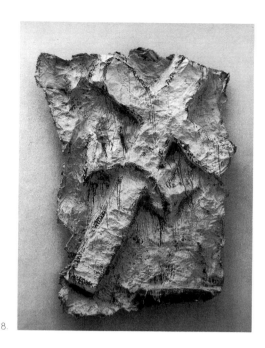

CLAES OLDENBURG

1. *White Shirt on Chair, 1962. CO 10 MOCA*
2. *Blue Pants on Chair, 1962. CO 14 MOCA*
3. *Bride, 1961. CO 4 MOCA*
4. *Umbrella and Newspaper, 1962. CO 11 MOCA*
5. *Hamburger, 1962. CO 12 MOCA*
6. *Piè à la Mode, 1962. CO 13 MOCA*
7. *Tennis Shoes, 1962. CO 15 MOCA*
8. *Pentecostal Cross, 1961. CO 2 MOCA*
9. *Cigarette Fragment, 1961. CO 6 MOCA*
10. *A Brown Shoe, 1961. CO 8 MOCA*
11. *Green Stocking, 1961. CO 9 MOCA*
12. *Fragment of Candies in a Box, 1961. CO 3 MOCA*
13. *Blue and Pink Panties, 1961. CO 5 MOCA*

8.

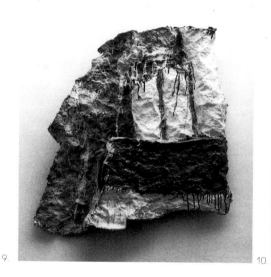

9.

10.

11.

12.

13.

149

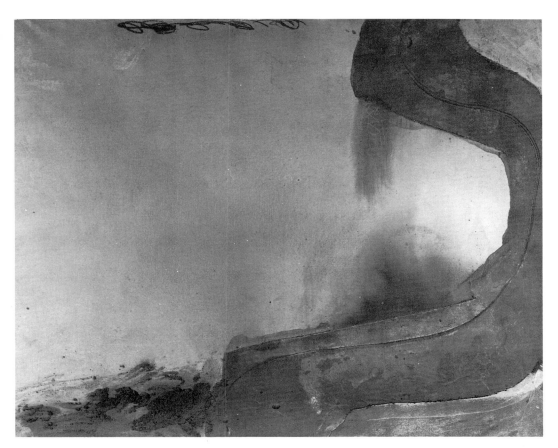

ANTONI TAPIES

1. *Grey with Red Sign*, 1958. AT 12 MOCA
2. *Collage on a Black Ground*, 1956. AT 5 MOCA
3. *Black-Ochre with Perforations*, 1957. AT 9 MOCA
4. *Grey and Black Cross*, 1955. AT 3 MOCA
5. *Sable-Ochre*, 1957. AT 10 MOCA
6. *Grey Relief Perforated by a Black Sign*, 1955. AT 2 MOCA
7. *All White*, 1955. AT 1 MOCA
8. *Grey on White*, 1956. AT 4 MOCA
9. *Grey With Six Marks*, 1959. AT 14 MOCA
10. *Ochre and Brown (New York)*, 1957. AT 8 MOCA
11. *Grey-Brown Composition*, 1957. AT 6 MOCA

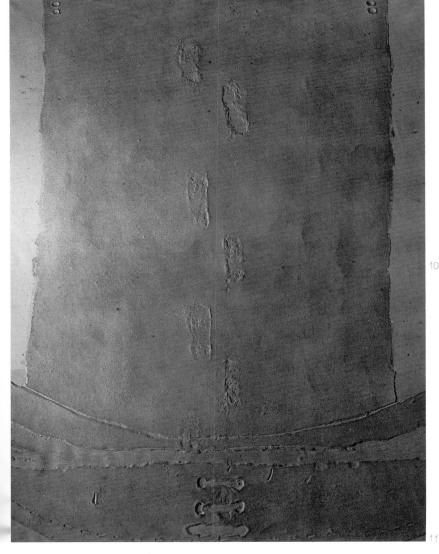

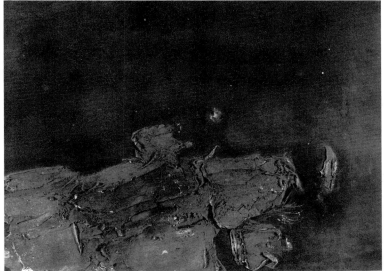

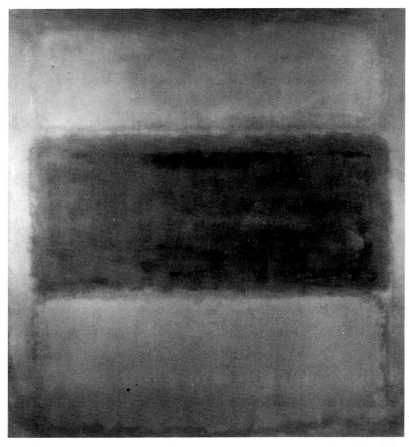

1.

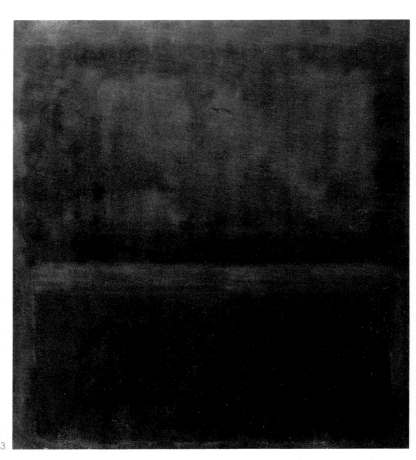

3.

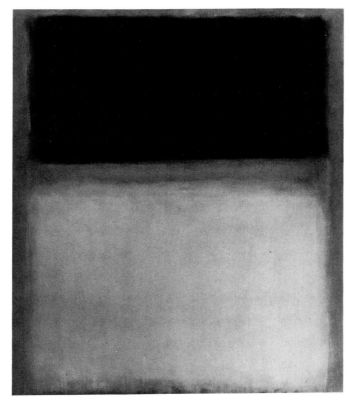

2.

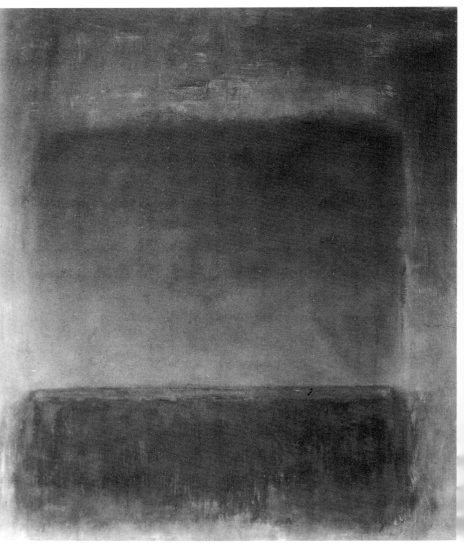

4.

152

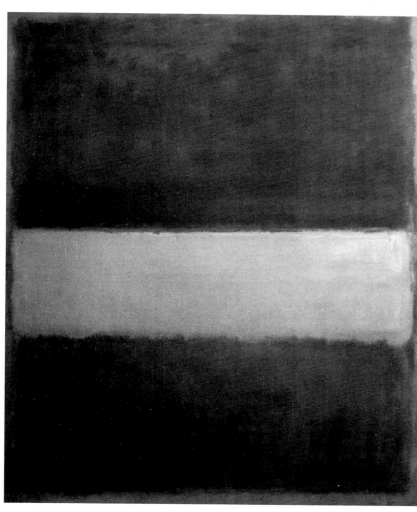

MARK ROTHKO

1. *Red and Blue over Red*, 1959. MR 6 MOCA
2. *Violet and Yellow in Rose*, 1954. MR 2 MOCA
3. *Black and Dark Sienna on Purple*, 1960. MR 7 MOCA
4. *Purple Brown*, 1957. MR 3 MOCA
5. *Brown, Blue, Brown on Blue*, 1953. MR 1 MOCA
6. *Black, Ochre, Red over Red*, 1957. MR 4 MOCA
7. *Red and Brown*, 1957. MR 5 MOCA

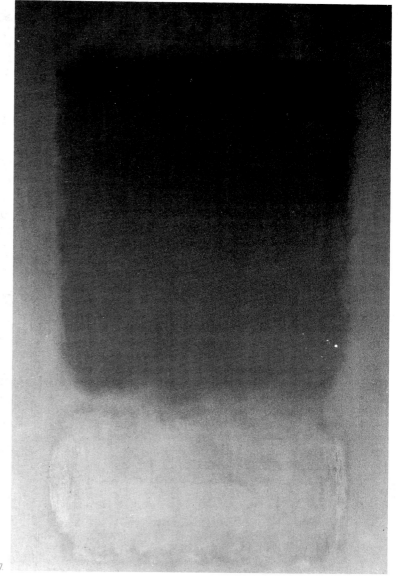

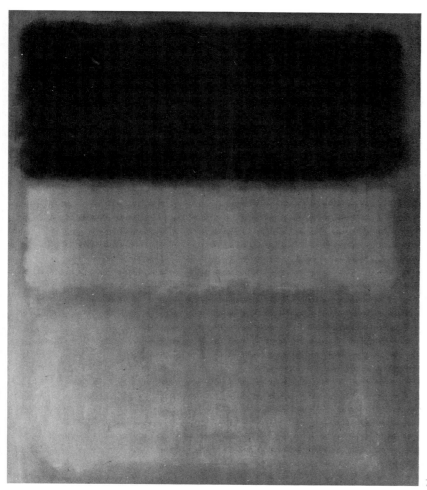

7.

JAMES ROSENQUIST

4.

1.

5.

2.

3.

6.

MARIO RADICE

Untitled, 1956. MRA 1

CY TWONBLY

Untitled, 1957. CT 1

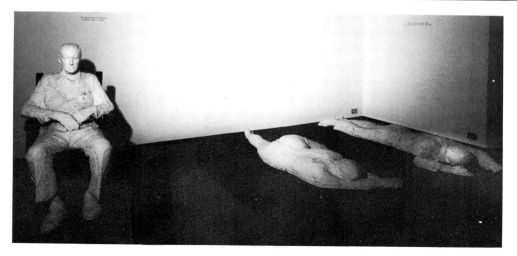

GEORGE SEGAL

Man in the Armchair (Helmut von Erffa), 1969. GS1 MOCA

Sunbathers on the Roof Top, 1963-1967. GS 2 MOCA

155

VITTORIO TAVERNARI

1. *Figura sdraiata*, 1971. VT 2
2. *Grande torso (il fiume)*, 1954. VT 1

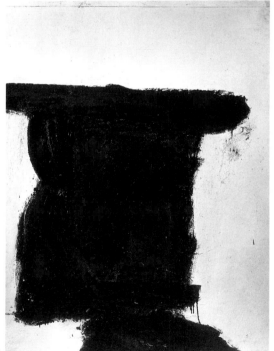

FRANZ KLINE

1. *Monitor*, 1956. FK 4 MOCA
2. *Thorpe*, 1954. FK 2 MOCA
3. Drawing, 1957. FK 13
4. *Hazelton*, 1957. FK 6 MOCA
5. *Buttress*, 1956. FK 5 MOCA
6. *Black Iris*, 1961. FK 12 MOCA
7. *Black and White*, 1957. FK 7 MOCA
8. *Tower*, 1953. FK 1 MOCA

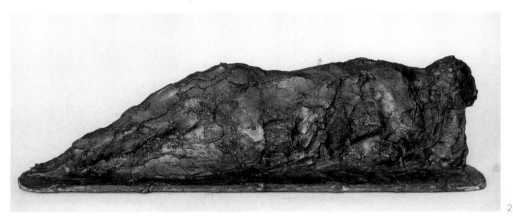

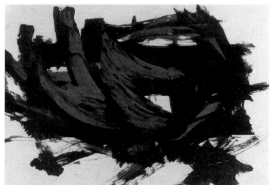

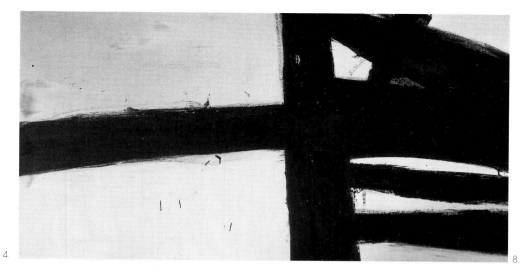

4.

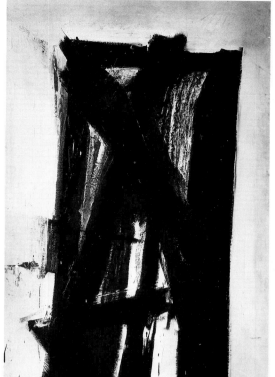

8.

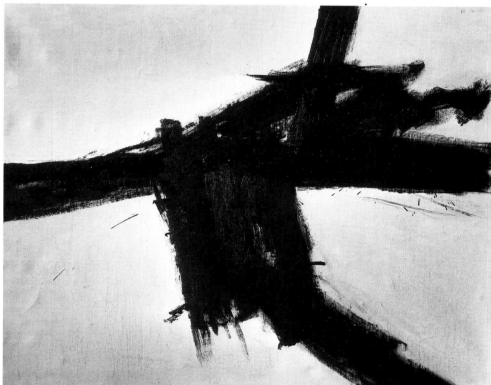

5.

9.

6.

7.

10.

JOSEPH BEUYS

1. *Untitled*, 1961. JB 2
2. *Fontana Dose*, 1963. JB 1

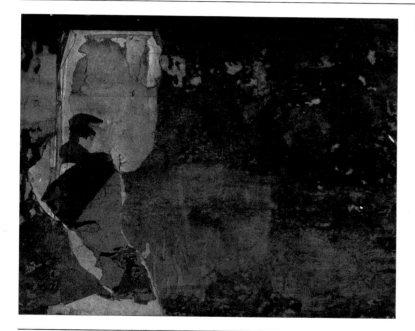

RAYMOND HAINS

Untitled, 1960. RH 1

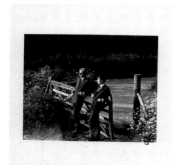

GILBERT AND GEORGE

We Are Only Human Sculptors, London 1970. GG 1

ROBERT RAUSCHENBERG

1.

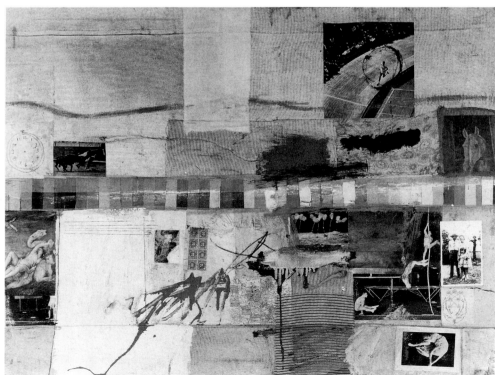

3.

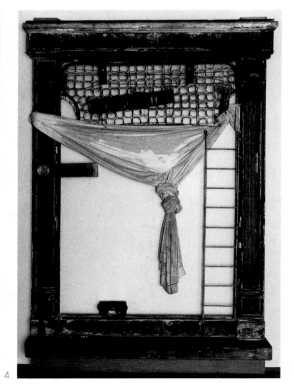

2.

4.

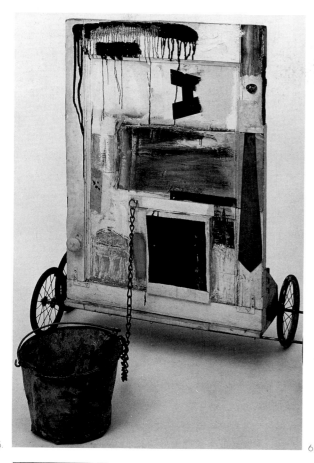

5.

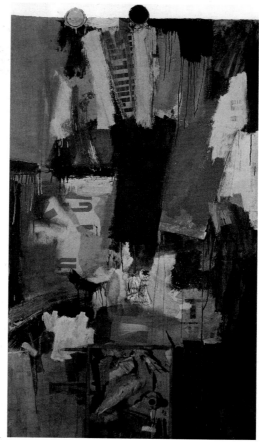

6.

7.

ROY LICHTENSTEIN

1. *Cézanne*, 1962. RL 1 MOCA
2. *The Grip*, 1962. RL 4 MOCA

1.

2.

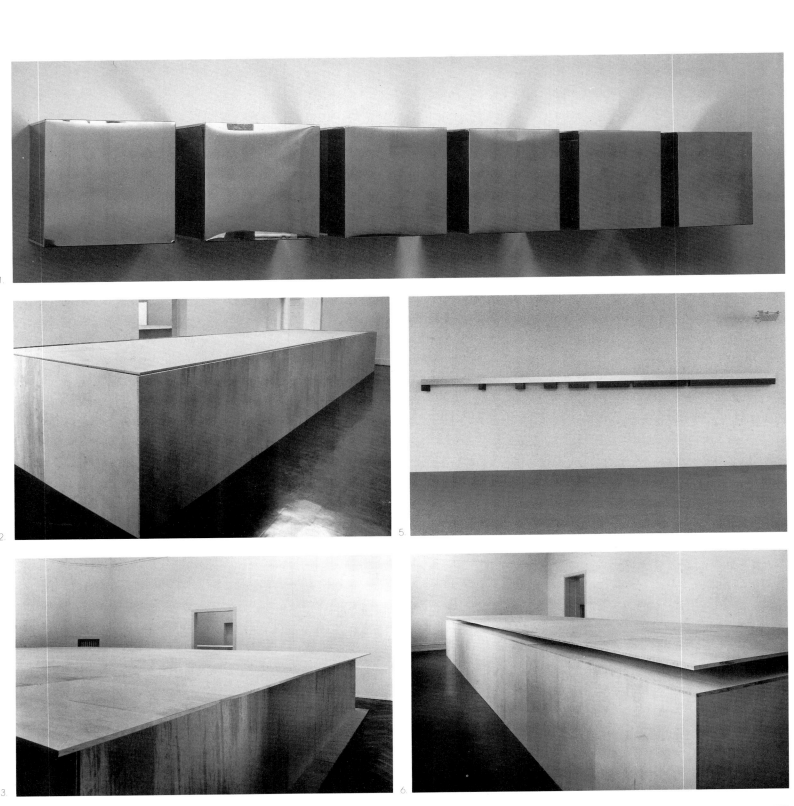

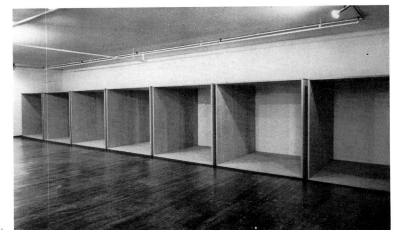

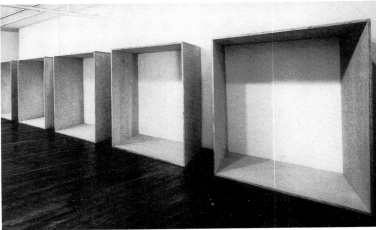

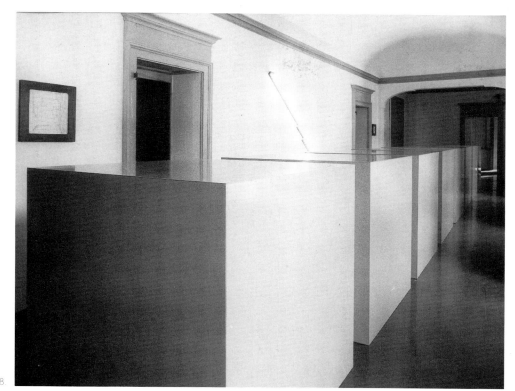

DONALD JUDD

1. *Untitled*, 1972. DJ 9
2. *Bern Piece no. 1*, Bern 1976. DJ 28
3. *Bern Piece no. 2*, Bern 1976. DJ 23
4. *Untitled*, 1972-1973. DJ 12
5. *Untitled*, 1970. DJ 5
6. *Bern Piece no. 3*, Bern 1976. DJ 30
7. *Untitled*, May 1972. DJ 13
8. *Untitled*, 1971. DJ 8
9. *Straight Single Tube*, 1974. DJ 24
10 *Untitled*, 1965. DJ 2
11. *Raised Top Plywood Piece (Lisson 1)*, 1974. DJ 29
12 *Untitled*, 1973. DJ 10
13. *Untitled*, 1965. DJ 1

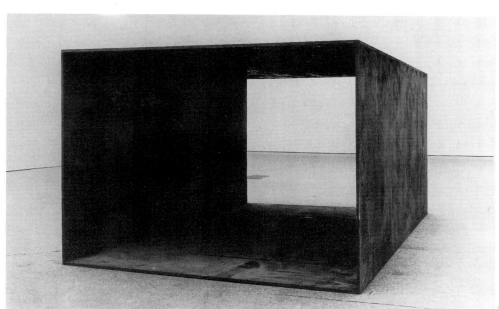

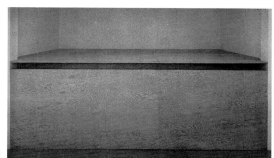

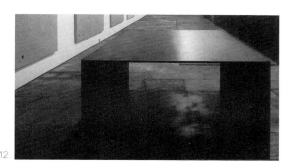

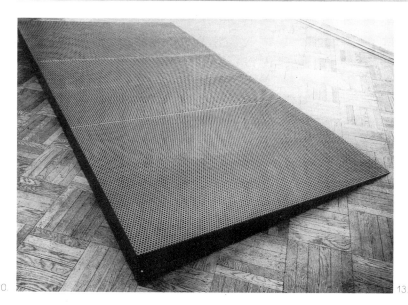

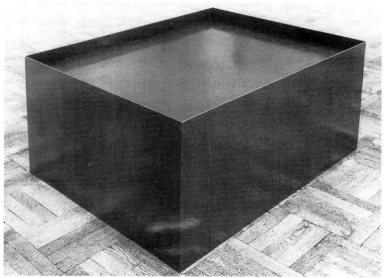

1½" ALUMINUM
8' X 16' ABOUT 15° PARALLELOGRAM
INNER SHEETS PARALLEL

14/A.

DONALD JUDD PURCHASE ORDER
REQUIS. NO.
SHIP TO Giuseppe Panza
di Biumo
PURCHASER UNLESS INDICATED Milan, Italy
DATE 1-24-80
CHANGE: Panza # DJ 28 (H.R.S. double wall) to....
Bern 1976 catalogue #1 in HOT ROLLED STEEL
½"-1" thick *
122 x 976 x 284 cm (48 x 382 x 111½") } Bern dimensions
free standing 150 cm from wall (60")
4" space all around
* DIMENSIONS to be determined by size
ca. 72" from wall
2/A.

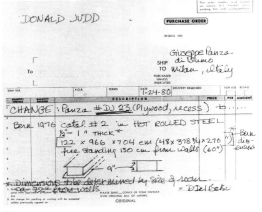

DONALD JUDD PURCHASE ORDER
REQUIS. NO.
SHIP Giuseppe Panza
TO di Biumo
Milan, Italy
DATE 1-24-80
CHANGE: Panza # DJ 23 (Plywood, recess) to....
Bern 1976 catal. #2 in HOT ROLLED STEEL
½"-1" thick *
122 x 966 x 704 cm (48 x 378¾ x 276") } Bern dimensions
free standing 150 cm from walls (60")
9"
* Dimensions to be determined by size of room
ca. 72" from walls
3/A.

DONALD JUDD PURCHASE ORDER
REQUIS. NO. 76-20
amendment, 1-24-80
SHIP Giuseppe Panza
TO di Biumo
PURCHASER UNLESS INDICATED Milan, Italy
DATE 1-24-80

QUANTITY ORDERED	QUANTITY RECEIVED	DESCRIPTION	PRICE	PER	AMOUNT
70		⅛"-¼" thick COLD ROLLED STEEL (change from brass) ea. 50 x 100 x 50 cm. ¼ recessed to be installed tightly together against wall Panza # DJ 32			

50
50
100
12.5 CM

Acknowledge promptly if you are unable to ship complete by date specified.
Seller warrants goods shipped produced in accordance with applicable provision Fair Labor Standard Act.
No charge for packing or crating will be accepted unless previously agreed on.
PLEASE SEND___ COPIES OF YOUR INVOICE WITH ORIGINAL BILL OF LADING. BY
ORIGINAL

15.

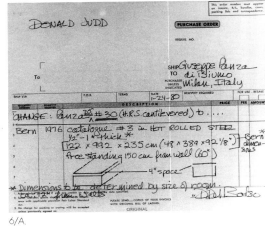

DONALD JUDD PURCHASE ORDER
REQUIS. NO.
SHIP Giuseppe Panza
TO di Biumo
Milan, Italy
DATE 1-24-80
CHANGE: Panza # DJ 30 (H.R.S. cantilevered) to....
Bern 1976 catalogue #3 in HOT ROLLED STEEL
½"-1" thick *
122 x 992 x 235 cm (48 x 389 x 92⅛") } Bern dimensions
free standing 150 cm from wall (60")
4" space
* Dimensions to be determined by size of room
ca. 72" from walls
6/A.

SINGLE STEEL WALL BENT

ROOM SHOULD BE AT LEAST 50 X 30
½" HOT ROLLED STEEL SHEARED
AS FEW JOINTS AS POSSIBLE
MATERIAL SHOULD NOT BE TOUCHED
ENDS OF BENT WALL SHOULD
BE AGAINST WALL OF ROOM
THAT HAS THE DOOR

⅜ OR ½ INCH SHEET BENT
15 INCHES
5 FEET HIGH
3 INCHES
FIXED NEATLY AND SPARINGLY TO THE WALL IF NECESSARY

16.

Donald Judd PURCHASE ORDER
INVOICE
made by: Opizzi
SHIPPED TO Giuseppe Panza
di Biumo, Milan

TERMS	INVOICE DATE 1979	YOUR ORDER NO.	OUR ORDER NO.	SALESMAN	SHIPPED VIA
QUANTITY		DESCRIPTION		UNIT PRICE	AMOUNT
	Panza # DJ 31 (change from alum. to HRS) HOT ROLLED STEEL - 3 cm thick (1 3/16") 5 x 15 x 8' with parallelogram inside (see archit. drawing)				

Thank You!

14/A.

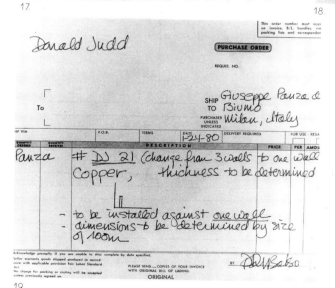

17.

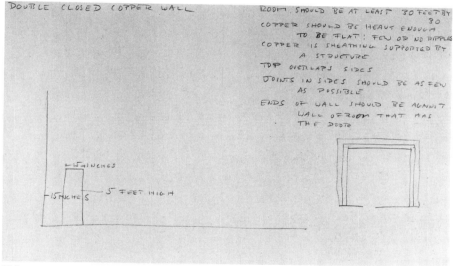

18.

19.

19/A.

20.

15/A.

JENE HIGHSTEIN

1. *Human Scale Black*, 1975. JH 3
2. *Fresno Aluminium Casting no. 2*, 1974.
 JH 5
3. *Fresno Aluminium Casting no. 3*, 1974.
 JH 6
4. *Two Horizontals*, 1974. JH 2
5. *Black Eliptical Cone*, Varese 1976. JH 7

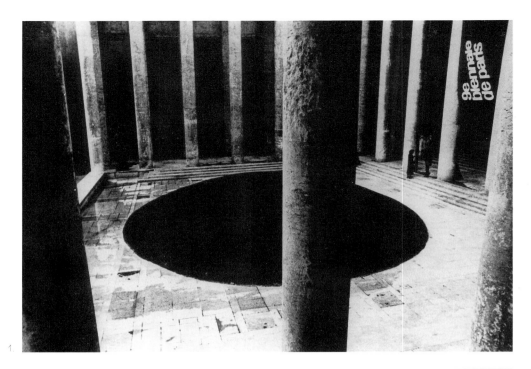

1.

2.

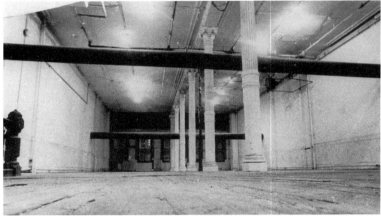

4.

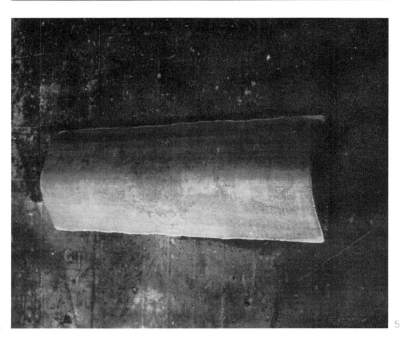

3.

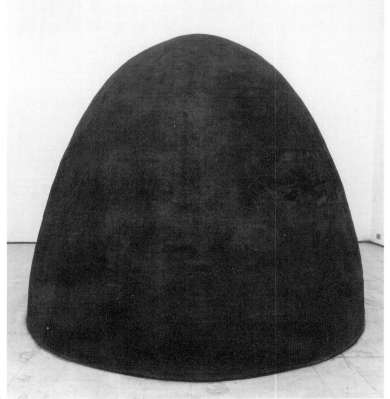

5.

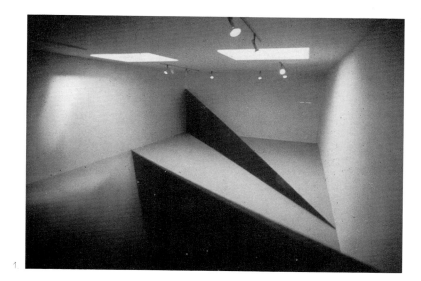

RICHARD SERRA

1 *One Cut Bisected Corners, 1973. RS 10*
2 *Shafrazi, 1974. RS 11*
3 *Zadikians, 1974. RS 12*
4 *Sign Board Prop, 1969. RS 7*
5 *Untitled, 1969. RS 6*

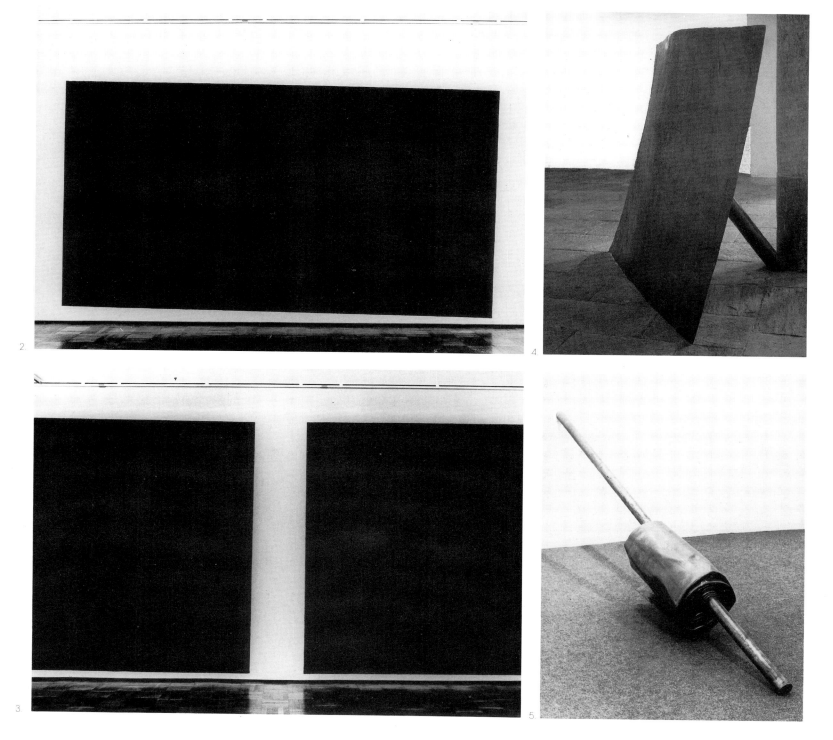

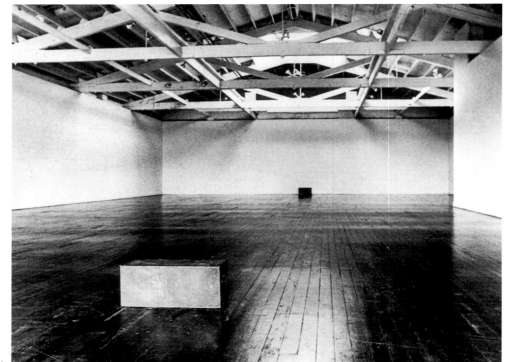

6.

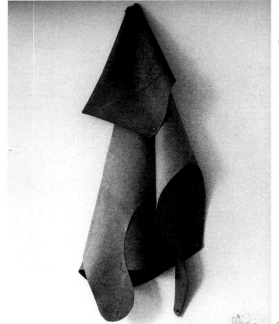

7.

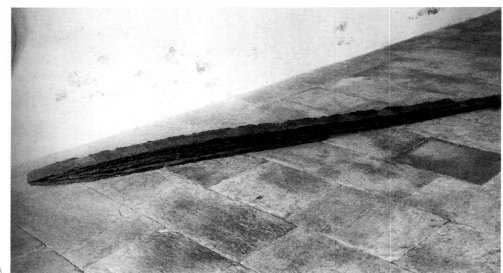

8.

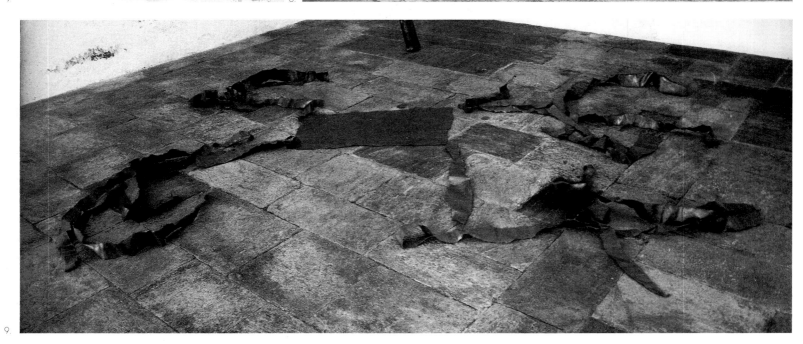

9.

CARL ANDRE

1. *Steel Piece*, 1967. CA 2
2. *Finely Divided Square Piece*, May 1970. CA 9
3. *Brass Square Piece*, March 1972. CA 8
4. *Reef*, 1966. CA 1
5. *Copper Square*, 1973. CA 10

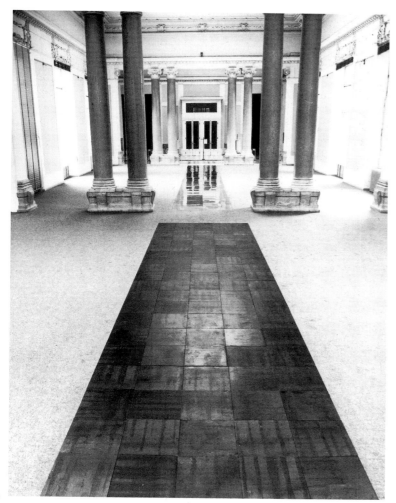

1.

```
FINELY DIVIDED SQUARE PIECE
FOR MARIANNE*
882 COLD-ROLLED STEEL CHIPS
1/64" X 9/32" X 9/16" EACH
1/64" X 11 13/16" X 11 13/16"
21 LONG X 42 WIDE ARRAY
NEW YORK
MAY 1970
©
*ONLY MARIANNE HAD THE PERCISTENCE OF VISION
NECESSARY TO FINISH THE PIECE
BE WELL & LOVE
Carl
```

2.

```
BRASS SQUARE PIECE
100 BRASS UNITS
1/16" X 1/16" X 1/64" EACH
7/8" X 7/8" X 1/64" OVERALL
WINDHAM COLLEGE
MARCH 1972
©
```

3.

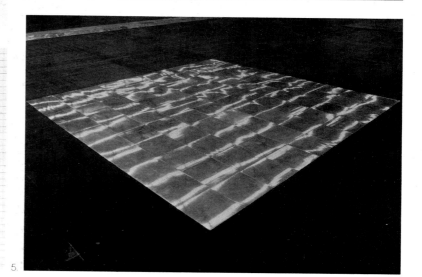

4.

5.

8.

6.

TITLE OF WORK: 2001 SLOPE

DATE OF WORK: 1968

MATERIAL: HOT-ROLLED STEEL

NUMBER AND CONFIGURATION OF ELEMENTS: 6-UNIT LINE (1X6), EXTENDING AT ANGLE FROM BASE OF WALL
DIMENSIONS OF EACH ELEMENT: 5 UNITS - 3/8" X 36" X 36"; ONE UNIT- 3/8" X 36" X 33" (TRAPEZOID)
OVERALL DIMENSIONS: 3/8" X 36" X 216"

PLACE OF ORIGIN: LOS ANGELES

DOCUMENTATION/AUTHENTICATION: THIS SHEET

DATE AND PLACE OF ACQUISITION: 1975, SPERONE, NEW YORK

SOURCE OF ACQUISITION: GIAN ENZO SPERONE

METHOD OF ACQUISITION (PURCHASE,TRADE,GIFT,OTHER): PURCHASE

PRESENT LOCATION: PANZA COLLECTION, MILANO

EXHIBITION HISTORY: IRVING BLUM GALLERY, LOS ANGELES, 1968

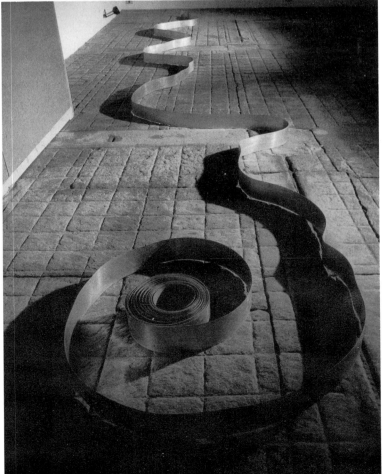

7.

9.

10.

JOEL SHAPIRO

1. *Untitled (Chair), 1973-1974. JS 4*
2. *Untitled (Table), 1974. JS 6*
3. *Untitled (Coffin), 1971-1973. JS 2*
4. *Untitled, 1974. JS 7*
5. *Untitled (Maquette for table), 1974. JS 6A*
6. *Untitled (Maquette for coffin), 1971. JS 2A*
7. *Untitled, 1971. JS 1*

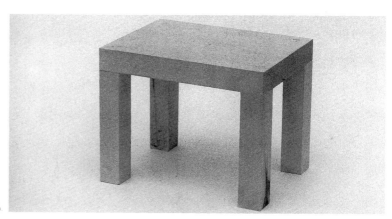

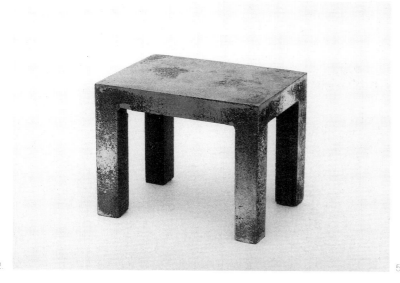

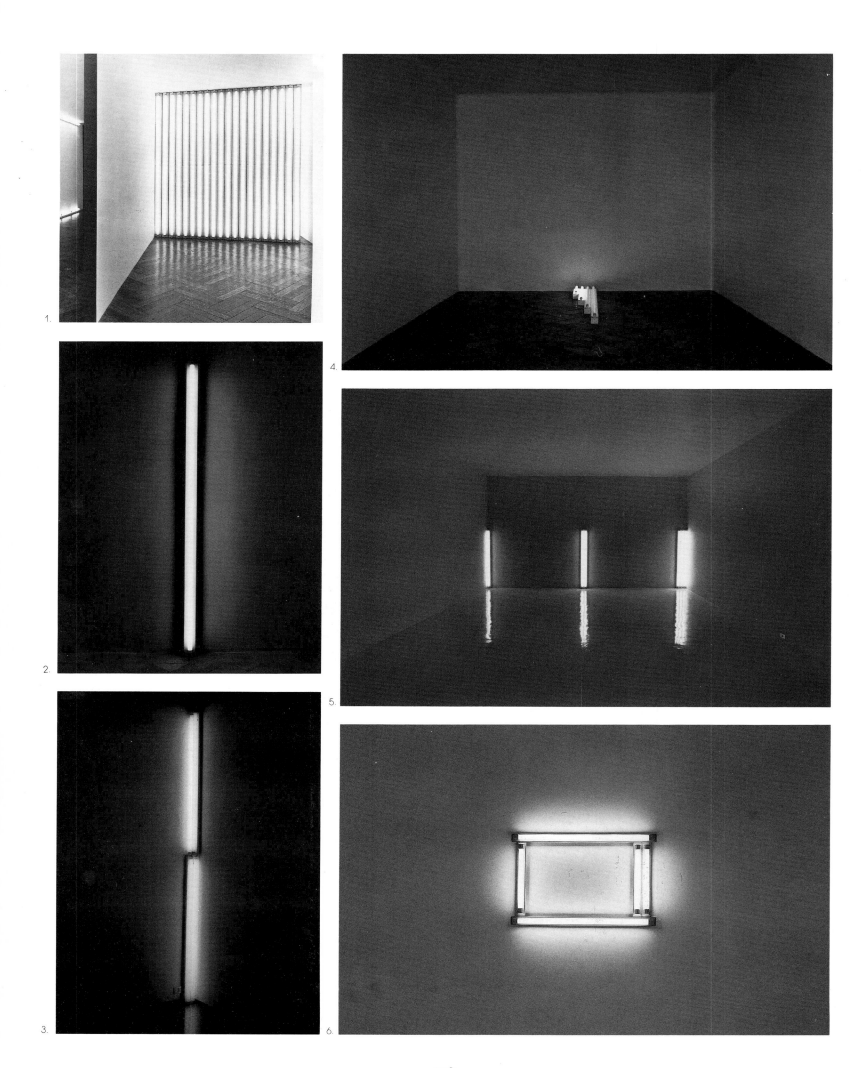

172

DAN FLAVIN

1. *Untitled (to Jan and Ron Greenberg), 1972-1973. DF 21*
2. *Untitled 1/3, 1963. DF 1*
3. *Untitled 1/3, 1963-1966. DF 3*
4. *Gold, Pink and Red, Red 1/3, 1964. DF 5*
5. *The Nominal Three (to William of Ockham) 2/3, 1963. DF 2*
6. *Ursula's One and Two Picture 1/3, 1964. DF 6*
7. *Untitled (Seven 20 watt fictures form the arc) 1/3, 1964. DF 7*
8. *Monument on the Survival of Mrs. Reppin 1/3, 1966. DF 8*
9. *Untitled 1/3, 1966. DF 9*
10. *Untitled 6 B, 1968. DF 13*
11. *Untitled 1/3, 1966. DF 10*
12. *Kunsthalle, Koln, Installation (with circular lights), 1972. DF 22*

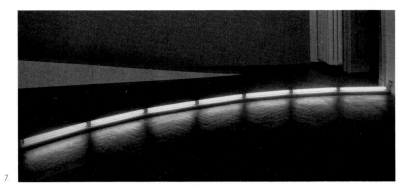

7.

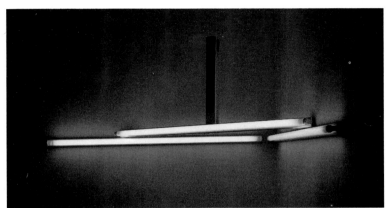

8.

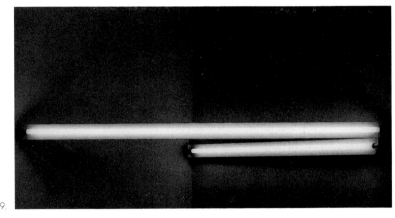

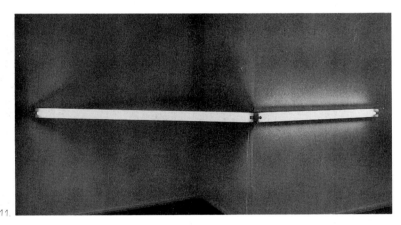

9.

11.

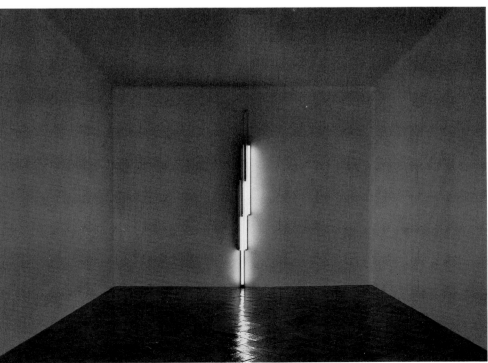

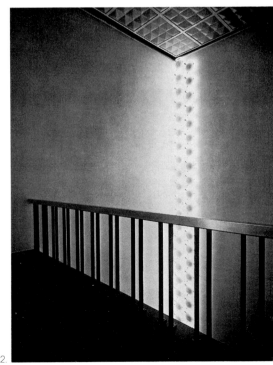

10.

12.

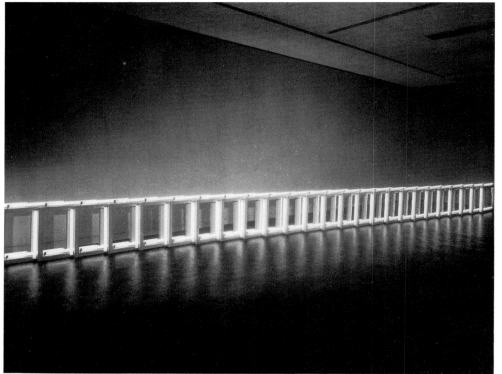

13.

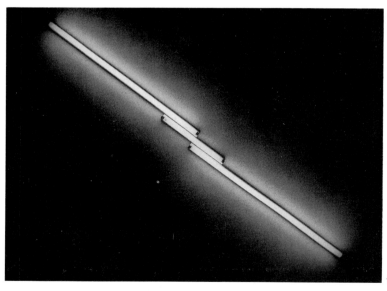

14.

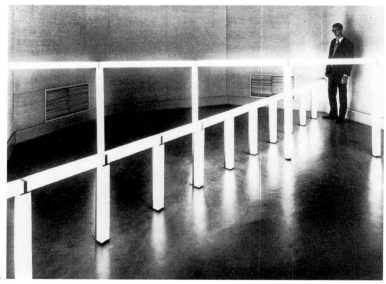

15.

16.

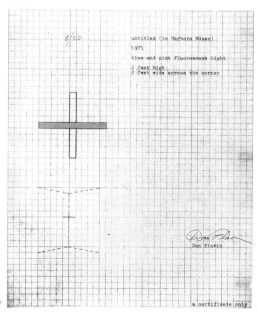

17.

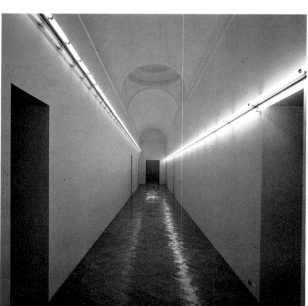

18.

174

RICHARD NONAS

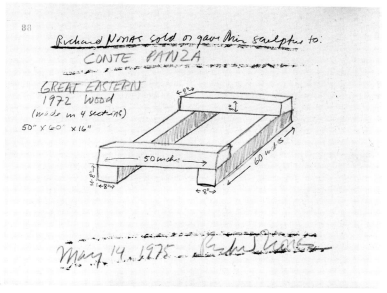

7.

11.

8.

12.

9.

13.

10.

14.

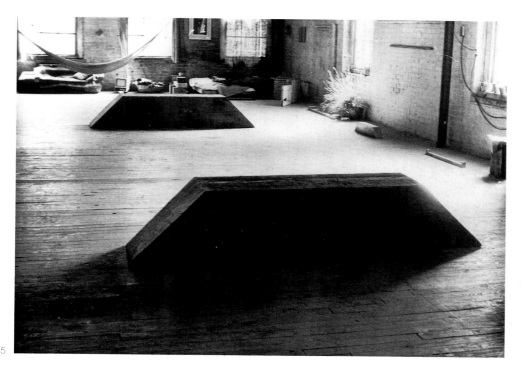

15

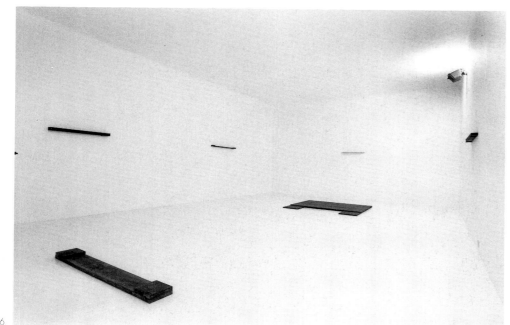

16

18

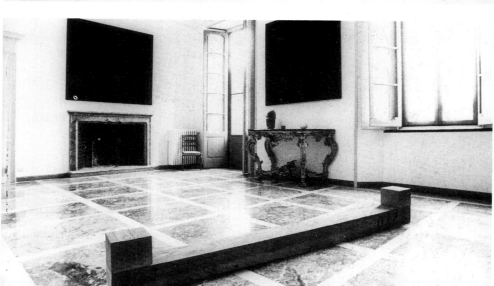

17

19

20.

21.

22.

23.

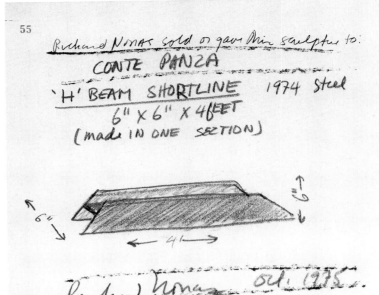

55

Richard Nonas sold or gave this sculpture to:

CONTE PANZA

'H' BEAM SHORTLINE 1974 Steel
6" X 6" X 4 FEET
(made in one section)

← 6" 6" ↕ ← 4L →

Richard Nonas Oct. 1975.

24.

25.

53

Richard Nonas sold or gave this sculpture to:

CONTE PANZA

SHORTLINE SERIES (WALL) MOSKUTZ' BROW
1974 Steel
75" X 6" X 1" (MADE IN ONE)
 SECTION
(WALL)

NAIL NAIL NAIL

WALL SCULPTURE RESTING
ON THREE NAILS
TO BE HUNG AT ABOUT EYE-
 LEVEL

Richard Nonas Oct. 1975.

26.

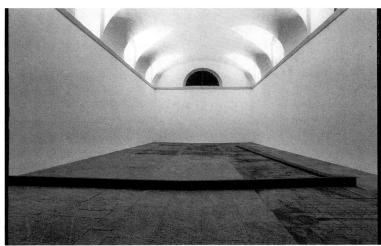

27.

27.

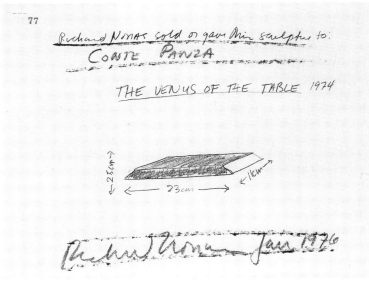

28.

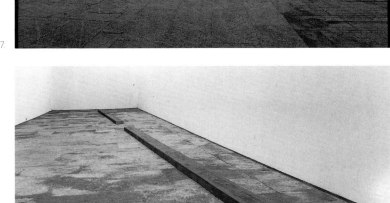

29.

31.

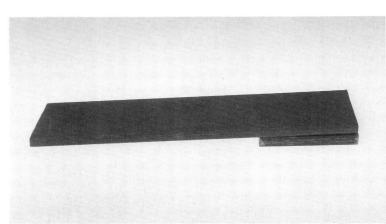

30.

32.

BRUCE NAUMAN

1. *Piece in Which One Can Stand,* 1966. BN 4
2. *Lighted Centerpiece,* 1968. BN 7
3. *Hologram (Full Figure Poses),* 1969. BN 10
4. *Untitled,* 1965-1966. BN 2
5. *Hologram (Making Faces),* 1968. BN 9
6. *Device for a Left Armpit,* 1967. BN 5
7. *Sound Breaking Wall,* 1969. BN 14
8. *Touch and Sound Walls,* December 1969. BN 15
9. *Two Fans Corridor,* January 1970. BN 22
10. *Untitled,* 1965-1966. BN 2

7.

8.

9.

10.

11.

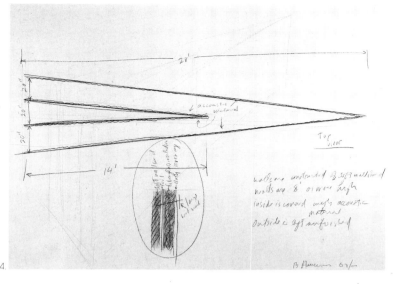

14.

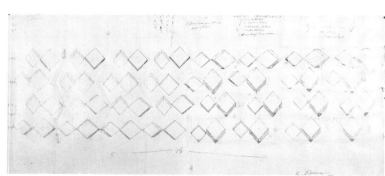

12.

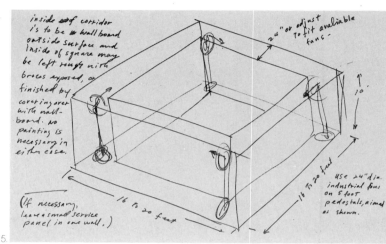

15.

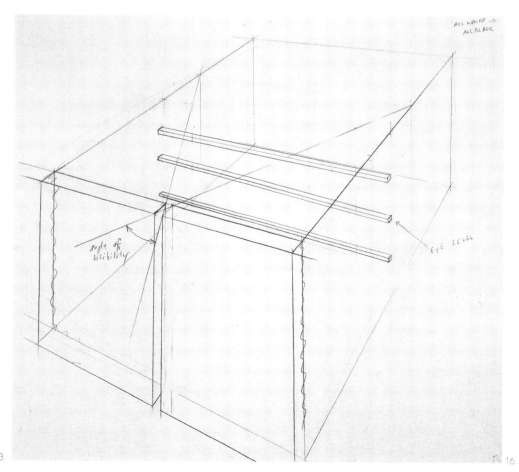

13.

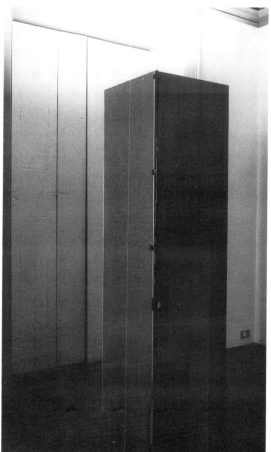

16

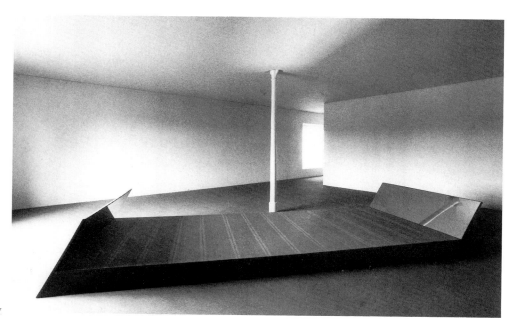

(can't find my blue pencil)

blue

when I first drew this piece, I was thinking of a space about 40 to 60 feet square, but I think it can be considerably smaller if I again give some thought to it and have some idea of the space available in case some one wants to build it.

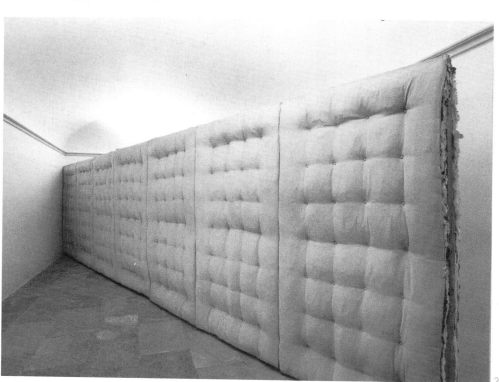

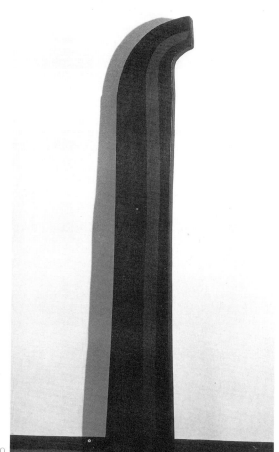

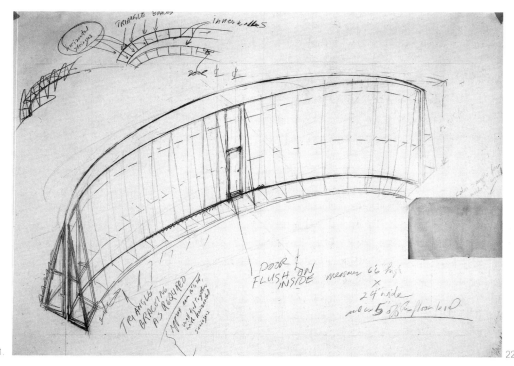

21.

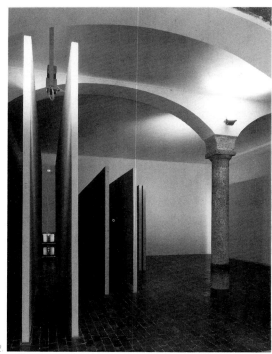

22.

23.

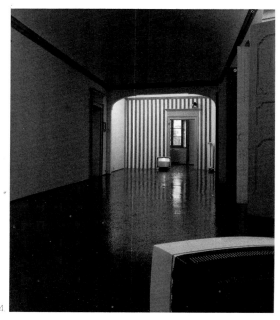

24.

25.

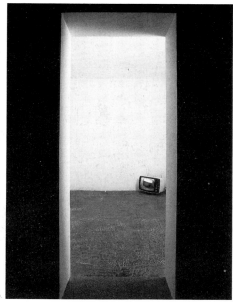

26.

27.

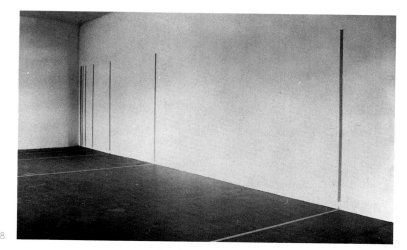

28.

29.

30.

32.

31.

33.

185

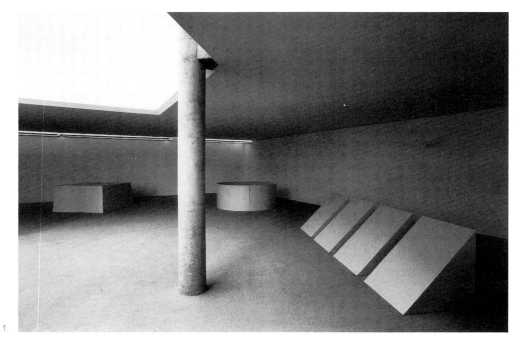

1.

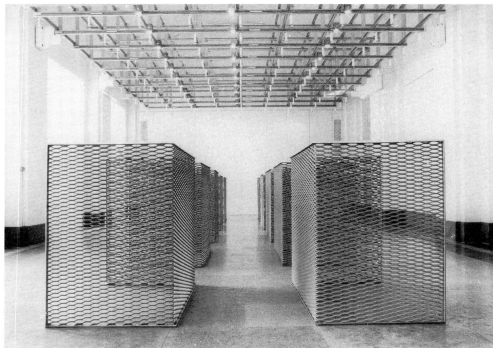

2.

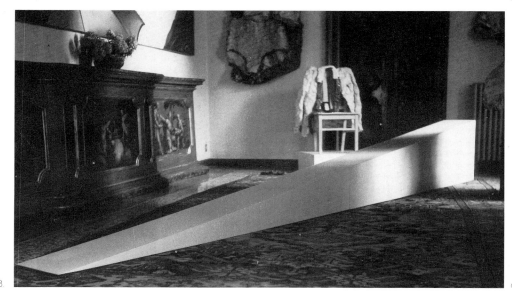

4

5.

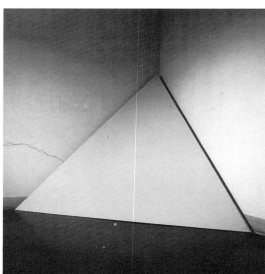

3.

6.

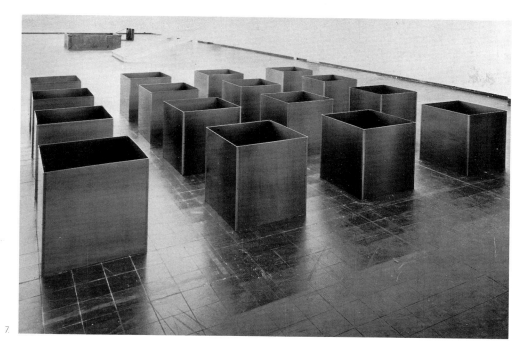

7.

ROBERT MORRIS

1. *Untitled (4 wedges)*, 1967. RM 5
 Untitled (4 round wedges), 1967. RM 5A
 Untitled (Piece with battered sides), 1966. RM 32
2. *Untitled (Aluminum grating)*, 1969. RM 9
3. *Untitled (Door stop)*, 1965. RM 4
4. *Untitled (Long wedge)*, 1966. RM 2
5. *Untitled (Square donut)*, 1968. RM 33
6. *Untitled (Corner piece)*, 1964. RM 1
7. *Untitled (16 steel boxes)*, 1967. RM 7
8. *Untitled (Steel grating)*, 1967. RM 8
9. *Untitled (Five timbers)*, 1969. RM 18
10. *Untitled (Brown felt)*, 1973. RM 14
11. *War Memorial*, 1970. RM 31

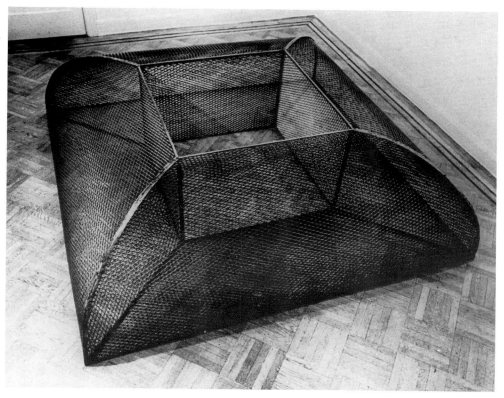

8.

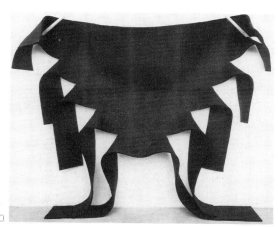

10.

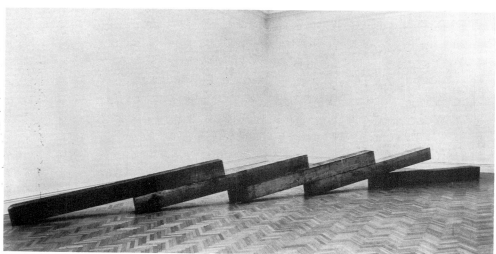

9.

11.

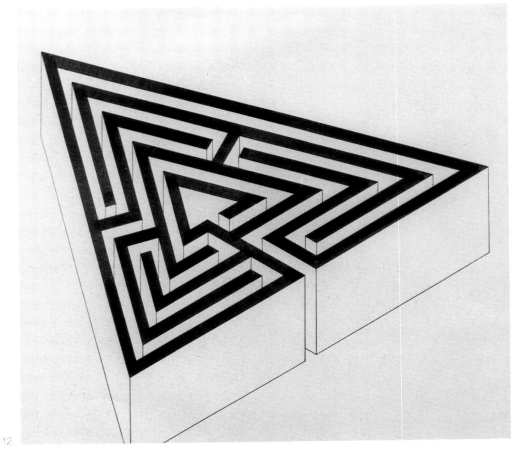

12.

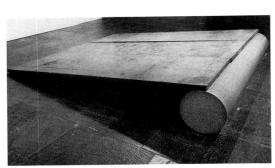

13.

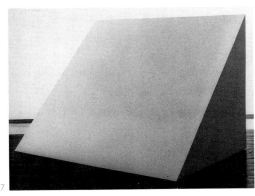

16.

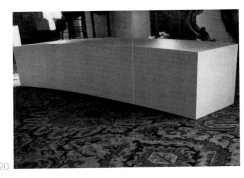

19.

14.

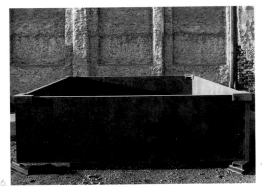

17.

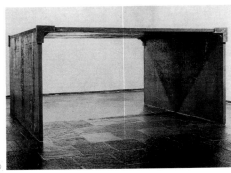

20.

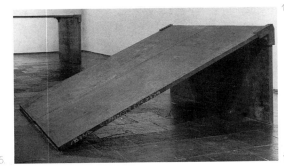

15.

18.

21.

188

BOB LAW

1. *No. 89 (Mauve, black, blue, black),* 1974. BL 8
2. *No. 86 (Violet, black, violet),* 1970. BL 4
3. *Castle XXVII,* February 1976. BL 14
4. *Castle no. 7,* 1975. BL 10
5. *Castle no. 3,* 1975. BL 9
6. *Castle no. 10,* August 1975. BL 11
7. *No. 87 (Violet, black, violet, blue),* 1970. BL 5
8. *Castle XXIV,* December 1975. BL 16
9. *Castle XXV,* January 1976. BL 12
10. *No. 64 (Purple, plum, black, violet),* 1967. BL 1

13.

11.

14.

12.

15.

ALAN CHARLTON

1. *82 in. Square,* 1970-1972. AC 4
2. *82 in. Square,* 1970-1972. AC 1
3. *Outer piece 90 x 174 in., each inner piece 74 ½ in. square, channel 1 ¾ in.,* November-December 1972. AC 18
4. *58 x 180 in.,* June 1970. AC 6
5. *82 in. Square,* 1970-1972. AC 2

6. *90 x 90 in., slit 78 in., August 1971. AC 9*

7. *90 x 90 in., slit 44 in., September 1971. AC 12*

8. *Outer piece 114 x 66 in., inner piece 98½ x 50½ in., channel 1 ¾ in., May-August 1972. AC 16*

9. *90 x 78 in., slit 66 in., August 1971. AC 10*

10. *No. 4/8 Outer piece 84 in. square, inner piece 68 4/10 square, channel 1 8/10 in., December 1972-May 1973. AC 22*

11. *Outer piece 51 ½ in. square, inner piece 24 in. square, channel 1 ¾ in., August 1973. AC 27*

12. *No. 1/8 Outer piece 84 in. square, inner piece 68 4/10 in. square, channel 1 8/10 in., December 1972 - May 1973. AC 19*

13. *No. 6/8 Outer piece 84 in. square, inner piece 68 4/10 in. square, channel 1 8/10 in., December 1972 - May 1973. AC 24*

14. *No. 5/6 Each piece 91 x 80½ in., January 1975. AC 33*

 No. 3/6 Each piece 98 x 66½ in., January 1975. AC 34

 No. 2/6 Each piece 101 x 59½ in., January 1975. AC 35

15. *90 x 102 in., each slit 90 in., January 1972. AC 15*

16. *Outer piece 66 in. square, inner piece 55 ½ in. square, channel 1 ¾ in., October 1973. AC 29*

17. *82 in. Square, 1970-1972. AC 5*

6.

8.

7.

9.

10.

11.

12.

13.

18. No. 5/8 Outer piece 84 in. square, inner piece 68 4/10 in. square, channel 1 6/10 in., December 1972 - May 1973. AC 23

19. 90 x 180 in., each slit 78 in., January 1972. AC 13

20. No. 8/8 Outer piece 84 in. square, inner piece 68 4/10 in. square, channel 1 6/10 in., December 1972 - May 1973. AC 25

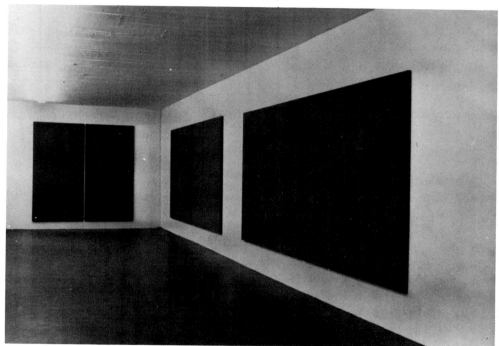

14.

16.

17.

15.

18.

21. No. 2/8 Outer piece 84 in. square, inner piece 68 4/10 in.
 square, channel 1 6/10 in., December 1972 - May 1973.
 AC 20

22. Outer piece 50 in. square, inner piece 39 1/2 in. square,
 channel 1 3/4 in., January 1974. AC 32

23. No. 3/8 Outer piece 84 in. square, inner piece 68 4/10 in.
 square, channel 1 6/10 in., December 1972 - May 1973.
 AC 21

24. Outer piece 56 in. square, inner piece 49 in. square,
 channel 1 3/4 in., January 1974. AC 31

22.

19.

20.

23.

21.

24.

PETER JOSEPH

1. *Grey with Ochre Border*, May 1976. PJ 13
2. *Cream with Ochre Border*, June 1976. PJ 14
3. *Untitled (Dark cream with blue border)*, 1975. PJ 9
 Untitled (Cream colour with black border), May 1975. PJ 5
4. *Untitled (Tan colour with dark blue border) I*, June 1974. PJ 2
 Untitled (Cream colour with black border) II, June 1974. PJ 3
5. *Cream with Brown Border*, February 1976. PJ 12
6. *Cream with Maroon Border*, January 1976. PJ 11
7. *Untitled (Dulled cream with black border)*, October 1975. PJ 10

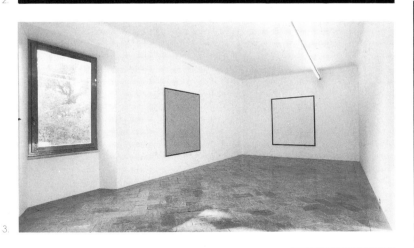

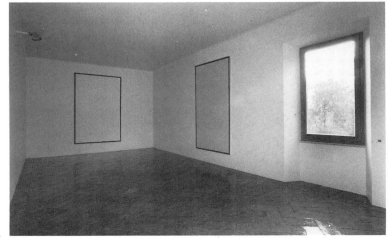

1.

2/10.

2/9.

2/2.

2/1.

2/8.

2/11.

2/3.

2/4.

196

ROBERT RYMAN

1. *Allied*, 1966. RRY 1
2. *Standard nos. 1-2-3-4-6-8-9-10-11-12-13*, 1967. RRY 2
3. *Aacon*, 1968. RRY 3
4. *Five Units (nos. 1-2-3-4-5)*, 1969. RRY 13
5. *Three Units (nos. 1-2-3)*, 1969. RRY 12
6. *Classico II*, 1968. RRY 6
7. *Classico 20*, 1968. RRY 10

3.

2/13.

2/12.

4/1.

6.

2/6.

5/1.

7.

8.

5/3.

10.

9.

4/2.

5/2.

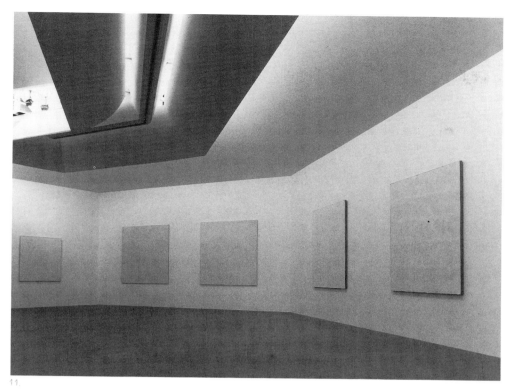

11.

4/4.

12.

4/3.

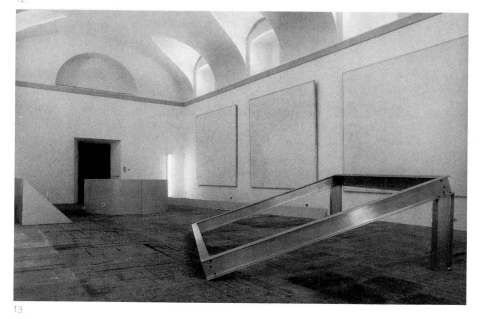

13.

14

19/1.

4/5.

15.

17/2.

17/1.

16.

18.

20.

20. *General Painting*, 1971. RRY 22
21. *Standard nos. 1-2-3-4-5-6-8-9-10-11-12-13*, 1967. RRY
22. *Lithograph*, 1971. RRY 31
23. *Impex*, 1968. RRY 4

21.

19/3.

22.

23.

19/2.

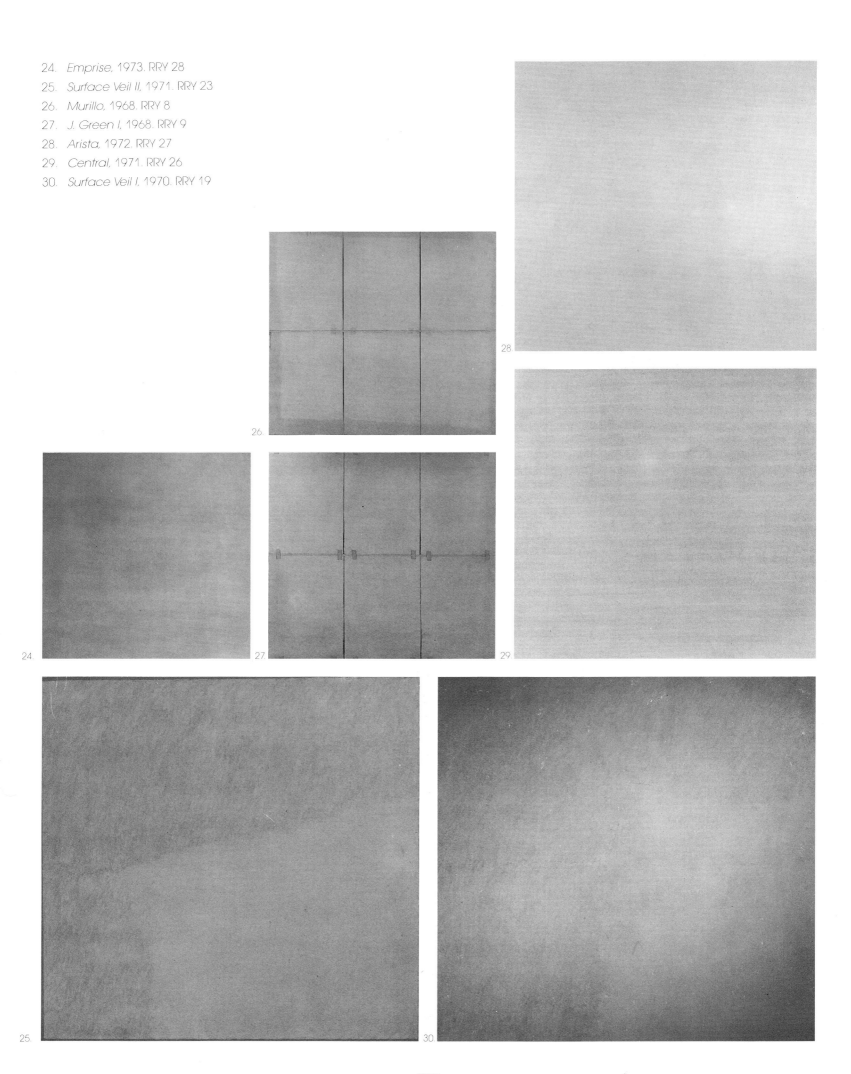

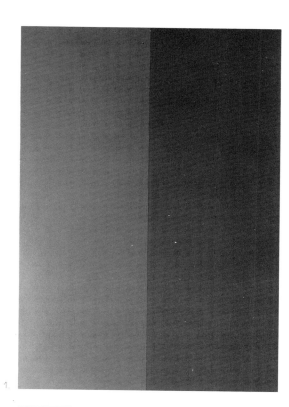

BRICE MARDEN

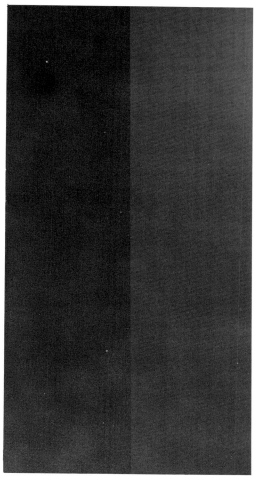

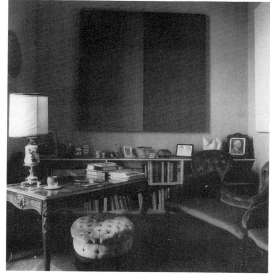

1

2

3

4

5

6

7

8

9

ROBERT MANGOLD

1. *Circle Painting 6 (Dark-red), 1973. RMA 8*
2. *Square Within a Square (Warm-green), 1974. RMA 28*
3. *Distorted Square Circle 7 (Green), 1973. RMA 13*
4. *Square Within a Rectangle (Blue-Grey), 1974. RMA 27*
5. *Incomplete Circle no. 1 (Yellow), 1972. RMA 3*
6. *Untitled (Brown), 1973. RMA 16*
7. *Square Within a Rectangle I (Orange), 1974. RMA 26*
8. *Incomplete Circle no. 2 (Brown), 1972. RMA 4*
9. *Distorted Square Circle 10 (Grey-blue), 1973. RMA 12*
10. *Circle In and Out of a Polygon II (Blue), 1973. RMA 17*
11. *Circle Painting 2 (Grey-violet), 1973. RMA 6*
12. *Distorted Square Within a Circle 2 (Violet), 1973. RMA 30*
13. *Distorted Square Within a Circle 3 (Grey-green), 1973. RMA 31*
14. *Square Within a Square (Yellow), 1974. RMA 25*

15.

16.

17.

18.

19.

20.

21.

LOUIS CANE

1. *Dark Blue Canvas*, March 16, 1973. LC 7
2. *Red Canvas*, May 15-16, 1973. LC 8

1.

2.

BERNARD JOUBERT

1. *Work*, 1974. BJ 1
3. *Work*, 1974. BJ 2
2. *Work*, 1974. BJ 3

1.

2.

3.

ENEA FERRARI

Untitled, 1945. EF1

Site Sculpture Project
Times Square Circle Shape
New York City

8 sites (A through H) were located approximately

4000' from central point (Y) so as to describe the

shape of a circle. A 1" diameter self adhering paper

sticker was placed at each site as a marker.

I

Locations

A. West 57th Street at Seventh Avenue

B. Park Avenue near 53rd Street

C. East 42nd Street at Third Avenue

D. East 32nd Street near Park Avenue

E. West 28th Street at Seventh Avenue

F. West 32nd Street at Tenth Avenue

G. West 42nd Street near Eleventh Avenue

H. Tenth Avenue near 53rd Street

Y. West 42nd Street at Seventh Avenue

December, 1968

Douglas Huebler (signature)

1

Duration Piece #14

Salisbury, New Hampshire

On October 7, 1968 four markers (styrofoam: 4" X 4" X 60")

were carried off into the Atlantic Ocean off Salisbury, New Hampshire

by the outgoing tide.

Twelve photographs taken at one minute intervals documented

the event and join with this statement to constitute the form of the

piece.

Douglas Huebler (signature)

October, 1968

2

DOUGLAS HUEBLER

3/1.

3/2.

Location Piece # 6

Los Angeles, California

During late February, 1969 two persons, visiting California
on other business, assisted the artist in making this piece by
placing markers (1" diameter self adhering paper stickers) at
eight different locations..and documenting each "marking" by
photographing the site.

No structuring system was used other than that the markers were
placed wherever and whenever it occured to either one of the two
persons to do so.

The eight photographs of the locations, not identified other-
wise, join with this statement to constitute the form of this
piece.

Douglas Huebler

March, 1969 Douglas Huebler

4.

3/3.

Variable Piece #4
New York City

On November 23, 1968 ten photographs were made with
the camera pointed west on 42nd Street in New York City.

With his eyes completely closed the photographer sat
on the corner of Vanderbilt Avenue ; each photograph was
made at the instant that the sound of traffic approaching
42nd Street stopped enough to suggest that pedestrians
could cross the street.

This statement and the ten photographs join together to
constitute the form of this piece.

Douglas Huebler

November, 1968 Douglas Huebler

3.

3/4.

Duration Piece #12

Venice, California - Plum Island, (Newburyport) Massachusetts

In March, 1969 a small quantity of sand was removed from
the ocean beach at Venice, California and taken to the ocean beach
at Plum Island, Massachusetts.

There it was placed where it would be carried into the
Atlantic Ocean by the outgoing tide. A similar quantity of sand was,
at that time, removed from the Plum Island location and taken
(May 1969) to Venice where it, in turn, was carried into the Pacific
Ocean.

Another exchange will mark the same sites in 1979 and so
on: once every ten years until a total of eleven markings have been
made at which time (2069) the piece will be complete. (It will be the
responsibility of the owner to arrange for the next ten such exchanges).

One photograph of each site and this statement constitute the
form of this piece.

May, 1969 *Douglas Huebler*

5.

Location Piece #9

New England

On Sunday afternoon March 23, 1969, eleven photographs were made to
document a ten mile drive through the New England landscape.

The "cue" for each photograph was taken from the mileage shown
on the speedometer (regardless of the speed of the automobile) as the
ten miles were traveled.

Six photographs were made at even mileage numbers (the camera
being directed "into" the landscape) and five photographs were at uneven
numbers (the camera being directed at an angle of approximately 45° to
the side of the automobile window).

The photographs with no further identification join with this statement
to constitute the form of this piece.

Douglas

March, 1969

6.

Location Piece #1

New York - Los Angeles

In February, 1969 the airspace over each of the thirteen states
between New York and Los Angeles was documented by a photograph
made as the camera was pointed more or less straight out the airplane
window (with no "interesting" view intended).

The photographs join together the east and west coast of the
United States as each serves to "mark" one of the thirteen states
flown over during that particular flight.

The photographs are not, however, "keyed" to the state over
which they were made, but only exist as documents that join with an
American Airlines System Map and this statement to constitute the
form of this piece.

Douglas Huebler

February, 1969

7.

Duration Piece #16

Global

This piece is designed to begin on the occasion of the death of its owner and continue from that time into infinity. The owner himself will enter into an authentic physical existence that will actually constitute the work. The owner must satisfy the following conditions.

1. Necessarily a male he must otherwise meet every qualification established for donors to 'banks' that create human life through artificial insemination.

2. He will arrange to have his spermatozoid in an amount sufficient to successfully inseminate ten willing young women as soon as possible after his mortal existence ceases.

3. He must establish an estate whose executor will administer the selection of mothers and payment, from an appropriate trust fund, of $2,500 a year to each for 21 years at which time the entire principal remaining in trust will be divided equally between each offspring.

This statement constitutes the form of this piece from this time until the death of the owner.

Douglas Huebler

December 1969

8.

Duration Piece # 4

Paris, France

12 photographs were made as the documentation of a system of "time" in which each successive stage is a reduction, by one half, of the previous time: one full hour of Greenwich mean time is approached, but impossible to be reached, at the same time that linear distance is described to the extent that physical, not theoretical, possibilities for further stages of documentation of the system are exhausted.

The first photograph was made on January 7, 1970 at the randomly selected intersection of Boulevard Montmarte and Rue de Richelieu with the camera directed towards infinity along Rue de Richelieu. That direction was then walked for 30 minutes and then a 90° right turn was made. Another photograph was taken towards "infinity" and that direction was walked for 7 minutes and 30 seconds: the next after 3 minutes, 45 seconds and so on through .0087 seconds. At that time, (at a location in Jardin des Tuileries), 58.3877 minutes having passed, the final photograph was made, thereby completing the piece.

(Obviously it was possible to increase or decrease the speed of the "walks" in order not to confront a physical obstacle at the instant of the "right turn.")

The 12 photographs and this statement constitute the form of this piece.

January 1970 Douglas Huebler

11.

Location Piece #23

Los Angeles - Cape Cod

For each day of the week beginning Monday August 11, 1969 and ending Saturday August 16, 1969 the exact dimensions of the gallery floor at ACE, Los Angeles, California will be "marked" onto a different physical location existing on Cape Cod, Massachusetts. Having been transposed in that manner the virtual physical substance of the area so marked will exist, for one day, within the actual space contained by the walls at ACE.

The photographs of the general area of each location on Cape Cod may be seen at ACE during the week of August 11. The actual marking of each location will be done in the morning on the date set by the following schedule.

Date	Location	Marker Material
1. August 11	Longnook Beach, Truro	Pebbles
2. August 12	Provincetown	3/4" Paper Stickers
3. August 13	Ballston Beach, Truro	6" Wood Stakes
4. August 14	Truro	6" Wood Stakes
5. August 15	Provincetown	3/4" Paper Stickers
6. August 16	Pamet River, Truro	6" Wood Stakes

As there is a 3 hour time differential between Cape Cod and Los Angeles a visitor at ACE in the late afternoon will be experiencing a location that is in near darkness.

A map of Cape Cod, this statement and 6 photographs constitute the form of this piece.

August, 1969 *Douglas Huebler*

9.

Variable Piece # 4

Paris, France

On January 7, 1970 a point was inscribed, (with a ball point pen), somewhere within the general location described by the photograph that accompanies this statement; the location of that point establishes the initial "step" of the piece.

It will be the responsibility of the owner of this piece to design, and execute, every aspect of a system that will actually complete the piece. Duration in "time" or location space, or both, will structure, logically or randomly, the form of the system.

The initial location was selected arbitrarily and is documented by the photograph mentioned above, as well as a map, but neither necessarily needs to be included in the final documentation of the piece.

The work on the piece should begin within 60 days from the time that its owner acquires it: its actual completion may occur any time thereafter.

All pieces within this series (10 altogether - Paris, 1970) may, at some future time, be brought back into one situation, if the owners agree, to be published or exhibited, or both.

The photograph, this statement and the map constitute the form of the piece until such time as they are joined by an indeterminate number of other documents that will accumulate within the system established by the owner for its completion.

Douglas Huebler

January 1970

12.

Location Piece # 8

Bradford, Massachusetts

In April, 1969 a memorandum (facsimile below) was sent to the approximately 400 girls who form the student body of Bradford Junior College.

On May 25, 1969 the ashes of 63 secrets were all mixed together and that mixture scattered in a random manner throughout the campus.

This statement and the facsimile of the original memorandum constitute the form of this piece.

Douglas Huebler

May, 1969 Douglas Huebler

Memorandum

Bradford Junior College
Bradford, Massachusetts

To: All students
From: Mr. Huebler
Re: A secret

I need to use an important secret of yours in order to complete a project on which I am working.

Simply write it down and then burn the paper on which it is written in on ashtray, seal the ashes in an envelope addressed to me and have it put into my faculty mail box.

I will complete the project by combining all ashes so returned into one mixture and then scattering it randomly throughout the campus.

10.

Location Piece # 10

Bradford, Massachusetts - Los Angeles, California

On May 13, 1969 a Five Dollar United States Federal Reserve Note was mailed in a clear vinyl envelope from Bradford, Massachusetts to ACE, Los Angeles, California to be used, (if actually received) as a piece for a scheduled "Currency" exhibition.

Correspondence from ACE June 17, 1969.

"Received the $5.00 bill but the Xeroxed copy was seized at the border when I entered Canada. Federal offence for copying American currency. It will be released at the end of this week.

Show should be in Sept - Oct".

Correspondence from ACE December 11, 1969.

"Many kind thanks for your work Location Piece # 10. Due to circumstances our currency show has been cancelled".

This statement, the envelope with the $5.00 Note and one Xerox copy of both sides of the envelope constitute the final form of this piece.

Douglas Huebler

Douglas Huebler

December, 1969

13.

Duration Piece # 9

Berkeley, California - Hull, Massachusetts

On January 9, 1969 a clear plastic box measuring 1" x 1" x ¾" enclosed within a slightly larger cardboard container that was sent by registered mail to an address in Berkeley, California. Upon its return as "undeliverable" it was left altogether intact and enclosed within another slightly larger container and sent again on registered mail to Riverton, Utah and once again returned to the sender as "undeliverable". Similarly another container enclosing all previous containers was sent to Ellsworth, Nebraska; similarly to Alpha, Iowa; similarly to Tuscola, Michigan; similarly and finally to Hull, Massachusetts which accomplished the "marking" of a line joining the two coasts of the United States during a period of nine weeks of time.

That final container, all registered mail receipts, and a map join with this statement to form the system of documentation that completes this work.

January, 1969

The above statement was printed in the catalog for When Attitudes Become Form (Kunsthalle, Bern, 22.3.-27.4. 1969).

In some unknown manner the container had lost its outer three layers when returned to the artist whereupon it was once again enclosed and sent by registered mail to Alpha, Iowa and Tuscola, Michigan and to Hull, Massachusetts (by certified mail) and its return from there completed, once again, the destiny of its design after nearly ten months of time had elapsed.

The container, the three additional mail receipts join with the earlier receipts and this revised statement to constitute the final form of this piece.

Douglas Huebler

October, 1969 Douglas Huebler

14.

LE POINT REPRÉSENTÉ CI-DESSUS SEMBLE POUR UN INSTANT ATTIRER ET FIXER CHAQUE ET TOUT AUTRE POINT SITUÉ DANS L'ESPACE "PHYSIQUE" DE CETTE SALLE . CETTE IMPRESSION CONTINUE A ÉVOLUER EN SÉQUENCES RÉGULIÈRES PENDANT TOUTE LA DURÉE DE LA PRÉSENCE DE L'OBSERVATEUR DANS LA SALLE MAIS CESSE IMMÉDIATEMENT D'EXISTER LORSQUE CE DERNIER EST PARTI.

THE POINT REPRESENTED ABOVE DRAWS ONTO ITSELF AND FIXES, FOR AN INSTANT, EACH AND EVERY OTHER POINT LOCATED WITHIN THE PHYSICAL SPACE OF THIS ROOM AND CONTINUES TO DO SO, IN A SEQUENTIAL PROCESS FOR THE ENTIRE TIME THAT THE PERCIPIENT REMAINS IN THE ROOM BUT IMMEDIATELY CEASES TO EXIST AT ALL WHEN THE PERCIPIENT HAS DEPARTED.

15 16

17. 18.

Variable Piece #49

Bradford, Massachusetts - New York City

On March 13, 1971 over 650 photographs were made that, altogether, document the entire visual appearance in the particular path of travel taken by the artist on a trip between his house in Bradford and the Castelli Gallery in New York.

In each case the photograph was made at the 'point' (on the highway or road) in the direction of travel that was as far as his eye could see; when that point was reached another photograph was made, etc.

For this work one view has been selected as the most 'boring' and its enlargement joins 20 proof prints, a map and this statement to constitute the form of this piece. (The owner may select an alternative 'boring' view for enlargement if he prefers.)

Douglas Huebler

March 1971

Duration Piece # 5
Amsterdam, Holland

12 photographs were made as the documentation of a system of "time" in which each successive stage is a reduction, by one half, of the previous time: one full hour of Greenwich mean time is approached, but impossible to be reached, at the same time that linear distance is described to the extent that physical, not theoretical, possibilities for further stages of documentation of the system are exhausted.

The first photograph was made on January 12, 1970 at the randomly selected intersection of Haarstraat, ter 14, and Bilderdijkstraat 14, with the camera directed towards infinity along Bilderdijkstraat 14. That direction was then walked for 30 minutes and then a 90° right turn was made. Another photograph was taken towards "infinity" and that direction walked for 15 minutes, after which another right turn was made. Another photograph was taken towards "infinity" and that direction walked for 7 minutes and 30 seconds; the next after 3 minutes, 45 seconds and so on through .0087 seconds. At that time, (at a location in Vondel Park), 58.3877 minutes having passed, the final photograph was made, thereby completing the piece.

(Obviously it was possible to increase or decrease the speed of the "walks" in order not to confront a physical obstacle at the instant of the "right turn.")

The 12 photographs and this statement constitute the form of this piece.

January 1970 Douglas Huebler

CETTE SURFACE REFLÈTE À CET INSTANT MÊME LE CHANGEMENT IMPERCEPTIBLE DE L'ESSENCE PHYSIQUE DE L'OBSERVATEUR.

THIS SURFACE IS, AT THIS INSTANT, REFLECTING THE IMPERCEPTIBLY CHANGING PHYSICAL ESSENCE OF ITS PERCIPIENT.

20. 19. 16/A

SOL LEWITT

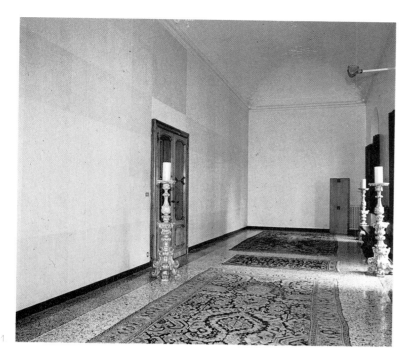

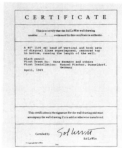

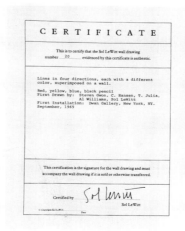

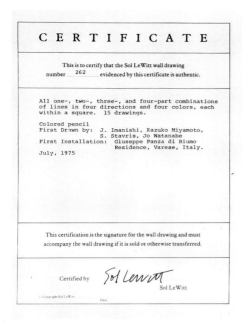

7.

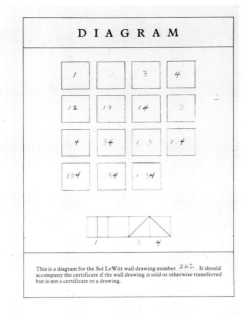

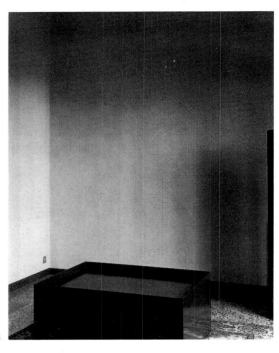

8.

3/A.

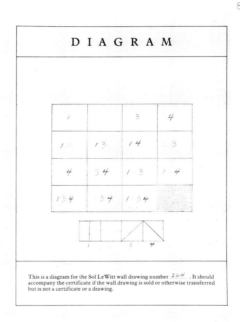

9.

1/A.

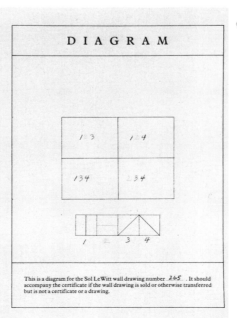

10.

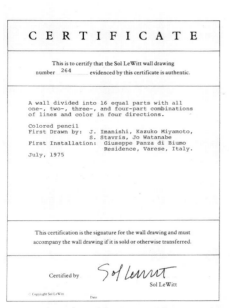

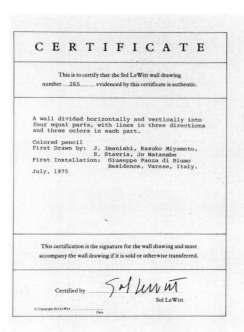

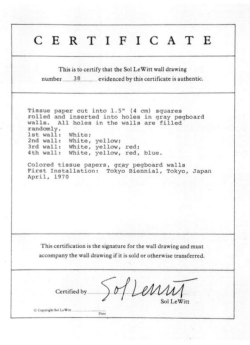

11.

2/1.

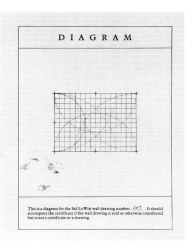

2/2.

12/3.

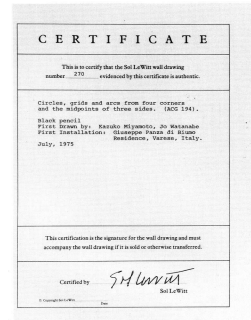
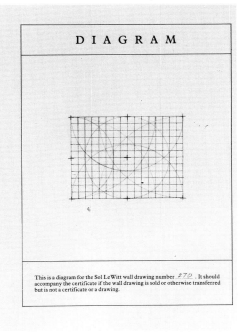
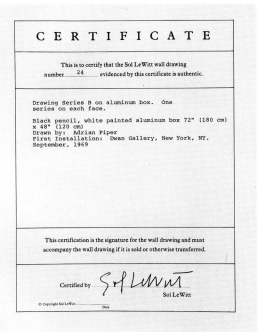

12/4.

4/A

CERTIFICATE

This is to certify that the Sol LeWitt wall drawing
number 151 evidenced by this certificate is authentic.

All combinations of a single line in four
directions. (15 parts).

Black crayon
First Drawn by: Jo Watanabe, Sol LeWitt
First Installation: John Weber Gallery, New York,
NY.

January, 1973

This certification is the signature for the wall drawing and must
accompany the wall drawing if it is sold or otherwise transferred.

Certified by _____ Sol LeWitt

© Copyright Sol LeWitt _____ Date

DIAGRAM

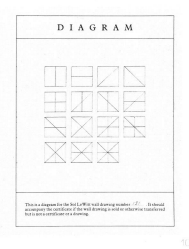

This is a diagram for the Sol LeWitt wall drawing number 151. It should
accompany the certificate if the wall drawing is sold or otherwise transferred
but is not a certificate or a drawing.

CERTIFICATE

This is to certify that the Sol LeWitt wall drawing
number 271 evidenced by this certificate is authentic.

Black circles, red grid, yellow arcs from
four corners, blue arcs from the midpoints
of four sides. (ACG 195).

Colored pencil
First Drawn by: J. Imanishi, Kazuko Miyamoto,
S. Stavris, Jo Watanabe
First Installation: Giuseppe Panza di Biumo
Residence, Varese, Italy.

July, 1975

This certification is the signature for the wall drawing and must
accompany the wall drawing if it is sold or otherwise transferred.

Certified by _____ Sol LeWitt

© Copyright Sol LeWitt _____ Date

DIAGRAM

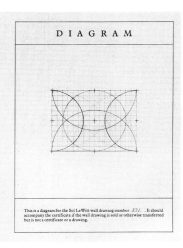

This is a diagram for the Sol LeWitt wall drawing number 271. It should
accompany the certificate if the wall drawing is sold or otherwise transferred
but is not a certificate or a drawing.

CERTIFICATE

This is to certify that the Sol LeWitt wall drawing
number 266 evidenced by this certificate is authentic.

Two-part drawing: Grid and arcs from two
adjacent corners and the midpoint of one side,
between. (ACG 118) One drawing has arcs from
the bottom. The second drawing has arcs from
the top.

Black pencil
First Drawn by: Kazuko Miyamoto, Jo Watanabe
First Installation: Giuseppe Panza di Biumo
Residence, Varese, Italy.

July, 1975

This certification is the signature for the wall drawing and must
accompany the wall drawing if it is sold or otherwise transferred.

Certified by _____ Sol LeWitt

© Copyright Sol LeWitt _____ Date

DIAGRAM

This is a diagram for the Sol LeWitt wall drawing number 266. It should
accompany the certificate if the wall drawing is sold or otherwise transferred
but is not a certificate or a drawing.

CERTIFICATE

This is to certify that the Sol LeWitt wall drawing
number 152 evidenced by this certificate is authentic.

Three-part Drawing: 1st Wall: Straight
horizontal lines. 2nd Wall: Not straight
horizontal lines. 3rd Wall: Broken
horizontal lines. The lines are about two-
inches (5 cm) apart.

Black pencil
First Drawn by: Kazuko Miyamoto
First Installation: Rosa Esman Gallery,
New York, NY.

January, 1973

This certification is the signature for the wall drawing and must
accompany the wall drawing if it is sold or otherwise transferred.

Certified by _____ Sol LeWitt

© Copyright Sol LeWitt _____ Date

DIAGRAM

This is a diagram for the Sol LeWitt wall drawing number 152. It should
accompany the certificate if the wall drawing is sold or otherwise transferred
but is not a certificate or a drawing.

CERTIFICATE

This is to certify that the Sol LeWitt wall drawing
number 176 evidenced by this certificate is authentic.

A horizontal line from the left side
(more than half way, less than all the
way).

Red crayon
First Drawn by: Sara Slavin, Paul Toner
First Installation: John Weber Gallery,
New York, NY.

May, 1973

This certification is the signature for the wall drawing and must
accompany the wall drawing if it is sold or otherwise transferred.

Certified by _____ Sol LeWitt

© Copyright Sol LeWitt _____ Date

DIAGRAM

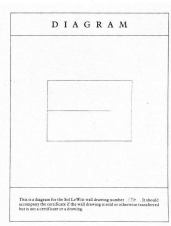

This is a diagram for the Sol LeWitt wall drawing number 176. It should
accompany the certificate if the wall drawing is sold or otherwise transferred
but is not a certificate or a drawing.

CERTIFICATE

This is to certify that the Sol LeWitt wall drawing

number ___150___ evidenced by this certificate is authentic.

Ten thousand one-inch (2.5 cm) lines evenly
spaced on each of six walls.

Black pencil
First Drawn by: S. Kato, Kazuko Miyamoto,
Ryo Watanabe

First Installation: Finch College, New York, NY.
October, 1972

This certification is the signature for the wall drawing and must
accompany the wall drawing if it is sold or otherwise transferred.

Certified by _____ Sol LeWitt

© Copyright Sol LeWitt _____ Date

CERTIFICATE

This is to certify that the Sol LeWitt wall drawing
number 54 evidenced by this certificate is authentic.

Six-part serial drawing with lines in two
directions (vertical, horizontal, diagonal left-,
or diagonal-right) and two colors superimposed
in each part.

Red, yellow, blue, black pencil
First Drawn by: B. Geest, G. Jones, P. de Jong,
E. Scheffer, F. Staverman, Sol LeWitt
First Installation: Gemeentemuseum, The Hague,
Holland

July, 1970

This certification is the signature for the wall drawing and must
accompany the wall drawing if it is sold or otherwise transferred.

Certified by _____ Sol LeWitt

© Copyright Sol LeWitt _____ Date

DIAGRAM

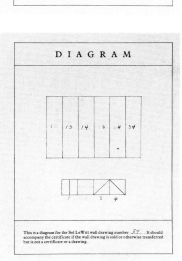

This is a diagram for the Sol LeWitt wall drawing number 54. It should
accompany the certificate if the wall drawing is sold or otherwise transferred
but is not a certificate or a drawing.

CERTIFICATE

This is to certify that the Sol LeWitt wall drawing number ___52___ evidenced by this certificate is authentic.

Four-part drawing with a different line direction and color in each part.

Red, yellow, blue, black pencil
First Drawn by: B. Geest, G. Jones, P. de Jong,
 E. Scheffer, F. Staverman, Sol LeWitt
First Installation: Gemeentemuseum, The Hague,
 Holland
July, 1970

This certification is the signature for the wall drawing and must accompany the wall drawing if it is sold or otherwise transferred.

Certified by Sol LeWitt

© Copyright Sol LeWitt Date

18

DIAGRAM

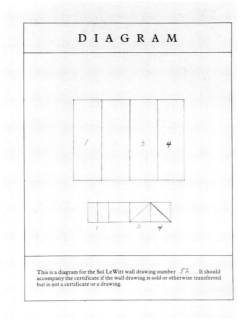

This is a diagram for the Sol LeWitt wall drawing number _52_. It should accompany the certificate if the wall drawing is sold or otherwise transferred but is not a certificate or a drawing.

CERTIFICATE

This is to certify that the Sol LeWitt wall drawing number ___53___ evidenced by this certificate is authentic.

Serial drawing with lines in three directions (vertical, horizontal, diagonal-left or diagonal-right) and three colors superimposed in each part.

Red, yellow, blue, black pencil
First Drawn by: B. Geest, G. Jones, P. de Jong,
 E. Scheffer, F. Staverman, Sol LeWitt
First Installation: Gemeentemuseum, The Hague,
 Holland
July, 1970

This certification is the signature for the wall drawing and must accompany the wall drawing if it is sold or otherwise transferred.

Certified by Sol LeWitt

© Copyright Sol LeWitt Date

19

DIAGRAM

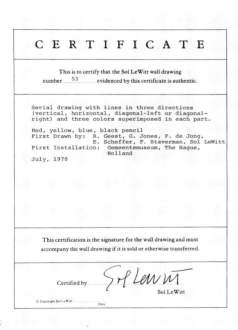

This is a diagram for the Sol LeWitt wall drawing number _53_. It should accompany the certificate if the wall drawing is sold or otherwise transferred but is not a certificate or a drawing.

CERTIFICATE

This is to certify that the Sol LeWitt wall drawing number ___272___ evidenced by this certificate is authentic.

An increasing number of horizontal lines about one inch (2.5 cm) apart from bottom to top, vertical lines from top to bottom, diagonal right lines from left to right, diagonal left lines from right to left.

Black pencil
First Drawn by: J. Imanishi, Kazuko Miyamoto
 S. Stavris, Jo Watanabe
First Installation: Giuseppe Panza di Biumo
 Residence, Varese, Italy.
July, 1975

This certification is the signature for the wall drawing and must accompany the wall drawing if it is sold or otherwise transferred.

Certified by Sol LeWitt

© Copyright Sol LeWitt Date

8/A

CERTIFICATE

This is to certify that the Sol LeWitt wall drawing number ___37___ evidenced by this certificate is authentic.

Intersecting symmetrical bands of parallel lines 36" (90 cm) wide, in four directions and colors, on four walls progressively.

Red, yellow, blue, black pencil
First Drawn by: Betts and others
First Installation: La Jolla Museum of Contemporary
 Art, La Jolla, CA.
April, 1970

This certification is the signature for the wall drawing and must accompany the wall drawing if it is sold or otherwise transferred.

Certified by Sol LeWitt

© Copyright Sol LeWitt Date

20

DIAGRAM

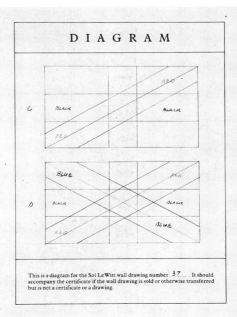

This is a diagram for the Sol LeWitt wall drawing number _37_. It should accompany the certificate if the wall drawing is sold or otherwise transferred but is not a certificate or a drawing.

DIAGRAM

This is a diagram for the Sol LeWitt wall drawing number _37_. It should accompany the certificate if the wall drawing is sold or otherwise transferred but is not a certificate or a drawing.

1.

LEO CASTELLI INC

4 EAST 77 ST • NEW YORK 100.

Dr. Giuseppe Panza
Milan, Italy

17 April 1973

NO.

ROBERT BARRY	9	IT CAN ONLY BE KNOWN AS SOMETHING ELSE 1969	
			$1,800.00
	33	UNTITLED SLIDE PIECE 1972	
		81 35mm slides	
		40 slides with text	
		41 blank slides	$1,800.00
		total:	$3,600.00

BUTTERFIELD 8-4820

2.

A part of a piece.

It could be with other things, or it could be alone. It could be part of something else and be dependent on it. It can be distinguished from other things and it could effect them.

It has some variety and an origin.

It has been arranged, but it could be changed. It is interrelated. It has some continuity, possibilities and limitations.

It can be appreciated, defended and repeated. It can also be avoided, isolated, restricted, removed, replaced and destroyed.

It has been influenced. So far it has been preserved.

It may seem familiar or strange or uncertain. It might be discussed, being rejected or accepted. It is vulnerable.

Robert Barry

1972

3.

4.

BASIC FORMAT FOR
WIRE INSTALLATION
FLOOR TO CEILING
90° ANGLE
SIDE VIEW
R. BARRY '68

5.

CEILING

STEEL DISC
SUSPENDED ⅛"
ABOVE FLOOR.
R. BARRY '67

FLOOR

6.

RADIATION INSTALLATION; CESIUM-137
1969

MUST BE INSTALLED OUTSIDE.
(EXAMPLE: ON ROOF
IN PARK
BURIED UNDERGROUND
IN FOREST, MOUNTAIN
IN THE NO...)

R.B.

7.

CEILING

BASIC FORMAT FOR
HANGING STRING
PIECE.
R. BARRY '68

FLOOR

Leo Castelli

8 July 1976

Dr. Giuseppe Panza
Corso di Porta Romana 78-1
Milano 20122
Italy

Dear Dr. Panza,

Robert Barry has asked me to respond to your letter to him
of 7 June. He has been out of town for several weeks and
just now received it.

The following Barry pieces were sent to you in Zurich in
March of this year:
Refrain (LC#45)
Appearances (LC # 40)
Untitled drawing (LC#D-10)

The "It is always changing piece" is titled Art Work, 1970
(LC # 36) and the complete text is
It is always changing.
It has order.
It doesn't have a specific place.
It affects other things.
It may be accessible but go unnoticed.
Part of it may also be part of something else.
Some of it is familiar.
Some of it is strange.
Knowing of it changes it.

The documentation for the piece is a framed page from the
catalogue of the "Information" show at the Museum of Modern
Art, New York, 1970. It was sent to you along with the other
works to Zurich.

The two other works you ask about - "Something which is unknown
to me" and "Something that is searching for me" belong to Paul
Maenz. When this was discovered, you took the slide piece
"Refrain" and the untitled drawing instead.

I hope this clears up your questions. If you need any
further information, let me know.

Sincerely,

Janelle Reiring
420 West Broadway New York 10012 Telephone (212) 431-5160

8.

9

10.

11.

12

13

219

HANNE DARBOVEN

1. *45 Drawings, 1971-1972,* HD 6
2. *51 Drawings, 1971-1972,* HD 4
3. *43 Drawings, 1971-1972,* HD 5
4. *Drawings nos. 1-2-3, 1972,* HD 3
5. *Index: 17k-58k, 1969,* HD 7
6. *27k - No 8 - No 26, 1968-1969,* HD 9

7/1.

7/2.

7/3.

8/1.

9/1.

8/2.

9/2.

10/1.

10/2.

222

11/1.

11/2.

12/1.

11/3

13/1

12/2

13/2

14

15/1

manuscarborn / 1972 / 1973 / Cordner: 1

15/2

manuscarborn / 1972 / 1973 / Cordner: 2

16/1

$$2)\ 1 \times 14\ \ 2 \times 15\ \ 3 \times 16\ \ 4 \times 17\ \ 5 \times 18\ \ \ F:15 \times 15$$
$$14 + 15 + 16 + 17 + 18 = 80$$

14 15 15 16 16 17 17 17 18 18 18 18 18 18
14 15 15 16 16 17 17 17 18 18 18 18 18 18
14 15 15 16 16 17 17 17 18 18 18 18 18 18
14 15 15 16 16 17 17 17 18 18 18 18 18 18
14 15 15 16 16 17 17 17 18 18 18 18 18 18
14 15 15 16 16 17 17 17 18 18 18 18 18 18
14 15 15 16 16 17 17 17 18 18 18 18 18 18
14 15 15 16 16 17 17 17 18 18 18 18 18 18
14 15 15 16 16 17 17 17 18 18 18 18 18 18
14 15 15 16 16 17 17 17 18 18 18 18 18 18
14 15 15 16 16 17 17 17 18 18 18 18 18 18
14 15 15 16 16 17 17 17 18 18 18 18 18 18
14 15 15 16 16 17 17 17 18 18 18 18 18 18
14 15 15 16 16 17 17 17 18 18 18 18 18 18

14 14 14 14 14 14 14 14 14 14 14 14 14 14
15 15 15 15 15 15 15 15 15 15 15 15 15 15
16 16 16 16 16 16 16 16 16 16 16 16 16 16
16 16 16 16 16 16 16 16 16 16 16 16 16 16
17 17 17 17 17 17 17 17 17 17 17 17 17 17
17 17 17 17 17 17 17 17 17 17 17 17 17 17
17 17 17 17 17 17 17 17 17 17 17 17 17 17
18 18 18 18 18 18 18 18 18 18 18 18 18 18
18 18 18 18 18 18 18 18 18 18 18 18 18 18
18 18 18 18 18 18 18 18 18 18 18 18 18 18
18 18 18 18 18 18 18 18 18 18 18 18 18 18
18 18 18 18 18 18 18 18 18 18 18 18 18 18

$$+, I, 14, 15, 16, 17, 18,$$
$$[II, III, IV, V]$$

indexzeichnung—1—, 1, 2, 3, F : 15 X 15
1) —/ 2, —/ 3, —5/

1X
2X
3X
4X
5X

—1—
1, 2, 3,

K : 15 X 15 = 225 : 5 = 45
—1—/I

ERSTES BUCH

ZUSAMMENFASSUNG

2 2 2 2 2 2 2 2 2 2 2 2 2 2 2 2 2 2 2
61 60 59 58 57 56 55 54 53 52 51 50 49 48 47 46 45 44 43

ZWEI-EINUNDSECHZIG/ZWEI-SECHZIG/ZWEI-NEUNUNDFÜNFZIG/
ZWEI-ACHTUNDFÜNFZIG/ZWEI-SIEBENUNDFÜNFZIG/ZWEI-SECHS
UNDFÜNFZIG/ZWEI-FÜNFUNDFÜNFZIG/ZWEI-VIERUNDFÜNFZIG/Z
WEI-DREIUNDFÜNFZIG/ZWEI-ZWEIUNDFÜNFZIG/ZWEI-EINUNDFÜ
NFZIG/ZWEI-FÜNFZIG/ZWEI-NEUNUNDVIERZIG/ZWEI-ACHTUND
VIERZIG/ZWEI-SIEBENUNDVIERZIG/ZWEI-SECHSUNDVIERZIG/ZW
EI-FÜNFUNDVIERZIG/ZWEI-VIERUNDVIERZIG/ZWEI-DREIUNDVI
ERZIG

2 eins zwei
 eins zwei drei vier fünf sechs sieben acht neun zehn
 elf zwölf dreizehn vierzehn fünfzehn sechzehn siebze
 hn achtzehn neunzehn zwanzig einundzwanzig zweiundzw
 anzig dreiundzwanzig vierundzwanzig fünfundzwanzig s
 echsundzwanzig siebenundzwanzig achtundzwanzig neunu
 ndzwanzig dreissig einunddreissig zweiunddreissig dr
 eiunddreissig vierunddreissig fünfunddreissig sechsu
 nddreissig siebenunddreissig achtunddreissig neunund
 dreissig vierzig einundvierzig zweiundvierzig dreiun
 dvierzig vierundvierzig fünfundvierzig sechsundvierz
 ig siebenundvierzig achtundvierzig neunundvierzig fü
 nfzig einundfünfzig zweiundfünfzig dreiundfünfzig vi
 erundfünfzig fünfundfünfzig sechsundfünfzig siebenun
 dfünfzig achtundfünfzig neunundfünfzig sechzig einun
 dsechzig 61
2 eins zwei
 eins zwei drei vier fünf sechs sieben acht neun zehn
 elf zwölf dreizehn vierzehn fünfzehn sechzehn siebze
 hn achtzehn neunzehn zwanzig einundzwanzig zweiundzw
 147

ZWEIUNDZWANZIGSTES BUCH

ZUSAMMENFASSUNG

23 23 23 23 23 23 23 23 23 23 23 23 23 23 23 23 23 23 23
 / / / / / / / / / / / / / / / / / / /
40 39 38 37 36 35 34 33 32 31 30 29 28 27 26 25 24 23 22

DREIUNDZWANZIG-VIERZIG/DREIUNDZWANZIG-NEUNUNDDREISSI
G/DREIUNDZWANZIG-ACHTUNDDREISSIG/DREIUNDZWANZIG-SIEB
ENUNDDREISSIG/DREIUNDZWANZIG-SECHSUNDDREISSIG/DREIUN
DZWANZIG-FÜNFUNDDREISSIG/DREIUNDZWANZIG-VIERUNDDREIS
SIG/DREIUNDZWANZIG-DREIUNDDREISSIG/DREIUNDZWANZIG-ZW
EIUNDDREISSIG/DREIUNDZWANZIG-EINUNDDREISSIG/DREIUNDZ
WANZIG-DREISSIG/DREIUNDZWANZIG-NEUNUNDZWANZIG/DREIUN
DZWANZIG-ACHTUNDZWANZIG/DREIUNDZWANZIG-SIEBENUNDZWAN
ZIG/DREIUNDZWANZIG-SECHSUNDZWANZIG/DREIUNDZWANZIG-FÜ
NFUNDZWANZIG/DREIUNDZWANZIG-VIERUNDZWANZIG/DREIUNDZW
ANZIG-DREIUNDZWANZIG/DREIUNDZWANZIG-ZWEIUNDZWANZIG

23eins zwei drei vier fünf sechs sieben acht neun zehn
 elf zwölf dreizehn vierzehn fünfzehn sechzehn siebze
 hn achtzehn neunzehn zwanzig einundzwanzig zweiundzw
 anzig dreiundzwanzig
 eins zwei drei vier fünf sechs sieben acht neun zehn
 elf zwölf dreizehn vierzehn fünfzehn sechzehn siebze
 hn achtzehn neunzehn zwanzig einundzwanzig zweiundzw
 anzig dreiundzwanzig vierundzwanzig fünfundzwanzig s
 echsundzwanzig siebenundzwanzig achtundzwanzig neunu
 ndzwanzig dreissig einunddreissig zweiunddreissig dr
 eiunddreissig vierunddreissig fünfunddreissig sechsu
 nddreissig siebenunddreissig achtunddreissig neunund
 dreissig vierzig 40
23eins zwei drei vier fünf sechs sieben acht neun zehn
 elf zwölf dreizehn vierzehn fünfzehn sechzehn siebze
 hn achtzehn neunzehn zwanzig einundzwanzig zweiundzw
 anzig dreiundzwanzig
 137

21/1

1) 1X27 2X29 3X31 4X33 5X35 F:15X15
27+29+31+33+35=155

+, I, 27,29,31,33,35,
[I,II,III,IV,V]

20/2

index-zeichnungen: ↓→ /① →④⑤ /①/②/③

(3X5=15) K: 15X15 = 225 : 5 = 45 (1+2+3+4+5 = 15)

indices: zeichnungen: ① →④⑤

K:5 / zahl ① K:225 / zahl ④⑤

Ⓘ abschnitt 1→15 Ⓙ abschnitt 16→30 Ⓚ abschnitt 31→45

hanne darboven / 1972/1973 / (ordner: 4)

16/3

1) 1X12 2X14 3X16 4X18 5X20 F:15X15
12+14+16+18+20=80

+, I, 12,14,16,18,20,
[I,III,IV,V]

21/2

zeichnungen: ↓→ / 31 (à3) → 45 (à3) /Ⓚ abschnitt

F:15X15

K:15X15 → K:225:5 = 45

K: 155 160 165 170 175 180 185 190 195 200 205 210 215 220 225

zahl 31 32 33 34 35 36 37 38 39 40 41 42 43 44 45

hanne darboven / 1972/1973 / (ordner: 3)

22/1

Varianten-aufzeichnungen
1 → 99

(ordner: 5)

hanne darboven /1972/1973

23/1

Varianten-aufzeichnungen
1 → 99

(ordner: 6)

hanne darboven /1972/1973

24/1

Varianten-aufzeichnungen
1 → 99

(ordner: 7)

hanne darboven /1972/1973

Varianten 1, 2, 3, 4, 5, I → 1

1) K:5 1) K:5

2) K:5 2) K:5

3) K:5 3) K:5

Variante 1, Plan Variante 1, Plan

1

Varianten – Pläne

zahlen:

1 ⟶ 99

1) ↓ 1) → 1) ↓ 1) →

3) ↓ 3) → 3) ↓ 3) →

5) 50 3) 50 3) 99 3) 99

50 99

50 ⟶ ⟶ 99

(ordner : 10)

hannelenborn /1972/1973

[→1] 1, 2, 3, 4, 5, Varianten

1)	46	48	50	52	54
	46	48	50	52	54
	46	48	50	52	54
	46	48	50	52	54
	46	48	50	52	54

K:250

1)	46	46	46	46	46
	48	48	48	48	48
	50	50	50	50	50
	52	52	52	52	52
	54	54	54	54	54

K:250

2)	48	49	50	51	52
	48	49	50	51	52
	48	49	50	51	52
	48	49	50	51	52
	48	49	50	51	52

K:250

2)	48	48	48	48	48
	49	49	49	49	49
	50	50	50	50	50
	51	51	51	51	51
	52	52	52	52	52

K:250

3)	50	50	50	50	50
	50	50	50	50	50
	50	50	50	50	50
	50	50	50	50	50
	50	50	50	50	50

K:250

3)	50	50	50	50	50
	50	50	50	50	50
	50	50	50	50	50
	50	50	50	50	50
	50	50	50	50	50

K:250

1. Oct. 24, 1971, New York 1971, OK 1
2. One Millions Years, 1970-1971, OK 3
3. Oct. 26, 1971, New York 1971, OK 2
4. Oct. 29, 1971, New York 1971, OK 4

ROMAN OPALKA

1.0.260 - 464.052, 1965, RO 1

VINCENZO AGNETTI

No. March 30, 1973, VA 1

LAWRENCE WEINER

THE RESIDUE OF A FLARE
IGNITED UPON A BOUNDARY

4.

A STONE LEFT UNTURNED

1.

A STAKE SET IN THE GROUND IN DIRECT LINE
WITH A STAKE SET IN THE GROUND
ON AN ADJACENT COUNTRY

5.

OVER AND OVER . OVER AND OVER
AND OVER AND OVER . AND OVER AND OVER

2.

ONE KILOGRAM OF LACQUER
POURED UPON A FLOOR

6.

SMUDGED

3.

FLUSHED

7.

JAN DIBBETS

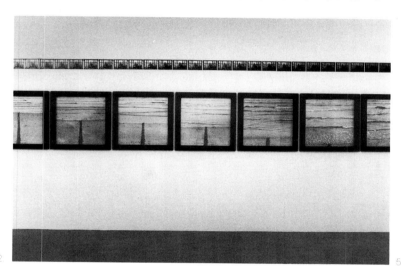

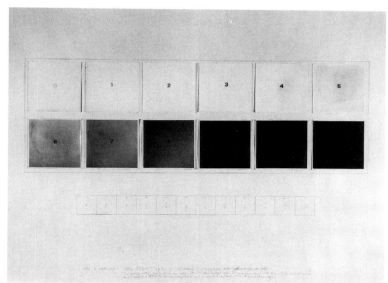

CIONI CARPI

3

TRASFIGURAZIONE / SPARIZIONE DUE.

1.

5.

2.

3.

6/9

6/1

6/2

4.

6/3.

6/4.

6/6.

6/5.

6/7.

6/8.

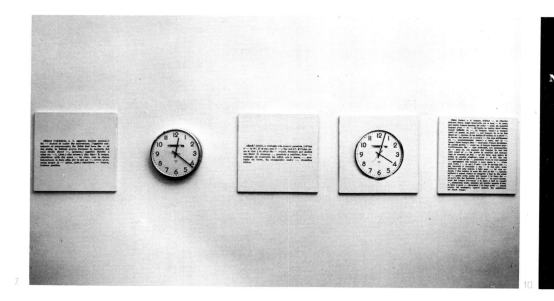

Nothing [ˈnʌθɪŋ]. I. *pron.* & *s.* nichts; das Nichts, die Kleinigkeit; (nought) die Null (also *fig.*); (*pl.*) Nichtigkeiten; — but, — else than, nur, lediglich; no —! rein garnichts, nicht so viel; — of a gentleman, feineswegs ein feiner, gebildeter Herr; **1.** (*with verbs*) be —, an nichts glauben (*Rel.*); there is — in it, das hat nichts auf sich; that is — to me, das ist mir ganz gleichgültig; he is — to us, er steht uns in keiner Beziehung nahe; he does — but..., er tut nichts als...; it will come to —, daraus wird nichts; (*coll.*) — doing, nichts zu machen, umsonst, nichts los; feel like — on earth, sich hundeelend fühlen; make — of, sich (*Dat.*) nichts aus (einer Sache) machen; nichts mit (einer S.) anfangen können; (*Prov.*) — venture, — have, frisch gewagt ist halb gewonnen.

ul'ti-mate, 1 ul'ti-mĭt; 2 ŭl'ti-mat, *a.* **1.** Beyond which there is none other; last of a series; final.

As a general rule, no man is able to foretell distinctly the *ultimate,* permanent results of any great social change. CHANNING *Works, Laboring Classes* lect. ii, p. 58. [A. U. A. 1883.]

2. Fundamental or essential; hence, not susceptible of further analysis; elementary; primary; as, *ultimate* truths; an *ultimate* idea. **3.** *Entom.* Last: said of the stage succeeding the scarabæidoid in the larval development of hypermetamorphic beetles, as oil-beetles. **4.** [Rare.] Most distant; farthest. **5.** *Mech.* Designating the maximum strength of a body, or a strain of the least intensity sufficient to cause rupture. [< LL. *ultimatus,* pp. of L. *ultimo,* come to an end.

noth-ing (nuth'ing). [Orig. two words, *no thing.*] **I.** *n.* No thing, not anything, or naught (as, to see, do, or say *nothing;* "I opened wide the door: Darkness there, and *nothing* more!" Poe's "Raven"); no part, share, or trace (*of:* as, the place shows *nothing* of its former magnificence; there is *nothing* of his father about him); also, that which is non-existent (as, to create a world out of *nothing;* to reduce something to *nothing,* as by a process of extinction or annihilation); also, something of no importance or significance (as, "Gratiano speaks an infinite deal of *nothing,*" Shakspere's "Merchant of Venice," i. 1. 114; "The defeat itself was *nothing* . . . but the death of the Prince was a blow," Besant's "Coligny," ix.); a trifling action, matter, circumstance, or thing (as, "In pompous *nothings* on his side, and civil assents on that of his cousins, their time passed": Jane Austen's "Pride and Prejudice," xv.); a person of no importance, or a nobody or nonentity; in *arith.,* that which is without quantity or magnitude; also, a cipher or naught (0).

nothing, *n.* nulla, niente; zero, *m.;* nessuna cosa, *f.* ~ *at all,* niente affatto, nulla a. *make* ~ *of,* non capire affatto. *a mere* ~, una cosa da nulla, una bagattella, un'inezia. ~**ness,** *n.* nullità, *f.;* oblio, *m.*

Nothing [nʊth'-ing], *s.* **1.** Nada, ninguna cosa. **2.** Nadería, cosa de poca entidad, friolera. **3.** Estado de lo que no tiene existencia; la nada. **4.** La cifra 0; cero. *That is nothing to me,* Eso nada me importa. *It is good for nothing,* Para nada sirve. *He had nothing to live upon,* No tenía nada con que mantenerse. *It signifies nothing,* Eso no significa nada, nada quiere decir. *He made nothing of his labour,* Nada sacó de su trabajo.

nothing ['nʌþiŋ] intet, ikke noget; ubetydelighed, nul; slet ikke, ikke spor af (fx. *I have been fortunate; I've had a number of offers ... Fortunate nothing! They were damned lucky to get you); a mere ~* en ren bagatel; *~ at all* slet intet; *~ (else) but* intet andet end, kun; *~ doing* **T** der er ikke noget at gøre; du kan tro nej; det bliver der ikke noget af; *the police has ~ on him* politiet har ikke noget på ham (ɔ: intet anklagemateriale); *they have ~ on us* (amr. **T**) de har ikke noget at lade os høre; *she is ~ if not pretty* hun er meget smuk; smuk det er hun; *~ like as large* ikke nær så stor; langt fra så stor; *make ~ of* ikke regne for noget; ikke få noget ud af; *I can make ~ of it* jeg kan ikke blive klog på det; *~ short of* intet mindre end; *~ venture, ~ have* hvo intet vover, intet vinder.

13

nothing [ˈnʌθiŋ] pron. Rien ; *nothing but*, rien que; *to see nothing*, ne rien voir. ‖ Rien de ; *nothing else matters*, rien d'autre n'importe, tout le reste n'est rien ; *nothing much*, pas grand-chose ; *nothing more*, rien de plus ; *nothing new*, rien de nouveau ; *there is nothing for it but to*, il n'y a rien d'autre à faire qu'à. ‖ Loc. *Nothing doing*, rien à faire ; *to be nothing if not intelligent*, être intelligent avant tout ; *to do nothing of the sort*, n'en faire rien.
— n. Rien *m.; as if nothing had happened*, comme si de rien n'était ; *for nothing*, gratuitement (free of charge) ; pour rien (in vain) ; sans raison (groundlessly) ; *for next to nothing*, pour trois fois rien. ‖ Rien, objet (*m.*) d'indifférence ; *to be nothing to*, n'être rien pour, être indifférent à ; *to make nothing of*, ne pas se soucier de (not to care about) ; ne rien comprendre à (not to understand) ; ne pas faire cas de (not to value). ‖ Rien, néant *m.; to come to nothing*, aboutir à zéro, faire fiasco, venir à rien. ‖ Rien *m.*, vétille *f.; a mere nothing*, un zéro (person) ; une bagatelle, une broutille (thing).
— adv. Pas du tout, aucunement, en rien ; *nothing less than*, rien moins que.

14

mēaninɡ, s.: disegno, *m.*, intenzione, *f.*, intento, *m.*; significazione, *f.*, significato, senso, sentimento, *m.*

15

Silen-ce; silènzo *m.* Dead —, silenzio mortale. To —, far tacere; spegner il fuoco di. Keep —, tacére. Keep — about, tacere. Pass over in —, passare sotto silenzio. — gives consent, chi tace acconsente. —! zitti! **-cer**; bariletto di scaricamento, camera di scarico, marmitta *f.* **-t**; tácito, taciturno. **-tly**; tacitaménte, pian piano.

16

237

DANIEL BUREN

White and Green Papers Collage,
Varese, December 1968. DB 1

1/A.

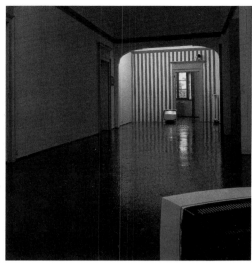

1

JEAN TINGUELY

1. *La Vittoria (Mille grazia),* Milano 1970.
 JTI 4

2. *La Vittoria (Vive Panza),* Milano 1970. JTI 2

3. *La Vittoria (Per Panza),* Milano 1970. JTI 3

4. *La Vittoria,* Milano 1970. JTI 1

1/1.

2

1/2

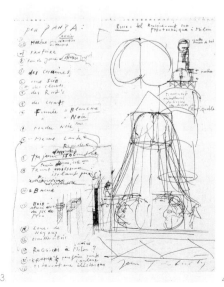

3

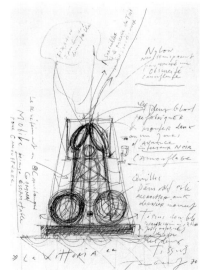

4

MARIA NORDMAN

6.

7. 9

8/1 8/2

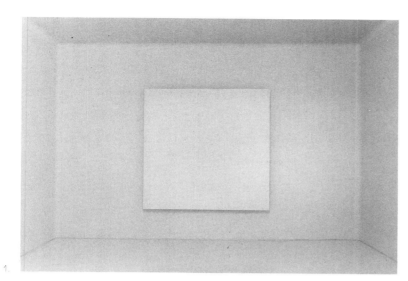

ROBERT IRWIN

1. *Dot Painting*, 1963-1965. RI 1
2. *Scrim (Ace Gallery)*, Los Angeles 1972. RI 5
3. *Varese Scrim*, 1973. RI 6
4. *Plastic Disc*, 1968-1969. RI 3
5. *12' Acrylic Column*, 1970-1971. RI 4

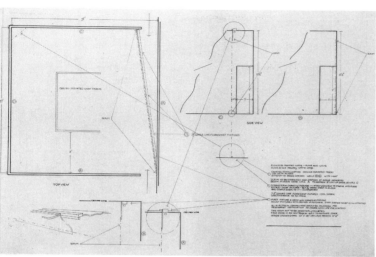

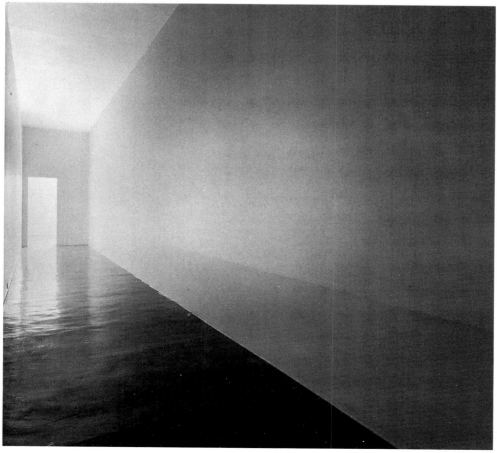

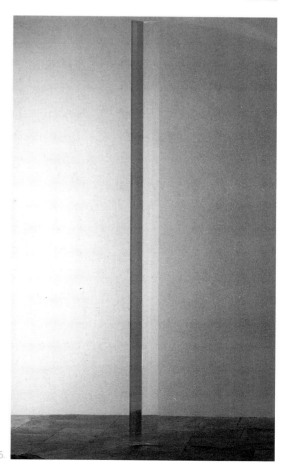

8.

9.

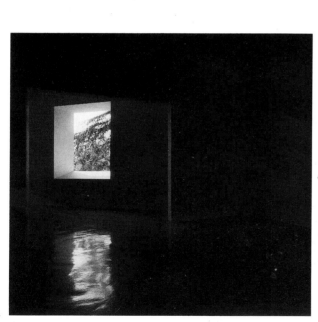

6.

7.

10.

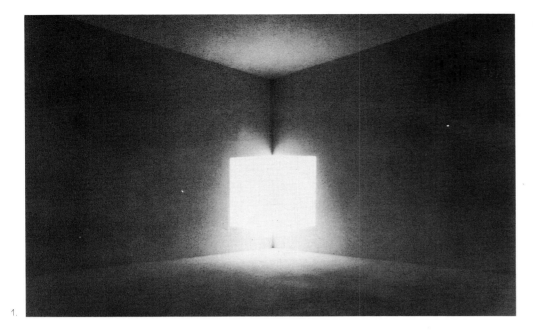

JAMES TURRELL

1. *Afrum I*, 1967. JT 2
2. *Iltar*, 1976. JT 11
3. *Argus*, Varese 1976. JT 1
4. *Wallen*, Varese 1976. JT 10

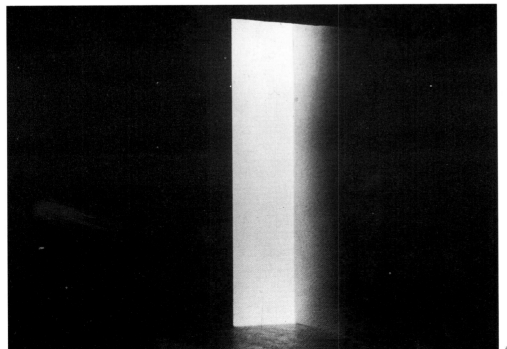

STANDARD RIVOLI PAINT

1233

NAME OF PIECE: ILTAR, 1976

James Turrell

SIDES

D C A B

BOTTOM TOP

COOL, TOWARD BLUE
AND VERY, VERY
FLAT

NO DIRECT, HARD
LIGHT

60 4' LIGHT TRACK

LIGHTS TOWARD WALL

3.0
TO FRONT OF WALL

15°

1.65

6.57

688

15°

756 108 200 110 60

Certificate of Ownership

This Agreement is entered into this **30** day of **July**, 19**76** by and between James Turrell (hereinafter "Turrell") and Dr. Giuseppe Panza di Biumo (hereinafter "Panza") and consists of the Certificate of Ownership, the Document of Realization, the Chain of Title Authentication and the art work, all as hereinafter described.

1) For good and valuable consideration, receipt of which is hereby acknowledged, Turrell does hereby sell, assign and transfer to Panza that certain work of art (hereinafter "original art work") described as:

Wallen
a xenon projection

together with the Certificate of Ownership, Document of Realization and Chain of Title Authentication, subject to all of the terms and conditions contained herein.

2) The original art work presently exists and is a sole, unique and one of a kind piece of personal property created by Turrell and said art work shall not be copied, duplicated, re-created or reproduced in any manner whatsoever except as expressly provided herein.

3) The Document of Realization consists of the plans, specifications and notes of Turrell for the production and materialization of the artistic and creative concept manifest in and by the original art work.

ERIC ORR

Zero Mass, 1974. EO 1

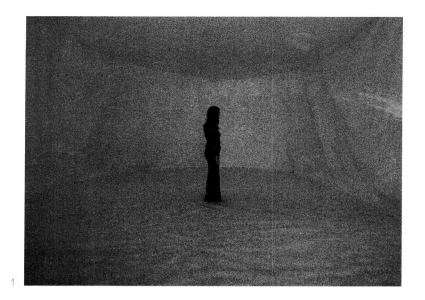

1

1/A. **ZERO MASS**

LARRY BELL

Two Glass Walls, 1971-1972. LB 4

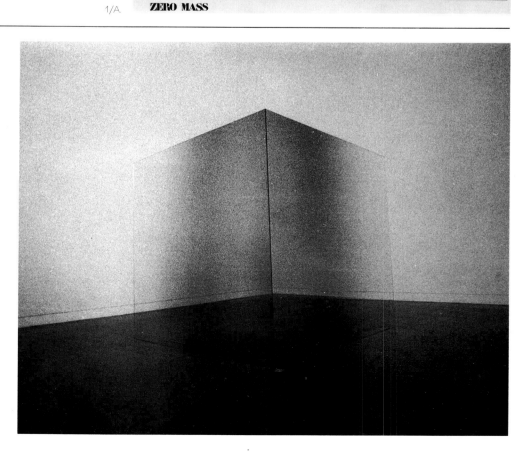

MAURIZIO MOCHETTI Milano, 19 novembre 1976

Specchio con sorgente luminosa

Il lavoro è realizzato con uno specchio di piccole dimensioni
(Ø mm.20) e una fonte luminosa. Lo specchio - autoadesivo -
può essere applicato in qualsiasi posizione (parete, pavimento,
soffitto) in modo tale però da permettere la relazione tra la
fonte luminosa, l'immagine riflessa e l'occhio. Quando la luce
colpisce lo specchio questo diventa fonte di luce.

Il lavoro è in numero di 5 esemplari.
La prima versione è stata realizzata per la collezione Giuseppe
Panza di Biumo.

1.

MAURIZIO MOCHETTI Milano, 19 novembre 1976

Grande specchio con punto opaco

Il lavoro si realizza costruendo un telaio in legno grande quanto
la parete scelta. Sul telaio viene applicata una plastica speciale
perfettamente specchiante. Il punto nero opaco autoadesivo viene
posto al centro della parete-specchio ad una altezza di cm. 160 da
terra (orizzonte ottico).

Il lavoro è un esemplare unico realizzato per la collezione Giusep-
pe Panza di Biumo.

2.

MAURIZIO MOCHETTI Milano, 19 novembre 1976

Linea di mercurio

L'opera è realizzata con un unico tubo di vetro (Ø esterno mm. 8,
interno mm. 5). La lunghezza è da determinarsi in funzione dello
spazio in cui il lavoro viene installato. Il tubo viene riempito
di mercurio sul posto e sigillato alle estremità. La linea di
mercurio non deve essere vincolata al pavimento.
La sorgente luminosa, esterna al tubo, deve essere posta in modo
che il rapporto tra fonte luminosa, immagine riflessa e occhio sia
possibile per tutta la lunghezza del tubo.

Il lavoro è in numero di 5 esemplari.
La prima versione è stata realizzata per la collezione Giuseppe
Panza di Biumo.

3.

CERTIFICATO DI AUTENTICAZIONE

Io maurizio mochetti dichiaro di
essere l'unico autore dell'opera
denominata (Contatore digitale
luminoso posto in uno spazio
indica continuamente il numero
crescente e decrescente delle persone
che si trovano in quello spazio)
progettato e costruito nell'anno
1971 in numero di 5 versioni.
Una di proprietà del Sig. Giuseppe
Panza Conte di Biumo.

 maurizio mochetti
Roma 4 maggio 1971

4.

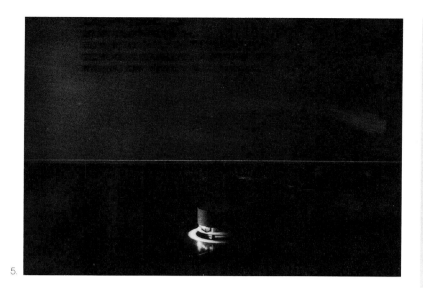

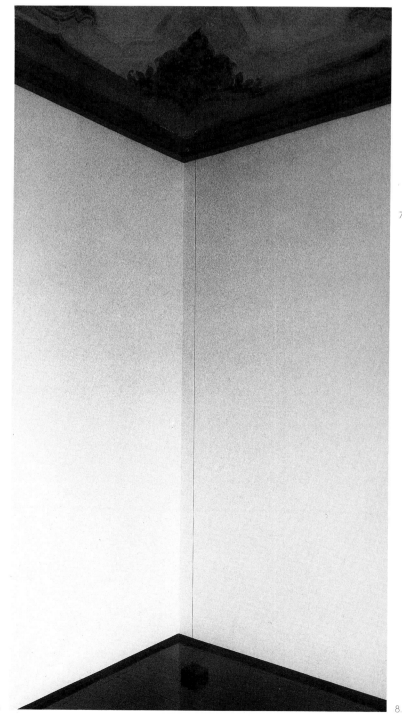

5.

6.

7.

8.

CERTIFICATO DI AUTENTICAZIONE-

Io maurizio mochetti dichiaro di essere l'unico autore dell'opera denominata "Cilindri luce-suono,, progettata e realizzata nell'anno 1969.

L'opera è stata eseguita in numero di 3 versioni differenti - Una di proprietà del Sig. Giuseppe Panza Conte di Biumo

maurizio mochetti

Dati tecnici.

L'opera consiste in due cilindri di Alluminio del diametro di cm 30, autonomi, corrispondenti, disposti l'uno di fronte all'altro ad una distanza X aventi un foro centrale di uguale diametro - Dal cilindro no 1 parte automaticamente ogni 15 secondi un impulso luminoso, al quale corrisponde nel cilindro no 2 un suono -

maurizio mochetti

Roma 26 marzo 1971

Carta di Autenticazione

Io maurizio Mochetti dichiaro di essere l'autore dell'opera denominata. Specchio Ø 10 mm. progettata e realizzata nel 1972 L'opera è stata eseguita in numero cinque versioni identiche - Una di queste opere è di proprietà del Sig.

Esiste un solo punto da cui l'osservatore può individuare l'immagine del punto riflessa nello specchio sul pavimento -

maurizio mochetti

Dati tecnici-

Specchio Ø 10 mm posto in un punto qualsiasi del pavimento - punto autoadesivo Ø 20 mm. posto in un punto del soffitto -

maurizio mochetti

milano 16/marzo 1973.

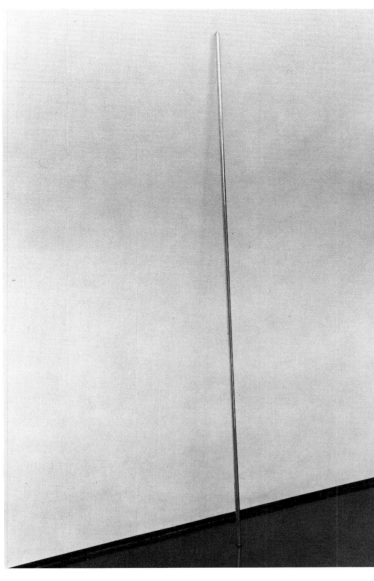

9.

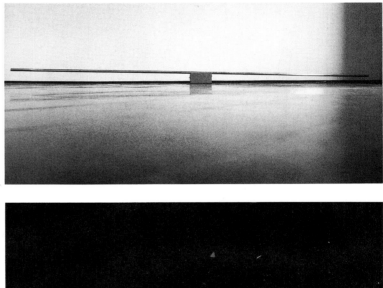

11.

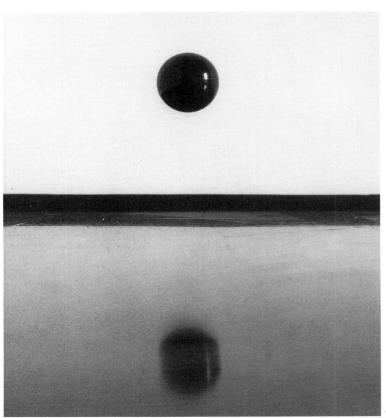

10.

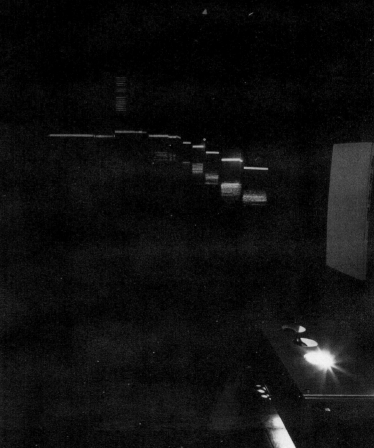

12.

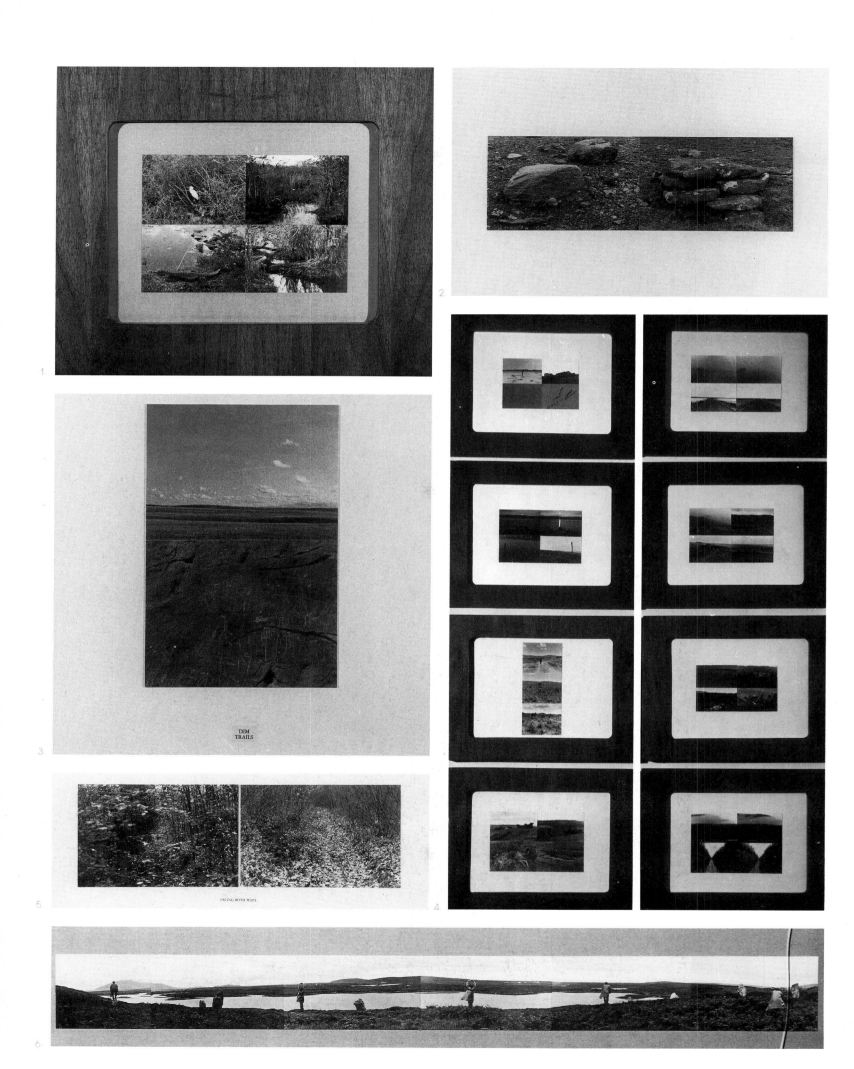

DIM
TRAILS

FACING BOTH WAYS

HAMISH FULTON

7

8

9

10

11

12

13. *France on the Horizon 1/3, Early Summer 1975.* HF 14

14. *Looking at Tomorrow (Scottish North West Highlands), 1974.* HF 15

14/2.

14/3.

14/4.

13.

14/1.

14/5.

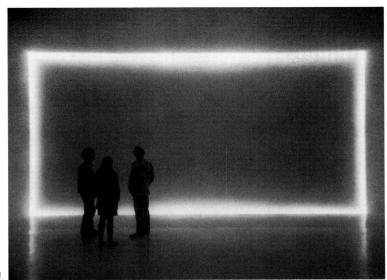

1.

DOUG WHEELER

1. *Ace Gallery Installation (Environmental light)*, January 1970. DW 1
2. *Amsterdam Stedelijk Museum Installation (Environmental light)*, September 1969. DW 3
3. *PSAD Synthetic Desert III*, 1971. DW 6
4. *Luminefepous Space*, 1968-1975. DW 8
5. *Eindhoven Stedelijk Van Abbemuseum Installation (Environmental light)*, 1969-1970. DW 2

2.

3.

4.

5.

6.

1/A

7.

10.

8.

11.

9.

12.

13.

14.

WALTER DE MARIA

Nº 75 © W. De Maria, 1966

HIGH ENERGY BAR

This Certifies that Giuseppe Panza di Biumo is the owner of High Energy Bar number 75 of an infinite series. This certificate will be incorporated as part of the whole work of art, to be known as the High Energy Unit.
All High Energy Bars in order to be operative and authentic must be accompanied by a properly executed certificate.
Ownership of this High Energy Bar has been recorded in the archives of the artist.
IN WITNESS WHEREOF I, Walter De Maria, have hereunto affixed my seal this thirteenth day of November A.D. 1970

Walter de Maria

1/A.

2. *Calendar no. 1/12*, 1961-1975. WM 4

3. *Balldrop*, 1961. WM 1

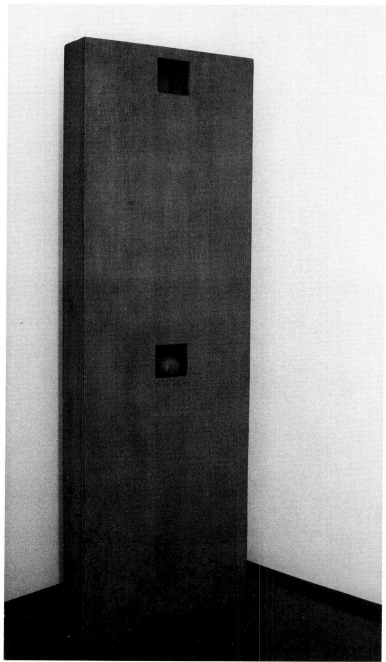

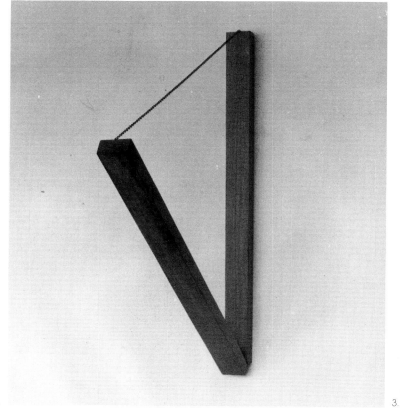

3.

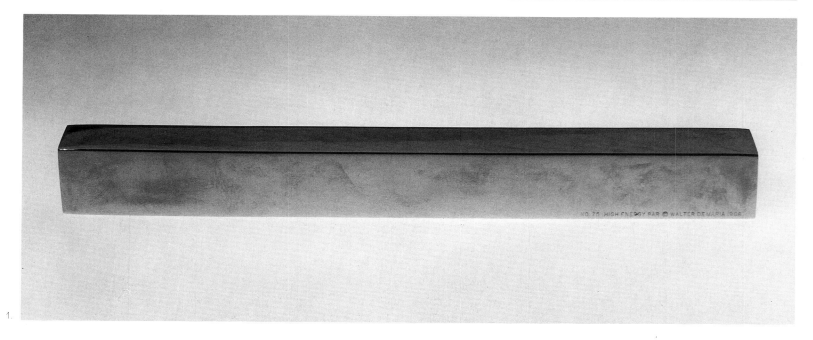

2.

1.

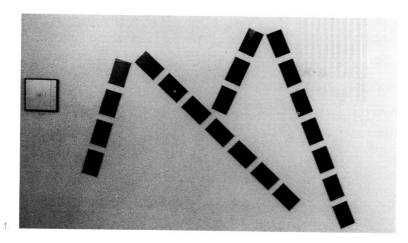

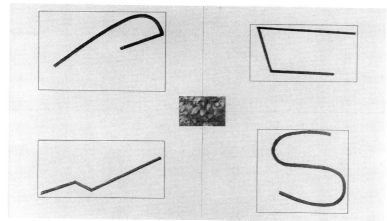

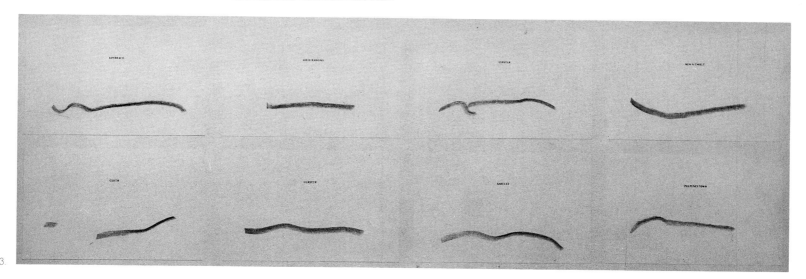

DAVID TREMLETT

1. *Cue*, 1974. DT 1

2. *Watching the Way the Rabbits Run in Milwaukee*, 1975. DT 2

3. *Scotland 1/2 (Lock Ness)*, 1975. DT 7

4. *Scotland 1/3 (Lock Ness)*, 1975. DT 8

255

5.

6.

7.

8.

9.

10.

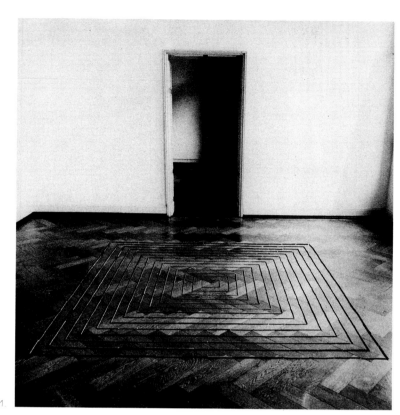

RICHARD LONG

1. *Square Wood Sculpture*, 1967. RLO 1

2. *Sculpture at Galerie Lambert*, Milano 1969. RLO 4

3. *Untitled-England*, 1967. RLO 2

4. *Sculpture at Sperone Gallery*, 1973. RLO 7

5. *Sculpture at Konrad Fischer*, Dusseldorf, July 1969. RLO 8

6. *Sculpture Untitled June 1968 England*, 1968. RLO 3

7. *2½ Mile Walk Sculpture*, 1969. RLO 6

8. *A Sculpture by Richard Long*, Wiltshire, 12-15 October 1969. RLO 5

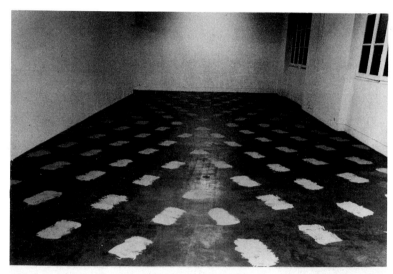

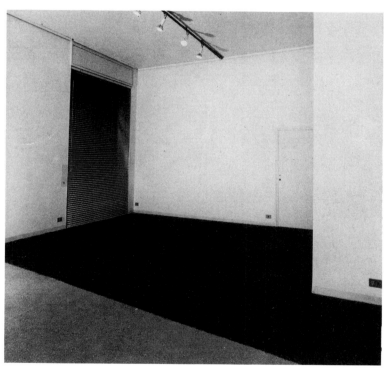

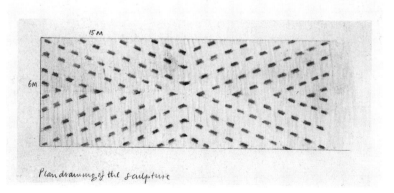

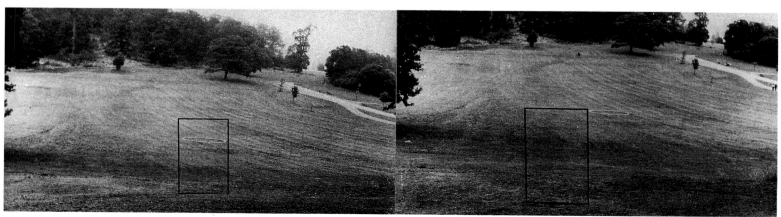

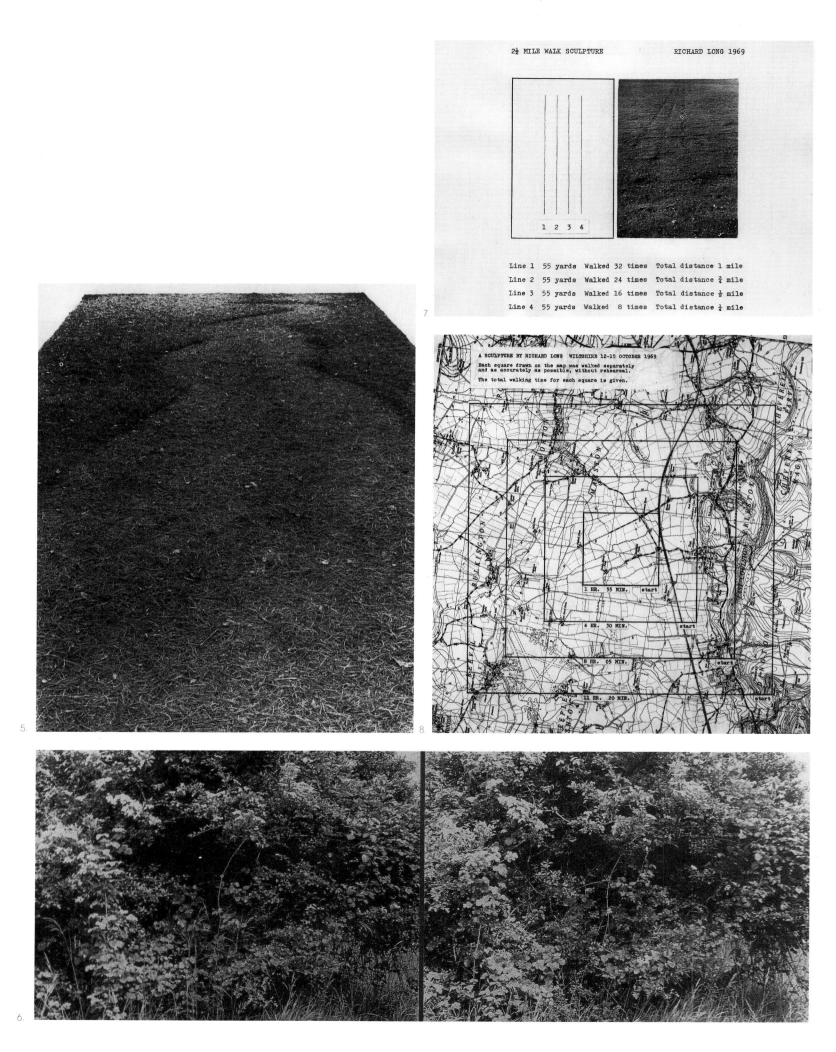

2½ MILE WALK SCULPTURE RICHARD LONG 1969

Line 1	55 yards	Walked 32 times	Total distance 1 mile
Line 2	55 yards	Walked 24 times	Total distance ¾ mile
Line 3	55 yards	Walked 16 times	Total distance ½ mile
Line 4	55 yards	Walked 8 times	Total distance ¼ mile

7.

A SCULPTURE BY RICHARD LONG WILTSHIRE 12-15 OCTOBER 1969

Each square drawn on the map was walked separately
and as accurately as possible, without rehearsal.

The total walking time for each square is given.

1 HR. 55 MIN. start

4 HR. 30 MIN. start

8 HR. 05 MIN. start

11 HR. 20 MIN. start

5.

8.

6.

VINCENZO AGNETTI (Milan, Italy, 1926-1981)

1. *No,* March 30, 1973. Two telegrams and receipts, 100x51 cm. (39³/₈x20 in.) VA 1
 Monologue, May 9, 1973. Chrome cassette. VA 2
 Statale Speech, May 5, 1972. Chrome cassette. VA 3

CARL ANDRE (Quincy, Massachusetts, 1935)

4. *Reef,* 1966. Orange styrofoam planks, lenghtwise from wall to wall, 80 units, each 10x20x108 in., overall 800x20x108 in. CA 1
1. *Steel Piece,* October 1967. 100 hot rolled units, each 0,5x50x50 cm. (³/₁₆x19 ³/₄x19 ³/₄ in.), overall 0,5x250x1000 cm. (³/₁₆x98 ³/₄x395 in.) CA 2
37. *2x18 Aluminium Lock,* 1968. 36 units, each 1x100x100 cm. (³/₈x39 ¹/₂x39 ¹/₂ in.), overall 1x200x1800 cm. (³/₈x79x711 in.) CA 3
38. *Hague Steel Piece,* 1968. 36 hot rolled units, each 1x100x100 cm. (³/₈x39 ¹/₂x39 ¹/₂ in.), overall 1x600x600 cm. (³/₈x237x237 in.) CA 4
39. *Fall,* 1968. Hot rolled steel, 21 L-shaped units, each 1x28x72x72 in., overall 1x72x72x588 in. CA 5
10. *Brass Piece,* 1969. 249 thin units, each 6,5x8,5 cm. (2 ¹/₈x3 ³/₈in.), overall 8,5x1835 cm. (3 ³/₈x722 ¹/₂ in.) CA 6
6. *Zinc Ribbon Piece,* 1969-1971. One strip, 0,1x9x2100 cm. (¹/₁₆x3 ¹/₂x826 ³/₄ in.) CA 7
3. *Brass Square Piece,* March 1972. 100 units, each ¹/₁₆x¹/₁₆x¹/₆₄ in., overall ⁷/₈x7/₈x¹/₆₄ in. CA 8
2. *Finely Divided Square Piece,* May 1970. 882 cold rolled steel chips, each ¹/₆₄x9/₃₂x9/₁₆ in., overall ¹/₆₄x11 ¹³/₁₆x11 ¹³/₁₆ in. CA 9
5. *Copper Square,* 1973. 100 units, each 0,5x50x50 cm. (³/₁₆x19 ³/₄x19 ³/₄ in.), overall 0,5x500x500 cm. (³/₁₆x197 ¹/₂x197 ¹/₂ in.) CA 10
7. *2001 Slope,* 1968. 6 hot rolled steel units, 5 units each ³/₈x36x36 in., 1 (trapezoid) unit ³/₈x36x33 in., overall ³/₈x36x216 in. CA 11
36. *Portland Regulus,* 1973-1974. 18 river stones and 17 geological specimens on 35 concrete blocks, each block 2x12x12 in., overall 2x204x300 in. CA 12
9. *Sevententh Copper Triode,* October 1975. 25-unit tee, each unit 0,5x50x50 cm. (³/₁₆x19 ³/₄x19 ³/₄ in.) CA 13
8. *Fifth Copper Triode,* October 1975. 7-unit tee, each unit 0,5x50x50 cm. (³/₁₆x19 ³/₄x19 ³/₄ in.) CA 14
8. *Third Copper Triode,* October 1975. 4-unit tee, each unit 0,5x50x50 cm. (³/₁₆x19 ³/₄x19 ³/₄ in.) CA 15

ART AND LANGUAGE (Terry Atkinson, 1939. Michael Baldwin, 1945. David Bainbridge, 1941. Harold Hurrell, 1940. All born in England)

The French Army: 22 Sentences, 1967. Text. AL 1
Hot Warm Cool Cold, 1967. Text. AL 2
Translation Piece I-II-III-IV-V 2/3, 1972. Five portfolios with typed sheets. AL 3
Olivet Discourse, 1971. Text. AL 4

ROBERT BARRY (New York City, 1936)

5. *Steel Disc Suspended ¹/₈ in. Above Floor,* 1967. Nylon string, steel disc 2 in. diameter and ⁵/₈ in. high. RB 1
7. *String Piece,* 1968. Extending floor to ceiling. RB 2
4. *Wire Installation,* 1968. Pencil on paper.8 x 10 in. Extending floor to ceiling to floor at 90° angle. RB 3
6. *Radiation Installation; Cesium 137,* 1969. Lead container 1x1x3 in. approx. Must be installed outside. RB 4
1. *It Can Only Be Known as Something Else,* 1969. Text. RB 5
83. *It Is Wholly Indeterminate. It Has No Specific Traits....,* 1970. Text. RB 6
12. *It Has Variety. It Can Change...,* 1969-1971. 60 slides with text. RB 7
13. *F. M. Carrier Wave (Approx 98 MC),* 1968. Wooden box with radio transmitter, 2x5x7 in. RB 8

9. *Untitled,* 1967. 4 panels each 2x2 in., hung 12 in. diagonally from the corners of a wall. RB 9
11. *It Can Seem to Be...,* 1971-1972. 80 slides, 40 with text and 40 blank. RB 10
15. *It Is and It Can Be,* 1971-1972. 80 slides, 40 with text and 40 blank. RB 11
84. 18. *Try. All In Now. Here...,* 1972. 80 slides, 40 with text and 40 blank. RB 12
2. *A Part of a Piece,* 1972. Text. RB 13
14. *Speculations,* 1973. 80 slides, 20 with text, 20 with blue spot and 40 blank. RB 14
17. *Right. Ever...,* 1973. 80 slides, 20 with text, 20 with blue spot and 40 blank. RB 15
10. *360°,* 1968. Book, 360 pages, drawn line on paper, 29x21,5x4 cm. (11¹/₂x8¹/₂x1¹/₂ in.). RB 16
8. *It Is Always Changing,* 1970. Text. RB 17
19. *Refrain,* 1975. 81 slides, 27 with text and 54 blank. RB 18
16. *Appearances,* 1973. 80 slides, 20 with text, 20 with blue spot and 40 blank. RB 20
3. *Untitled,* 1975. Prestype and pencil on paper, 29x37¹/₄ in. RB 21

LARRY BELL (Chicago, Illinois, 1939)

110. *Light Brown Box,* 1968. Coated glass, 51 x 51 x 51 cm. (20 x 20 x 20 in.) LB 1
111. *Two Glass Walls-Diagonal Top,* 1973. 2 coated panels, each 72 x 72 in. LB 2
112. *Two Glass Walls,* 1971-1972. 2 coated panels, each 96 x 60 in. LB 3
1. *Two Glass Walls,* 1971-1972. 2 coated panels, each 72 x 72 in. LB 4

JOSEPH BEUYS (Kleve, West Germany, 1921 - Düsseldorf, West Germany, 1986)

2. *Fontana Dose,* 1963. Blackboard, 30,5 x 21,5 cm. (12x8 ¹/₂ in.) JB 1
1. *Untitled,* 1961. Plastic pail, 16x18x18 cm. (6 ¹/₄x7 ¹/₈x7 ¹/₈ in.) JB 2
 Multiple 97/100, 1971. Felt and tape, 16x25x25 cm. (6 ¹/₄x9 ³/₄x9 ³/₄ in.) JB 3

STANLEY BROUWN (Paramaribo, Suriname, 1935)

My steps in Torino, 1971. My total number of steps in Torino: 16.827. SB 1
My steps in Milan, 1971. The total number of my steps in Milan in 1971: 168.584. SB 2

DANIEL BUREN (Boulogne, France, 1938)

White and Green Papers Collage, Varese, December 1968. Approx. 30 paper sheets. DB 1

VICTOR BURGIN (Sheffield, England, 1941)

Perfomatif Narratif Piece 1/3, 1971. Text with photographs on paper. VB 1
VI 4/9, 1973. Text with photographs on paper. VB 2

PIERPAOLO CALZOLARI (Bologna, Italy, 1943)

Telegram no. 349, April 26, 1976. PC 1
Telegram no. 252, April 27, 1976. PC 2
Telegram no. 20, April 28, 1976. PC 3
Telegram no. 198, April 28, 1976. PC 4
Telegram no. 0705, April 28. 1976. PC 5
Telegram no. 221, April 29, 1976. PC 6

LOUIS CANE (Beaulieu-sur-Mer, France, 1943)

Red-White Canvas, January 10-1973. Oil on cotton, 505x241 cm. (199 3/4x95 in.) LC 1

Dark Brown Square Canvas, March 18-1973. Oil on cotton, 362x344 cm. (142 1/2x135 1/2 in.) LC 2

Clear Brown Canvas, November 15-1972. Oil on cotton, 626x245 cm. (246 1/2x96 1/2 in.) Wall-floor-floor. LC 3

Red Square Canvas, May 1973. Oil on cotton, 440x433 cm. (173 1/4x171 1/2 in.) LC 4

Yellow Square Canvas, March 25-1973. Oil on cotton, 312x321 cm. (123x126 1/4 in.) LC 5

Clear Blue Canvas, July 1973. Oil on cotton, 414x292 cm. (163x115 in.) Wall-floor. LC 6

1. *Dark Blue Canvas,* March 16-1973. Oil on cotton, 618x240 cm. (243 1/2x94 1/2 in.) LC 7

2. *Red Canvas,* May 15-16, 1973. Oil on cotton, 654x243 cm. (257 1/2x96 in.) LC 8

Clear Brown Canvas, July 1973. Oil on cotton, 545x242 cm. (214 1/2x95 1/4 in.) Wall-floor-floor. LC 9

Black-Red Canvas, October 10-1973. Oil on cotton, 402x242 cm. (158 1/4x95 1/4 in.) Wall-floor. LC 10

Blue Canvas, January 25-1974. Oil on cotton, 547x241 cm. (215 1/2x95 in.) LC 11

Red Bordeaux Canvas, February 15-1974. Oil on cotton, 495x242 cm. (191x95 1/2 in.) Wall-floor. LC 12

Drawing, February 4-1973. Coloured pencil and pen on paper, 21x27 cm. (8 1/2x10 3/4 in.) LC 13

Drawing, February 1973. Coloured pencil and pen on paper, 21x27 cm. (8 1/2x10 3/4 in.) LC 14

Drawing, June 1973. Coloured pencil and pen on paper, 21x27 cm. (8 1/2x10 3/4 in.) LC 15

Drawing, May 1974. Coloured pencil and pen on paper, 29,5x41,5 cm. (11 1/2x16 1/4 in.) LC 16

CIONI CARPI (Milan, Italy, 1923)

3. *L'opera che continua a porsi...,* 1974. Drawing, 29,5 x 19,5 cm. (11 5/8 x 7 3/4 in.) CC 1

Trasfigurazione/Sparizione Uno, 1966-1974. Text and photographs on paper, 2 sets, each 44 x 99 cm. (17 1/4 x 39 in.) CC 2

2. *Trasfigurazione/Sparizione Due,* 1966-1974. Text and photographs on paper, 5 sets, each 39 x 81 cm. (15 1/2 x 32 in.) CC 3

Trasfigurazione/Sparizione Quattro, 1966-1974. Text and photographs on paper, 5 sets, each 37 x 80 cm. (14 1/2 x 31 1/2 in.) CC 4

Trasfigurazione/Sparizione Cinque, 1966-1974. Text and photographs on paper, 4 sets, each 37 x 79 cm (14 1/2 x 31 in.) Edition of 2. CC 5

55 cm. sul livello del mare 1/5, 1972. 16 mm. film. CC 6

Trasfigurazione Zero, 1966-1974. 16 mm. film. CC 7

Abbiamo creato atipici sistemi, 1963-1974. Text and photographs on paper, 9 sets, each 50 x 40 cm. (19 3/4 x 15 3/3 in.) CC 8

1. *CDFB Ritorno ai campi d'azione abbandonati,* 1974-1975. 100 slides and tape. CC 9

CDFB Whole cello improsession, 1975. Tape 3/15. CC 10

Per un otto coricato, 1977. 100 slides and tape. CC 11

Sebspass 001 (Quadro Collage), 1964-1977. Mixed media on masonite, 20,5 x 20,5 x 4 cm. (8 x 8 x 1/2 in.) CC 12

4. *Sebspass 01 (Sequoia semper virens),* 1976. Mixed media on paper, 40 x 50 cm. (15 3/4 x 19 3/4 in.) CC 13

Palinsesto 8 stadi, 1963. Mixed media, 50 x 68 cm. (19 3/4 x 27 3/3 in.) CC 14

ALAN CHARLTON (Sheffield, England, 1948)

2. *82 in. Square,* 1970-1972. Acrylic on canvas. AC 1
5. *82 in. Square,* 1970-1972. Acrylic on canvas. AC 2
73. *82 in. Square,* 1970-1972. Acrylic on canvas. AC 3
1. *82 in. Square,* 1970-1972. Acrylic on canvas. AC 4
17. *82 in. Square,* 1970-1972. Acrylic on canvas. AC 5
4. *58x180 in.,* June 1970. Acrylic on canvas. AC 6

70. *112x56 in., slit 100 in.,* March 1971. Acrylic on canvas. AC 7
70. *90x180 in., slit 156 in.,* August-November 1971. Acrylic on canvas. AC 8
6. *90x90 in., slit 78 in.,* August 1971. Acrylic on canvas. AC 9
9. *90x78 in., slit 66 in.,* August 1971. Acrylic on canvas. AC 10
71. *90x56 in., slit 44 in.,* September 1971. Acrylic on canvas. AC 11
7. *90x90 in., slit 44 in.,* September 1971. Acrylic on canvas. AC 12
19. *90x180 in., each slit 78 in.,* January 1972. Acrylic on canvas. AC 13
72. *90x78 in., each slit 78 in.,* January 1972. Acrylic on canvas. AC 14
16. *90x102 in., each slit 90 in.,* January 1972. Acrylic on canvas. AC 15
8. *Outer piece 114x66 in., inner piece 98 1/2x50 1/2 in., channel 1 3/4 in.,* May-August 1972. Acrylic on canvas. AC 16
70. *Outer piece 84x144 in., inner piece 68 1/2x128 1/2 in., channel 1 3/4 in.,* May-August 1972. Acrylic on canvas. AC 17
3. *Outer piece 90x174 in., each inner piece 74 1/2 in. square, channel 1 3/4 in.,* November-December 1972. Acrylic on canvas. AC 18
12. *No. 1/8: outer piece 84 in. square, inner piece 68 4/10 in. square, channel 1 8/10 in.,* December 1972-May 1973. Brown, blue, grey acrylic on canvas. AC 19
21. *No. 2/8: outer piece 84 in. square, inner piece 68 4/10 in. square, channel 1 8/10 in.,* December 1972-May 1973. Green, brown, grey acrylic on canvas. AC 20
23. *No. 3/8: outer piece 84 in. square, inner piece 68 4/10 in. square, channel 1 8/10 in.,* December 1972-May 1973. Green, grey acrylic on canvas. AC 21
10. *No. 4/8: outer piece 84 in. square, inner piece 68 4/10 in. square, channel 1 8/10 in.,* December 1972-May 1973. Black, white acrylic on canvas. AC 22
18. *No. 5/8: outer piece 84 in. square, inner piece 68 4/10 in. square, channel 1 8/10 in.,* December 1972-May 1973. Brown, grey acrylic on canvas. AC 23
13. *No. 6/8: outer piece 84 in. square, inner piece 68 4/10 in. square, channel 1 8/10 in.,* December 1972-May 1973. Brown, blue, grey acrylic on canvas. AC 24
20. *No. 8/8: outer piece 84 in. square, inner piece 68 4/10 in. square, channel 1 8/10 in.,* December 1972-May 1973. Black, white acrylic on canvas. AC 25
75. *Outer piece 58 in. square, inner piece 18 in. square, channel 1 5/8 in.,* September 1973. Acrylic on canvas. AC 26
11. *Outer piece 51 1/2 in. square, inner piece 24 in. square, channel 1 3/4 in.,* August 1973. Acrylic on canvas. AC 27
76. *Outer piece 63 1/2 in. square, inner piece 12 in. square, channel 1 3/4 in.,* September 1973. Acrylic on canvas. AC 28
16. *Outer piece 66 in. square, inner piece 55 1/2 in. square, channel 1 3/4 in.,* October 1973. Acrylic on canvas. AC 29
74. *Outer piece 60 in. square, inner piece 38 1/2 in. square, channel 1 3/4 in.,* December 1973. Acrylic on canvas. AC 30
24. *Outer piece 56 in. square, inner piece 49 in. square, channel 1 3/4 in.,* January 1974. Acrylic on canvas. AC 31
22. *Outer piece 50 in. square, inner piece 39 1/2 in. square, channel 1 3/4 in.,* January 1974. Acrylic on canvas. AC 32
14. *No. 5/6: each piece 91x80 1/2 in.,* January 1975. 2 pieces. Acrylic on canvas. AC 33
14. *No. 3/6: each piece 98x66 1/2 in.,* January 1975. 2 pieces. Acrylic on canvas. AC 34
14. *No. 2/6: each piece 101 1/2x59 1/2 in.,* January 1975. 2 pieces. Acrylic on canvas. AC 35

HANNE DARBOVEN (Munich, West Germany, 1941)

27. *August 1, 1972.* Drawing, 59 x 42 cm. (23 1/4 x 16 1/2 in.) HD 1
29. *August 1,* 1972. Drawing, 59 x 44 cm. (23 1/4 x 17 3/8 in.) HD 2
4. *Drawings nos 1-2-3,* 1972. Each 29 x 20,5 cm. (11 3/8 x 8 1/8 in.) HD 3
5. *Index 17K-58K,* 1969. 42 typewritten drawings, each 41 x 29 cm. (16 1/8 x 11 3/8 in.) HD 7
6. *27K - No 8 - No 26,* 1968-1969. 146 typewritten drawings, each 29,5 x 21 cm. (11 5/8 x 8 1/4 in.) HD 10

7. *OO → 99 = No 1 → 2K → 20K,* 1969-1970. 138 drawings, each 29,5 x 21 cm. (11⅝ x 8¼ in.) HD 9
form a work of 6 parts:
13. *101 Drawings,* 1971-1972. Each 42 x 29,5 cm. (16½ x 11⅝ in.) HD 16
2. *51 Drawings,* 1971-1972. Each 41,5 x 29 cm. (16⅜ x 11⅜ in.) HD 4
1. *45 Drawings,* 1971-1972. Each 41,5 x 29 cm. (16⅜ x 11⅜ in.) HD 6
3. *43 Drawings,* 1971-1972. Each 41,5 x 29 cm. (16⅜ x 11⅜ in.) HD 5
14. *85 Drawings,* 1971-1972. Each 42 x 29,5 cm. (16½ x 11⅝ in.) HD 17
17. *49 Drawings,* 1971-1972. Each 42 x 29,5 cm. (16½ x 11⅝ in.) HD 18
form a work of 5 parts:
8. *I/II/III,* 1970-1971. 96 typewritten drawings, each 29,5 x 21 cm. (11⅝ x 8¼ in.) HD 11
9. *IV/V/VI,* 1970-1971. 96 typewritten drawings, each 29,5 x 21 cm. (11⅝ x 8¼ in.) HD 12
10. *VII/VIII/IX,* 1970-1971. 96 typewritten drawings, each 29,5 x 21 cm. (11⅝ x 8¼ in.) HD 13
12. *X/XI/XII,* 1970-1971. 96 typewritten drawings, each 29,5 x 21 cm. (11⅝ x 8¼ in.) HD 14
11. *365 × 100 + 1 × 25 = 36525, Index,* 1970-1971. 202 typewritten drawings, each 29,5 x 21 cm. (11⅝ x 8¼ in.) HD 15
form a work of 2 parts:
18. *Erstes Buch 2-61-43,* 1972. 138 typewritten drawings, each 29,5 x 21 cm. (11⅝ x 8¼ in.) HD 19
19. *Zweiundzwanzigstes Buch 23-40-22,* 1972. 128 typewritten drawings, each 29,5 x 21 cm. (11⅝ x 8¼ in.) HD 20
form a work of 10 parts:
15. *K : 15 x 15 —F : 15 x 15 (ordner : 1),* 1972-1973. 46 drawings, each 42 x 30 cm. (16½ x 11¾ in.) HD 21
16. *K : 15 x 15 —F : 15 x 15 (ordner : 2),* 1972-1973. 46 drawings, each 42 x 30 cm. (16½ x 11¾ in.) HD 22
21. *K : 15 x 15 —F : 15 x 15 (ordner : 3),* 1972-1973. 46 drawings, each 42 x 30 cm. (16½ x 11¾ in.) HD 23
20. *K : 15 x 15 (ordner : 4),* 1972-1973. 46 drawings, each 42 x 30 cm. (16½ x 11¾ in.). HD 24
22. *Varianten-aufzichungen 1 → 99 (ordner : 5),* 1972-1973. 51 drawings, each 42 x 30 cm. (16½ x 11¾ in.) HD 25
23. *Varianten-aufzichungen 1 → 99 (ordner : 6),* 1972-1973. 51 drawings, each 42 x 30 cm. (16½ x 11¾ in.) HD 26
24. *Varianten-aufzichungen 1 → 99 (ordner : 7),* 1972-1973. 46 drawings, each 42 x 30 cm. (16½ x 11¾ in.) HD 27
25. *Varianten-Pläne-Kurven zahlen : 1 → 99 (ordner : 9),* 1972-1973. 45 drawings, each 42 x 30 cm. (16½ x 11¾ in). HD 28
26. *Varianten-Pläne zahlen : 1 → 99 (ordner : 9),* 1972-1973. 50 drawings, each 42 x 30 cm. (16½ x 11¾ in.) HD 29
28. *Varianten-Pläne zahlen : 1 → 99 (ordner : 10),* 1972-1973. 51 drawings, each 42 x 30 cm. (16½ x 11¾ in.) HD 30
not included 35 letters

DOUGLAS DAVIS (Washington D.C., 1933)

Studies in Myself II, 1973. Color videotape, 30 mins. DD 1
Studies in Color Videotape II, 1972. Color videotape, 30 mins. DD 2
Talk-Out, 1972. Color videotape, 65 mins. DD 3
The Santa Clara Tapes, 1973. Color videotape, 30 mins. DD 4
The Austrian Tapes, 1974. Color videotape, 15 mins. DD 5
Fragment for a New Art of the Seventies, 1975. Color videotape, 30 mins. DD 6
The Last Videotape, 1975. Color videotape, 10 mins. DD 6A
The Florence Tapes, 1974. Bl/wh videotape, 18 mins. DD 7
Three Silent and Secret Acts, 1976. Color videotape, 30 mins. DD 8
The Last Nine Minutes, 1977. Color videotape, 9 mins. DD 9
Reading Marx Box, 1976. Documentation of multimedia performance held in Bologna 1976. 2 Books and videotape presented in a plexiglass box, 33 x 51 x 10 cm. (13 x 20 x 4 in.) DD 10

Seven Thoughts, 1976. Documentation of perfomance held in Huston Astronome Dec. 26, 1976 presented in a wooden box, 17 x 22 x 23 cm. (6¾ x 8¾ x 9 in.). DD 11
Double Entendre, 1981. Color videotape, 30 mins. DD 12
Double Entendre Double Print, 1981. 3 printed sheets, each 48 x 42 cm. (19 x 16½ in.) DD 13

WALTER DE MARIA (Albany, California, 1935)

3. *Balldrop,* 1961. Plywood box with pencil wording and wooden ball, 76 x 24 x 6⅜ in. Edition of 6. WM 1
1. *High Energy Bar no. 75,* 1966. Stainless steel, 3,7 x 35,7 x 3,7 cm. (1½ x 14 x 1½ in.) WM 2
Hard Core no. 3/100, 1969. 16 mm. film. WM 3
2. *Calendar no. 1/12,* 1961-1975. Wood and link chain, 178,6x6,4x3,3 cm. (70¼ x 2⅛ x 1¼ in.) WM 4

JAN DIBBETS (Weert, Holland, 1941)

2. *The Shortest Day of 1970 Photographed in My House Every 6 Minutes,* Amsterdam 1970. 79 bl/wh photographs, overall 12x1422 cm. (4¾x559⅞ in.) JD 1
2. *Tide,* 1969. 10 bl/wh photographs each 60x60 cm. (23⅝x23⅝ in.), overall 60x600 cm. (23⅝x236¼ in.) JD 2
6. *Shadows in The Sperone Gallery,* Torino, March 10, 1971. 12 bl/wh photographs and pencil on paper, 70x100 cm. (27½x39⅜ in.) JD 3
1. *The Sperone Gallery Photographed From Wall A to Wall B,* Torino 1971. 10 bl/wh photographs and pencil on paper, 70x70 cm. (27½x27½ in.) JD 4
5. *A White Wall,* Amsterdam 1971. 12 bl/wh photographs and pencil on paper, 70x100 cm. (27½x39⅜ in.) JD 5
4. *Horizon Up and Down (Land),* 1971. 28 colour photographs on paper, 28x198 cm. (11x78 in.) JD 6
10. *Sea/Horizon,* 1971. 15 colour photographs on aluminium, 3 panels each 17x112 cm. (6¾x44⅛ in.), overall 17x336 cm. (6¾x133⅜ in.) JD 7
9. *Sea Horizon 0°-135°,* 1971, 10 colour photographs on aluminium, 5 panels each 49,5x98 cm. (19½x38⅝ in.), overall 49,5x490 cm. (19½x193⅛ in.) JD 8
3. *0°-135° Cross,* 1972. 10 bl/wh photographs and pencil on paper, 70x89 cm. (27½x35 in.) JD 9
10. *Black Vase,* 1972. Film strip. 40 colour photographs on aluminium, 5 panels each 9x90 cm. (3½x35½ in.), 1 panel 9x64 cm. (3½x25¼ in.), overall 9x514 cm. (3½x202¼ in.) JD 11
11. *Black Vase,* 1976. Film strip. 40 colour photographs on aluminium, 10 panels each 24x146,8 cm. (9½x57¾ in.), overall 24x1468 cm. (9½x577½ in.) JD 12
8. *Panorama (Dutch Mountain) L 15°,* 1971. 22 colour photographs and pencil on paper, 71x70,5 cm. (28x27¾ in.) JD 13
12. *Big Comet 3°-60° Land/Sky/Land,* 1973. 20 individually framed colour photographs on aluminium. Wall installation dimensions 450x600 cm. (177⅛x236¼ in.) JD 14
10. *White Table,* 1972. Film strip. 40 colour photographs on aluminium, 8 panels each 12,8x90 cm. (5x35½ in.), overall 12,8x720 cm. (5x284 in.) JD 15

JEAN FAUTRIER (Paris, France, 1898 - Châtenay Malabry, France, 1964

4. *Tête d'otage no. 1,* 1943. Mixed media on canvas, 35x27 cm. (14x10 ½ in.) F 1 MOCA
9. *Nu,* 1943. Mixed media on canvas, 55x38 cm. (21 ½x15 in.) F 2 MOCA
10. *Tête d'otage no. 14,* 1944. Mixed media on canvas, 35x27 cm. (13 ¾x10 ½ in.) F 3 MOCA
1. *Profil,* 1945. Mixed media on canvas, 27x21 cm. (10 ½x8 ¼ in.) F 4 MOCA

8. *Dépouille,* 1946. Mixed media on canvas, 96x146 cm.
 (37 3/4x57 1/2 in.) F 5 MOCA
5. *Le pot,* 1947. Mixed media on canvas, 33x41 cm. (13 1/2x16
 in.) F 6 MOCA
2. *Untitled,* 1936. Gouache on paper, 10x13 cm. (3 7/8x5 1/8 in.)
 F 7
3. *Untitled,* 1950. Gouache on paper, 11x16 cm. (4 3/8x6 1/4) F 8

ENEA FERRARI (Soncino, Italy, 1908)

1. *Untitled,* 1945. Plaster on cardboard, 56,5x39,5 cm.
 (22 1/4x15 1/2 in.) EF 1

DAN FLAVIN (New York City, 1933)

2. *Untitled 1/3,* 1963. Green fluorescent light, 96 in. high. Dwan
 Gallery, New York, November-December 1970. DF 1
5. *The Nominal Three (to William of Ockham) 2/3,* 1963.
 Daylight fluorescent light, 72 in. high. DF 2
3. *Untitled 1/3,* 1963-1966. Cool white (upper lamps) and warm
 white (lower lamps) fluorescent light, 305 cm. (120 in.)
 high. R. Zwirner Gallery, Cologne, September-October
 1966. DF 3.
16. *Untitled (to Henri Matisse) 2/3,* 1964. Pink, yellow, blue and
 green fluorescent light, 96 in. high. DF 4
4. *Gold, Pink and Red, Red 1/3,* 1964. Red, pink and yellow
 fluorescent light, 96 in. long. Green Gallery, New York,
 November-December 1964. DF 5
6. *Ursula's One and Two Picture 1/3,* 1964. Ultra violet
 fluorescent light, 126x81x16 cm. (49 5/8x32x6 1/4 in.) R.
 Zwirner Gallery, Cologne, September-October 1966. DF 6
7. *Untitled (Seven 20 watt fixtures form the arc) 1/3,* 1964.
 Cool white deluxe fluorescent light, 410,5 cm. (161 5/8 in.)
 long. R. Zwirner Gallery, Cologne, September-October
 1966. DF 7
8. *Monument on the Survival of Mrs. Reppin 1/3,* 1966. Warm
 white and red fluorescent light, 213 cm. (84 in.) wide. R.
 Zwirner Gallery, Cologne, September-October 1966. DF 8
9. *Untitled 1/3,* 1966. Cool white fluorescent light, 96 in. wide
 across the corner. N. Wilder Gallery, Los Angeles,
 December 1966. DF 9
11. *Untitled 1/3,* 1966. Cool white fluorescent light, 168 in. wide.
 N. Wilder Gallery, Los Angeles, December 1966. DF 10
7. *Monument for Those Who Have Been Killed in Ambush (to
 P.K. who reminded me about death) 2/3,* 1966. Red
 fluorescent light, 96 in. wide across the corner. The Jewish
 Museum, New York, April-June 1966. DF 11
14. *Untitled (diagonal on the wall),* 1966. Daylight, warm white
 and cool white fluorescent light, 305 cm. (120 in.) long.
 Sperone Gallery, Milano 1967. DF 12
10. *Untitled 6 B,* 1968. Red and green fluorescent light, 120 in.
 high. H. Friedrich Gallery, München, May-July 1968. DF 13
17. *Untitled (to Barbara Nüsse) 8/50,* 1971. Blue and pink
 fluorescent light, 24 in. high, 24 in. wide. DF 14
15. *Green Crossing Green (to Piet Mondrian who lacked green),*
 1966. Green fluorescent light, 264 and 240 in. long approx.
 Stedelijk van Abbemuseum, Endhoven, September-
 December 1966. DF 16
46. *Ultra Violet Fluorescent Light Room,* 1968. Documenta IV°,
 Kassel, 1968. DF 17
 A room with a four corner installation, 1972. DF 18
4. 5. *Varese Corridor,* 1976. Green, pink and yellow fluorescent
18. light. DF 19
13. *An Artificial Barrier of Blue, Red and Blue Fluorescent Light
 (to Flavin Starbuck Judd),* 1968. 660 in. long approx.
 Statische Kunsthalle, Düsseldorf, January-February 1969.
 DF 20
1. *Untitled (to Jan and Ron Greenberg),* 1972-1973. Yellow (one
 side) and green (other side) fluorescent light, 96 in. high.
 DF 21
12. *Kunsthalle, Köln, Installation with circular lights,* 1972. DF 22

HAMISH FULTON (London, England, 1946)

4. *Eight Photographic Works,* 1970. 8 sets of photographs on
 paper, each 30 x 39,5 cm. (12 x 15 1/2 in.) HF 1
2. *Untitled 2/3,* 1972. 2 photographs on paper, 50 x 60 cm. (19 5/8
 x 23 5/8 in.) HF 2
5. *Facing Both ways 2/3,* 1972. 2 photographs wiht text on
 paper, 50 x 60 cm (19 5/8 in. x 23 5/8 in.) HF 3
3. *Dim Trails 2/3,* 1972. 2 photographs with text on paper, 50 x
 60 cm. (19 5/8 in.) HF 4
6. *Untitled (Artist in front of a lake) 2/3,* 1971. 6 photographs
 on paper, 30 x 51 cm. (12 x 20 in.) HF 5
1. *Untitled (4 colour photos of Florida wild life),* 1971,
 Photographs on paper, 23 x 30 cm. (9 x 12 in.) HF 6
116. 117. *Goat Fell Mountain, Isle of Arran, Scotland,* Spring 1970. 10
 7. Set of photographs, 1 drawing and 1 letter concerning the
 work presented in a loose leaf binder, 2 x 8 1/2 x 11 in. HF 7
 9. *Untitled (Landscape with cows),* 1970. 2 photographs, 31 x
 43,5 cm. (12 1/4 x 17 in.) HF 8
 12. *Untitled,* 1970. 2 photographs on paper, 29 x 39,5 cm. (11 1/2 x
 15 1/2 in.) HF 9
 11. *Untitled (4 photos with eagles),* 1970. Photographs on paper,
 31 x 43,5 cm. (12 1/4x 17 in.) HF 10
 115. *Untitled (4 photos with land of stones),* 1970. Photographs on
 paper, 29,5 x 39,5 cm. (11 1/2 x 15 1/2 in.) HF 11
 8. *Untitled (Iceland 1975) 2/3,*Late Spring 1975. 3 photographs
 with text on paper, 39 1/2 x 109 1/8 in. HF 12
 10. *Skyline Ridge 2/3,* Summer 1974. Photograph with text on
 paper, 104,5 x 121,5 cm. (41 x 48 in.) HF 13
 13. *France on the Horizon 1/3,* Early Summer 1975. Photograph
 with text on paper, 101 x 121 cm. (40 x 47 1/4 in.) HF 14
 14. *Looking at Tomorrow (Scottish North West Highlands),* 1974.
 5 photographs with text on paper, each 61 x 85,5 cm. (24 x
 33 1/2 in.) HF 15

GILBERT AND GEORGE (Gilbert Proesch, Dolomite Mountains, Austria, 1943. George Passmore, Totnes Devon, England, 1942)

1. *We Are Only Human Sculptors,* London 1970. Text on paper,
 37x56 cm. (14 1/2x22 in.) Work in edition. GG 1

RAYMOND HAINS (Saint-Brieuc, France, 1926)

1. *Untitled,* 1960. Paper on zinc plate, 32x40 cm. (12 5/8x15 3/4
 in.) H 1

JENE HIGHSTEIN (Baltimore, Maryland, 1942)

27. 28. *Untitled,* 1974. Seamless steel pipe, 1229 cm. (484 in.) long,
 32,39 cm. (12 3/4 in.) inside diameter. JH 1
 4. *Two Horizontals,* 1974. Seamless steel pipe, 2 units, each 420
 in. long and 16 in. diameter. JH 2
 1. *Human Scale Black,* 1975. Steel armature and black cement,
 660 and 600 in. base diameters, 78 in. high. JH 3
 2. *Fresno Aluminium Casting no. 2,* 1974. Unique casting,
 41x14x3 in., 100 lbs. JH 5
 3. *Fresno Aluminium Casting no. 3,* 1974. Unique casting,
 41x14x5 in., 200 lbs. JH 6
 5. *Black Eliptical Cone,* Varese 1976. Wood armature and black
 cement, 230 cm. (90 1/2 m.) and 253 cm. (99 5/8 in.) base
 diameters, 195 cm. (76 3/4 in.) high. JH 7

DOUGLAS HUEBLER (Ann Arbor, Michigan, 1924)

1. *Site Sculpture Project, Times Square Circle Shape,* New York
 City, December 1968. 1 statement 41x34 cm. (16 1/8x13 3/8
 in.), 1 map 33x40 cm. (13x15 3/8 in.), 9 photographs each
 32x37 cm. (12 5/8x14 5/8 in.) DH 1
2. *Duration Piece no. 14,* Salisbury, New Hampshire, October
 1968. 1 statement (4 styrofoam markers) 40x33 cm.
 (15 3/8x13 in.), 3 sets of 4 photographs each 44,5x58 cm.
 (17 1/2x23 in.) DH 2

3. *Variable Piece no. 4,* New York City, November 1968. 1 statement (Closed eyes photographs) 40x34 cm. (15 3/8x13 3/8 in.), 10 photographs each 31,5 x 36,5 cm. (12 1/4x14 3/8in.) DH 3

99. 7. *Location Piece no. 1,* New York - Los Angeles, February 1969. 1 statement (Thirteen States airspace) 40,5x34 cm. (16x13 3/8 in.), 1 map 40,5x70 cm. (16x27 5/8 in.), 13 photographs each 31x36 cm. (12 1/4x14 1/8 in.) DH 4

6. *Location Piece no. 9,* New England, March 1969. 1 statement (Ten mile drive) 40x34 cm. (15 3/8x13 3/8 in.), 11 photographs each 34x30 cm. (13 3/8x11 7/8 in.) DH 5

4. *Location Piece no. 6,* Los Angeles, March 1969. 1 statement (Paper stickers) 40x33 cm. (15 3/8x13 in.), 8 photographs each 30x36 cm. (11 7/8x14 1/8 in.) DH 6

5. *Duration Piece no. 12,* Venice, California - Plum Island, Massachusetts, May 1969. 1 statement (Sand exchange) 40x34 cm. (15 3/8x13 3/8 in.), 2 photographs each 36x31 cm. (14 1/8x12 1/4 in.) DH 7

10. *Location Piece no. 8,* Bradford, Massachusetts, May 1969. 1 statement (Secret) 40x33 cm. (15 3/8x13 in.), 1 text 31x38,5 cm. (12 1/4x15 1/4 in.) DH 8

9. *Location Piece no. 23,* Los Angeles - Cape Cod, August 1969. 1 statement (Ace Gallery transposition) 40 x 33 cm (15 3/8x13 in.), 1 map 33x40 cm. (13x15 3/8 in.), 6 photographs each 37x42 cm. (14 5/8x16 1/2 in.) DH 9

14. *Duration Piece no. 9,* Berkeley, California - Hull, Massachusetts, January-October 1969. 1 statement (Mail sending) 40x33 cm. (15 3/8x13 in.), 1 map 39,5x50 cm. (15 1/2x19 5/8 in.), 9 mail receipts framed 57,5x49 cm. (22 5/8x19 1/4 in.) 1 box 8,5x13x7 cm. (3 3/8x5 1/8x2 3/4 in.) DH 10

13. *Location Piece no. 10,* Bradford, Massachusetts - Los Angeles, California, December 1969. 1 statement (Currency) 40x33 cm. (15 3/8x13 in.), 1 envelope with $5.00 24x35 cm. (9 1/2x13 3/4 in.), 1 xerox copy 33x39 cm. (13x15 3/8 in.) DH 11

8. *Duration Piece no. 16, Global,* December 1969. 1 statement (Spermatozoid) 40,5x34 cm. (16x13 3/8 in.) DH 12

99. 12. *Variable Piece no. 4,* Paris, France, January 1970. 1 statement (Place Kossuth) 33x40 cm. (13x15 3/8 in.), 1 map 71x90 cm. (28x35 1/2 in.), 1 photograph 38x43 cm. (15x17 in.) DH 13

11. *Duration Piece no. 4,* Paris, France, January 1970. 1 statement (One half previous time) 41x31 cm. (16 1/8x12 1/4 in.), 12 photographs each 31x36 cm. (12 1/4x14 1/8 in.) DH 14

16. *Duration Piece no. 5,* Amsterdam, Holland, January 1970. 1 statement (One half previous time) 40,5x34 cm. (16x13 3/8 in.), 12 photographs each 31,5x36 cm. (12 1/2x14 1/8 in.) DH 15

20. *Variable Piece no. 49,* Bradford, Massachusetts - New York City, March 1971. 1 statement (Home-Castelli Gallery trip) 40,5x34 cm. (16x13 3/8 in.), 1 map 34,5x32,5 cm. (13 1/2x12 3/4 in.), 5 sets of 36x4 proof prints each 53x63 cm. (21x24 1/2 in.), 1 photograph 33x38 cm. (13x15 in.) DH 16

15. *Drawing,* 1970. (Sequential process), 14 1/8x12 3/8 in. DH 17

19. *Drawing,* 1970. (Reflecting essence), 14 1/8x12 3/8 in. DH 18

17. *Variable Piece no. 44, Global,* March 1971. Work in process, Giuseppe Panza no. 6/100. Cardboard sheet 18x24 in. with spaces for photographs and statement, 10x8 1/2 in. DH 19

18. *Variable Piece no. 44, Global,* March 1971. Work in process, Giovanna Panza no. 5/100. Cardboard sheet 18x24 in. with spaces for photographs and statement, 10x8 1/2 in. DH 20

ROBERT IRWIN (Long Beach, California, 1928)

1. *Dot Painting,* 1963-1965. One of a series of ten each unique. Acrylic on canvas on board, 82 x 84 in. RI 1

100. *Disc Coloured Pale Grey Green Pink Violet,* 1966-1967. Painted steel disc 152 cm. (60 in.) diameter and 4 placed lamps. RI 2

4. *Plastic Disc,* 1968-1969. One of a series of 18 each unique. Cast acrylic disc with acryl colour coating 135 cm. (53 in.) diameter and 4 placed lamps. RI 3

5. *12' Acrylic Column,* 1970-1971. One of a series of 8 each unique. Poured optical acrylic material, 144 in. high, cross section triangular with 5 facets. RI 4

2. *Scrim (Ace Gallery),* Los Angeles 1972. Transparent nylon material and light, room dimension: 200 x 324 x 336 in. RI 5

3. *Varese Scrim,* 1973. Transparent nylon material, room dimensions: 400 x 400 x 1700 cm. (157 1/2 x 157 1/2 x 670 in.) RI 6

10. *Dividing Wall (The Pace Gallery),* New York, December 1973. Wall height 69 1/2 in., room dimensions: 120 x 660 x 264 in. RI 7

101. 7. *Varese Window Room,* 1973. Room dimensions: 400 x 600 cm. (157 1/2 x 237 in.) RI 8

102. 6. *Varese Portal Room,* 1973. Room dimensions: 500 x 1000 cm. (197 x 394 in.) RI 10

8. *Soft Wall-Scrim Piece (The Pace Gallery),* New York, November 1974. Transparent nylon material and light, room dimensions: 120 x 660 x 264 in. RI 11

9. *Scrim-Fractured Light (Museum of Modern Art),* New York, November 1970 - March 1971. Transparent nylon material and light, room dimensions: 144 x 180 x 360 in. RI 17

PETER JOSEPH (London, England, 1929)

78. *Untitled (Cream colour with brown border),* March 1974. Oil on canvas, 60x105 in. PJ 1

4. *Untitled (Tan colour with dark blue border) I,* June 1974. Oil on canvas, 105x60 in. PJ 2

4. *Untitled (Cream colour with black border) II,* June 1974. Oil on canvas, 105x66 in. PJ 3

78. *Untitled (Grey-blue colour with black border),* November 1974. Oil on canvas, 74x62 in. PJ 4

77. 3. *Untitled (Cream colour with black border),* May 1975. Oil on canvas, 79x66 in. PJ 5

79. *Untitled (Grey with blue border),* 1975. Acrylic on canvas, 80x56 in. PJ 7

77. *Untitled (Cream colour with dark blue border),* 1976. Acrylic on canvas, 76x61 1/2 in. PJ 8

3. *Untitled (Dark cream with blue border),* 1975. Acrylic on canvas, 75x53 in. PJ 9

7. *Untitled (Dulled cream with black border),* October 1975. Acrylic on canvas, 60 1/2 x 106 in. PJ 10

6. *Cream with Maroon Border,* January 1976. Acrylic on canvas, 59 1/2 x 90 in. PJ 11

5. *Cream with Brown Border,* February 1976. Acrylic on canvas, 76 x 54 in. PJ 12

1. *Grey with Ochre Border,* May 1976. Acrylic on canvas, 60 x 85 in. PJ 13

2. *Cream with Ochre Border,* June 1976. Acrylic on canvas, 59 x 92 in. PJ 14

BERNARD JOUBERT (Paris, France, 1946)

1. *Work,* 1974. Three red vertical strips, 120x240 cm. (47 1/4x94 1/2 in.) BJ 1

3. *Work,* 1974. Two red vertical strips, 240x240 cm. (94 1/2x94 1/2 in.) BJ 2

2. *Work,* 1974. Three strips, blue, red and yellow, 200x600 cm. (78 3/4x236 1/4 in.) BJ 3

DONALD JUDD (Excelsior Springs, Missouri, 1928)

13. *Untitled,* 1965. Brown painted aluminium, 30x50x37 in. DSS 122 2/2. DJ 1

10. *Untitled,* 1965. Perforated steel ramp, 8x120x66 in. DSS 131 1/3. DJ 2

54. *Untitled,* 1969. Large stack, solid copper with mirror finish, 10 units, each 9x40x31 in. DSS 204. DJ 3

56. *Untitled,* 1970. Perforated cold rolled steel, 12x138x117 in. DSS 240. DJ 4

5. *Untitled,* 1970. 21'. Fibonacci progression, clear and blue anodized aluminium, 8 1/4 x253x8 in. DSS 223 1/3. DJ 5

53. *Untitled,* 1970. Copper round progression, 5x69x8 1/2 in. DSS 233 3/3. DJ 6

53. *Untitled,* 1966-1972. Large round progression, brass, 14 1/2 x76 1/2 x25 1/2 in. DSS 267 3/3. DJ 7

8. *Untitled,* 1971. Orange painted cold rolled steel boxes, 8 units, each 48x48x48 in. DSS 243. DJ 8
1. *Untitled,* 1972. Brass and red fluorescent plexiglass boxes, 6 units, each 34x34x34 in. DSS 282. DJ 9
12. *Untitled,* 1973. Hot rolled steel tube, 33x48x68 in. DSS 292. DJ 10
53. *Untitled,* 1973. Brass and blue plexiglass, 33x48x68 in. DSS 291. DJ 11
57. 4. *Untitled,* 1972-1973. Open cube series, plywood, 7 units, each 72x72x72 in. DJ 12
7. *Untitled,* May 1972. Open 26,5° parallelogram series, plywood, 5 units, each 72x72x42 in. DSS 265. DJ 13
17. *Untitled,* 1974. 8 closed back units, plywood, each 72x72x72 in. DJ 19
18. *Untitled,* 1974. 8 open back units, plywood, each 48x48x48 in. DJ 20
19. *Double Closed Copper Wall,* 1974. Against one wall, 60 in. high dimensions according to room size. DJ 21
16. *Single Steel Wall Bent,* 1974. 3/8-1/2 in. thick hot rolled steel, along 3 walls, 15 in. apart, 60 in. high, 15 in. bent. DJ 22
3. *Bern Piece no. 2,* Bern 1976. 1/2 - 1 in. thick hot rolled steel, 72 in. approx from walls, dimensions according to room size. DJ 23
9. *Straight Single Tube,* 1974. Hot rolled steel, 60x144x84 in. DJ 24
20. *Wall of Boxes,* 1974. 1/8 in. thick galvanized iron, each unit 50x100x50 cm. (19 3/4x39 3/8x19 3/4 in.), closed back. DJ 25
55. *Eight Hot Rolled Steel Boxes,* 1974. Each 60x60x60 in. DJ 26
52. *Galvanized Iron Wall,* 1974. Along 3 walls, 8 in. apart, 60 in. high. DJ 27
2. *Bern Piece no. 1,* Bern 1976. 1/2-1 in. thick hot rolled steel, 72 in. approx from walls, dimensions according to room size. DJ 28
11. *Raised Top Plywood Piece (Lisson 1),* 1974. 3/4 in. thick, plywood against one wall, dimensions according to room size. DJ 29
6. *Bern Piece no. 3,* Bern 1976. 1/2-1 in. thick hot rolled steel, 72 in. approx from walls, dimensions according to room size. DJ 30
14. *Large Tube, Parallelogram Inside,* 1974. 3 cm. (1 5/16 in.) thick hot rolled steel, 60x180x96 in. DJ 31
15. *Wall of Boxes,* 1974. 1/8-1/4 in. thick cold rolled steel, each unit 50x100x50 cm. (19 3/4x39 3/8x19 3/4 in.) with end recessed 12,5 cm. (5 in.) DJ 32

ON KAWARA (Aichi Prefecture, Japan, 1933)

1. *Oct. 24. 1971,* New York 1971. Today series no. 95. Cardboard box with piece of newspaper and liquitex painted canvas, 25,6x33,2 cm. (10x13 in.) OK 1
3. *Oct. 26. 1971,* New York 1971. Today series no. 97. Cardboard box with piece of newspaper and liquitex painted canvas, 25,2x32,7 cm. (10x12 7/8 in.) OK 2
2. *One Millions Years,* 1970-1971. 10 books each 29,5x23,4x8 cm. (11 5/8x9 5/8x3 1/8 in.) Edition of 12. OK 3
4. *Oct. 29. 1971,* New York 1971. Today series no. 98. Carboard box with piece of newspaper and liquitex painted canvas, 20x25,5 cm. (8x10 in.) OK 4

FRANZ KLINE (Wilkes - Barre, Pennsylvania, 1910 - New York City, 1962)

8. *Tower,* 1953. Oil on canvas, 81x52 in. FK 1 MOCA
2. *Thorpe,* 1954. Oil on canvas, 62x43 1/4 in. FK 2 MOCA
14. *Ilza,* 1955. Oil on canvas, 41 1/4x33 in. FK 3 MOCA
1. *Monitor,* 1956. Oil on canvas, 78 3/4x115 3/4 in. FK 4 MOCA
5. *Buttress,* 1956. Oil on canvas, 46 1/2x55 1/2 in. FK 5 MOCA
4. *Hazelton,* 1957. Oil on canvas, 41 1/4x78 in. FK 6 MOCA
7. *Black and White,* 1957. Oil on canvas, 32x24 in. FK 7 MOCA
15. *Alva,* 1958. Oil on canvas, 40 1/2x36 1/2 in. FK 8 MOCA
11. *Line Through White Oblong,* 1959. Oil on canvas, 60 1/4x81 in. FK 9 MOCA
13. *Orleans,* 1959. Oil on canvas, 101x76 in. FK 10 MOCA
12 *Sabro II,* 1959-1960. Oil on canvas, 62x79 in. FK 11 MOCA
6. *Black Iris,* 1961. Oil on canvas, 108 1/4x79 1/2 in. FK 12 MOCA

3. Drawing, 1957. Oil on paper, 51x72 cm. (20x28 1/4 in.) FK 13
9. Drawing, 1957. Oil on paper, 31x41 cm. (12 1/4x16 1/8 in.) FK 14
14. Drawing, 1957. Oil on paper, 47x39 cm. (18 1/2x15 3/8 in.) FK 15
10. Drawing, 1957. Oil on paper, 28x20 cm. (11x7 7/8 in.) FK 16

JOSEPH KOSUTH (Toledo, Ohio, 1945)

5. *Three Color Sentence,* 1965. Red blue and green neon tubing, 119 cm. (46 7/8 in.) long. JK 1
96. *Self-defined,* 1965. White neon tubing, 30 in. approx. long. JK 2
4. *Five Five's (to Donald Judd),* 1965. White neon tubing, 338 cm. (133 in.) long. JK 3
1. *One and Eight - a Description (Green),* 1965. Green neon tubing, 310 cm. (122 in.) long. JK 4
1. *One and Eight - a Description (Blue),* 1965. Blue neon tubing, 306 cm. (120 1/2 in.) long. JK 5
1. *One and Eight - a Description (Red),* 1965. Red neon tubing, 304 cm. (119 3/4 in.) long. JK 6
95. *Box, Cube, Empty, Clear, Glass - a Description,* 1965. 5 glass cubes with black lettering, each 100x100x100 cm. (40x40x40 in.) JK 7
2. *Clear, Square, Glass, Leaning,* 1965. 4 glass plates with black lettering, each 36 or 60 in. square. JK 8
7. *One and Five (Clock),* 1965. 1 clock, 1 photograph of clock and 3 photographs of definitions (time, clock, object), each 50x50 cm. (20x20 in.) JK 9
94. *Titled (Art as idea as idea),* 1966. Definition of paint in a set of 8 parts printed on cardboard, each 120x120 cm. (47 1/2x47 1/2 in.) JK 11
8. *Titled (Art as idea as idea),* 1967. Definition of ultimate (english) printed on cardboard, 145x145 cm. (57x57 in.) JK 13
95. *Titled (Art as idea as idea),* 1967. Definition of idea (english) printed on cardboard, 145x145 cm. (57x57 in.) JK 14
15. *Titled (Art as idea as idea),* 1967. Definition of meaning (italian) printed on cardboard, 120x120 cm. (47 1/2x47 1/2 in.) JK 15
16. *Titled (Art as idea as idea),* 1967. Definition of silence (italian) printed on cardboard, 120x120 cm. (47 1/2x47 1/2 in.) JK 16
9. 14. *Titled (Art as idea as idea),* 1967. Definition of nothing, printed on cardboard, 120x120 cm. (47 1/2x47 1/2 in.), italian JK 17; english JK 18; german JK 19; spanish JK 20; french JK 21; danish JK 22.
3. *Twenty-five Works in a Contest as One Work (Special investigation),* New York 1968 - Los Angeles 1969. 25 stikers. JK 23
97. *The Eighth Investigation, proposition 3,* 1971. Installation with various material. JK 24
98. *The Tenth Investigation, proposition 4,* 1974. Installation with various material. JK 26
6. *Nine Paintings with Words as Art,* 1966. 9 grey canvas with white word, each 56x95 cm. (22x37 1/2 in.) JK 27

DAVIS LAMELAS (Buenos Aires, Argentina, 1946)

Reading of an Extract from "Labyrinths" by J.L. Borges, 1970. 16 mm. bl/wh film. DL 1

BOB LAW (Brentford, England, 1934)

82. 10. *No. 64 (Purple, plum, black, violet),* 1967. Ink on canvas, 66x69 in. BL 1
11. *No. 84 (Blue, black, black, violet),* 1970. Ink on canvas, 66x69 in. BL 2
14. *No. 85 (Violet, violet, black, violet),* 1970. Ink on canvas, 66x69 in. BL 3
2. *No. 86 (Violet, black, violet),* 1970. Ink on canvas, 66x69 in. BL 4
7. *No. 87 (Violet, black, violet, blue),* 1970. Ink on canvas, 66x69 in. BL 5

13. *No. 82 (Violet, black)*, 1971. Ink on canvas, 66x69 in. BL 6
81. *No. 83 (Crimson, blue, violet, black)*, 1971. Ink on canvas, 66x69 in. BL 7
1. *No. 89 (Mauve, black, blue, black)*, 1974. Ink on canvas, 66x69 in. BL 8
5. *Castle no. 3,* 1975. Acrylic on canvas, 60x63 in. BL 9
4. *Castle no. 7,* July 1975. Acrylic on canvas, 60x63 in. BL 10
6. *Castle no. 10,* August 1975. Acrylic on canvas, 60x63 in. BL 11
9. *Castle XXV,* January 1976. Acrylic on canvas, 60x63 in. BL 12
15. *Castle XXVI,* January 1976. Acrylic on canvas, 60x63 in. BL 13
3. *Castle XXVII,* February 1976. Acrylic on canvas, 60x63 in. BL 14
80. *Castle XXVIII,* February 1976. Acrylic on canvas, 60x63 in. BL 15
8. *Castle XXIV,* December 1975. Acrylic on canvas, 60x63 in. BL 16
12. *Castle XXIX,* March 1976. Acrylic on canvas, 60x63 in. BL 17

SOL LEWITT (Hartford, Connecticut, 1929)

91. 5. *Wall Drawing no. 3,* April 1969. A 40 in. (100 cm.) band of vertical and both sets of diagonal lines superimposed, centered top to bottom, running the lenght of the wall. Black pencil. SL 1
6. *Wall Drawing no. 20,* September 1969. Lines in four directions, each with a different color, superimposed on a wall. Red, yellow, blue, black pencil. SL 2
92. 7. *Wall Drawing no. 262,* Varese, July 1975. All one -, two -, three -, and four-part combinations of lines in four directions and four colors, each within a square. 15 drawings. Red, yellow, blue, black pencil. SL 3
3. *Wall Drawing no. 264,* Varese, July 1975. A wall divided into 16 equal parts with all one -, two -, three -, and four-part combinations of lines and color in four directions. Red, yellow, blue, black pencil. SL 4
20. *Wall Drawing no. 37,* April 1970. Intersecting symmetrical bands of parallel lines 36 in. (90 cm.) wide, in four directions and colors, on four walls progressively. Red, yellow, blue, black pencil. SL 5
9. *Wall Drawing no. 38,* April 1970. Tissue paper cut into 1 1/2 in. (4 cm.) squares rolled and inserted into holes in gray pegboard walls. All holes in the walls are filled randomly. First wall: white. Second wall: white, yellow. Third wall: white, yellow, red. Fourth wall: white, yellow, red, blue. SL 6
18. *Wall Drawing no. 52,* July 1970. Four-part drawing with a different line direction and color in each part. Red, yellow, blue, black pencil. SL 7
19. *Wall Drawing no. 53,* July 1970. Serial drawing with lines in three directions (vertical, horizontal, diagonal-left or diagonal-right) and three colors superimposed in each part. Red, yellow, blue, black pencil. SL 8
2. *Wall Drawing no. 54,* July 1970. Six-part serial drawing with lines in two directions (vertical, horizontal, diagonal-left or diagonal-right) and two colors superimposed in each part. Red, yellow, blue, black pencil. SL 9
10. *Wall Drawing no. 271,* Varese, July 1975. Black circles, red grid, yellow arcs from four corners, blue arcs from the midpoints of four sides (ACG 195). Colored pencil. SL 10
1. *Wall Drawing no. 265,* Varese, July 1975. A wall divided horizontally and vertically into four equal parts, with lines in three directions and three colors in each part. Red, yellow, blue pencil. SL 11.
90. 14. *Wall Drawing no. 266,* Varese, July 1975. Two-part drawing. Grid and arcs from two adjacent corners and the midpoint of one side, between (ACG 118). One drawing has arcs from the bottom. The second drawing has arcs from the top. Black pencil. SL 12
12. *Wall Drawing no. 267-268-269-270,* July 1975. Arcs from four corners and the midpoints of three sides (ACG 47-96-145-194). One room. Black pencil. SL 13
8. *Wall Drawing no. 272,* Varese, July 1975. An increasing number of horizontal lines about 1 in. (2,5 cm.) apart from bottom to top, vertical lines from top to bottom, diagonal right lines from left to right, diagonal left lines right to left. Black pencil. SL 14

89. 11. *Wall Drawing no. 146,* September 1972. All two-part combinations of blue arcs from corners and sides and blue straight, not straight and broken lines. Blue crayon. SL 15
17. *Wall Drawing no. 150,* October 1972. Ten thousand 1 in. (2,5 cm.) lines evenly spaced on each of six walls. Black pencil. SL 16
13. *Wall Drawing no. 151,* January 1973. All combinations of a single line in four directions (15 parts). Black crayon. SL 17
16. *Wall Drawing no. 152,* January 1973. Three-part drawing. First wall: straight horizontal lines. Second wall: not straight horizontal lines. Third wall: broken horizontal lines. Lines about 2 in. (5 cm.) apart. Black pencil. SL 18
15. *Wall Drawing no. 176,* May 1973. A horizontal line from left side (more than half way, less than all the way). Red crayon. SL 19
4. *Wall Drawing no. 24,* September 1969. Drawing Series B on aluminum box. One series on each face. Black pencil and white painted aluminum box, 72x48 in. (180x120 cm.) SL 20

ROY LICHTENSTEIN (New York City, 1923)

1. *Cézanne,* 1962. Acrylic on canvas, 70x48 1/2 in. RL 1 MOCA
26. *Desk Calendar,* 1962. Acrylic on canvas, 48 1/2 x68 in. RL 2 MOCA
25. *Meat,* 1962. Acrylic on canvas, 21 1/4x25 1/4in. RL 3 MOCA
2. *The Grip,* 1962. Acrylic on canvas, 30x30 1/4 in. RL 4 MOCA

RICHARD LONG (Bristol, England, 1945)

1. *Square Wood Sculpture,* 1967 420 twig pieces, each 15 cm. (6 in.) long, 210 x 210 cm. (83 x 83 in.) RLO 1
3. *Untitled-England,* 1967. 2 photographs, 51 x 101 cm. (20 x 40 in.) RLO 2
6. *Sculpture Untitled, June 1968 England,* 1968. 2 photographs, 37 x 63 cm. (14 1/2 x 25 in.) RLO 3
2. *Sculpture at Galerie Lambert,* Milano 1969. Pine needles, 443 x 335 cm. (175 x 132 in.) RLO 4
8. *A sculpture by Richard Long,* Wiltshire, 12-15 October 1969. Map with text, 35 x 33 cm. (14 x 13 in.) RLO 5
7. *2 1/2 Mile Walk Sculpture,* 1969. Photograph and text on paper, 18 x 20 cm. (7 x 8 in.) RLO 6
4. *Sculpture at Sperone Gallery,* 1973. Paint on floor, 1500 x 600 cm. (591 x 236 in.) RLO 7
5. *Sculpture at Konrad Fischer,* Dusseldorf, July 1969. Pine needles, 850 x 280 cm. (335 x 110 1/4 in.) RLO 8
119. *Stone Circle,* Roma 1976. About 105 stones, 218 cm. (86 in.) diameter. RLO 9
118. *Stone Circle,* Roma 1976. About 182 stones, 220 cm. (87 in.) diameter. RLO 10

ROBERT MANGOLD (North Tonawanda, New York, 1937)

59. 25. *Neutral Pink Area,* 1966. Oil on masonite, 48x96 in. RMA 1
27. *Elipse Within a Square (Grey),* 1972. Acrylic on canvas, 72x72 in. RMA 2
5. *Incomplete Circle no. 1 (Yellow),* 1972. Acrylic on canvas, 60x60 in. RMA 3
8. *Incomplete Circle no. 2 (Brown),* 1972. Acrylic on canvas, 60x60 in. RMA 4
60. *Circle Painting 1 (Yellow),* 1972. Acrylic on canvas, 72 in. diameter. RMA 5
11. *Circle Painting 2 (Grey-violet),* 1973. Acrylic on canvas, 72 in. diameter. RMA 6
60. 16. *Circle Painting 3 (Green-grey),* 1973. Acrylic on canvas, 72 in. diameter. RMA 7
58. 1. *Circle Painting 6 (Dark-red),* 1973. Acrylic on canvas, 72 in. diameter. RMA 8
58. *Distorted Square Within a Circle (Dark-red),* 1973. Acrylic on canvas, 48 in. diameter. RMA 9
61. 30. *Distorted Square Within a Circle (Yellow),* 1973. Acrylic on canvas, 20 in. diameter. RMA 10

61. 21. *Distorted Square Within a Circle (Violet)*, 1973. Acrylic on canvas, 20 in. diameter. RMA 11

9. *Distorted Square Circle 10 (Grey-blue)*, 1973. Acrylic on masonite, 16x16 in. RMA 12

3. *Distorted Square Circle 7 (Green)*, 1973. Acrylic on masonite, 15x15 in. RMA 13

23. *Blue Grey Distorted Circle*, 1973. Acrylic on canvas, 72x72 in. RMA 14

24. *Untitled (Yellow)*, 1973. Acrylic on canvas, 72x72 in. RMA 15

6. *Untitled (Brown)*, 1973. Acrylic on canvas, 72x72 in. RMA 16

10. 26. *Circle In and Out of a Polygon II (Blue)*, 1973. Acrylic on canvas, 72x72 in. RMA 17

29. *180° Arc Within a Square (Yellow)*, 1973. Acrylic on masonite, 14x14 in. RMA 18

15. *Two 90° Arc Within a Square (Pink)*, 1973. Acrylic on masonite, 14x14 in. RMA 19

17. *Untitled (Cream)*, 1973. Acrilic on canvas, 48x48 in. RMA 20

28. *Untitled (Ochre)*, 1973. Acrylic on canvas, 48 1/4x50 1/4 in. RMA 21

22. *Untitled (Blue-green)*, 1973. Acrylic on canvas, 48 1/4x46 1/4 in. RMA 22

20. *Untitled (Study for a larger work)*, 1973. Acrylic on canvas, 36x36 in. RMA 23

18. *Untitled (Blue-grey)*, 1973. Acrylic on canvas, 84x84 in. RMA 24

14. *Square Within a Square (Yellow)*, 1974. Acrylic on canvas, 60x60 in. RMA 25

7. *Square Within a Rectangle I (Orange)*, 1974. Acrylic on canvas, 63x60 3/8 in. RMA 26

4. *Square Within a Rectangle (Blue-grey)*, 1974. Acrylic on canvas, 63 3/8x60 in. RMA 27

2. *Square Within a Square (Warm green)*, 1974. Acrylic on canvas, 60x60 in. RMA 28

19. *Distorted Square Within a Circle 1 (Yellow)*, 1973. Lithograph 54/75, 27 1/2x27 1/2 in. RMA 29

12. *Distorted Square Within a Circle 2 (Violet)*, 1973. Lithograph 54/75, 27 1/2x27 1/2 in. RMA 30

13. *Distorted Square Within a Circle 3 (Grey-green)*, 1973. Lithograph 54/75, 2 1/2x27 1/2in. RMA 31

61. *Circle Painting 6 (Dark-red)*, 1973. Acrylic on canvas, 17 3/4 in. diameter. Model. RMA 32

59. 25. *One-Third Grey Curved Area*, 1966. Sprayed oil on masonite, 48x84 in. RMA 33

BRICE MARDEN (Bronxville, New York, 1938)

6. *Private Title*, 1966. Oil and wax on canvas, 48x96 in. BM 1

1. *Paris Painting*, 1969. Oil and wax on canvas, 2 panels, 72x48 in. BM 2

68. *D'après la Marquise de la Solana*, 1969. Oil and wax on canvas, 3 panels, 77x117 in. BM 3

3. *Tour*, 1970-1971. Oil and wax on canvas, 2 panels, 96x48 in. BM 4

2. *To May Madness*, 1972. Oil and wax on canvas, 2 panels; 72x72 in. BM 5

5. *Sea Study (Blue-grey)*, 1972-1973. Oil and wax on canvas, 2 panels, 72x48 in. BM 6

69. *Adriatic*, 1972-1973. Oil and wax on canvas, 2 panels, 72x108 in. BM 7

7. *Untitled*, 1973. Oil and wax on canvas, 2 panels, 72x72 in. BM 8

4. *Passage*, 1973-1974. Oil and wax on canvas, 3 panels, 74x72 in. BM 9

MAURIZIO MOCHETTI (Rome, Italy, 1940)

10. *Sfera con movimento verticale pseudo perpetuo*, 1969. Nylon string, fiberglass sphere with mechanism for continuous vertical movement 7,5 cm. (3 in.) diameter. Edition of 5. MM 1

9. *Generatrice*, 1968. Aluminium pole with mechanism for continuous rotation 2 cm. (3/4 in.) diameter and 241 cm. (95 in.) high. Edition of 3. MM 2

11. *Asse oscillante*, 1968-1969. Aluminium pipe containing a steel sphere with mechanism for continuous oscillation 2 cm. (3/4 in.) diameter and 397 cm. (148 1/2 in.) long. Edition of 2. MM 3

12. *O → X → O*, 1969. Illuminous line projector, 35 x 20 x 11 cm. (14 x 8 x 4 1/2 in.) Edition of 4. MM 4

7. *Cilindri luce-suono*, 1969. Two aluminium cylinders, one emitting an illuminous impulse the other an ensuing sound, each 30 cm. (12 in.) diameter. Edition of 3. MM 5

5. *Punto di luce*, 1969-1970. Rotary spot of light projector, 23 cm. (9 in.) diameter and 8 cm. (3 1/4 in.) high. Edition of 3. MM 6

6. *Elastico estensibile*, 1969. Floor to ceiling vertical elastic string, box with mechanism for stretching 4,5 x 10 x 10,5 cm. (1 3/4 x 4 x 4 1/8 in.). Edition of 3. MM 7

4. *Contatore di persone*, 1971. Counter of the increasing or decreasing number of persons in a space. Edition of 5. MM 10

8. *Specchio Ø 10 mm.*, 1972. Mirror 1 cm. (3/8 in.) diameter on the floor and dot 2 cm. (3/4 in.) diameter on the ceiling. Edition of 5. MM 11

2. *Grande specchio con punto opaco*, 1970-1976. Reflecting surface wall with black opaque dot at 160 cm. (63 in.) from floor. MM 12

1. *Specchio con sorgente luminosa 1/5*, 1974. Mirror 2 cm. (3/4 in.) diameter related with illuminous source. MM 13

3. *Linea di mercurio 1/5*, 1974-1976. Glass pipe filled with mercury 0,8 cm. (3/8 in.) diameter related with illuminous source. MM 14

ROBERT MORRIS (Kansas City, Missouri, 1931)

6. *Untitled (Corner piece)*, 1964. Grey painted plywood, 78 in. high, 108 in. wide RM 1

4. *Untitled (Long wedge)*, 1966. Grey painted plywood, 12x384x12 in. RM 2

20. *Untitled (Waped bench)*, 1965. Fiberglass, 18x96x18 in. RM 3

3. *Untitled (Door stop)*, 1965. Fiberglass, 24x192x12 in. RM 4

1. *Untitled (4 wedges)*, 1967. Fiberglass, each 47x48x47 1/2 in. RM 5

29. 1. *Untitled (4 round wedges)*, 1967. Fiberglass, each 47 1/2x85x47 1/2 in. RM 5A

34. *Untitled (Aluminum I-beams)*, 1967. 54x104x104 in. RM 6

7. *Untitled (16 steel boxes)*, 1967. Each 36x36x36 in., overall 36x252x252 in. RM 7

8. *Untitled (Steel grating)*, 1967. 31x109x109 in. RM 8

2. *Untitled (Aluminum grating)*, 1969. 10 expanded aluminum units, each 63x42x61 1/2 in. Overall 63x126x468 in. RM 9

35. *Untitled*, 1968. Aluminium grating 1/4x6 in. 1/4x3 in. elements, 4 central units 96x96 in. additional perifheral units. RM 10

Untitled (8 wedges), 1972. Cast aluminum, 5x5 and 5x7 1/2 in. Model. Edition of 25/9. RM 13

10. *Untitled (Brown felt)*, 1973. 194x431x2 cm. (76 3/8x169 5/8x3/4 in.). RM 14

21. *Untitled (Black felt)*, 1973. 6 strips, each 30x680 cm. (11 3/4x267 3/4 in.). RM 15

18. *Untitled (Pink felt)*, 1970. 63 pieces of different size. RM 16

9. *Untitled (Five timbers)*, 1969. Each 12x144x12 in. RM 18

33. *Untitled (1/2 round piece)*, 1967. Grey painted plywood, 48x144x144 in. RM 19

17. *Untitled (Grey wedge)*, 1966. Grey painted plywood, 72x120x72 in. RM 20

13. *Untitled (Steel plate on granite column)*, 1969. Plate 120x120x3 in., red granite cylinder 120 in. long and 18 in. diameter. RM 21

19. *Untitled (4 steel plate piece)*, 1969. Each 60x120x2 in. RM 22

16. *Untitled (4 steel plate piece)*, 1969. Each 36x120x2 in. RM 23

31. 15. *Untitled (3 steel plate piece)*, 1969. 2 plates each 60x120x2 in., 1 plate 54x120x2 in. RM 24

31. *Untitled (5 steel plate piece)*, 1969. Each 60x120x2 in. RM 26

32. *Untitled (Aluminum I-beams)*, 1967. 66x306x402 in. RM 27

30. *Philadelphia Labyrinth*, 1974. 96 in. high, 360 in. diameter. RM 28

12. *Triangular Labyrinth*, 1973. RM 29

14. *War Memorial*, 1970. Large cross-shaped trench with stream. RM 30

11. *War Memorial,* 1970. Steel ball and trench. RM 31

29. 1. *Untitled (Piece with battered sides),* 1966. Grey painted plywood, 48x96x96 in. RM 32

5. *Untitled (Square donut),* 1968. Fiberglass, 72x96x18 ½ in. RM 33

BRUCE NAUMAN (Fort Wayne, Indiana, 1941)

20. *Untitled,* 1964-1965. Oil on shaped canvas, 168x32 cm. (66x12½ in.) BN 1

4. *Untitled,* 1965-1966. Latex rubber with cloth backing, 96x50x3½ in. BN 2

10. *Untitled,* 1966. Black fiberglass, 211x9x5 cm. (83x3½x2 in.) BN 3

1. *Piece in Which One Can Stand,* 1966. Laquered metal, 22x69x44 cm. (8¾x27¼x17¼ in.) BN 4

6. *Device for a Left Armpit,* 1967. Copper painted plaster, 14x7x10 in. BN 5

51. *My Last Name Exaggerated Fourteen Times Vertically,* 1967. Pale purple neon tubing, 63x33 in. BN 6

2. *Lighted Centerpiece,* 1968. 4 lamps each 1000 watts on aluminium plate, 107x107 cm. (42x42 in.) BN 7

11. *Hologram (Making Faces),* 1968. Holographic image on glass, 8x10 in. BN 8

5. *Hologram (Making Faces),* 1968. Holographic image on glass, 8x10 in. BN 9

3. *Hologram (Full Figure Poses),* 1969. Holographic image on glass, 8x10 in. BN 10

16. *Lighted Performance Box,* 1969. Aluminium box with 1000 watts spot light, 78x20x20 in. BN 11
 Art Makeup, 1967-1968. Four 16 mm color films. BN 12

22. *Performance Corridor,* 1968-1970. Wallboard, 96x240x20 in. BN 13

7. *Sound Breaking Wall,* 1969. Wallboard, tape and speakers, 108x288 in. BN 14

8. *Touch and Sound Walls,* December 1969. Wallboard, microphons and speakers, 108x156 and 108x240 in. approx. BN 15

14. *Sound Wedge (Double wedge),* 1969-1970. Wallboard and acoustic material, 96 in. or more high, 336x60 in. BN 16

22. *Live-Taped Video Corridor,* 1969-1970. Wallboard, camera, videotape and 2 monitors, ceiling high, 384x20 in. BN 17

22. *Parallax Corridor,* 1969-1970. Wallboard, 96x144x2 in. BN 18

26. *Video Surveylance Piece (Public room-private room),* 1969-1970. 2 rooms with a camera and a monitor each. BN 19

19. *Diagonal Sound Wall,* February 1970. Wallboard and acoustic material, 96 in. high, 420 in. long approx. BN 20

24. *Video Corridor (for San Francisco),* January 1970. 2 cameras and 2 monitors, 480 in. minimum apart. BN 21

9. *Two Fans Corridor,* January 1970. In an existing room, wallboard and 2 fans, ceiling high, 24 in. wide approx. BN 22

15. *Four Fans Room (Enclosed),* 1970. Wallboard and 4 fans, 120 in. high, 192 to 240 in. square. BN 23

47. *Green Light Corridor,* 1970. Wallboard and green fluorescent light, 120x480x12 in. BN 24

17. *Performance Parallelogram (Rolling),* 1970. Plywood and 2 mirrors, basement 25 cm. (10 in.) high, platform 500 cm. (197 in.) long and 220 cm. (87 in.) wide, mirrors 60 cm. (24 in.) high. BN 25

18. *Yellow-Blue-Yellow Corridor on Three Sides of a Room,* 1970. Wallboard and yellow and blue fluorescent light, 120 in. high, 12-20-10 in. wide. BN 26

31. *None Sign Neon Sign,* 1970. Ruby-red and cool-white neon tubing, 13x24¼ in. Edition of 6. BN 27
 Violin-Jumping Ball , 1971. Film. BN 28

30. *Triangle Room,* 1980. Plywood board and 3 yellow sodium vapor lamps, cadmium-red painted inside, one wall 120x360 in. and two 120x240 in. each. BN 29

13. *Parallax Room with Three Horizontal Bars,* 1971. Plaster walls and 3 in. square steel plate bars, white painted inside, 300x800x400 cm. (118x316x158 in.) BN 30

49. 50. *Pink and Yellow Light Corridor (Variable Lights),* 1972. Pink and yellow fluorescent light, dimensions according to room size. BN 31

29. *Double Wedge Corridor (with mirror),* 1970-1974. Wallboard and mirror, white painted inside, ceiling high, 336x60 in. BN 32

32. *Spinning Spheres (Film installation),* 1970. Colour film and 4 endless projectors. BN 33

28. *Compression and Disappearance,* 1974. Tape 3,8 cm. (1½ in.) wide sticked on floor up to wall, space required 224,5x460x822 cm. (88½x181x324 in.) BN 34

27. *Floating Room (Light outside, dark inside),* 1972. In an existing room, wallboard and fluorescent light. Inside room: 192x192 in., walls 96 in. high and 5 in. from the floor. BN 35

21. *Eliptical Space (Kassel Corridor),* 1972. Wallboard, 450 cm. (177 in.) high, 1452 cm. (572 in.) long. BN 36

25. *Acoustic Corridor (Castelli Gallery),* 1973. Wallboard and acoustic material, dimensions according to room size. BN 37

48. *Yellow Room (Triangular),* 1973. Wallboard and yellow fluorescent light, 3 walls 120x216 in. each. BN 38

23. *Double Doors - Projection and Dispacement,* 1973. Wallboard, 360x800x400 cm. (142x316x158 in.) BN 39

33. *False Silence,* 1975. Wallboard and tape. Corridor with 2 triangular rooms. Corridor ceiling high, 792 in. long and 15 in. wide. Top triangle base 216 in. and height 132 in. Bottom triangle: base 264 in. and height 108 in. BN 40

12. *Forced Perspectives: Open Mind, Closed Mind, Parallel Mind, Equal Mind (allegory and symbolism),* 1975. 64 stone blocks (rhomboids) of four different sizes. Overall 372x120 in. BN 42

RICHARD NONAS (New York, 1936)

1. *The Venus of the South,* Bari, January 1975. Steel, 12x120x17 cm. (4 ¾x47 ¼x6 ¾ in.) RN 1

2. *Southern Boundry,* Bari, January 1975. Steel, 2 pieces, each 7x240x3,5 cm. (2 ¾x94 ½x1 ⅜ in.) RN 2

3. *Southern Shortline,* New York 1974. Steel, 2 pieces, each 5 1/16x24x5/32 in. RN 3

4. *Untitled,* Bari, January 1975. Wood, 15,5x128x20 cm. (6 ⅛x50 ⅜x7 ⅞ in.) RN 4

8. *Boundry Man,* 1974. Steel, 2 bars in 2 adjacent rooms, 684 in. long (6 sections) and 570 in. long (5 sections), each section 2 ½x114x1 ½ in. RN 5

5. *Great Eastern,* 1972. Wood, 4 sections, 16x50x60 in. RN 7

7. *Jaw Bone,* 1973. Wood, 3 sections, one 12x312x8 in. and two 12x204x8 in. each. RN 8

9. *Fresno Shortline,* 1974. Wood, 5 sections, 24x600x14 in. RN 9

12. *Stopper Bar (Down),* 1974. Steel, 3 sections, 3 ½x49 ½x2 ¼ in. RN 10

15. *Pia-Oik,* 1975. Wood, 2 sections, each 18x96x18 in., placed 240 in. apart. RN 11

13. *Edge,* 1975. Steel, 2 sections, each 2x42x6 in., placed 42 in. apart. RN 12
 Untitled, 1975. Brass, 0,5x12x0,45 cm. (3/16x4 ¾x3/16 in.) RN 13

6. *Salita Nord no. 1 (1 down),* 1974. Steel, 4 sections, 4x160x160 cm. (1 ¾x63x63 in.) RN 14

11. *Salita Nord no. 2 (Fault line),* 1974. Steel, 3 sections, 4x113x200 cm. (1 ¾x44 ½x79 in.) RN 15

16. *Genoa Flat (Stopped bar series),* 1974. Steel, 3 sections, 6x160x20 cm. (2 ⅝x63x7 ⅞ in.) RN 16

10. *Down in Front,* 1974. Steel, 2 sections, 6x70x20 cm. (2 ⅝x27 ½x7 ⅞ in.) RN 17

16. *Genoa Slot Series (2 down 2 up),* 1974. Steel, wall sculpture, 4 sections, 5,4x100x7,5 cm. (2 ⅛x39 ⅜x2 ½ in.) RN 18

14. 16. *Genoa Slot Series (1 up 1 down),* 1974. Steel, wall sculpture, 3 sections, 5,4x100x7,5 cm. (2 ⅛x39 ⅜x2 ½ in.) RN 19

16. *Genoa Slot Series (2 up),* 1974. Steel, wall sculpture, 3 sections, 3,6x100x7,5 cm. (1 ¾x39 ⅜x2 ½ in.) RN 20

16. *Salita Nord no. 3 (2 down),* 1974. Steel, 5 sections, 4x180x160 cm. (1 ¾x70 ⅞x63 in.) RN 22

16. *Southern Flats,* 1974. Wood, wall sculpture, 0,75x75x9 cm. (5/16x29 ½x3 ½ in.) RN 23

19. *Southern Cork,* Bari, January 1975. Steel, 2 pieces in a corner, each 17x12x12 cm. (6 ¾x4 ¾x4 ¾ in.) RN 24

17. *Bari Shortline,* Bari, January 1975. Wood, 3 sections, 33x257x21 cm. (13x101x8 1/4 in.) RN 25
20. *Scarp,* 1975. Steel, 2 sections, 6x48x48 in. RN 26
18. *Shortline Flats,* 1974. Steel, 1/8x144x6 in. RN 27
21. *Stopped Bar Series (Straight up),* 1975. Steel, 3 sections, 6 1/2x54 1/2x5 in. RN 28
26. *Shortline Series, Moskutz' Brow,* 1974. Steel, wall sculpture, 1x75x6 in. RN 29
25. *Blue Line,* 1974. Blue coloured steel, 3 sections, 2 1/2x83x1 1/2 in. RN 30
24. *H Beam Shortline,* 1974. Steel, 6x48x6 in. RN 31
22. *Inlet,* 1973. Wood, 9 sections, 6x156x72 1/2 in. RN 32
23. *Mound,* 1975. Wood, 10 sections, 4x80x76 in. RN 34
29. *The Venus of the Table,* 1974. Steel, 2,5x23x11 cm. (1x9x4 3/8 in.) RN 35
28. *Drive (Shortline series),* 1976. Steel, 8x1640x20 cm. (3 1/8x642x7 7/8 in.) RN 36
31. *The Circle of Giotto (San Francisco's Dance),* Spoleto 1976. Steel, 4 sections, 5x125x60 cm. (2x49 1/4x23 1/4 in.) RN 39
32. *The Death of San Francisco (Giotto's Hat),* Spoleto 1976. Steel, 3 sections, 5x125x125 cm. (2x49 1/4x49 1/4 in.) RN 40
27. *Cesarino's Bone (Maria's Mirror),* 1976. Steel, 5 units, 8x740x1090 cm. (3 1/8x291 3/8x429 1/8 in.) RN 41
Varese Cut-Off (House Pets), 1976. Steel, 2 pieces each in 2 units, each unit 5x20x5 cm. (2x7 7/8x2 in.) RN 42
30. *House Pet (Varese Cut-Off),* 1976. Steel, 2 sections, 3x36,5x11 cm. (1 1/8x14 3/8x4 3/8 in.) RN 43

MARIA NORDMAN (Goerlitz, East Germany, 1943)

4. *Irwine Room,* 1973. An existing room with a current entry made for the person, the light, the sound. Entering at ground level with 51 feet entrance, beginning 22 inches wide opening to 5 feet, with a floor to ceiling mirror (second image of entry) dividing the room in two diagonal light room touching a dark room. MN 1
2. *Toselli Room,* Milano 1974. With the given light and with the given sound in a city dark entry way (280 x 880 x 480 cm.) light entrance area not directly lighted (880 x 309 x 480 cm.) MN 2
8. *June 22 Azimuth,* 1974. With the given daylight and with the given sound at the edge of a city, 112 x 441 x 149 in. MN 3
7. *Open White Room - Closed Dark Room,* 1974. With the given light and with the given sound at the edge of a city, each room 144 x 324 x 324 in. MN 4
1. *Room Determined by One Istant of Light,* New Port Beach 1973. Negative light extensions with the given daylight and with the given Sound in a city. MN 5
6. *Room with 1 1/2 in. Opening to Skylight,* Pasadena 1972. 154 1/2 to 156 in. high, 312 x 156 in. MN 6
3. *Varese Room,* 1976. With the given daylight and the given sound for one or two people. Two antirooms with doors (dimensions 77 x 206 cm. each with transparent mirror at eye level). Each antiroom opens in a larger (given) room which warries two bodies of daylight entering parallel with the antirooms (from ground level, each 579 x 303 x 428 cm.). Between both is an area without direct light from outside (579 x 303 x 428 cm.) MN 12
5. *Villa Scheibler Proposal I,* 1976. A room open to changing condition from the west, changing condition from the east. 1550 x 480 cm. (610 1/2 x 189 in.) MN 13
9. *Villa Scheibler Proposal II,* 1976. Two equal sized rooms (using existing doors and windows). East room with direct sun light and sound/antiroom without; south room without/antiroom with direct sun light and sound. 810 x 620 cm. and 610 x 670 cm. (319 x 244 in. - 240 x 264 in.) MN 14

CLAES OLDENBURG (Stockholm, Sweden, 1929)

22. *Mu Mu,* 1961. Enamel on plaster, 64x41 1/2x4 in. CO 1 MOCA
8. *Pentecostal Cross,* 1961. Enamel on plaster, 52 3/4x40 1/2x6 in. CO 2 MOCA
12. *Fragment of Candies in a Box,* 1961. Enamel on plaster, 44x32x6 in. CO 3 MOCA

3. *Bride,* 1961. Enamel on plaster, 61x37 1/2x35 1/2 in. CO 4 MOCA
13. *Blue and Pink Panties,* 1961. Enamel on plaster, 62 1/4x34 3/4x6 in. CO 5 MOCA
9. *Cigarette Fragment,* 1961. Enamel on plaster, 32 3/4x30 3/4x6 3/4 in. CO 6 MOCA
23. *Pepsi-Cola,* 1961. Enamel on plaster, 58 1/4x46 1/2x7 1/2 in. CO 7 MOCA
10. *A Brown Shoe,* 1961. Enamel on plaster, 23 1/2x43 1/4x5 in. CO 8 MOCA
11. *Green Stocking,* 1961. Enamel on plaster, 43 1/4x18x4 in. CO 9 MOCA
1. *White Shirt on Chair,* 1962. Enamel on plaster and mixed media, 39 3/4x30x25 1/4 in. CO 10 MOCA
4. *Umbrella and Newspaper,* 1962. Enamel on mixed media, 38 1/2x19 1/2x6 in. CO 11 MOCA
5. *Hamburger,* 1962. Enamel on plaster, 7x9x9 in. CO 12 MOCA
6. *Pie à la Mode,* 1962. Enamel on plaster, 22x18 1/2x11 3/4 in. CO 13 MOCA
2. *Blue Pants on Chair,* 1962. Enamel on plaster and wood, 37x17x26 3/4 in. CO 14 MOCA
7. *Tennis Shoes,* 1962. Enamel on plaster, 24x24x10 in. CO 15 MOCA
24. *Breakfast Table,* 1962. Enamel on plaster and wood, 34 1/2x35 1/2x34 1/2 in. CO 16 MOCA

ROMAN OPALKA (Abbeville, France, 1931)

1. *460.260-464.052,* 1965. Acrylic on canvas, 195x145 cm. (77x57 in.) RO 1

DENNIS OPPENHEIM (Mason City, Washington, 1938)

Various material presented in a paperboard box (38 x 38 x 21 cm. - 15 x 15 x 8 1/4 in.) form one work. DO 1:
Cancelled Crop/Finsterwhode Holland, 1969. Plastic bag with seeds inside, 42 x 27 cm. (16 1/2 x 10 3/4 in.)
Exhibit E Calf, 1969. Leather sheet, 85 x 70 cm. (33 1/2 x 27 1/2 in.)
Exhibit BI Calf, 1969. Leather sheet, 69 x 51 cm. (27 1/4 x 20 in.)
Exhibit Calf, 1969. Steel brand, 13 cm. (5 1/8 in.) diameter and 2 cm. (3/4 in.) thick.
The Artist View Point, December 4, 1969. Text and tape.
Untitled, 1967-1968. 20 slides of various scupltures.
Gallery Heat in Slowly Replaced by Exterior Temperature Proposal, 1968. Booklet with 4 calendar pages of Jan. 1969, 33 x 28 cm. (13 x 1 in.)
Removal Project, 1968. 6 pages booklet, 25 x 24 cm. (10 x 9 1/2 in.)
Gallery Art, June 1967. 5 pages booklet, 28 x 29 cm. (11 x 11 1/2 in.)
Untitled, June 1968. 8 colour photographs on cardboard, each 27 x 27 cm. (10 5/8 x 10 5/8 in.)
Untitled, 1968-1970. 37 colour photographs on cardboards, each 34 x 26,5 cm. (13 1/2 x 10 1/2 in.)

ERIC ORR (Covington, Kentucky, 1939)

Zero Mass, 1974. Paper room installation, 144 x 480 x 138 in. EO 1

LUCIO POZZI (Milan, Italy, 1935)

Level Group, 1975. Acrylic on canvas, 2 panels, each 17 3/16 x 11 1/2 in., depth: 3 1/2 in. (left) and 2 3/4 in. (right) LP 1
Level Group, 1975. Acrylic on canvas, 2 panels, each 17 3/16 x 11 1/2 x 5 1/4 in. LP 2
Level Group, 1975. Acrylic on canvas, 2 panels, each 17 3/16 x 11 1/2 in., depth: 2 5/8 in. (left) and 3 1/2 in. (right). LP 3

Level Group, 1975. Acrylic on canvas, 2 panels, each 17³/₁₆ x 11¹/₂ x 2¹/₂ in. LP 4

Level Group, 1975. Acrylic on canvas, 2 panels, each 17³/₁₆ x 11¹/₂ x ¹/₂ in. LP 5

ROYDEN RABINOWITCH (Toronto, Canada, 1943)

Barrel Sculpture, 1964. Wood, 90 x 89 cm. (35¹/₂ x 35 in.) RRA 1

MARIO RADICE (Como, Italy, 1900-1987)

1. *Untitled,* 1956. Oil on wood, 4 panels, each 146x65x4 cm. (57 ¹/₂x25 ¹/₂x1 ¹/₂ in.) MRA 1

ROBERT RAUSCHENBERG (Port Arthur, Texas, 1925)

17. *Untitled Combine,* 1955. Mixed media, 86 ¹/₂x37x26 ¹/₄ in. RR 1 MOCA
16. *Interview,* 1955. Mixed media, 72 ³/₄x49 ¹/₄ in. RR 2 MOCA
2. *Small Rebus,* 1956. Mixed media, 35x46 in. RR 3 MOCA
3. *Factum I,* 1957. Mixed media, 61 ¹/₂x35 ³/₄ in. RR 4 MOCA
19. *Coca-Cola Plan,* 1958. Mixed media, 26 ³/₄x25 ¹/₄x4 ³/₄ in. RR 5 MOCA
18. *Painting with Grey Wing,* 1959. Mixed media, 31x21 in. RR 6 MOCA
7. *Kickback,* 1959. Mixed media, 75x32 in. RR 7 MOCA
5. *Gift for Apollo,* 1959. Mixed media, 43 ³/₄x29 ¹/₂ in. RR 8 MOCA
6. *Inlet,* 1959. Mixed media, 84 ¹/₂x48 ¹/₂ in. RR 9 MOCA
1. *South Carolina Fall,* 1961. Mixed media, 55x20 in. RR 10 MOCA
4. *Trophy III,* 1961. Mixed media, 96x65 ³/₄ in. RR 11 MOCA

JAMES ROSENQUIST (Grand Forks, North Dakota, 1933)

5. *White Cigarette,* 1961. Acrylic on canvas, 60 ¹/₂x35 ³/₄ in. JR 1 MOCA
1. *Push Button,* 1960-1961. Acrylic on canvas, 82 ³/₄x105 ¹/₂ in. JR 2 MOCA
3. *Capillary Action,* 1962. Acrylic on canvas, 92 ¹/₂x136 ¹/₄ in. JR 3 MOCA
21. *Waves,* 1962. Acrylic on canvas, 56x77 in. JR 4 MOCA
2. *A Lot to Like,* 1962. Acrylic on canvas, 92 ¹/₂x203 in. JR 5 MOCA
20. *Vestigial Appendage,* 1962. Acrylic on canvas, 72x93 ¹/₄ in. JR 6 MOCA
6. *Noon,* 1962. Acrylic on canvas, 36 ¹/₄x48 ¹/₂ in. JR 7 MOCA
4. *Shave,* 1964. Acrylic on canvas, 58 ¹/₄x50 ¹/₂ in. JR 8 MOCA

MARK ROTHKO (Dvinsk, Russia, 1903 - New York City, 1970)

5. *Brown, Blue, Brown on Blue,* 1953. Acrylic on canvas, 115 ³/₄x91 ¹/₄ in. MR 1 MOCA
2. *Violet and Yellow in Rose,* 1954. Acrylic on canvas, 83 ¹/₂x67 ³/₄ in. MR 2 MOCA
4. *Purple Brown,* 1957. Acrylic on canvas, 84x72 in. MR 3 MOCA
6. *Black, Ochre, Red over Red,* 1957. Acrylic on canvas, 99 ¹/₄x 81 ¹/₂ in. MR 4 MOCA
7. *Red and Brown,* 1957. Acrylic on canvas, 68x43 in. MR 5 MOCA
1. *Red and Blue over Red,* 1959. Acrylic on canvas, 93x80 ³/₄ in. MR 6 MOCA
3. *Black and Dark Sienna on Purple,* 1960. Acrylic on canvas, 119 ¹/₄x105 in. MR 7 MOCA

ROBERT RYMAN (Nashville, Tennessee, 1930)

 1. *Allied,* 1966. Oil on cotton, 76x76 in. RRY 1
62. 2. *Standard nos. 1-2-3-4-5-6-8-9-10-11-12-13,* 1967. Enamel on
 21. steel, 12 panels, each 48x48 in. RRY 2
 3. 11. *Aacon,* 1968. Oil on linen, 98x98 in. RRY 3
11. 23. *Impex,* 1968. Oil on linen, 96x96 in. RRY 4
 12. *Classico I,* 1968. Acrylic on paper, 93x90 in. RRY 5
 6. *Classico II,* 1968. Acrylic on paper, 62x67 in. RRY 6
 65. *Classico IV,* 1968. Acrylic on paper, 91x91 in. RRY 7
67. 26. *Murillo,* 1968. Acrylic on paper, 80x84 in. RRY 8
67. 27. *J. Green I,* 1968. Acrylic on paper, 84x86 in. RRY 9
 7. *Classico 20,* 1968. Polymer on paper, 123x113 in. RRY 10
 63. *Four Units,* 1969. Enamelac on corrugated paper, 121x120 in. RRY 11
 66. 5. *Three Units (nos. 1-2-3),* 1969. Enamelac on corrugated paper, each panel 60x60 in. RRY 12
 66. 4. *Five Units (nos. 1-2-3-4-5),* 1969. Enamelac on corrugated paper, each panel 60x60 in. RRY 13
 16. *Untitled,* 1969. Enamelac on fiberglass, 18 ¹/₂x18 ¹/₂ in. RRY 14
 15. *Untitled,* 1969. Enamelac on fiberglass, 20x20 in. RRY 15
 17. *Mylar Pieces (nos. 1-2),* Milano 1969. Paint on mylar, 2 panels, each 15x15 in. RRY 17
 19. *Mylar Three Pieces (nos. 1-2-3),* Milano 1969. Paint on mylar, each panel 15x15 in. RRY 18
13. 30. *Surface Veil I,* 1970. Oil on linen, 144x144 in. RRY 19
 18. *General Painting,* 1970. Enamel on cotton, 49x49 in. RRY 20
 20. *General Painting,* 1971. Enamel on cotton, 53x53 in. RRY 22
13. 25. *Surface Veil II,* 1971. Oil on linen, 144x144 in. RRY 23
9. 13. 13. *Surface Veil III,* 1971. Oil on cotton, 144x144 in. RRY 24
 8. *Lenox,* 1971. Enamelac on cotton, 59x59 in. RRY 25
 29. *Central,* 1971. Enamelac on cotton, 69x69 in. RRY 26
 28. *Arista,* 1972. Enamelac on cotton, 70x70 in. RRY 27
 24. *Emprise,* 1973. Gripz on canvas, 70x70 in. RRY 28
10. 11. *Capitol,* 1973. Oil on canvas, 96x96 in. RRY 29
64. 11. *Empire,* 1973. Oil on linen, 96x96 in. RRY 30
 22. *Lithograph,* 1971. 29 ¹/₂x29 ¹/₂ in. RRY 31
 14. *Zenith,* 1974. Oil on wood, 96x144 in. RRY 32

GEORGE SEGAL (New York City, 1924)

1. *Man in the Armchair (Helmut von Erffa),* 1969. Plaster and wood, 49 ¹/₂x30x31 ¹/₂ in. GS 1 MOCA
1. *Sunbathers on the Roof Top,* 1963-1967. Plaster and mixed media, 34 ¹/₄x143 ¹/₂x96 in. GS 2 MOCA

RICHARD SERRA (San Francisco, California, 1939)

44. 45. *Belts,* 1966-1967. 9 vulcanized ruber units and blue neon tubing, 84x288x20 in. RS 1
43. 7. *Untitled,* 1967. Vulcanized rubber, 96 in. long approx. RS 2
43. 8. *Angle Slabs,* 1967. Fiberglass encased in rubber, 6x6x121 in. RS 3
43. 9. *Tearing Lead from 1:00 to 1:47,* 1968. 16x270x144 cm. (6 ¹/₄x107x57 in.) RS 4
 43. *Shovel Plate Prop,* 1969. Steel, 80x84x32 in. RS 5
 5. *Untitled,* 1969. Lead and steel, 98x121x20 cm. (38 ¹/₂x47 ¹/₂x8 in.) RS 6
 4. *Sign Board Prop,* 1969. Lead antimony, 60x60x33 in. RS 7
 41. *Clothes Pin Prop,* 1969. Lead antimony, 90x6x100 in. RS 8
 42. *Strike (to Roberta and Rudy),* 1969-1971. Hot rolled steel, 96x288x⁵/₈ in. RS 9
 1. *One Cut Bisected Corners,* 1973. 2 hot rolled steel triangles, each 104x504x1 ¹/₄ in. RS 10
 2. *Shafrazi,* 1974. Oil on linen, 114 ¹/₁₆x213 ¹/₄ in. RS 11
 3. *Zadikians,* 1974. Oil on linen, 2 units, each 129x102 in. RS 12
 40 *Different and Different Again Unequal Elevations,* 1973. 4 hot rolled steel units, 2 units each 12x180x12 in. and 2 units each 12x14x12 in. RS 13
 6. *Unequal Elevations,* 1975. 2 hot rolled steel units, 12x24x12 in. and 10x24x12 in., placed 960 in. apart. RS 14

JOEL SHAPIRO (New York City, 1941)

7. *Untitled,* 1971. Texas limestone, 5 1/2x4 3/4x4 3/4 in. JS 1
3. *Untitled (Coffin),* 1971-1973. Cast iron, 2 1/2x11 1/2x5 in. JS 2
6. *Untitled (Maquette for coffin),* 1971. Pine and italian poplar, 2 5/8x11 3/4x5 in. JS 2A
1. *Untitled (Chair),* 1973-1974. Cast iron, 3x1 1/4x1 1/4 in. JS 4
2. *Untitled (Table),* 1974. Cast iron, 5 3/8x6x4 7/8 in. JS 6
5. *Untitled (Maquette for table),* 1974. Bass wood, 5 3/8x6x4 7/8 in. JS 6A
4. *Untitled,* 1974. Cast brass, 2 3/8x5 7/8x5 3/4 in. JS 7

ANTONI TAPIES (Barcelona, Spain, 1923)

7. *All White,* 1955. Mixed media on canvas, 146x97 cm. (57 1/2x38 1/4 in.) AT 1 MOCA
6. *Grey Relief Perforated by a Black Sign,* 1955. Mixed media on canvas, 149x97 cm. (57 1/2x38 1/4 in.) AT 2 MOCA
4. *Grey and Black Cross,* 1955. Mixed media on canvas, 146x114 cm. (57 1/2x45 in.) AT 3 MOCA
8. *Grey on White,* 1956. Mixed media on canvas, 130x162 cm. (51 1/4x63 3/4 in.) AT 4 MOCA
2. *Collage on a Black Ground,* 1956. Mixed media on canvas, 130x162 cm. (51 1/4x63 3/4 in.) AT 5 MOCA
11. *Grey-Brown Composition,* 1957. Mixed media on canvas, 80x130 cm. (35x51 in.) AT 6 MOCA
12. *Brown-Ochre with Black Crevice,* 1957. Mixed media on canvas, 130x97 cm. (51 1/4x38 1/4 in.) AT 7 MOCA
10. *Ochre and Brown (New York),* 1957. Mixed media on canvas, 54x81 cm. (21 1/4x32 in.) AT 8 MOCA
3. *Black-Ochre with Perforations,* 1957. Mixed media on canvas, 146x114 cm. (57 1/2x45 in.) AT 9 MOCA
5. *Sable-Ochre,* 1957. Mixed media on canvas, 195x130 cm. (76 3/4x51 in.) AT 10 MOCA
11. *Red-Brown,* 1958. Mixed media on canvas, 114x146 cm. (45x57 1/2 in.) AT 11 MOCA
1. *Grey with Red Sign,* 1958. Mixed media on canvas, 146x89 cm. (57 1/2x35 in.) AT 12 MOCA
13. *Hammered Grey,* 1959. Mixed media on canvas, 116x89 cm. (45 1/2x35 in.) AT 13 MOCA
9. *Grey with Six Marks,* 1959. Mixed media on canvas, 260x190 cm. (102 1/4x74 3/4 in.) AT 14 MOCA

VITTORIO TAVERNARI (Milan, Italy, 1919 - Varese, Italy 1987)

2. *Grande torso (il fiume),* 1954. Wood, 150x58x45 cm. (59x23x17 3/4 in.) VT 1
1. *Figura sdraiata,* 1971. Bronze, 56,5x39,5 cm. (22 1/4x15 1/2 in.) VT 2
 Figura, 1965. Drawing on paper, 69x49 cm. (27 1/8x19 1/4 in.) VT 3

JEAN TINGUELY (Fribourg, Switzerland, 1925)

4. *La Vittoria,* Milano 1970. Drawing, 41,6x29,4 cm. (16 3/8x11 5/8 in.) JTI 1
2. *La Vittoria (Vive Panza),* Milano 1970. Drawing, 40,8x32,7 cm. (16x12 7/8 in.) JTI 2
3. *La Vittoria (Per Panza),* Milano 1970. Drawing, 41,5x33 cm. (16 3/8x13 in.) JTI 3
1. *La Vittoria (Mille grazia),* Milano 1970. Drawing on both sides, 41x33 cm. (16 1/8x13 in.) JTI 4

DAVID TREMLETT (St. Austell, England, 1945)

1. *Cue,* 1974. 21 drawings in asymetical shape on wall, each 12,7 x 20 cm. (5 x 8 in.). DT 1
2. *Watching the Way the Rabbits Run in Milwawkee,* 1975. 4 drawings, photograph and text on paper, 76 x 128 cm. (30 x 50 1/2 in.) DT 2

5. *Watching the Way the Rabbits Run in Kalgorlie,* 1975. 4 drawings, photographs and text on paper, 76 x 128 cm. (30 x 50 1/2 in.) DT 3
6. *Watching the Way the Rabbits Run in Aberdeen,* 1975. 4 drawings, photograph and text on paper, 76 x 128 cm. (30 x 50 1/2 in.) DT 4
 Form one work of 6 parts:
7. *Scotland 1/1 (Lock Ness),* 1975. 8 drawings and text on paper, 33,5 x 91,5 cm. (13 1/4 x 36 in.) DT 6
3. *Scotland 1/2 (Lock Ness),* 1975. 8 drawings and text on paper, 33,5 x 91,5 cm. (13 1/4 x 36 in.) DT 7
4. *Scotland 1/3 (Lock Ness),* 1975. 8 drawings and text on paper, 33,5 x 91,5 cm. (13 1/4 x 36 in.) DT 8
8. *Scotland 1/4 (Lock Ness),* 1975. 8 drawings and text on paper, 33,5x91,5 cm. (13 1/4 x 36 in.) DT 9
10. *Scotland 1/5 (Lock Ness),* 1975. 8 drawings and text on paper, 33,5 x 91,5 cm. (13 1/4 x 36 in.) DT 10
9. *Scotland 1/6 (Lock Ness),* 1975. 8 drawings and text on paper, 33,5 x 91,5 cm. (13 1/4 x 36 in.) DT 11

JAMES TURRELL (Los Angeles, California, 1943)

3. *Argus,* Varese 1976. A room projection. JT 1
1. *Afrum I,* 1967. A room projection. JT 2
108. 109. *Virga,* Varese 1976. Ambient sky light and fluorescent light. JT 3
105. 106. *Sky Space I,* Varese 1976. An overhead portal cut to outside
107. sky interior fill light. JT 4
103. 104. *Sky Window I,* Varese 1976. A vertical portal cut to outside sky and interior fill. JT 5
4. *Wallen,* Varese 1976. A room projection. JT 10
2. *Iltar,* 1976. Wall (400 x 657 cm. - 158 x 259 in.) with cut (200 x 327 cm. - 79 x 129 in.) placed at 300 cm. (118 in.) from endwall of room, artificial light. JT 11

CY TWONBLY (Lexington, Virginia, 1929)

1. *Untitled,* 1957. Mixed media on canvas, 20x25 cm. (8x10 in.) CT 1

LAWRENCE WEINER (New York City, 1940)

4. *Cat. No. 029. THE RESIDUE OF A FLAIRE IGNITED UPON A BOUNDARY,* 1969. LW 1
6. *Cat. No. 052. ONE KILOGRAM OF LACQUER POURED UPON A FLOOR,* 1969. LW 2
86. *Cat. No. 051. 1000 GERMAN MARKS WORTH MEDIUM BULK MATERIAL TRANSFERRED FROM ONE COUNTRY TO ANOTHER,* 1969. LW 3
5. *Cat. No. 85. A STAKE SET IN THE GROUND IN DIRECT LINE WITH A STAKE SET IN THE GROUND OF AN ADJACENT COUNTRY,* 1969. LW 4
 Cat. No. 089. A WALL STRIPPED OF PLASTER OR WALLBOARD, 1969. LW 5
 Cat. No. 090. THE JOINING OF FRANCE GERMANY AND SWITZERLAND BY ROPE, 1969. LW 6
 Cat. No. 091. A STAKE SET, 1969. LW 7
 Cat. No. 146. A RUBBER BALL THROWN ON THE SEA, 1969. LW 8
 Cat. No. 147. A STONE WALL BREAKED, 1969. LW 9
 Cat. No. 148. AN AMOUNT OF MATERIAL PLACED UPON THE OCEAN NORTH TO THE COAXIAL CABLE AN AMOUNT OF MATERIAL PLACED UPON THE OCEAN SOUTH OF THE COAXIAL CABLE, 1970. LW 10
1. *Cat. No. 150. A STONE LEFT UNTURNED,* 1970. LW 11
87. *Cat. No. 151. EARTH TO EARTH ASHES TO ASHES DUST TO DUST,* 1970. LW 12
 Cat. No. 157. TO THE SEA, 1970. LW 13
 Cat. No. 158. ON THE SEA, 1970. LW 14
 Cat. No. 159. FROM THE SEA, 1970. LW 14A
 Cat. No. 160. AT THE SEA, 1970. LW 15
 Cat. No. 161. BORDERING THE SEA, 1970. LW 16
3. *Cat. No. 099. SMUDGED,* 1970. LW 17

7. *Cat. No. 100. FLUSHED,* 1970. LW 18
Cat. No. 101. MARRED, 1970. LW 19
85. *Cat. No. 102. REDUCED,* 1970. LW 20
Cat. No. 218. WEAKENED FROM WITHIN, 1970. LW 21
Cat. No. 229. BESIDE ITSELF, 1970. LW 22
2. *Cat. No. 238. OVER AND OVER. OVER AND OVER. AND OVER*
AND OVER. AND OVER AND OVER., 1971. LW 23
Cat. No. 276. TO HAVE AND HAVE NOT, 1972. LW 24
Cat. No. 277. TO HAVE AND TO HOLD, 1972. LW 25
Cat. No. 278. TO SEE AND BE SEEN, 1972. LW 26
Cat. No. 279. TO GIVE AND TO TAKE, 1972. LW 27
Cat. No. 280. TO SHOW AND TO TELL, 1972. LW 28
Cat. No. 257. AFFECTED AS TO PRESSURE AND/OR PULL
EFFECTED AS TO PRESSURE AND/OR PULL, 1971. LW 29
Cat. No. 282. LOUDLY MADE NOISE (forte) AND/OR
MODERATELY LOUDLY (mezzoforte), 1972. LW 30
Cat. No. 283. SOFTLY MADE NOISE (piano) AND/OR
MODERATELY SOFTLY (mezzopiano), 1972. LW 38
Cat. No. 284. NOISE MADE VERY LOUDLY (fortissimo)
AND/OR MODERATELY LOUDLY (mezzoforte), 1972.
LW 39
Cat. No. 285. NOISE MADE VERY SOFTLY (pianissimo)
AND/OR MODERATELY SOFTLY (mezzopiano), 1972.
LW 40
Cat. No. 258. AFFECTED AS TO HEAT AND/OR
COLD EFFECTED AS TO HEAT AND/OR COLD, 1971.
LW 45
Cat. No. 259. AFFECTED AS TO EXPLOSION AND/OR
IMPLOSION EFFECTED AS TO EXPLOSION AND/OR
IMPLOSION, 1971. LW 46
Cat. No. 260. AFFECTED AS TO CORROSION AND/OR
VACUUM EFFECTED AS TO CORROSION AND/OR
VACUUM, 1971. LW 47
Cat. No. 261. AFFECTED AS TO NOISE AND/OR
SILENCE EFFECTED AS TO NOISE AND/OR SILENCE,
1971. LW 48
First Quarter, 1972. 16 mm. black and white film, F-3 copy B.
LW 52

DOUG WHEELER (Globe, Arizona, 1939)

113. 114. *Ace Gallery Installation (Environmental light),* January 1.
1. 1970. 180 x 352 in. DW 1

5. *Eindhoven Stedelik Van Abbemuseum Installation*
(Environmental light), 1969-1970. 144 x 192 in. DW 2
2. *Amsterdam Stedelijk Museum Installation (Environmental*
light), September 1969. 192 x 384 in. DW 3
13. *Tate Gallery Installation,* 1970-1975. 192 x 843 x 633 in. DW 4
9. *Suspended Volume in Reflecting Spectrum,* 1975. 144 x 288 x
288 in. DW 5
3. *PSAD Synthetic Desert III.* 1971. 480 x 480 in. DW 6
12. *CC OSZ 75 Counter Orientation Space,* 1975.
144 x 504 x 504 in. DW 7
4. *Luminefepous Space,* 1968-1975. 144 x 288 x 288 in. DW 8
11. *RM LA DW 75 Invisible Reflecting Horizontal Plane,* 1975. 144
x 312 x 240 in. DW 9
10. *WM NY DW 75 Sequential Planal Rotational Piece,* 1975, 153
x 468 x 288 in. DW 10
14. *SA MI DW SM 2 75 Continum Atmospheric Environment,*
1975. Ceiling height approx twice that of man, depth and
width equal, and at least 5 times man's reach. DW 11
8. *Invisibly Defined Cube in Free Space,* 1971. 144 x 432 x 432
in. DW 12
7. *LC OP 75 70 DW Space Corridor - Dissected 360°*
Hemisphere, 1970-1975. 192 x 840 x 600 in. DW 13
6. *Diagonal Light Passage - Synthetic Shear DW 7 4 75,* 1975.
144 x 480 x 336 in. DW 14

IAN WILSON (New York, 1940)

Discussion: January 1972. IW 1
Discussion: June 1972. IW 2
Discussion: April 8, 1973. IW 3
Discussion: May 5, 1974. IW 4
Discussion: May 9, 1974. IW 5
Discussion: October 30, 1974. IW 6
Discussion: November 3, 1974. IW 7

Typesetted by
CONÈDIT (interview)
ELLEDUE (catalogue)
Milan

Color separations by
MEDIOLANUM
Milan

Printed in Italy by
LEVA SPA. ARTI GRAFICHE
Sesto S. Giovanni (Milan)

Bound by
PIOLINI
Milan